MASKMAKING

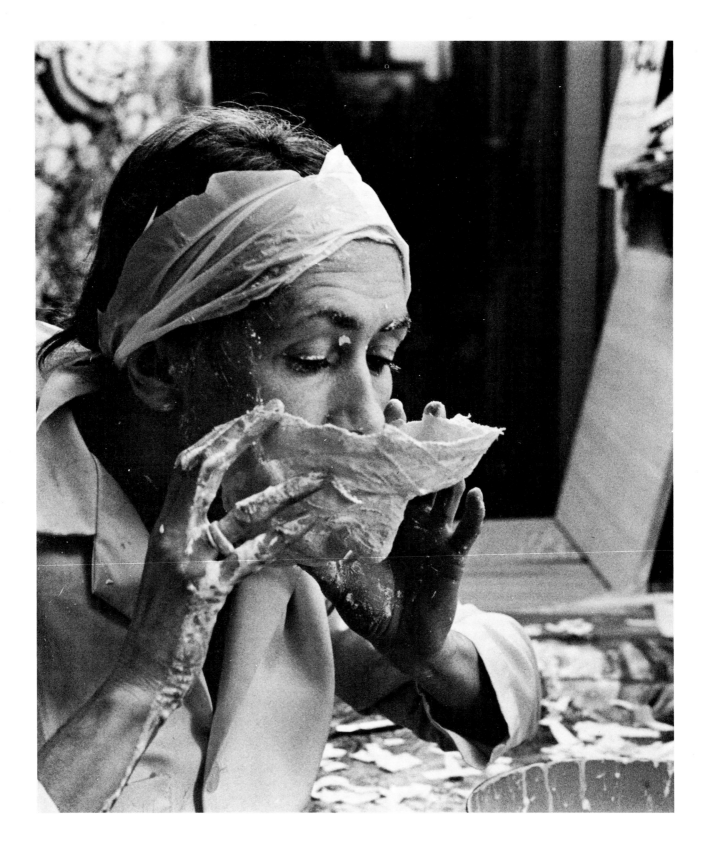

MASKMAKING

Carole Sivin

Davis Publications, Inc.
Worcester, Massachusetts

To my parents,
Edward and Gladys Delmore,
who always wanted me to write this book.

CAROLE SIVIN was trained in art education and painting at SUNY, Buffalo. She has given maskmaking workshops at Harvard University, Boston Museum School of Fine Arts, York University in Toronto and the Rhode Island School of Design. She has been commissioned to make masks for Pilobolus Dance Theatre and New York's Feld Ballet. Her work has been exhibited internationally. Currently she teaches at Temple University and the Philadelphia College of Textiles and Science.

Unless otherwise noted, all masks in this book are by Carole Sivin. All photos, unless otherwise noted, are by Carole or Nathan Sivin.

Cover Photo:
A Korean dance mask from the author's collection.

Back Cover:
Masks by Art Brannick, an eighth grade student at Reading Fleming Middle School, Flemington, NJ. His art teacher was Diann Berry. Used by permission.

Copyright 1986
Davis Publications, Inc.
Worcester, Massachusetts U.S.A.

Design: Dede Cummings
Printed in the United States of America
Library of Congress Catalog Card Number: 86-70902
ISBN: 0-87192-178-2

10 9 8 7 6 5

Acknowledgements

Many people have helped me over the years with this book. I particularly wish to thank Nathan Sivin for his constant encouragement, support and help with photography and proofreading.

Virginia Dalton has typed endless copies and her daughters Hilary and Dabney have been available at a moment's notice to try on a mask or explore a new technique. Keith Styrcula helped with the typing, phone calls, query letters, and endless encouragement. Jerome Aumente and Sallie Warden gave me valuable writing advice when the book was in its early stages. Charlotte Shoemaker suggested Davis Publications, Inc. as a publisher. Alison Chase of Pilobolus tried many zany poses with masks so I could get a photograph. Larry Maxwell and Kammy Brooks of "Mask Transit" days and Selma Odom of Toronto were influential in showing me the power of masks in dance and theatre at the very beginning. Elaine Cohen and others at the R. B. Pollock Elementary School made it possible to work with the creative children whose work is included in the book. Peter Sasgen and Birgitta Ralston have taken magical photographs over the years and Jack Zankman and his staff at Chestnut Hill Camera gave me much good photographic advice. Max Frei printed my own photographs.

I am grateful to students and friends at the George Brown College in Toronto, Cambridge Adult Center, Temple University and the Philadelphia College of Textiles and Science.

I wish to thank Aylette Jenness, Carolyn Conrad, Joseph Hodnick, Roberta Delaney, Christine Gratto, Martha Gittelman, Charles Weiner and others who were always a phone call away.

Special thanks goes to my editors at Davis Publications for their sound judgement and great sense of humor.

Carole Sivin

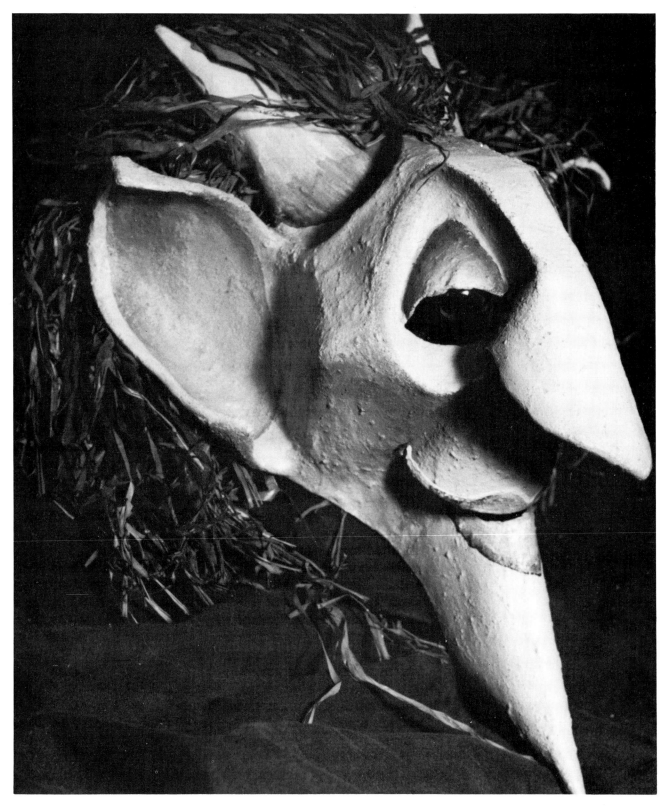

Devil, celastic and paper. Courtesy
Pandemonium Puppet Co. Photo by
Bonnie Meier.

Table of Contents

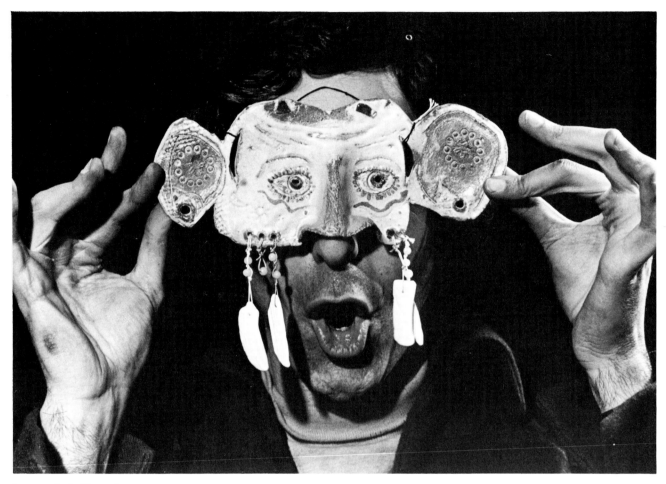

A ceramic half-mask.

Introduction

The human face communicates. Cover it with almost anything and the transformation can be disconcerting, horrifying or hilarious. Masks—even the simplest ones—powerfully change the human face. When altered by a mask, the wearer becomes anonymous, denies us access to the signals we are accustomed to, or sends us new messages to interpret.

Masks evoke and commemorate as well as describe a person. Through the mask, expressions of anger, fatigue and peace are revealed and concealed. Masks, especially those made from a mold, capture states of mind as well as the bone structure of the model. The value of the mask can be fully seen only when it is worn. Then the mask, a face alive without living, becomes part of the being who charges it with a life force.

People have worn masks for centuries, all over the world, and they still do. The Greeks used masks to isolate particular human

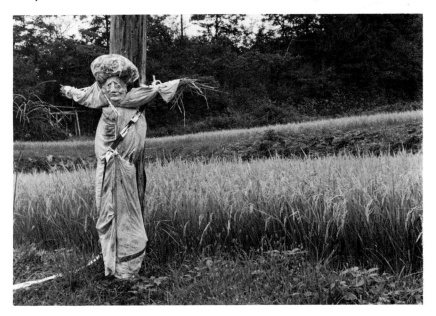

A scarecrow in a Japanese field, adorned with one of the author's masks.

characteristics such as lust, greed, despair and virtue; they also used megaphones in masks to reach their vast audiences. The Northwest Coast Indians created complicated transformation masks that combined human and animal attributes, and gave the wearers supernatural power by connecting them to the natural and spiritual worlds at the same time.

Today, masks appear not only in museums and galleries, but also at political demonstrations, sports events, festivals and carnivals, on the faces of football players, motorcyclists and astronauts. Sunglasses, goggles, respirators and surgical masks, while primarily used for protection, also disguise the face and have become professional symbols.

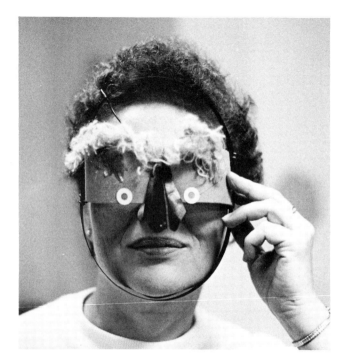

This half-mask was made from found materials by Jean Adelman.

This book celebrates masks and maskmaking. Its purpose is to make artists, craftspeople, teachers and students aware of the diversity of masks and the rich sources of inspiration to be found in old and new materials and methods. The book first explains how to make the simplest masks from familiar materials, goes on to explore negative and positive mask molds of plaster and clay, and then describes the use of less common materials such as buckram and celastic. A chapter on decorating the finished mask provides practical information about paints, varnishes and special effects. Teachers of young children will find the final chapter on maskmaking activities for the elementary grades especially useful.

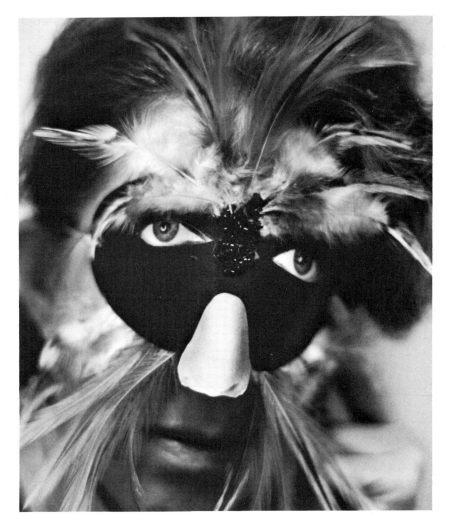

A domino mask by Valli Korin is accented with feathers, cutout eyes and a nose.

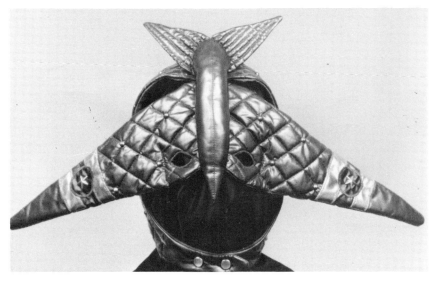

Philadelphia artist Kate Murphy used quilted fabric embellished with studs for her airplane.

Clay mask.

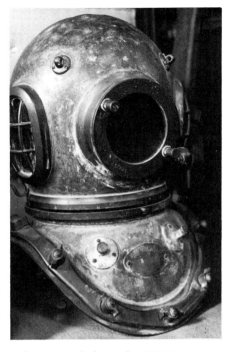

A diving mask from the 1940's can provide inspiration for mask designs.

Before You Begin

A simple black dime store mask can make an emphatic statement. To move beyond the simple mask, however, and explore maskmakings's innumerable expressive possibilities, it is important to look carefully at masks—in this book, in museums and in the everyday world. Look at the materials of which these masks are made, and consider what is available to you. Substitute lace or leather for paper, for example. Could a mask be made of string? Onion skins? Corks?

Look carefully at the faces of people around you. Familiarity with the size of the face and its features will help you identify effective maskmaking materials and suggest possible ways to exaggerate or understate the mask itself. You will begin to see the many planes of the face and discover endless variations in wrinkles, eminences and hollows. A journal or notebook will help you keep track of your observations, inspirations and discoveries. It will give you a place to sketch design ideas and record technical information.

Finally, think about the skills and knowledge you have that you take for granted—your experience in daily activities such as cooking, repairing things, gardening, sewing. These can also be incorporated into mask work or used for inspiration. You'll find that maskmaking helps you look at yourself—and the rest of the world around you—with a new and sharper eye.

Even sunglasses can be a kind of mask.

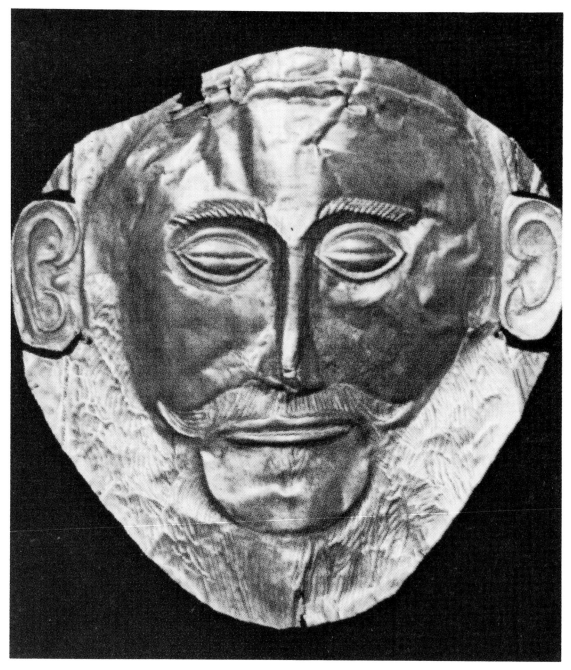

Funeral mask, about 1500 B.C. Beaten
gold, about 12″ (30 cm) high. Royal
Tombs, Mycenae. National Archeologi-
cal Museum, Athens.

1 *The History of Masks*

"The actor, before placing the mask on his face, stares at it intently, holding it by the two unpainted places near the earholes (the only place where the surface should be touched). From the moment the mask is in place, he considers himself completely transformed into the character he is to portray. The actor is taught that he is not to put the mask on, but that he must put his whole self, body and soul into the mask."

— *Nōh*, DAIJI MARUOKA AND TATSUO YOSHIKOSHI,

Masks have been used for more than 30,000 years, on all six continents. The ancient Greek word for mask is *prosopon* (face); the Latin word is *persona*, while *personare* means "to sound through."

The Ancient World

Cave walls from prehistory show some of the first images of humans, and some of these first images are figures wearing masks. In the "Trois Freres" caves in France, for example, a human believed to be a sorcerer or shaman is represented. It wears a stag's head topped with immense antlers, an owl's face, ears like a wolf's, a long goat's beard, arms ending in bear's paws and a horse's tail. Other early mask representations are found on cave walls in Tassali, near South Algeria. Paleolithic depictions of men in animal disguises have been found on cave walls in Spain and Dordogne.

As early as 2000 B.C., the Egyptians used burial masks, modelled to the visage of the deceased. The masks were made of

Flat masks like these, made of heavy paper, have been worn for centuries in the annual Bull Festival outside Kyoto, Japan.

layers of linen pressed together and covered with a thin stucco upon which the features were painted. In Ancient Greece, masks were used in tragedies, comedies and satirical plays. Thespis introduced the use of a white linen mask over the face, while face-painting using white lead and wine lees was also popular. Sophocles and Euripides wrote elaborate plays in which several characters could be impersonated by one actor changing masks, and bull-masked men can be seen in early Greek frescoes.

In the second century A.D., exaggerated masks made of cork and wood used a megaphone-like mouthpiece inside for vocal delivery in vast auditoriums. Masks representing supernatural and demonic beings were often used in rituals. In Rome, as in Greece, theatrical masks were a necessary part of seasonal and religious ceremonies.

Ancient deathmasks of Mycenae, Peru, Manchuria, Korea and Egypt were made of plaster, gold, silver, bronze and terra cotta. Because these masks—especially the gold ones—were made of incorruptible material, they preserved facial features erased by death. In many cultures the mask, like the head, was regarded as the seat of the life of the soul. Wax deathmasks of Roman nobility were made from molds, painted in natural colors by an embalmer and placed on the dead man's face. A man was followed to his tomb by masked impersonators of all of his ancestors. After the burial, the mask of the deceased person was hung in the atrium.

The East

Japanese Mask Drama

Some of the oldest extant masks are found in Japan, where theater is alive and revered. According to theatre writer Faubion Bowers, "Japan stands as the only country whose theater has never suffered an eclipse nor undergone any drastic revivification or renovation. Both its dance and drama are intact, obedient to their original conceptions, and all their traditions of hereditary acting families, conventionalized stagecraft and archaic costumes have been preserved."

Nōh drama (*nōh* means talent) is about five hundred years old. It has been compared to Greek drama because of its use of masks, a chorus, poetry and song. It was originally performed in temple precincts, but there are now over eighty *Nōh* theaters in Japan and about three hundred plays in existence.

Nōh masks are carved from cypress, a lightweight wood with a fine grain. The masks are smaller than the actor's face, are always worn by men, and because of the small eye apertures,

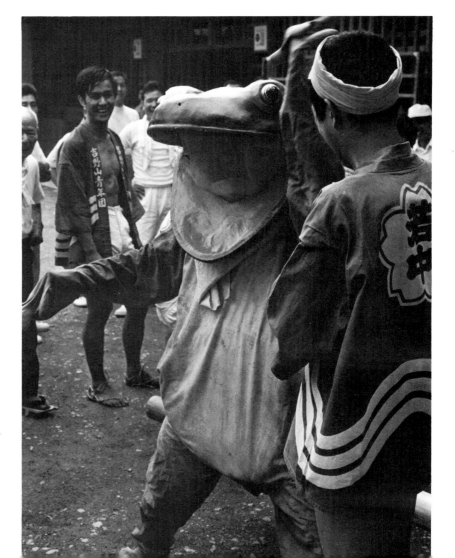

A participant in the Frog Festival, an annual Japanese religious festival. Inside the "frog" is a person who peers through an open, gauze-covered mouth.

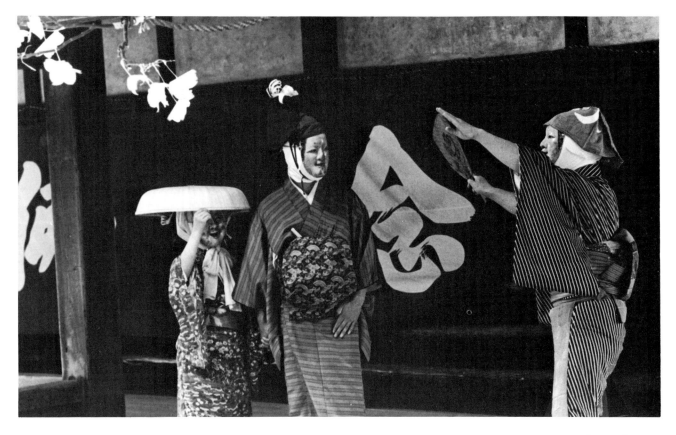

A mask pantomime at the Mibu Temple, Kyoto, Japan. Actors wear ancient masks and costumes in a week of performances, accompanied only by the haunting music of a drum, a flute and a gong.

afford limited vision. The maskmaker carves slowly and carefully, using sharp chisels, a mallet and paring knives. He follows an exact, rigorous procedure established long ago. Before the carving begins, the artist spends long periods contemplating the block of wood, preparing his materials and concentrating on the form to be created.

Once the mask is finished, the actor who wears it must give it life. Through nuances of movement and subtle changes in the tilt of the actor's head, the mask can become radiant one moment and grief-stricken the next. Masked characters represented in the *Nōh* drama are the female, old people, the warrior and demons.

Kyōgen are short farces featuring masks and pantomime, used as interludes during the lengthy *Nōh* performance. Mibu Kyōgen, a specialty of Kyoto, Japan, is performed annually during April at the Mibu temple. These plays are Buddhist legends, each with a moral, that also explore *Nōh* themes. The actors, clothed in fourteenth century costumes and masks, perform acrobatics and hilarious ribald mime using folding fans and very few other props.

Bugaku and *Gigaku* dances first appeared in the Japanese

Imperial Court 1300 years ago, and are still performed occasionally today. Each Bugaku dance has its own particular mask, whether human or bestial. Gigaku masks are larger, and cover the face and the upper part of the head. Because of their value and fragility, the oldest of these masks can only seen in museums.

Kabuki, the most famous drama in Japan, incorporates song, dance and spectacular stage effects. While many people think of masks when they think of Kabuki, actors actually use facial make-up reminiscent of Chinese theatre.

China Masks were first used in Chinese opera during the T'ang Dynasty, 618–907 A.D. Elaborate face painting gradually replaced them (although some rural festivals still use papier-mâché masks) but the rules that governed face painting developed from

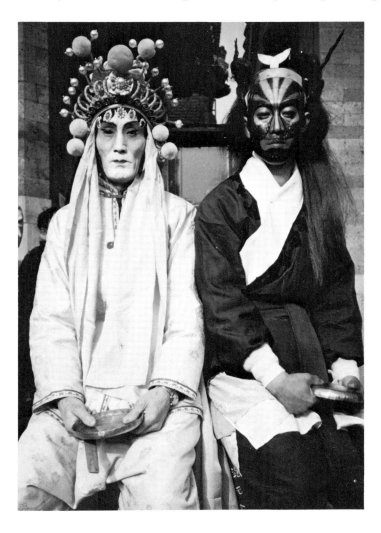

Made-up faces of Chinese stilt dancers. Photo by Li Shi Yu.

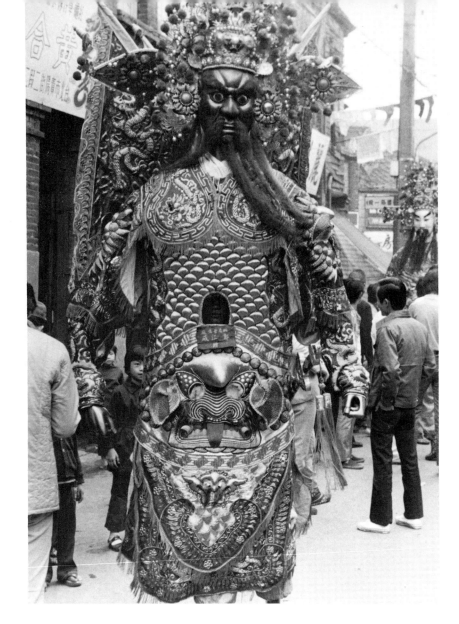

A large temple god constructed on a wooden framework walks in a procession in Taipei, Taiwan. The wearer looks out through a window in the stomach.

those early masks. Particular colors came to represent particular attributes: red for loyalty, white for treachery, gold and silver for supernatural beings. Uneven facial features depicted cunning, while two straight eyebrows indicated an upright person.

Korea Since the fifth century A.D., masks have been a precious and intimate part of Korean life. Early masks were used primarily in religious rites, for dispelling evil spirits, curing illness, promoting a good harvest. Today, in village festivals and celebrations in many parts of Korea, actors use masks and puppets of

paper, cloth, leather, bamboo, wood and gourds. Color symbolism and the shape of the features show the character of each person represented. Black means evil, red means power, for example. A cloth hood covers the back of the head and is used for tying the mask on.

Bali Masks are greatly revered in Bali. Many are carved of wood from the Cinchona tree and represent characters such as kings, ministers, old men and buffoons. Each actor plays several roles during the performance by changing masks; actors in half-masks narrate, while those in full masks perform in pantomime. Performers in the masked Topèng drama are trained since childhood in voice, dance and historical literature.

Every activity associated with the mask, from carving, through performance, to the mask's storage and preservation, is treated with grave respect. An offering to the gods is given before each performance.

Carved wooden mask made in Bali.

Large but lightweight, this bamboo mask was made by a New Guinea artist, sealed with clay and painted with a mixture of charcoal, lime, ocher and palm oil. It is four feet high and six feet wide.

Africa

Masks have been most important in African culture in the west, where there has been the most artistic development. The area between Senegal and Angola, bordered in the north by the Sahara Desert, in the south by the Kalahari Desert and in the east by the great lakes, is known for its artistic activity. The masks described here are from that area.

African masks vary in size and show ingenious combinations of form, color and texture. Although wood is the most common material, clay, ivory, metal and bone are also used. The skillful craftsperson uses dedication and laborious carving techniques. Usually an offering or prayer will be given before carving commences by the artist, who generally has high status within the tribe. The masks are used in initiation ceremonies, cult rituals, celebration of harvest, judgement of prisoners, exorcism of evil spirits, and in entertainment.

Stylized Dogon masks are large wooden masks which represent mythical ancesters, as well as crocodiles, antelopes, ostriches and lions. Some Dogon masks are simple triangular shapes, while others support a high superstructure. Shells and fibers are often attached to the mask.

White masks from Bagon have an oriental feel. The mask is painted with Kaolin, has an elaborate crested coiffure and long slits for eyes. Most of these delicate masks have scarification patterns carved in relief on the cheeks or forehead. They are known as "duma" or "mvudi," which means dance. Each of the masks represents a dead woman who has returned from the dead and taken up abode in the mask. They are usually worn by dancers wearing raffia, performing on stilts in the full moon. Stilt dancing with masks is also found in Guinea and Liberia.

The Bamileke tribe has a long tradition of covering masks with beads and cowrie shells. Each of these masks contains a vital spirit or force which takes over the dancer who wears it. The dancer is transformed into the spirit of the mask, and his own identity is temporarily obliterated.

The great vitality and power of African masks has acted as a catalyst and influenced many twentieth century painters and sculptors.

Poro Society mask. N'Gere peoples, Ivory Coast, Africa. Wood, fiber and fur, about 18" (46 cm) high. Baltimore Museum of Art, gift of Mr. and Mrs. Leonard Whitehouse and Dr. and Mrs. Bernard Berk.

17

The Western World

Mystery and Morality

While theater was suppressed by the Catholic church in the middle of the sixth century, medieval mystery plays were used within the church to tell the story of church liturgy and recount incidents in the lives of saints. Recent research indicates that the use of masks in medieval theater was much more widespread than has been previously imagined.

From the mystery plays, morality plays evolved. They were a mixture of farce, ritual, satire, pageantry, acrobatics, music, fireworks and masks, performed in the vernacular on a stage. The plays often focused on the struggle between good and evil, with actors portraying specific human qualities. The devil—a favorite character—and death figured prominently in these plays, and wore fantastic costumes and masks. In one account, the devil is described as hairy and frightening, with bloodshot eyes, a cat's head and sharp teeth.

Comic theatrical traditions, maintained by minstrels, mummers and mimes, have always persisted in spite of religious edicts. The masked carnival, for example, has survived since the Middle Ages as an annual opportunity to shed inhibitions and social distinctions, and rejoice. Haunting old Swiss and German masks used in the carnival can be seen in museums in Basel, Munich, Berlin and Leiden. Santa Claus, nature spirits, and polished, lifelike human faces are among those on display. Both old and new masks are still given life yearly in European carnivals. The emphasis is always on the grotesque: false noses, protruding bellies and buttocks, and asses' ears make it impossible for the wearer to take him or herself seriously.

Hieronymus Bosch and Pieter Breugel the Elder, Flemish artists who lived when morality plays were being performed (c. 1450–1525), depicted the contrasts of good and evil in their paintings. Masked figures, carnival scenes, malevolent objects and demoniacal creatures ranged through Bosch's unforgettable works. Breugel painted masked figures and got many of his ideas from local folklore and the celebrations of common people.

Sixteenth through Eighteenth Centuries

The *commedia dell'arte*, improvised popular comedy using stock characters, arose in Italy in the middle of the sixteenth century and continued for two hundred years. Actors used half-masks, made of leather and lined with linen, which placed emphasis on the actor's whole body by erasing facial features.

By the end of the sixteenth century, masks were extremely popular among European noblewomen. They were worn to the theatre to avoid recognition and outdoors to protect the complexion. Occasionally, men also wore these masks, made of velvet, satin and taffeta and lined with thin leather or silk.

In the seventeenth and eighteenth centuries, masks were used for disguise, coquetry and as protection in bad weather. A small black velvet Venetian mask was called *loup*, meaning "wolf," because it frightened children. Some silk masks covered the whole face and were held in place by a glass or silver button clenched between the teeth. Some were held by a handle, others by a string attached to the sides and tied back. Artists of the time, such as Pietro Longhi, Callot, Tiepolo and Watteau, were inspired by masked figures and included them in their paintings.

In England, Inigo Jones and Ben Jonson developed theatrical productions called masques, performed for and by the aristocracy. Scenery and costumes were elaborate, and visual surprise was the norm. The characters were masked goddesses, nymphs and other mythological figures.

Native Americans

A small leather and fur mask, made in Alaska.

From the sixteenth to late nineteenth centuries, the Northwest Coast Indians inhabited an area that covered over 1000 miles, from Washington State to southern Alaska. The spectacular dual masks of the Kwakiutl had complicated, ingenious components. Drawstrings operated by the dancer snapped open the outside hinged animal or bird mask to reveal a human mask inside. Eyelids, jaws and other parts were also sometimes animated. These large dance masks, made of cedar, made a bold sculptural statement. The often surrealistic "portrait" masks of the Tsimshian, Haida and Tlingit present the most refined examples of native American maskmaking.

Inuit (Eskimo) masks were varied and imaginative, and commemorated Shamans' journeys to the spirit world. Among the Alaskan tribes, men generally wore face masks, while women danced wearing intricate finger masks.

The Iroquois of the northeastern U.S. carved and painted wooden "false-face" masks that portrayed mythical beings who could inflict and cure sickness. Some Iroquois masks had hair attached to them; others were made of plaited corn husks.

Southwestern Indian tribes such as the Hopi, Zuni, Navajo and Apache also made masks which were carved, painted or made of leather, pumpkins or cloth.

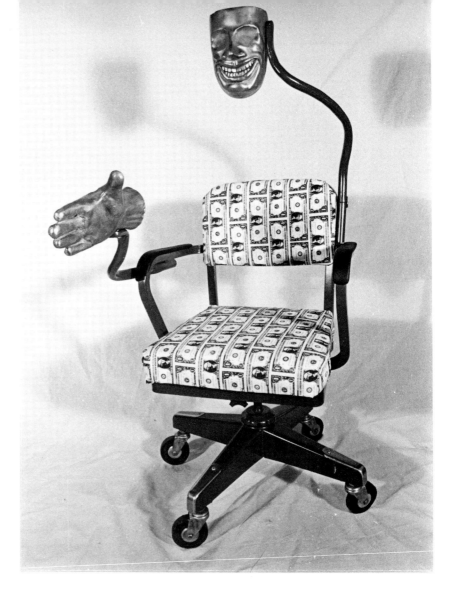

Gard Jones, *Office Furniture for the Young Urban Professional III—The Phony.* Mixed materials, 60″ (152 cm) high. Courtesy the artist.

To the Present Many artists and writers of the nineteenth and twentieth centuries have been influenced by masks and their use in ceremony and ritual, and often this influence is visible in their work. James Ensor, a Belgian painter born in 1860, responded to Flemish carnivals and masked figures in much the same way Bosch and Breugel had, incorporating them symbolically into his paintings. In the early years of the twentieth century, Pablo Picasso made careful studies of the commedia dell'arte, and used masked figures in ballet collaborations with Eric Satie. Artists such as Vassily Kandinsky, Andre Derain, Maurice de Vlaminck, Amedeo Modigliani and Henri Matisse were also interested in masks.

Dada artists in Zurich during the first World War used masks in the "Cabaret Voltaire" to express their disgust and defiance toward the war. Oskar Kokoschka, Paul Klee and Jean Arp depicted political events and the terror of wartime Europe through paintings, plays and puppet shows in which masks had a prominent role.

Playwrights W.B. Yeats, Bertolt Brecht, Eugene O'Neill and Luigi Pirandello were writers for whom masks were an important theatrical ingredient. Yeats' "At the Hawk's Well" and "The Only Jealousy of Emer," and O'Neill's "The Great God Brown" and "Lazarus" are good examples of the mask's use in modern theater.

Today artists draw on centuries of maskmaking tradition, revitalizing ancient designs and creating new ones. Whether used in meditative silence or to the persistent drumming of instruments, whether simply hung or intricately lit, masks continue to conceal and reveal, communicating the innumerable messages of cultures worldwide.

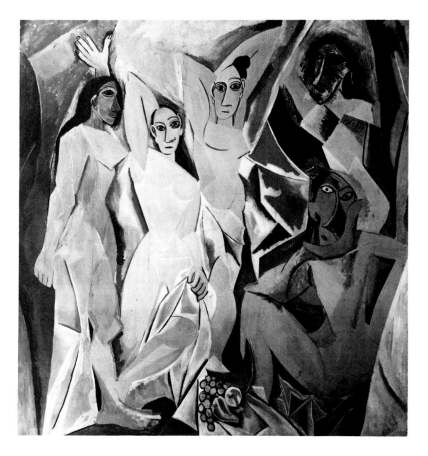

Pablo Picasso, *Les Demoiselles D'Avignon*, 1907. The Museum of Modern Art, acquired through the Lillie P. Bliss Bequest.

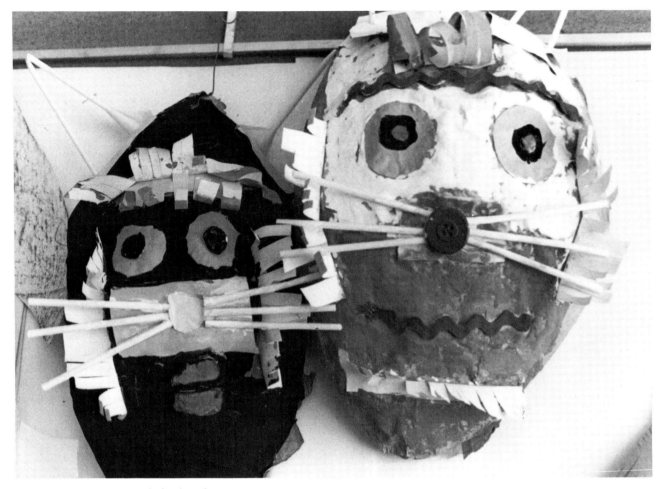

These two cats were made by fourth-graders who applied papier-mâché over a balloon form.

2 *Easy-To-Make Masks*

Even though the simple maskmaking techniques described in this chapter use modern materials, people have been making masks from cloth and, later, paper, for many centuries. Acrobats especially have always needed lightweight masks they could make themselves. Among the oldest Japanese masks are the ones painted on cloth and tied around the head.

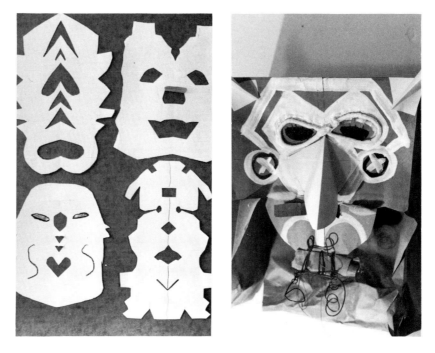

Left: Simple cutout shapes can be made into individual masks. Reinforce them or glue them to the front of a paper bag for an effective, strong design.

Right: The creator of this paper bag mask used paper sculpture techniques.

A simple paper bag mask with mixed media.

Paper Bag Masks

One of the most readily available materials for maskmaking is the plain brown grocery bag. It can be slipped over the head to rest on the shoulders, or cut off to become a half-mask. Press with the point of a crayon to mark the position of the eyes and the nose. Although the paper bag by itself cannot support heavy decorations, it can be easily reinforced for extra strength. When decorating, use paper sculpture methods such as curling, weaving, scoring, bending and twisting. Use glue, staples, paper fasteners or wire to attach appendages. Both children and adults find paperbag maskmaking challenging. An inventive theater group called the "Paper Bag Players" uses simple paper bags and cardboard boxes as their main costume elements, incorporating found objects into their designs in an imaginative way.

Materials

Paper bag
Glue, staples, paper fasteners or wire
Crayons or paint for decoration

A mystical paper bag mask that seems capable of flight is the work of a seventh-grader. Courtesy Fulton County Schools, Atlanta, Georgia.

Courtesy Milwaukee, Wisconsin Public Schools.

A scene from "I Won't Take a Bath," performed by The Paper Bag Players. Photo by Bill Powers.

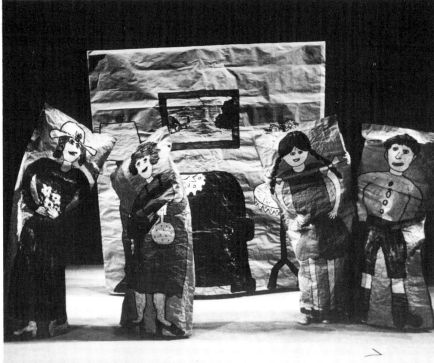

A paper plate with hair and fabric glued to it nearly disguises the wearer. Student work.

Results of a mask workshop.

Paper Plate Masks

A paper plate can provide an excellent base for a mask. Most paper plates are strong enough to support any number of appendages. It is fun to see how many ways they can be altered so that they no longer resemble paper plates.

Materials

Kraft paper
Paper plates
Scissors
Construction paper
Crayons and water-based marking pens
Clear glue
Toothpicks (for applying glue)
Assorted materials for decoration

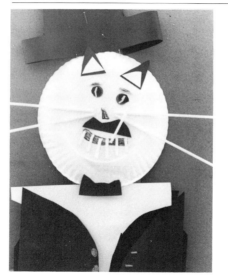

Paper plate mask and costume made by a second-grader.

If you are going to wear the paper plate, position the eyeholes and cut them out. You may decide that a mask that ties around the head is inconvenient and that this one should be mounted on a stick. In that case, make the upright stick of dowelling and the cross bar of thinner dowel, chopstick or paintbrush. This support can be firmly sandwiched between two paper plates. If you decorate the two plates differently, the actor can be two characters.

For decorating the surface of the paper plate mask, use construction paper, paint or felt, or extend the mask with other paper plates.

Cover an inflated balloon with strips of torn paper dipped in glue.

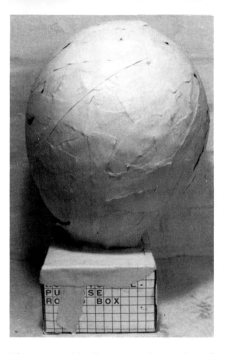

The covered balloon may be anchored to a box for convenience.

Balloon Masks

To make a balloon mask, use an inflated balloon as an armature. Cover it with paper strips soaked in glue or paste (see the chapter on papier-mâché). The covered balloon is an ideal size and shape to fit over the head. It is lightweight and its surface is easily decorated.

Materials

Balloon
Flour or wheat paste
Water
Newspapers or plastic to cover workspace
Kraft paper, newspaper or tissue for covering balloon
Masking tape

Inflate the balloon until it is a good size for a mask. Attach smaller balloons for ears and a nose, if you like. Knot the end of the balloon so that it will stay inflated while you work. A small wire twisted around the knot and taped to the work area will keep the balloon in place. Dip small strips of torn newspaper or Kraft paper in glue or paste—they will adhere well to the balloon shape. Apply about four successive layers of glue

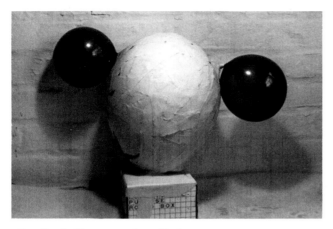

Smaller balloons can be added to create other features.

A balloon mask in progress is braced while it dries.

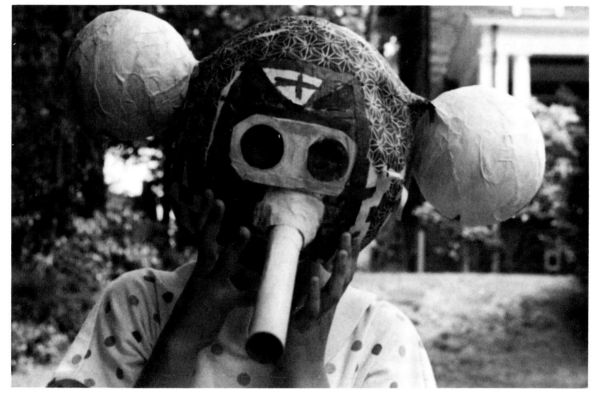

Embellish the dried form with your favorite materials.

and paper, allowing each to dry before adding the next. Each time you apply a strip of paper, smooth it with your fingers to eliminate lumps or ridges.

Let the paper dry for a day or two before bursting the balloon. When the balloon has been popped, slice the bottom of the paper form horizontally so it will fit over the head. If you cut the form vertically, you will have two long masks.

Decorate the hardened masks with paper plates, found objects, wire, mirrors—anything you choose.

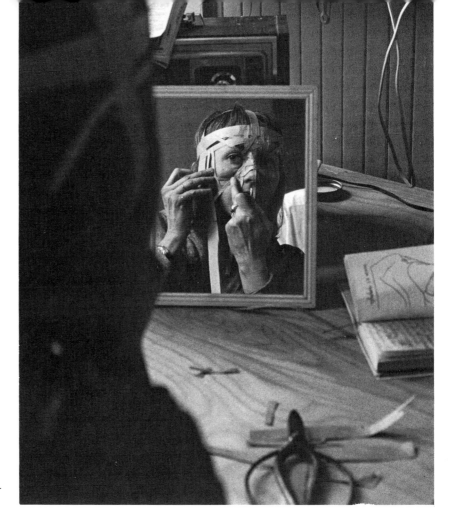

The headband can be started on your-
self in front of a mirror.

Paper Headband Masks

With no more than a few paper bags and a tablespoon of white glue, it is possible to create a paper headband mask. The headband method assures a good fit, and is appropriate for those who do not like petroleum jelly, plaster or clay applied to their faces. The resulting mask can be as intricate and formfitting as the paper masks that come out of molds. It can be built up and modelled to make a large, lightweight fantasy mask which fits well and can be seen at great distances. While work is in progress, these masks can be removed easily, worked on and then put back on to be checked in front of a mirror. If you are making several masks at a time, use inexpensive Styrofoam wig stands or mannequin heads, purchased from display companies or department stores.

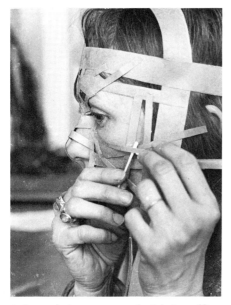

A drop of glue on a toothpick is suffi-
cient for joining one strip to another.

By guiding the paper with gentle but
constant pressure into the depressions
and elevations of the face, an accurate
mask can be created.

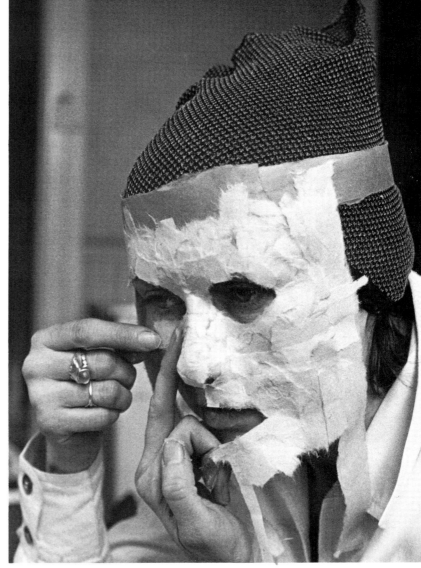

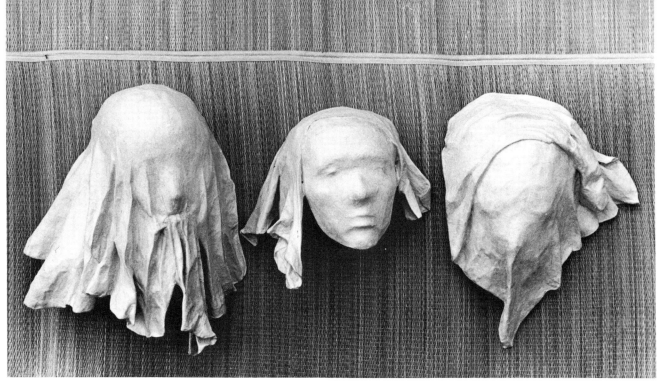

The Three Fates Mourn for Sadat. The masks were formed by the headband technique and strengthened with laminated paper strips. Glue-soaked fabric was formed over the masks, dried, and layered with paper strips. Japanese mulberry paper was applied as a final layer. Collection of Barbara Russell.

An animal mask made with the headband technique. Student work.

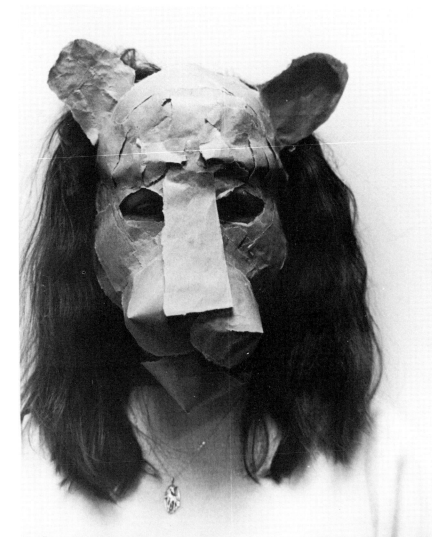

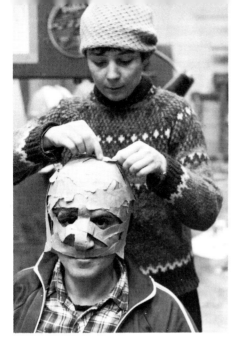

Students can begin the headband form on one another.

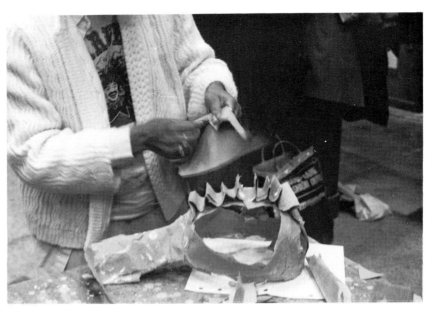

Remove the headband to work carefully toward a finished product.

Materials

Kraft paper
Clear glue
Paper, felt, buttons, yarn, etc., for decoration
Scissors
Brushes

Start with torn strips of Kraft paper or paper torn from heavy brown paper bags. These strips should be ½″ wide and long enough to go around the forehead to be joined (with a drop of glue) at the back, like a headband. A toothpick is good for applying the glue. The next strip of paper is attached to either side of the band and goes over the head like the top of a close-fitting hat.

Curling paper and attaching the pieces to the form creates a strong structure.

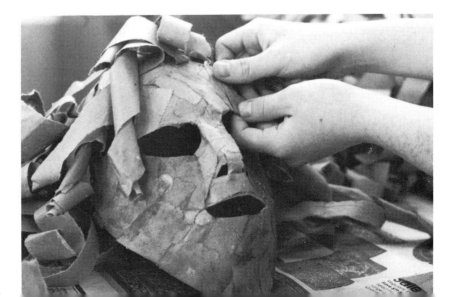

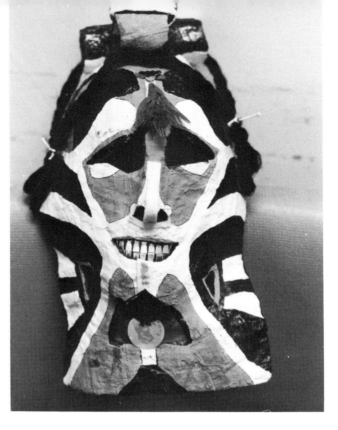

A mask made with the paper headband technique by Karen Schwartz.

Attach two other strips to the headband on either side and join them under the chin. These, and a narrow vertical strip covering the bridge of the nose, complete the basic framework of the headband mask.

Using the wearer's head as a mold, attach strips of torn paper to this framework. By guiding the paper with gentle but constant pressure over the elevations and into the depressions of the model's face with one hand, and gluing the paper to the existing framework, an accurate mask can be created. The model can assist by holding the glued area in place to dry while another paper strip is applied. Gradually interlace more strips of paper, strengthening the framework until a beginning form has been made that fits the wearer.

At this point the wearer can strengthen the form, either by working in front of a mirror or taking the mask off and stuffing it with newspaper to keep the form intact. Decide on the shape of the eyes and the size and shape of other features. With the mask off, adjust these shapes with scissors. Add laminated paper strips to the basic mask form until it is rigid and holds its shape well. If enough layers are not added, the mask will not be able to support the weight of any added decoration.

Add exaggerations and inventions to this paper foundation, and you will take the mask into the realm of make-believe.

Crumpling paper creates wrinkles and texture.

Pleating paper can be effective for hair or headdress designs.

Perforated paper to be used in a mask design.

Combining Other Techniques

By incorporating paper sculpture techniques such as curling, twisting, folding or bending, you can create extensions, reinforcing them with laminated paper, and adding volume and height to your mask. Scoring paper by scratching it with a sharp blade or scissors point and bending it along the scratch will give a crisp straight edge. Affix metal appendages, if you like, taping them temporarily and studying them from a distance before

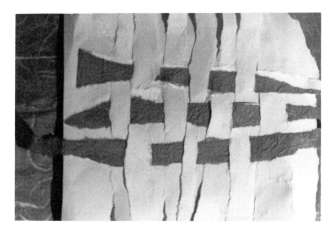

Woven paper provides a variety of values and textures.

Scoring paper with a scissors or an awl point creates a sharp edge.

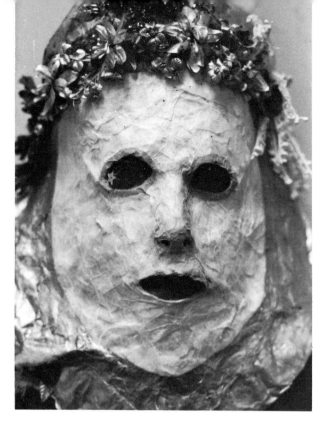

A haunting paper strip mask. Student work.

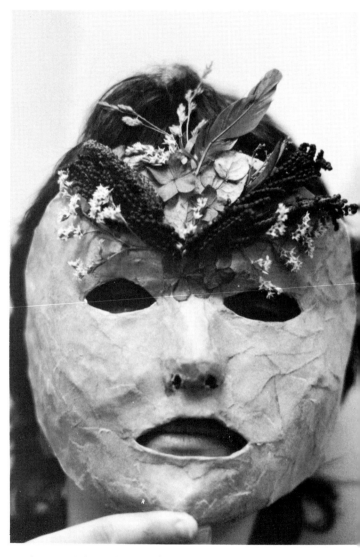

Feathers and dried flowers decorate this paper strip mask by Pat Schrieber.

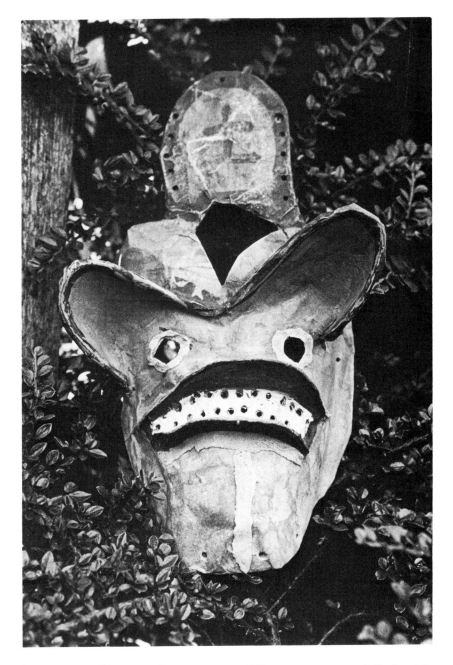

This mask by the author is covered with leather and paper.

laminating them to the structure. When you are satisfied with these extensions, the mask should be strengthened and built up with paper.

The beauty of the headband technique is that it is simple, portable and requires little equipment. It is a good way to get a preliminary measurement of an individual's head. Even if the model is not available for a second fitting, this rough mask can be developed and strengthened in stages.

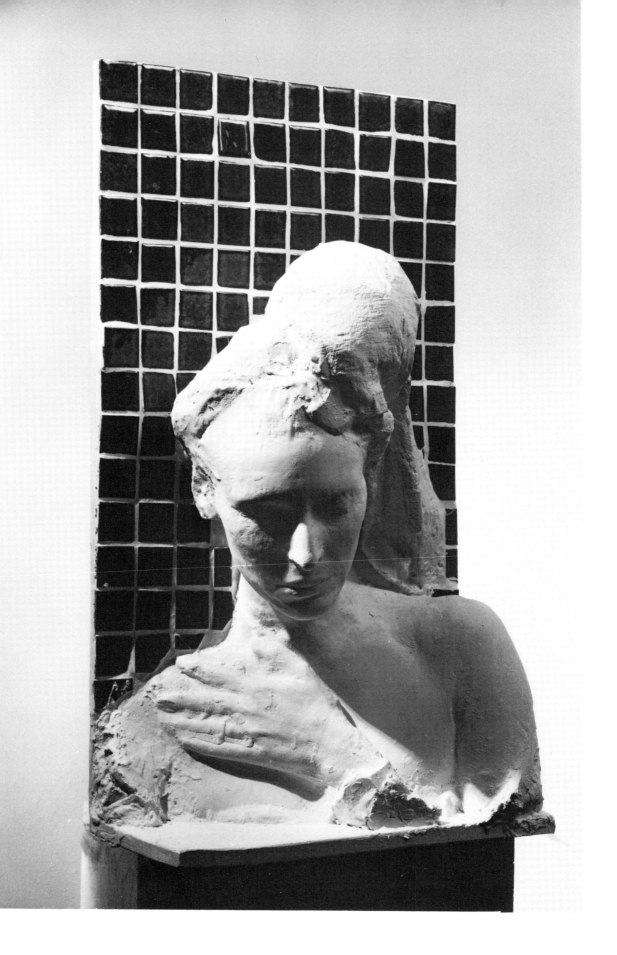

3 *Plaster Masks*

George Segal, *Woman Against Blue Tile Wall*, 1983. Plaster and glazed ceramic. Courtesy Sidney Janis Gallery, New York.

Plaster has been used for more than four thousand years to preserve facial expressions. Its absence of grain and rapid setting qualities make it capable of reproducing fine surface detail. The life masks of American sculptor John Henry Isaac Browere (1792–1834), for example, are imbued with a human warmth and animation that transcends mere duplication of features. He used plaster to create busts of such famous personalities of his day as John Quincy Adams, Thomas Jefferson, James Madison and Martin Van Buren.

Gangster Willie Sutton used plaster casting techniques in an attempt to escape from prison. With paints and clippings from his own hair, he created a lifelike head which he placed on his pillow to simulate a "sleeping Sutton." Sutton nearly escaped; the mask is now on display in a museum.

George Segal, a contemporary American sculptor, casts real people to use in his life-sized sculptures. He arranges these figures in formal environments that make them appear to be powerful presences frozen in time. Segal says of his casting experiences, "It's different each time . . . I've done the same person over six or seven times and I've been absolutely amazed

to find that even slight differences in state of mind come through that I can't control in the finished sculpture."

This book describes the creation of both positive and negative molds. A negative mold is a mold made from a human face or other object. A positive cast is made from the inside of a negative mold.

The plaster molds described here are made of plaster-impregnated gauze which can be cut into strips of various lengths. This gauze, used to make casts for broken bones, can also be used by artists for sculpture and to strengthen papier-mâché. Plaster gauze can be purchased from large drugstores, medical supply houses and artists' supply stores.

The plaster gauze mold technique is important and fundamental. The plaster mold, when dry, can be used immediately as a mask, or further finished and refined. It can also be used as a mold from which to create many other masks featured in this book. Plaster molds can be strengthened and used again and again.

Direct Plaster Gauze Molds

(Note: It is important to have your materials ready as this process involves quick work.)

Materials

Cover the face and chin with a protective layer of petroleum jelly.,

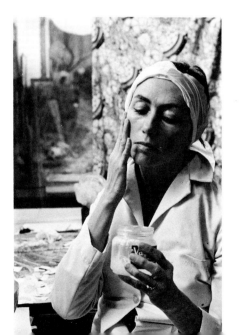

Roll of plaster gauze, used for making casts and protecting injuries. One roll will usually make at least one mask with some left over.

Petroleum jelly

Shower cap

Old clothes

Old scissors (plaster is hard on scissors)

Drop cloths and newspapers to protect the floor

Paper towels or rags for cleanup

Warm water in container **Note: When finished with this water, do not dispose of it in conventional drains or toilets. Fragments of plaster will wreak havoc on domestic plumbing systems. Young children should be supervised when working with plaster. If swallowed, plaster can harden in the stomach.**

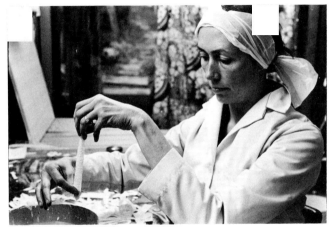

Moisten the strip of plaster gauze and
squeeze out the excess water. Be sure
face and lashes are well covered with
petroleum jelly and hair is protected.

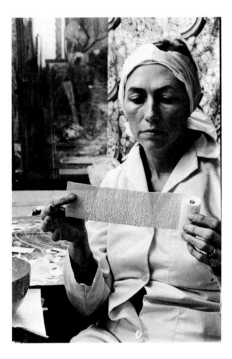

The plaster gauze strip before being
moistened. Cut it into various sizes ½
to 1½ inches.

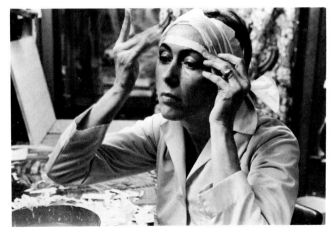

Place strips of gauze on the oiled face
and press down so the strip conforms
to the planes of the face. Use larger
strips for larger surfaces (the forehead).

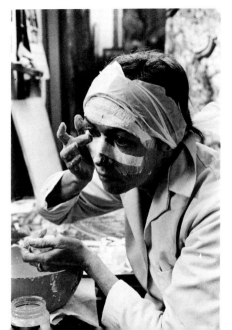

Press the gauze carefully over the ridge
of the nose and hollows near the eyes.
The accuracy of the finished mask de-
pends on how well the gauze is applied.

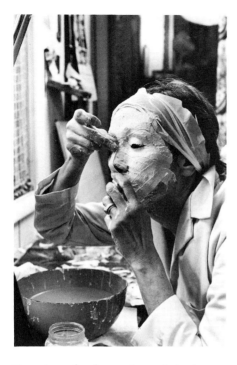

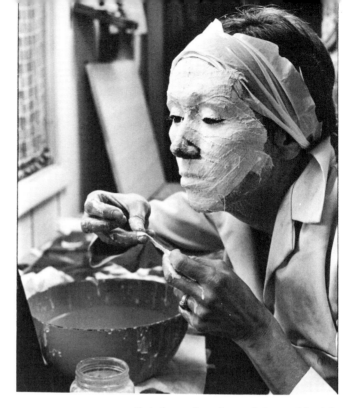

Press into the depressions of the face and overlap one piece of gauze over another.

Reinforce the edges of the mold with more moistened gauze for strength.

When it is firm (approximately 15 minutes) the mold may be removed by moving the mouth and gently pulling the edges of the mold. This is like a chrysalis.

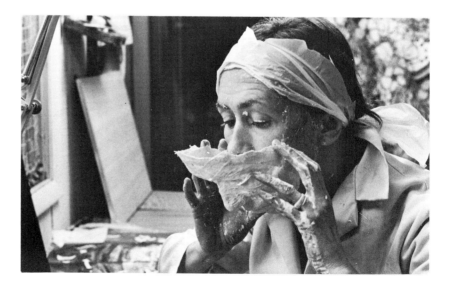

Preparing the model

First cover the person's face—including the underside of the chin—with a thick, protective layer of petroleum jelly. Eyelids and eyelashes should be well covered. Any loose hair should be scooped up inside a bathing cap or hairband, and the surface of sideburns, beards and mustaches should be well coated with jelly. I have covered the faces of many bearded actors, but they have lost few precious hairs because of these precautions.

Some people may be reluctant at the outset to have their faces smeared with petroleum jelly or covered with plaster, but their hesitation is usually overcome once they have assisted in the process and have seen the lifelike results of the mold.

Applying the gauze

The gauze must be applied quickly, but carefully. This is best done with two people working on a third to save time and backstrain. Cut the plaster gauze beforehand into strips of various lengths and widths, depending on the size of the model's face, and keep these strips dry until ready to be used. Determine at this point whether the model wishes to have the eyes covered or uncovered and whether the mouth will be open or shut. To avoid eye irritation, remove contact lenses. The model should be assured that holes will be left so the nostrils remain free for normal breathing.

Saturate the gauze strips one at a time by dipping them in a shallow bowl of water, warm enough to be comfortable on the model's face. Drain excess water from the strips either by placing them on paper towels for a moment or by squeezing them out between the fingers. Eliminating this excess water will make the sitter more comfortable and allow the plaster to start filling in the holes of the gauze fabric.

Press a moistened strip on the subject's forehead and rub lightly for maximum adherence and accuracy. Make certain there are no air holes. Position another strip so that it overlaps the preceding one and continue pressing and rubbing until the model's face is covered and the gauze is at least two layers thick. If the eyes are to be open on the mold, both eyeholes should be the same size and shape. If they are to be closed on the mold, cover each of the model's eyes with a square piece of gauze. Press the gauze carefully when you apply it. When doing the mouth, press a square of gauze between the lips and around the contour of the mouth to capture its shape accurately. It is important to continue the mold slightly under the chin (about $3/4"$) so the shape of the face does not end too abruptly. When everything else is finished, put an extra layer around the entire edge of the mold for added strength.

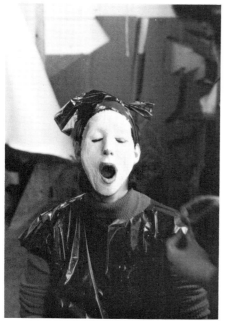

A student has a mold made while keeping her mouth open for more than fifteen minutes.

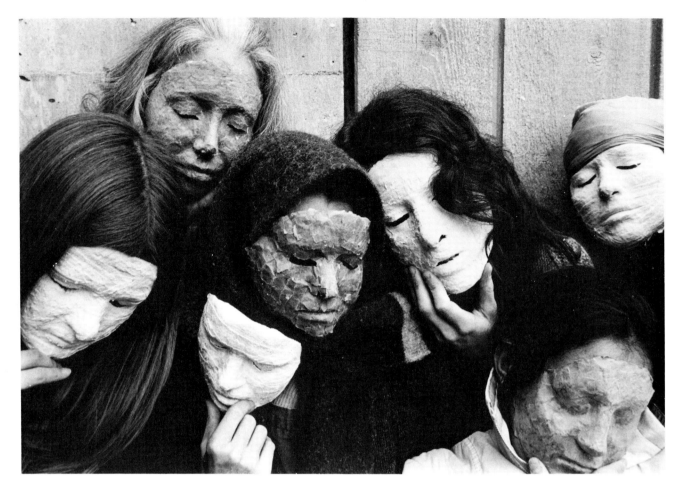

Students wearing their molds as masks.
Photo by Birgitta Ralston.

Drying the mold The masked sitter can now stretch out, relax and wait five to ten minutes for the mold to dry enough to be removed. A fan or hairdryer speeds up the drying process.

The sitter's face is totally enclosed in plaster, with the exception of the nostril holes or possibly the eye holes. Remember that he or she cannot speak and perhaps cannot see either; because of this vulnerable state, the sitter should never be left alone.

When the mold is dry enough to be removed, the sitter can usually start loosening it by moving the facial muscles. Gentle pulling from the forehead will also aid in its removal.

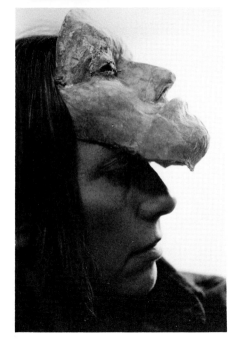

The finished mold (when dry) may be decorated.

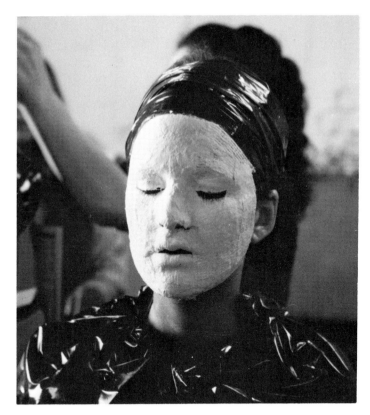

A finished mold is worn by a student.

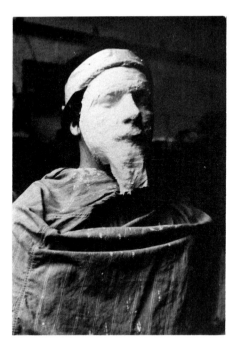

A bearded student is covered with plaster gauze.

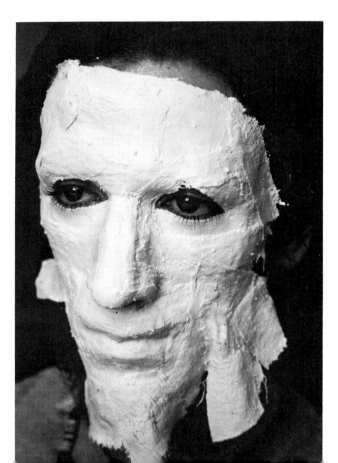

The mold before strengthening. Where light shows through, the mask needs strengthening. Pencil lines make any further work more visible.

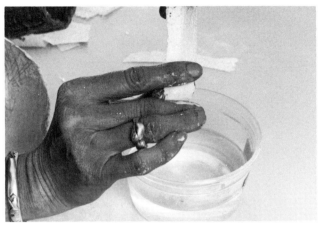

Squeeze excess water from the plaster strips.

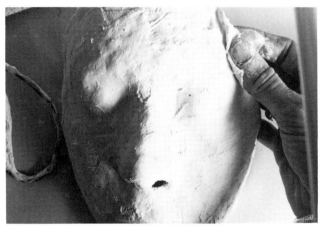

Apply plaster to the outside of the mold.

Strengthening the Mold

Molds must be thoroughly dry and reinforced before being used-for further work. Hold the mold up to the light. Wherever light shows through, the mold is weak and should be strengthened. The best way to add rigidity is to apply moistened plaster gauze strips to the *front* (outside) of the mold. First, rub a white, clear-drying glue into the moistened gauze. Cover the entire front of the mold with the gauze, and allow it to dry.

When the front of the mold has been reinforced and has dried, draw light pencil lines on the back (inside) of the mold so that any work you do on the inside will be more visible. Paint the front and back of the mold with varnish, clear polyurethane, shellac or acrylic clear medium for protection.

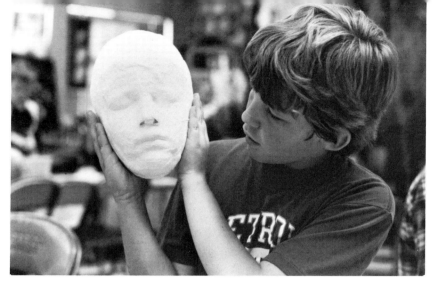

A student holds his plaster mold.

The mold itself can also be developed into a finished mask by using any number of art materials. Mask by Barbara Merdiushev.

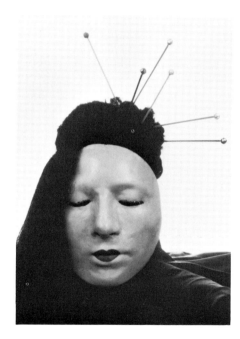

Spring Moon by Kate Murphy. The plaster gauze mold is made into a finished mask. The artist uses layers of modeling paste and acrylic gel thinned with water. She sands the surface carefully to achieve this powerful beauty. Photo by Richard Barker.

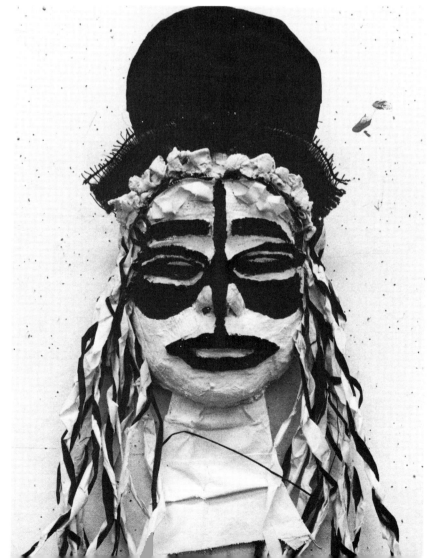

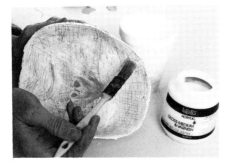

Pencil lines make the area to be covered more visible.

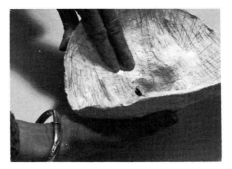

Waterproof the gauze mold with shellac.

Plaster gauze is cut into strips.

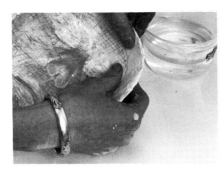

The strips are applied one at a time to the mold which has a layer of petroleum jelly.

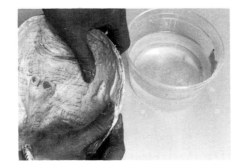

Apply the strips one at a time to the greased mold.

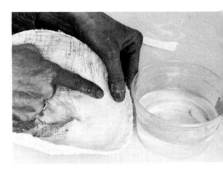

Press the strips into depression of mold.

A Pressed Plaster Gauze Cast

The simplest way to make a cast from a strengthened plaster mold is to use plaster gauze. Gauze strips produce a lightweight mask that is easily removed from the mold and that captures the likeness of the model with startling accuracy. This gauze cast can be combined with other materials such as papier-mâché and various found objects.

Materials

Strengthened plaster mold (see Strengthening the Mold, page 46)
Plaster gauze
Petroleum jelly
Scissors
Container of warm water
Newspapers (to protect the work surface)

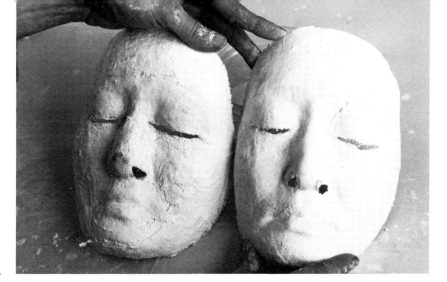

Remove the completed cast.

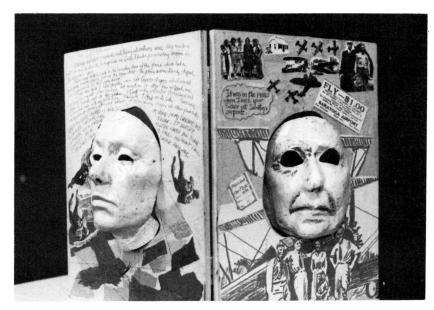

A 3-D piece using plaster casts.

Apply a thin coat of petroleum jelly over the inside surface of the strengthened mold before cutting various lengths of gauze strips. Saturate the strips and pull off the excess water between your fingers. Press the moistened strips inside the mold so that each one overlaps the preceding one. Continue this process until the inside of the original mold is covered. Two layers of gauze are usually sufficient. An extra layer of gauze should be pressed around the edge of the cast to give it extra stength. When the gauze cast has dried, pull it carefully out of the original mold. Any damaged areas can be repaired with some additional strips of plaster gauze.

A Poured Plaster Cast

Some artists want to cast a more solid three-dimensional mask. To do this, use the original mold, strengthened, along with plaster of paris or other casting media such as hydrocol or white art plaster. Special surface effects may be obtained by placing textured fabric, corrugated cardboard, metal screening or other textured materials in the mold before pouring the plaster. Direct plaster can yield bold or subtle effects. The finished piece can be painted or decorated to resemble a carved stone or clay head.

Materials used in pouring a cast from a mold.

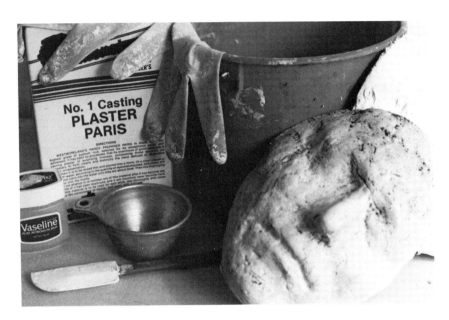

Materials

Strengthened mold (see Strengthening the Mold, page 46)
Box a little larger than mold, to hold it in place
Petroleum jelly or release agent
Container for mixing plaster
Measuring cup
Rubber gloves or spatula for stirring mixture
Plaster of paris, hydrocal or white art plaster
Water
Newspaper for covering work area

Strengthen the mold and place it face down in a box so the top is level. The nostril and eye openings should be closed with plaster gauze applied to the front of the mold. This will keep the plaster from seeping out. Brush the inside of the mold with petroleum jelly. Mix the casting medium according to directions. Plaster of paris is mixed with two parts plaster to one

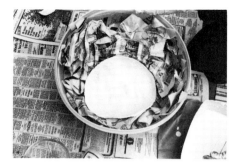

Put mold face-side down so the top rim is level.

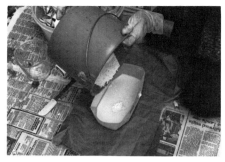

Pour the plaster into the measured water until it forms an island or peak above the water.

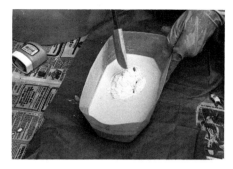

Stir with a spatula or rubber gloves.

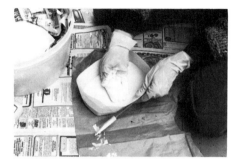

Stir until there are no air bubbles.

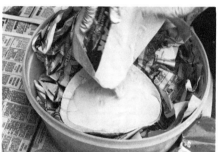

Pour until the mold is filled or until it is the desired thickness.

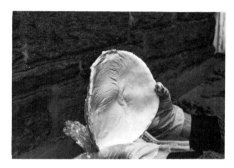

The plaster mold dries in about forty minutes.

part water. Slowly sift the plaster into the water in a plastic container or a large coffee can. An average mask uses about four cups of plaster to two cups of water. Tap the sides of the container to dissolve air bubbles. When a small conical island of plaster forms above the surface, use your fingers to stir the water and powder gently until it is thoroughly mixed. You will have about ten minutes to apply it to the mold before it hardens. If you intend to hang the finished cast, insert a bent piece of wire into the plaster while it is still soft. The wire should be bent so that the two ends can be twisted together; otherwise it will pull out of the cast.

After about forty minutes, pull the poured plaster replica away from the original mold. Because both are rigid, you may have to break up the original mold to separate the two.

To decorate a poured plaster mask, it is important to treat the hardened cast with a sealer to close the pores and protect the surface. Varnish, white shellac or polyurethane may be used as sealers. To give the mask cast the appearance of metal, sprinkle metallic powder on the surface while the sealer is still wet. After the cast has dried, shoe polish or spray paint can be used to give the cast a patina.

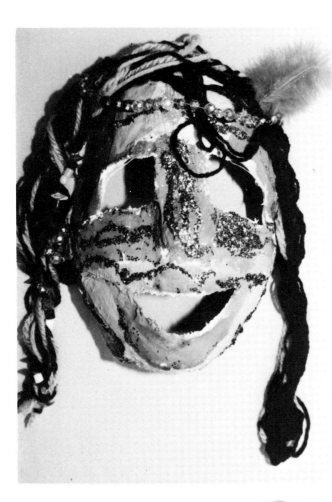

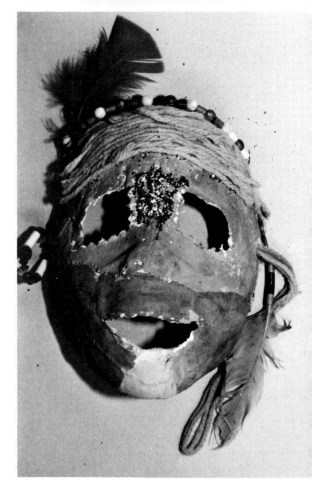

Student masks made of Pariscraft, tempera and yarn.

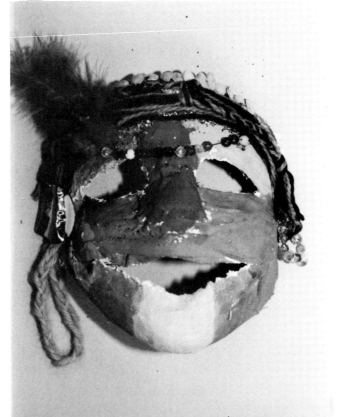

A Pariscraft bust by an elementary
school student.

4 *Clay Masks*

"Maskmaking is a peculiar kind of sculpture where one must at the same time consider the aesthetic and the practical side of it, the exterior and interior of the mask, the character it is intended to represent and the fitting to the head of the wearer. One must also remember to make the mask as thin as possible and yet strong and durable."

— WLADYSLAW THEODORE BENDA, *Masks*

Cut the wedged clay in half with a wire to check for airholes.

Clay offers possibilities for spontaneity and sensitivity that have appealed to artists for centuries. When using clay to make masks, it can be beneficial to explore the clay's special tactile qualities beforehand. Roll, pull, press and tap the clay. A blindfold may help you concentrate on what your fingers are doing. Take the blindfold off, roll the clay into a ball and create textures by pressing stiff brushes, nails, seed pods, bamboo, string and numerous other items into it. The clay accepts these texture impressions easily, and they may suggest decorative motifs. You might let this ball of clay stiffen, roll ink over the surface and record the impressions in a notebook for future reference. The stiffened clay, when inked, acts as a stamp or seal to transfer the design.

Wedging

Before it can be used, clay must be wedged. Wedging gives clay a uniform texture throughout and frees it of air pockets. A wedging board made of plaster is the best surface to work on, but a sturdy table securely covered with canvas is sufficient.

Cut the clay in half with a wire. Throw one half onto the plaster surface, then throw the other half on top of it. Divide and slam together in this manner about twenty-five times, until the inner surface is of even tone and free of air holes when cut with a wire.

Students experiment with clay.

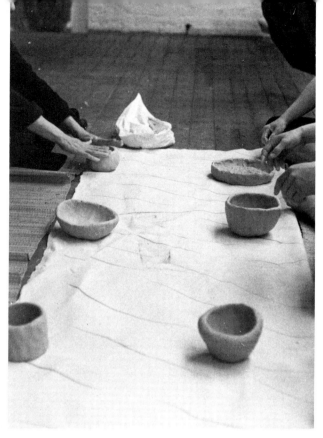

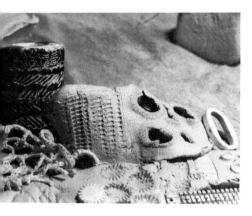

Try different textures pressed into the clay.

Direct Clay Masks

Materials

Petroleum jelly for covering the face
Clay
Newspapers to protect work area
Hair dryer (optional)
Brushes, nails, seeds, bamboo, string, etc., to create textures in clay
Plastic wrapping to cover clay when not in use

Start by applying a layer of petroleum jelly to the face so the clay can be removed easily later on. Cut a piece of clay about the size and shape of your face and press it directly to your features. Be sure to leave nostril holes in the clay to breathe through.

It is beautiful to see the ways people touch their faces while applying the clay. Tapping and slapping sounds become quieter as the exploration proceeds. Sometimes the clay falls apart at the beginning because of treatment that is too forceful; if this happens, start again. It takes some time to learn clay's strengths and limitations.

A student presses the clay directly to her face, which has been covered with petroleum jelly.

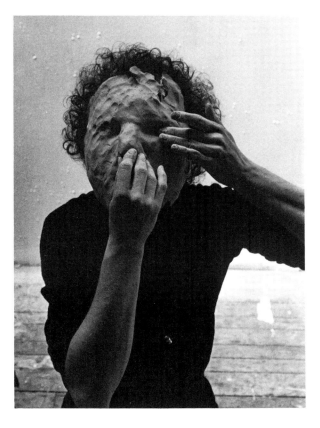

Press the clay gently against the face.

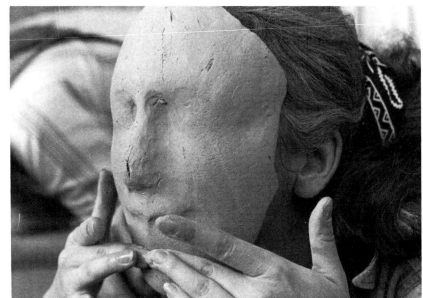

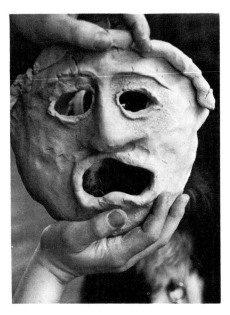

A student's simple clay mask.

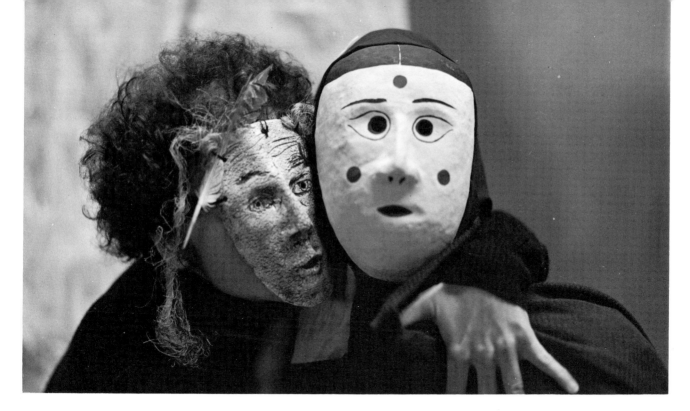

A ceramic mask by the author and a papier-mâché Korean shaman mask, worn by dancers. Photo by Birgitta Ralston.

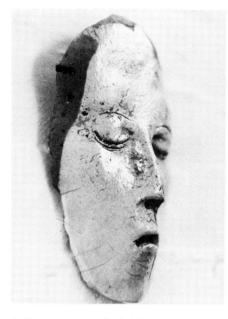

A direct clay mask, fired and glazed.

Remove this simple mask and place it on a mound of crumpled paper or plastic. Examine it. If it shows possibilities for further development, set it aside to become a little firmer, and then fire it in a kiln if one is available.

It can be very interesting to have a small group of people make direct clay masks together. After making simple masks of their own faces, have each person in the group work on someone else's face with the same direct technique. By this time, everyone will have begun to learn clay's characteristics, and will be more sensitive when preparing and applying the clay. When the masks are finished, remove them carefully and place them on mounds of paper. You may choose to look upon these activities as experiments, although some of the masks you produce may be art objects worthy of firing and glazing if the facilities are available. If you keep any of the masks, pierce a hole or holes in the clay with a sharp object—a pencil, perhaps—so that when the mask is dry it can be hung.

Cat and mask.

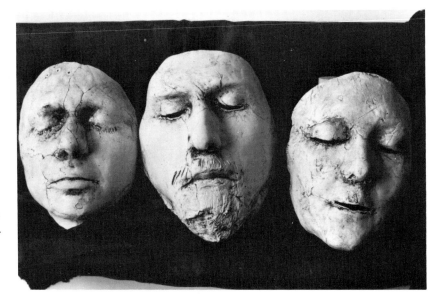

Three Artists. These porcelain masks were made from a simple press mold.

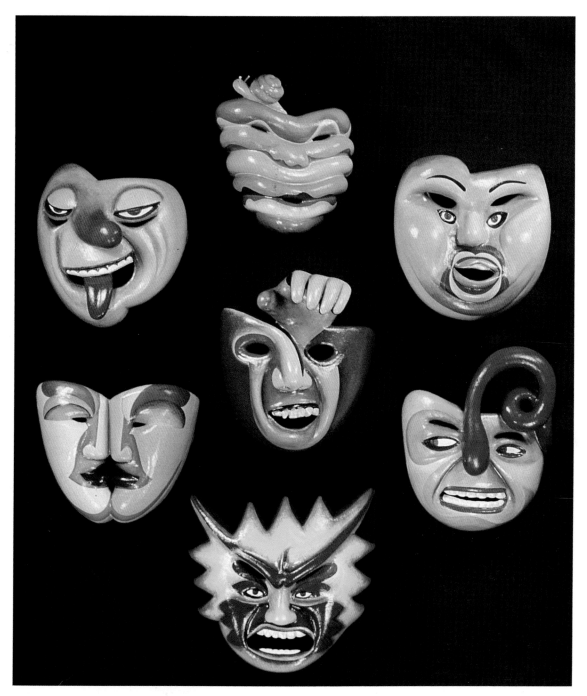

June Linowitz, *Seven Deadly Sins*, 1985–86. Mixed media. Courtesy the artist. Photo by Stacy Duncan.

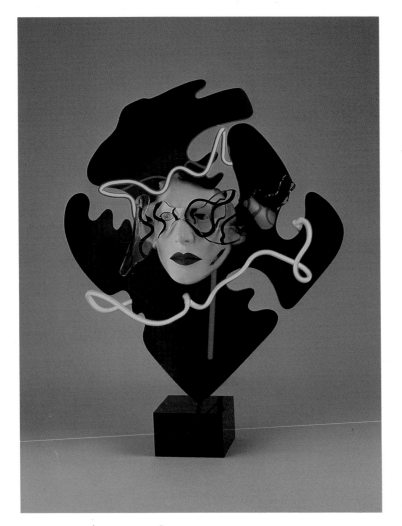

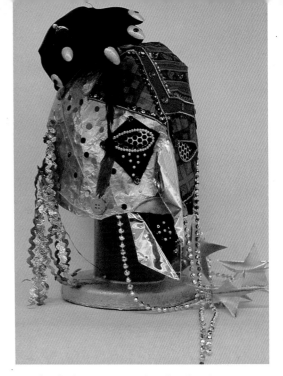

Michael Shannon, *Mask.* This head-band mask has been strengthened and decorated with collage materials, paint, fabric and jewelry.

Craig A. Kraft, *Storm Rider*, 1986. Mixed media with neon, 24 × 18 × 8″ (61 × 41 × 20 cm).

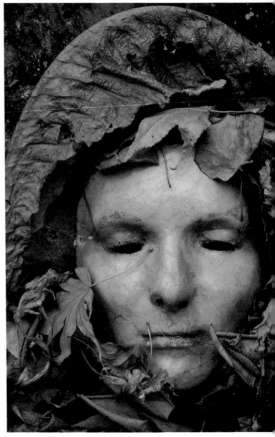

Mask with leaves, by the author. Laminated oriental paper, painted and sanded.

Deb Kramer, *Music Mask*,
1986. Handmade paper, 6 × 5″
(15 × 13 cm). Courtesy Deckle Edge
Designs. Photo by Danny Sutherland.

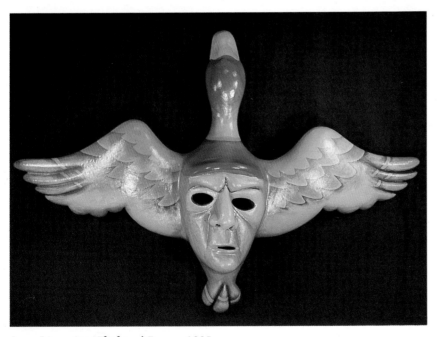

June Linowitz, *Flight of Fancy*, 1985.
Mixed media, 22¼ × 33¼ × 6″
(56 × 84 × 15 cm). Courtesy the
artist. Photo by Stacy Duncan.

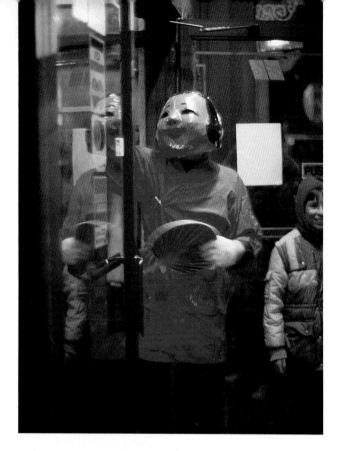

Chinese New Year mask of papier-mâché.

Joyce Whitcomb, *Mermaid*, 1984. Polystyrene-saturated fabric, 10 × 10″ (25 × 25 cm). Photo by Lorrie Stover.

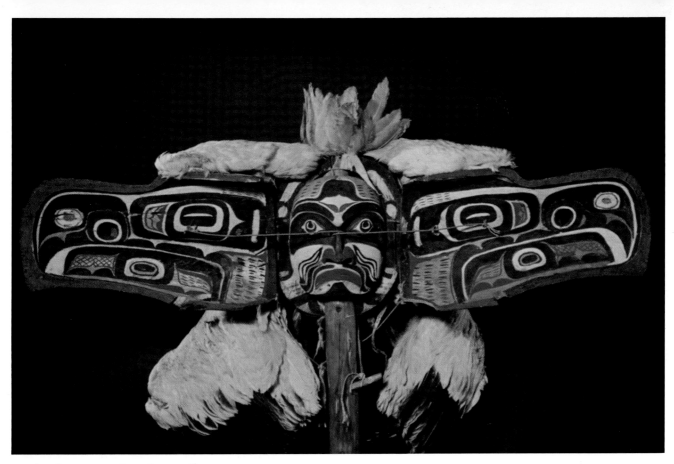

Kwakiutl Two-Faced Mask, Northwest Coast Indian, Vancouver Island, British Columbia. Courtesy Department Library Services, American Museum of Natural History.

Therese Bisceglia, *Untitled*, 1986. Handmade paper, 6 × 4" (15 × 10 cm). Courtesy Deckle Edge Designs.

Adam Kurtzman, *Demon*. The artist sculpts his masks in plasticene and laminates ten coats of building paper over the form. He paints the mask with oil paint and varnish.

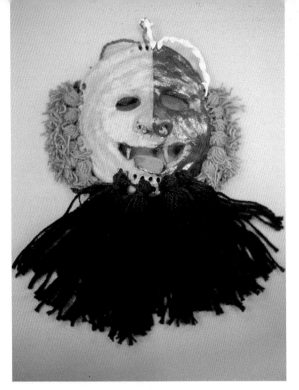

Student work, eighth grade.
Clay and yarn. Courtesy
Fulton County Schools,
Atlanta, Georgia.

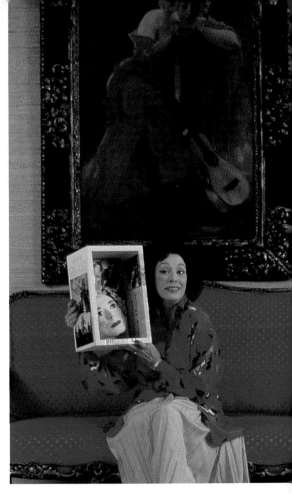

Marguerite Piazza with self-
portrait mask by maskmaker
Maggie Sherman. Photo by
Dennis Wile.

Student mask, eleventh grade. Hand-
made paper and paint. Courtesy Fulton
County Schools, Atlanta, Georgia.

Craig A. Kraft, *A Square Waves*, 1985. Mixed media with neon, 20 × 14 × 8″ (51 × 36 × 20 cm). Courtesy the artist. Photo by Murry Bognovitz.

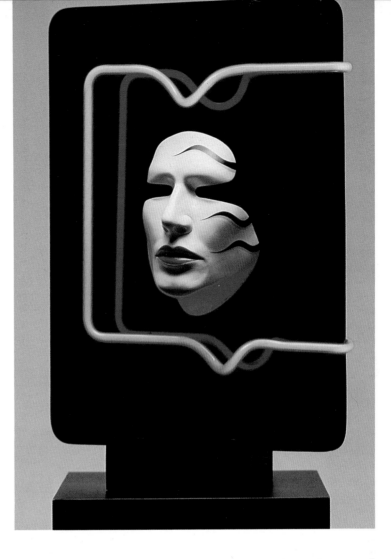

Marcia Lloyd, *Seaform III*, 1985. Wetformed cowhide, airbrushed with fabric dyes, 12 × 12 × 6″ (30 × 30 × 15 cm). Courtesy the artist. Photo by George Erml.

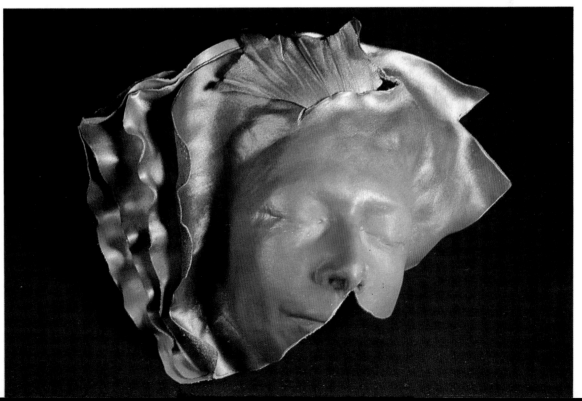

Student work, fourth grade. Cut paper over watercolor. Courtesy Milwaukee, Wisconsin Public Schools.

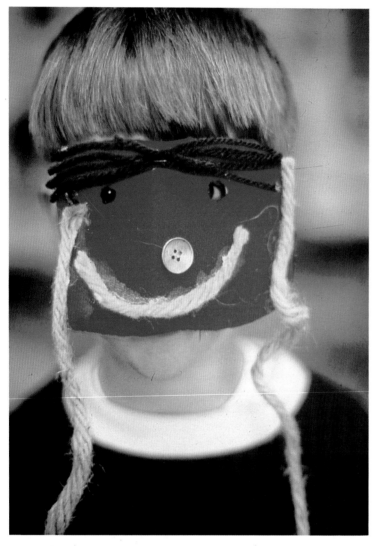

A simple, charming child's mask.

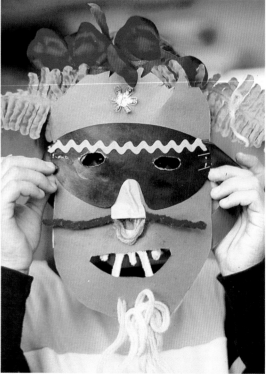

Construction paper mask by a young student.

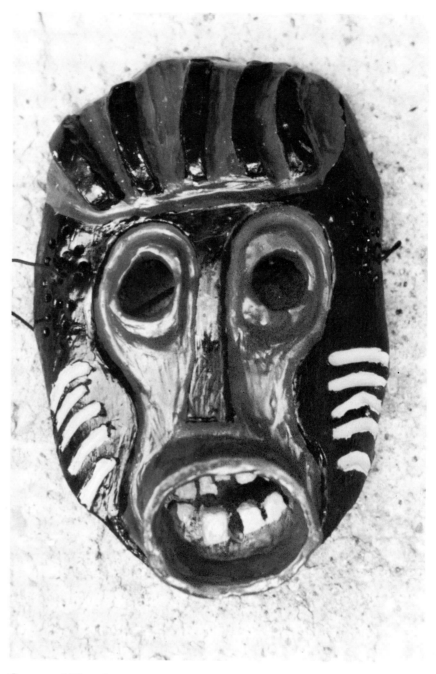

Courtesy Milwaukee, Wisconsin Public
Schools.

Building a Mask Over a Clay Form

Some artists model a head directly out of clay or plasticene, and then apply papier-mâché, plaster gauze or laminated paper over it. By using the modeled clay form, it is possible to create powerful masks with distorted or exaggerated features, especially effective in theatrical productions. The papier-mâché combines the special qualities of strength and lightness important for props and masks. The final surface is ideal for painting.

Materials

Clay or plasticene
Newspaper
Petroleum jelly or plastic wrap for covering clay
Papier-mâché, laminated paper strips or plaster gauze

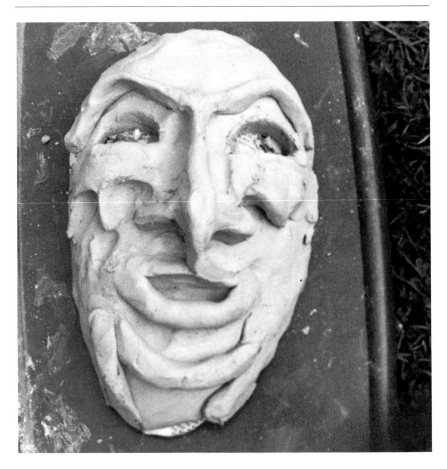

Sculpt a simple form out of clay.

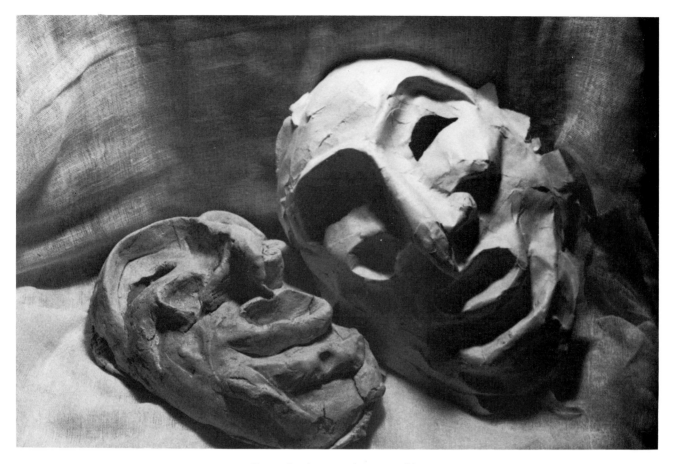

Cover the form with strips of laminated paper. When dry, you have a positive mask made from the clay form.

Plasticene or clay works well for fashioning a structure. The base need not be solid clay; to save clay, build the structure over a ball of crushed newspaper. It is best to build the clay form with bold, simple shapes, as some of the detail may be lost when covering the form with paper. Avoid undercuts in the modeling so that the gauze or paper layers will come off the clay mold easily. When the clay form has been sculpted, cover the entire clay surface with plastic wrap or petroleum jelly. Start applying strips of glue-saturated paper. Overlap these strips, and press them tightly to the clay form until the paper layer is about ½" thick. At this point you may add paper-pulp details or texture. When the papier-mâché is nearly dry, remove it by lifting it carefully. Embellish it as you like. The clay may be reused.

A Clay Mask from a Simple Press Mold

By pressing clay into a strengthened plaster gauze mold, you can capture the intricate details and textures of the human face in a mask that has a simple, beautiful vitality. If you are not using a self-hardening clay or a clay that can be baked in your home oven, you will need special equipment for firing and glazing your mask. If the mold has been strengthened, it is possible, with practice, to obtain at least twenty copies from a plaster gauze mold.

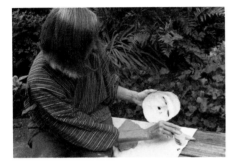 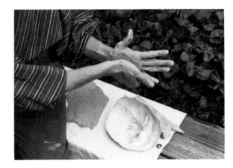 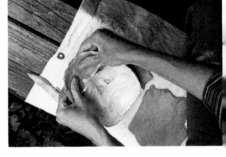

Coat the inside of the strengthened mold with petroleum jelly.

Pat a square of clay between the palms to make the desired thickness.

Press the clay into the mold.

Materials

Strengthened plaster gauze mold (see chapter 3)
Clay, plasticene or self-hardening clay
Canvas or oilcloth-covered surface
Artist's knife or ceramic trimming tool
Petroleum jelly
Dry cleaner's plastic to cover clay
Newspapers to cover work area
Plastic container of water
Rolling pin

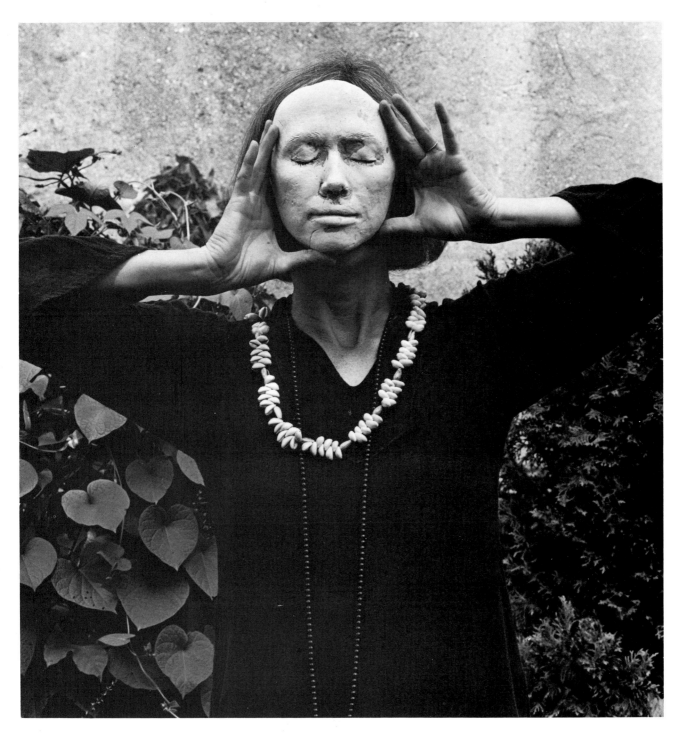

Self-portrait mask. Photo by Peter Sasgen.

Pressing Clay into the Mold

Close up the apertures on the mold by applying pieces of plaster gauze to the outside of the mold. This keeps the clay from squeezing through to the outside. Roll out the clay with a rolling pin until it is about ⅛″ to ¼″ thick. Tear this rolled-out clay into little squares. Press the squares between your palms and then into the mold, which should be coated beforehand with petroleum jelly. The inner surface of the mold must be covered with the clay pieces. Smooth the seam lines where squares have been overlapped until the back of the mask is smooth and of the same thickness. Experience will tell you how much pressure to use. When the inside of the mold has been evenly covered with clay, trim off the excess clay that has squeezed out over the edges of the mold or through the eye and nose apertures. Build up a thicker edge of clay around the outside edge of the mask—to make it easier to pull out later—and wait for it to stiffen. If you want to accelerate stiffening, put the clay-filled mold in a 200 degree oven for fifteen minutes or use a hairdryer. While waiting, prepare a mound of plastic, cloth or soft paper to support the clay head when it comes out of the mold.

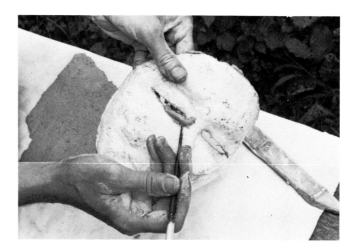

Remove excess clay from open places on mold and around the edges.

Removing the Mask

When the clay has stiffened and begun to pull away from the edges of the plaster mold, it can be removed. This can be difficult, and requires patience. Occasionally, the mask will stick to the inside of the mold at the nose if there is not enough petroleum jelly there. Keep very plastic, malleable clay on hand for patching. When the clay head is out of the mold, place it on the mound of paper or cloth to dry. Do not discard the water you use while working with clay down the sink as it may clog the drain.

A container of water is useful, but never empty it into the sink!

 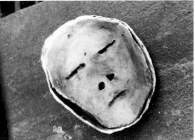

The clay shrinks as it dries.

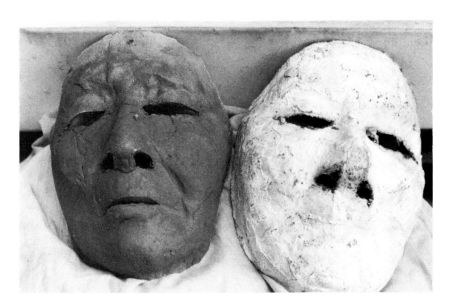

Remove the clay carefully from the mold.

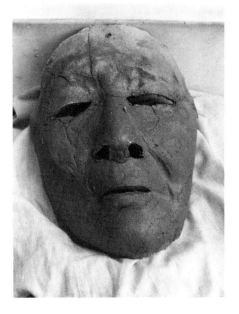

Self-hardening clay does not need to be fired.

This clay head has been fired in an artists' kiln.

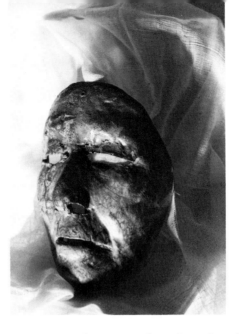

Firing As you work, remember that the shrinkage rate of fired clay is approximately fifteen percent, and that clay masks are relatively fragile. This is especially vital if the masks will be used in performance.

To avoid disappointment, it is best to make several pressed clay masks from the same mold. If you fire your mask, be familiar with the temperature required to fire the clay you use. Do not fire the mask until it is thoroughly dry. Sometimes the most beautiful mask is the one that is unglazed and shows the imprints of the artist's work.

Self-hardening clay and plasticene do not need to be fired. Follow package instructions.

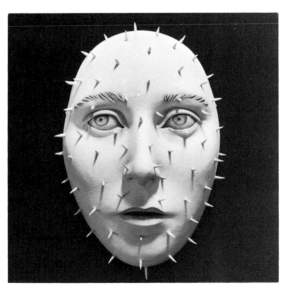

Beverly Mayeri, *Prickly Heat*, 1983. Whiteware clay with acrylic paint, 8½″ (22 cm) high. Photograph: Garth Clark Gallery. Courtesy the artist.

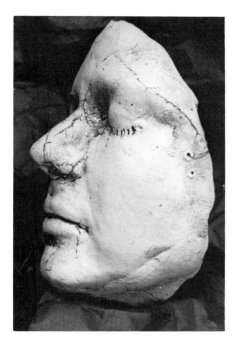

A clay mask.

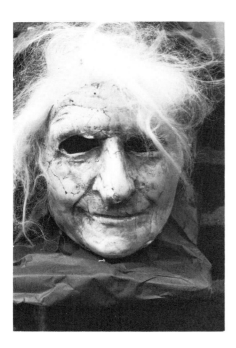

Portrait. Although this mask is made from a mold, it has been manipulated and exaggerated to be more than simply a copy of a face.

Slip-Cast Molds

When an object is to be identically reproduced in clay, slip-cast molds can be used. These elaborate molds use deflocculated slip, a fluid suspension of clay. I find this slip technique too mechanical for my purposes, but some ceramics books listed in the bibliography describe such molds and techniques.

Courtesy Milwaukee, Wisconsin Public Schools.

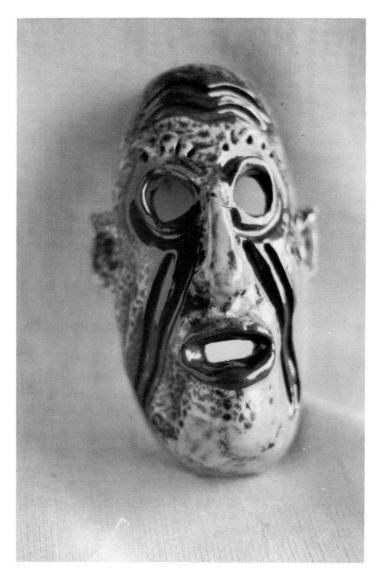

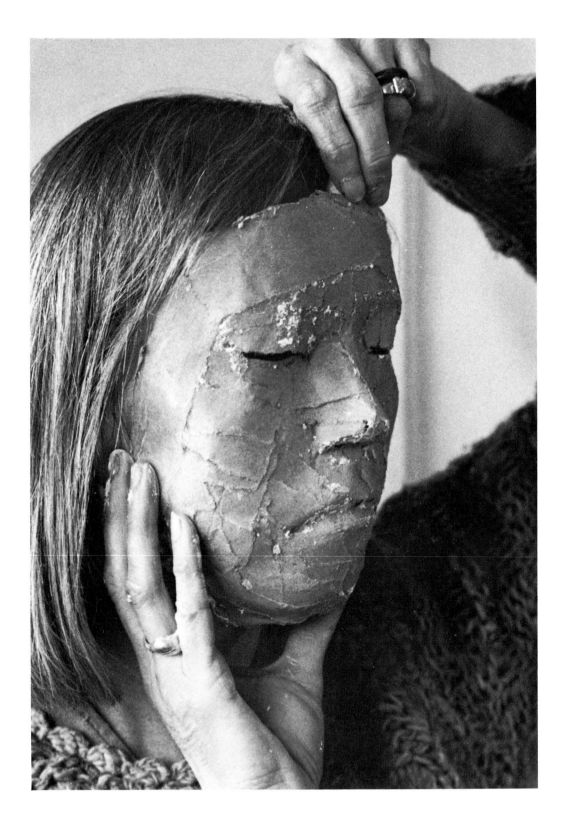

5 Laminated Paper Masks from Plaster Molds

While we are alive, we cannot escape from masks or names. We are inseparable from our fictions—our features. We are condemned to invent a mask for ourselves and afterward to discover that the mask is our true face.

— OCTAVIO PAZ, *Posdata*

Paper masks have become my preferred way of working because the resulting masks are light, durable and fit like a second skin. The mask is made from the back of the plaster mold—the surface that directly touched the model's face. If made carefully, the mask can give the impression of being a real face, and can be as strong as a wooden mask. Any number of paper masks can be made from the plaster mold once the mold is strengthened.

Wladyslaw Benda (1873–1948), a Polish painter and illustrator, became fascinated with masks in 1914. His favorite technique used laminated unbleached paper, glued in layers, strengthened at the edges with wire and finished with a few coats of varnish and oil colors. His masks were $\frac{1}{16}''$–$\frac{1}{8}''$ thick, composed of roughly twenty-five layers of tiny, joined strips of paper.

Materials

Strengthened plaster gauze mold
Kraft paper or acid-free paper
Clear-drying glue
Brushes, toothpick, for applying glue
Containers, for water and diluted glue

Choosing Paper

The paper that I usually begin with is brown wrapping paper (Kraft paper) which is sold in most stationery stores. You can also use colored drawing paper, blotting paper, acid-free or charcoal paper or shelf-lining paper. Avoid newspaper or newsprint—it is not durable. Glossy magazine paper is too stiff and sometimes water-repellent. My preference after many years of maskmaking is *kozo* paper, a handmade, long-fibre mulberry paper from Japan. Many large art stores sell *Kozo* and other Oriental papers.

It is best to tear the paper instead of cutting it, when making laminated paper masks. Tearing provides rough, hairy edges that attach easily to other torn strips of paper.

Tear strips of various sizes to fit the inside of the mold.

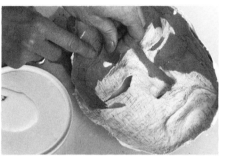

Glue paper strips to each other inside the mask. Do not put glue on mold.

Remove the paper mask (ease it gently out of the mold).

Gluing Paper Strips into the Mold

Choose glue that dries quickly and clearly. No glue should touch the mold. Apply a small drop with a stick or toothpick to each piece of paper, and press each piece carefully into the contours and depressions of the mold so the subtleties will be transferred to the paper mask.

For maximum accuracy, use smaller pieces of brown paper in higher curved areas. If the paper pulls out of the mold at the beginning of the process, anchor it with three or four strips of brown paper extended over the edge and glued lightly to the front of the mold. When the first layer is finished and the plaster mold is no longer visible, most people cannot resist the temptation to pull the paper head carefully out of the mold and see what it looks like. The brown shell is beautiful, but fragile and easily bent out of shape. If the paper mask stays in the mold until three or four layers have made it stronger, there is less chance of its warping or of its shape being altered.

For the other paper layers, dilute the glue to the consistency of heavy cream and brush it over the preceding layer. Overlap the additional torn paper strips, and press them into the mold. Continue this process with each layer until the mask is absolutely rigid (ten to twelve layers).

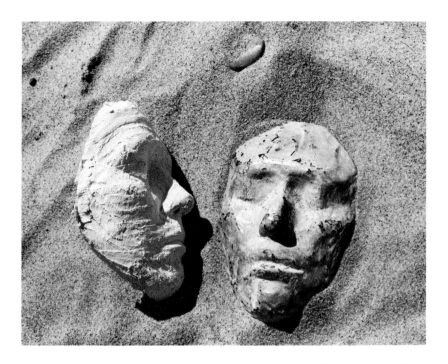

A plaster gauze mold faces the laminated paper mask which has been sanded.

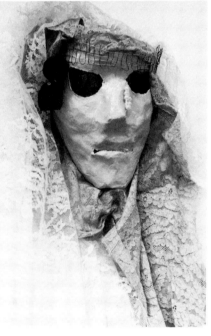

Mortitia is a laminated paper mask by Heidi Vass.

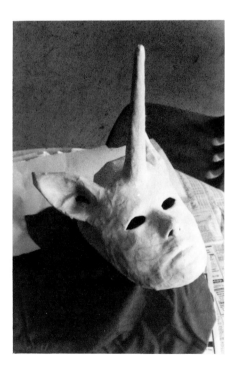

A painted paper unicorn mask, simple and striking, by Betsy Erace.

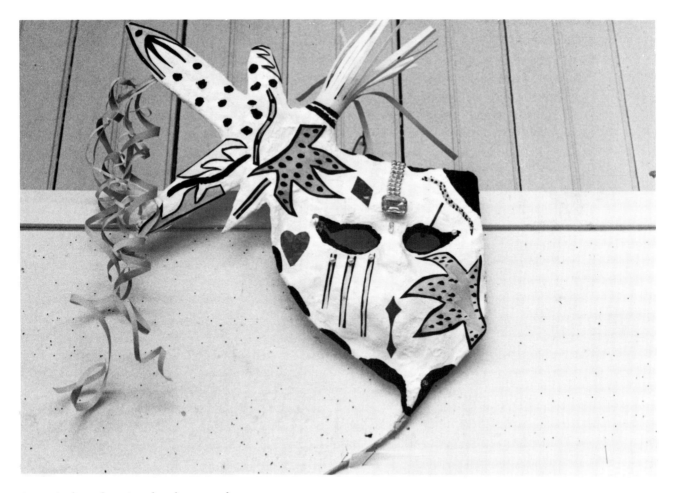

A carnival mask, painted and mounted on a wire handle. Mask by Michelle Wiest.

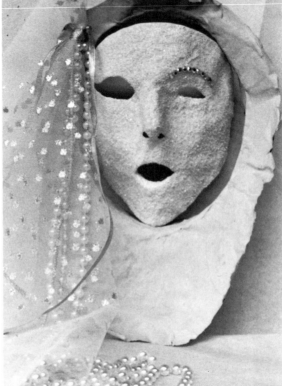

White glitter gives this mask (by Regina Pellegrino) an aura of magic. It sits in a laminated paper frame that can also be used as a hat.

This mask by the author is from her "Oriental Opera" series.

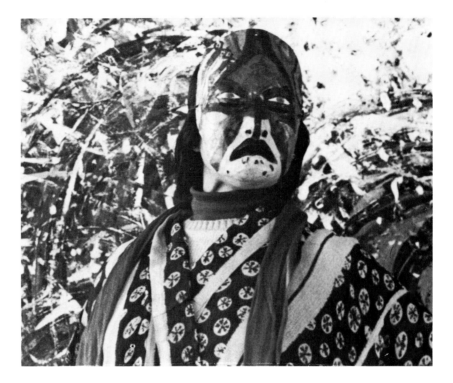

Decorating the Mask

Once the mask is rigid, examine it carefully, sand both front and back with fine sandpaper to make it smooth, and hang the mask at a distance to consider its possibilities. Sometimes sanding creates such a subtly beautiful surface that very little paint or embellishment is needed. The mask may appear ancient with an agelessness created by the patina of time and use. If you want to add color and pattern, there are endless ways to enhance the surface (see the chapter on Finishing the Mask).

Grandmother Mask for Pilobolus was made with laminated mulberry paper.

Laminated Paper Masks **73**

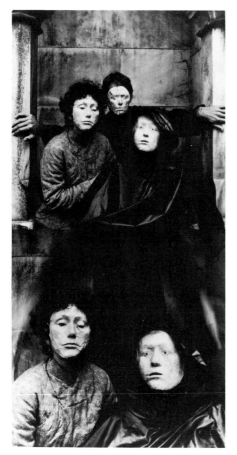

Laminated paper self-portraits worn by members of the Mask Transit Company. Photo by Peter Sasgen.

Mask made for Alison Chase of Pilobolus using the laminated paper technique.

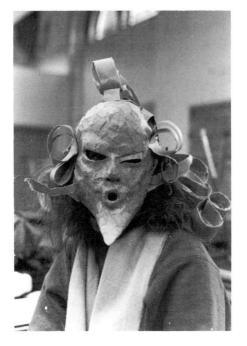

An elaborate paper strip mask construction. Student work.

A self-portrait mask using the laminated paper technique. Photo by Don Wagner.

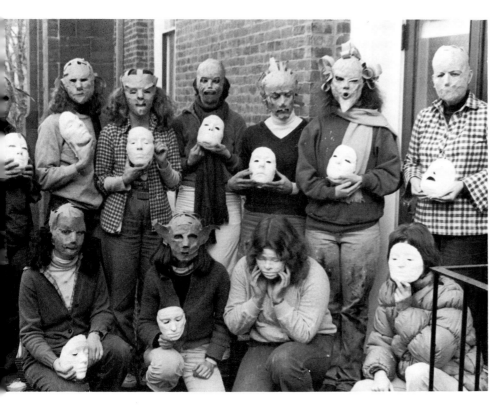

Students wear paper strip masks and hold the plaster molds from which they were made.

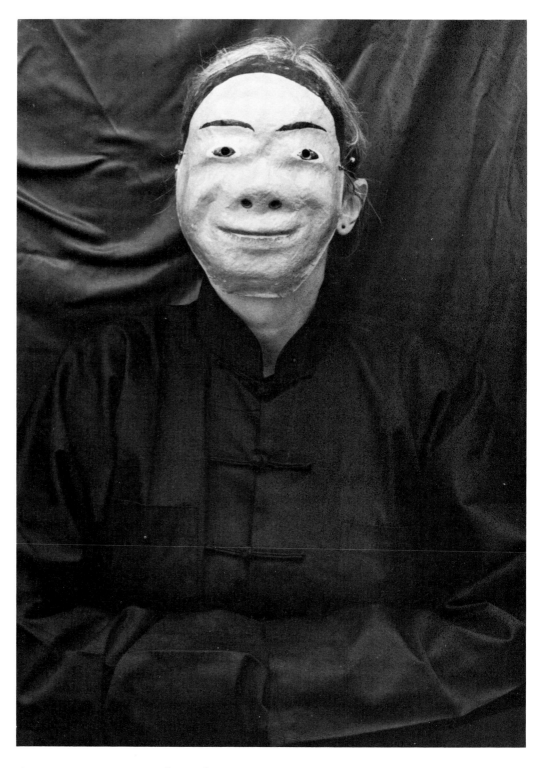

A contemporary papier-mâché mask
made from a mold in Yang Shuo,
China.

6 *Papier-Mâché Masks*

"The true value of a mask is revealed only when worn by a performer on the stage. There, a superior mask can become part of the actor's body by dint of his superior artistry; it is alive and his blood courses through it."

— KONGO IWAO, *Nō to Nōmen*

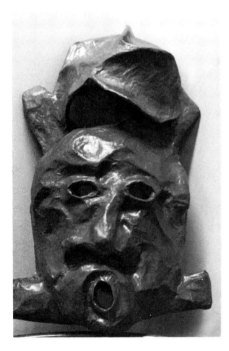

A papier-mâché mask made by Karen Schwartz over a crushed newspaper form.

Papier-mâché (French for "mashed paper") has great strength, versatility and a remarkable hardness which enables it to be dropped, hit and exposed to weather conditions which would harm other materials. Easily sculpted, it produces durable, lightweight masks.

Papier-mâché has a long history. In ancient Egypt it was used to line coffins. It was popular in the Orient around the end of the seventeenth century for waterproofing layers of paper. In eighteenth century England, papermaker Henry Clay patented a papier-mâché process that was used to make parts for coaches, panels and furniture. He soaked several sheets of specially made paper in a glue solution, pasted them together and pressed them into a mold. The molded mass was then dried in a stove. Another recipe included pulped paper mixed with sizing of glue and paste, to which was added ground chalk, clay and fine sand. In the 1830's, an artisan named Charles Frederick Bielefeld constructed a full-scale village of ten cottages and a ten-roomed villa out of papier-mâché, and assembled it in Australia.

Papier-mâché has long been used in theatre for masks, props and scenic furniture. In the Orient and South America, papier-mâché masks have been made for centuries.

Materials

Strengthened plaster gauze mold (see chapter 3)
Petroleum jelly
Paper such as Kraft paper, blotting paper, old drawings, charcoal paper, shelf-lining paper, Oriental papers
Pot or basin for soaking paper
Metal pot for boiling paper pulp
Wooden spoon
Stove or hot plate
Plaster of paris, ball clay or whiting as fillers
Newspapers for protecting work area
Wheat paste

Choosing Paper The paper used in the laminated paper technique is fine for papier-mâché. Experience will show you which papers work best for you. Avoid newspaper or newsprint because their high acidity makes them impermanent.

Glue, Paste, Adhesives Wheat paste has been used for years with paper to make a successful papier-mâché composition. Sold in hardware stores, it is used for applying wallpaper. Mix according to package directions. About one cup of paste mixture will be sufficient for a face-sized mask. Follow instructions on the package.

White polyvinyl glue (Elmer's or Sobo, for example) dries to a tough, clear substance and can be purchased in most hardware and craft stores. Mixed with equal parts of water, these glues are superb for papier-mâché work. Mix one-half to one cup of glue for a mask.

Metylan wallpaper paste is a powdered, vinyl-based adhesive which should be mixed according to the directions on the package.

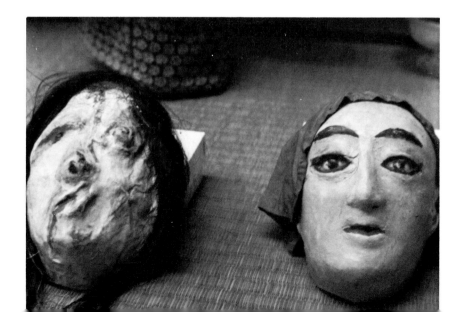

Two Japanese papier-mâché masks.

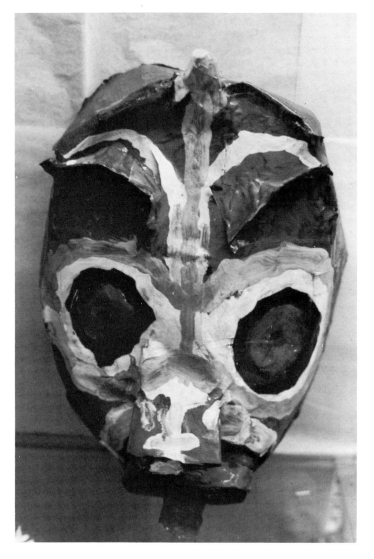

Courtesy Milwaukee, Wisconsin Public Schools.

Fillers Fillers are optional. They make the finished surface of the mask harder and somewhat smoother. Fillers such as plaster, ball clay and sawdust also make the finished product heavier. Experiment with amounts added to the basic glue solution, starting with one tablespoon of filler to one cup of mixed glue or paste.

Making a Papier-Mâché Mash

To make a mash or pulp, tear the paper into small pieces—about ½″ square or smaller—and place them in a pan of hot water for twenty-four hours. After this period, make sure there is enough water to cover the soaked paper and boil it for a few hours. Stirring will help break the mixture into a fibrous mass. Finally, put small amounts of the boiled paper into a blender with plenty of water, to create a usable pulp. After the paper has been pulped,

squeeze it to eliminate excess water. Small amounts of the glue mixture previously described can be added to the squeezed pulp and kneaded until the mass becomes smooth, fine and workable.

Instant Papier-Mâché

Most art supply stores sell instant papier-mâché pulp which is used in many classrooms to save time. It is a more expensive and sometimes wasteful way of working with papier-mâché, but it is an interesting, durable material to use. If you decide to try it, follow the instructions carefully. Once the instant mash is mixed, it can be pressed into a strengthened mold, or modeled over a paper or clay form. "Celluclay" is the trade name of one instant papier-mâché.

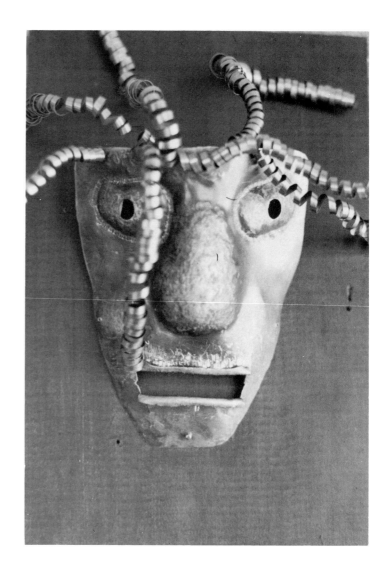

Courtesy Milwaukee, Wisconsin Public Schools.

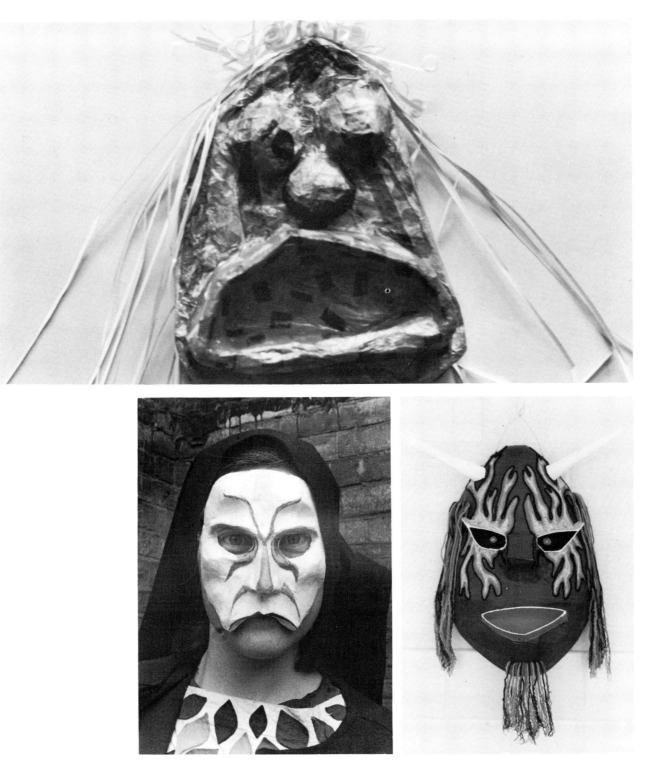

Papier-mâché mask by P. Whitelaw, Toronto.

Top, and above: Courtesy Milwaukee, Wisconsin Public Schools.

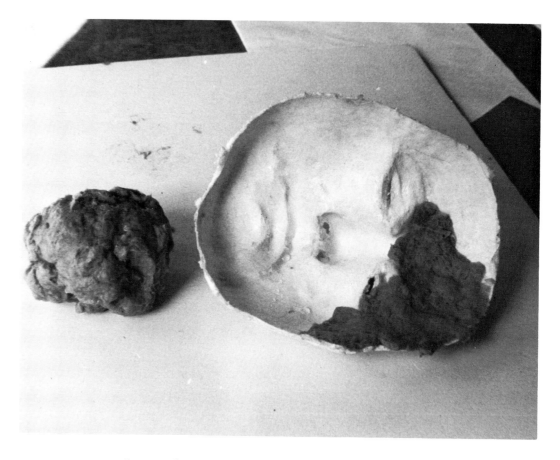

Squeeze the excess water out of the
pulp and press it into the strengthened
mold.

**A Pressed Papier-Mâché
Mask**

The plaster mold you use should be a stengthened one, because
paper pulp is heavy and taxes the mold with its weight. Coat
the inside of the mold with a thick layer of petroleum jelly for
easy removal of the mask.

Press a layer of pulp about ¼″ thick into the mold so it fills
all of the depressions and hollows. To help press the pulp, use
a wadded cloth or ball of paper towel. Drying can be accelerated
by placing the mold and its contents in the sun or on a warm
radiator.

Remove the mask from the mold and trim any rough edges
or areas. Glue a layer of laminated paper around the edges of
the mask to finish it and make it neater.

A high school student used handmade paper to make an arresting sculpture. Courtesy Fulton County Public Schools, Atlanta, Georgia.

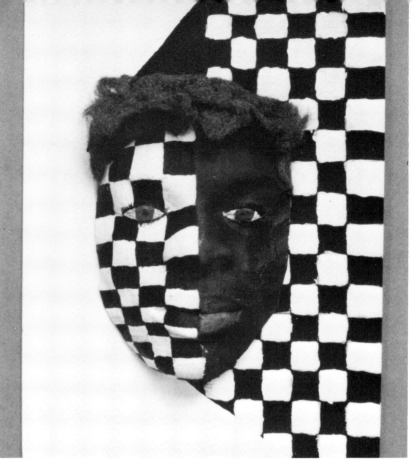

A simple design in black and white paint is used with dramatic effect on a student's handmade paper mask. Courtesy Fulton County Schools, Atlanta, Georgia.

A Modeled Pulp Mask Place a handful of mash (with excess water squeezed out) over a simple clay or paper form. The features of the form should not be too detailed, as the plastic wrap or mash may blur them. The form should be covered with plastic wrap to keep the pulp from sticking to it. (See also chapter 4, Building a Mask Over a Clay Form.)

The mash (pulp) can be smoothed, pinched or rolled (as clay would be) and pressed firmly to form a large, simple shape. You can cut away, shape and reshape this papier-mâché until the desired mask has been achieved. Remove the mask from the form and let it dry.

A papier-mâché mask is being formed over a crumpled newspaper shape by overlapping strips of torn paper.

A Layered Papier-Mâché Mask

This maskmaking method requires layering strips of paste-soaked paper over a basic form. Clay or wadded newspapers can be used to make the form. (See also chapter 4, Building a Mask Over a Clay Form.) Although it should be simple, this preliminary form should also be inventive, as it can be the prototype for other masks.

Press plastic wrap carefully over the form to insure easy removal of the mask later on. (If you use a clay form, petroleum jelly will serve the same purpose.) Prepare the glue or paste, following the directions on the package.

Tear strips of paper ½" to 1" in length. For the first layer, dampen them only with water and lay them over the form. Do not put glue on this first layer of paper. Instead, criss-cross and overlap the strips for strength. For the other layers, thoroughly rub the paste solution on each paper strip with your fingers and fasten it to the completed first paper layer. Continue working in this fashion until the mask is about six layers thick and rigid enough to be removed from the clay or newspaper form.

Whenever possible, allow the paper mask to dry naturally to prevent distortion. When it is thoroughly dry, it is ready to be painted.

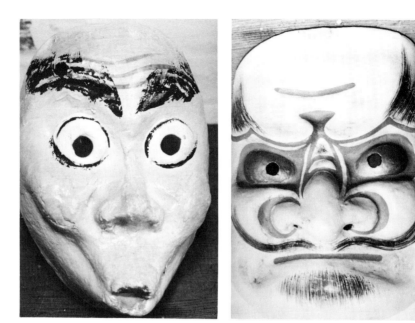

Two Japanese papier-mâché masks made over clay forms.

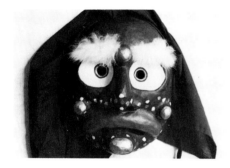

The exterior and interior of a Korean papier-mâché mask. The interior shows the signature of the artist. Most Korean masks have a cloth hood attached to the mask.

This Japanese mask is made from papier-mâché over a clay form.

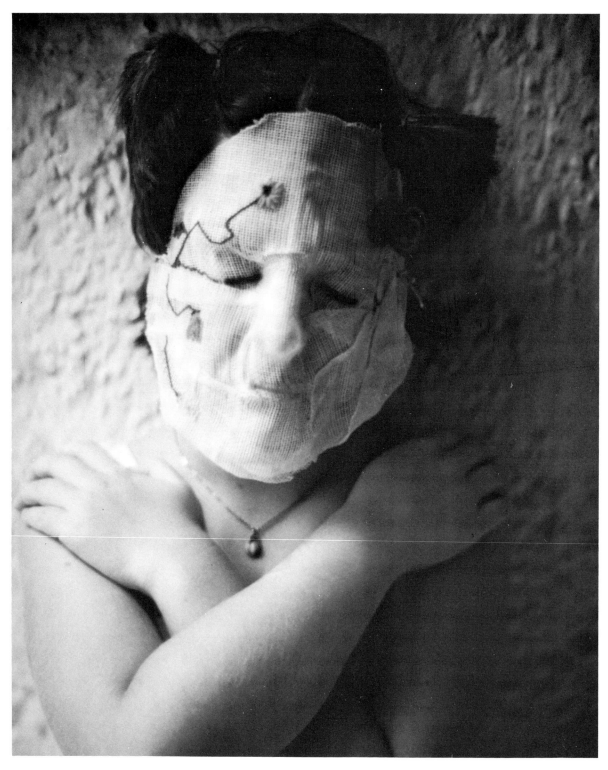

This buckram mask has been decorated
with stitchery.

7 Buckram Masks

Buckram.

Buckram is a stiff material used by milliners in hatmaking. It can be purchased in large fabric stores and sometimes through display companies. Used in window displays and some art exhibitions, buckram masks are also effective in performance because of their lightness and transparency. When moistened, buckram can be pressed into the required shape (a mold or form of some kind is necessary) and will retain that shape once it is dry. Millinery buckram is cut on a straight edge while cape buckram, which is used for shaping fur coats, is woven on the bias and has more flexibility or "give."

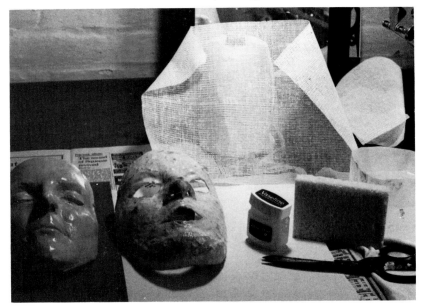

Materials used for making buckram masks.

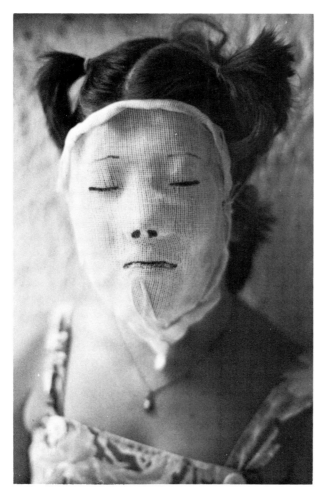

A simply decorated buckram mask.

Buckram allows the wearer good visibility.

Materials

Clay or plaster mold
Buckram (½ yard = two masks)
Thick, blunt stick for pushing fabric into shape
Scissors
Paint and brushes or felt-tipped markers for decoration
Needle and thread for decorative stitchery
Container of water or an atomizer
Sponge
Petroleum jelly

Allow some excess buckram for each mask because of the folding and pressing involved in the process.

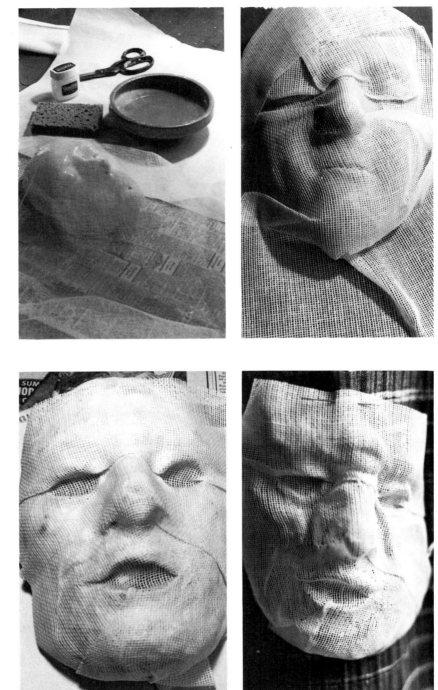

Moisten and press the buckram over the form.

Let it dry.

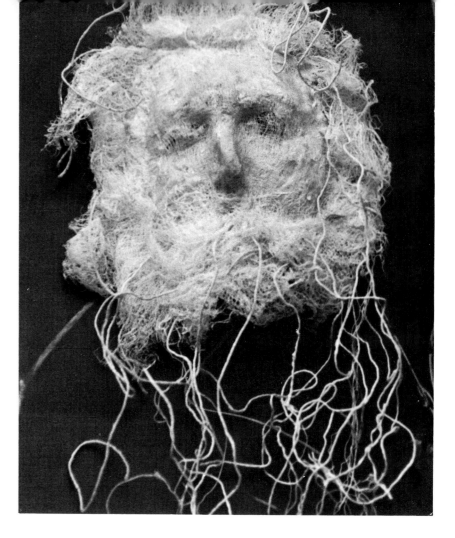

A student mask composed of buckram and covered with glue-soaked cheese-cloth and string.

Let the clay or plaster mold dry hard, and coat it with petro-leum jelly. Cut a generous piece of buckram to cover the mold or clay form. Sponge the buckram with water and press it into the form, using a blunt stick or knife for additional pressure. Folds in the buckram may be pressed together and allowed to set. When the buckram is dry, remove it from the mold and trim the edges.

The edges may be strengthened by stitching them with a needle and thread, attaching wire or gluing one or two layers of paper or cheesecloth to the back of the buckram mask.

Felt-tipped markers or spray paint are useful for decoration. Creative needlework can also enhance the final product. Visibility for the wearer is excellent, although it is nearly impossible for the audience to see the wearer's face through the buckram surface. Holes may be cut for the eyes or mouth, although the number of small holes in the fabric make breathing very easy.

Some of the qualities of buckram are visible in this Mexican wire frame mask. The artist has used decorative materials imaginatively.

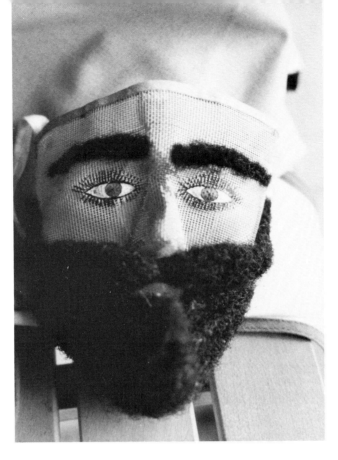

Interior view of a Mexican wire frame mask.

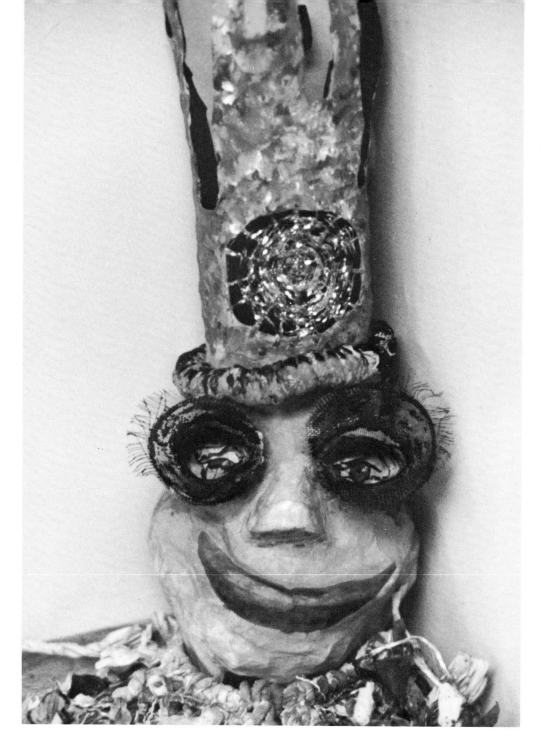

Mask and crown of chicken wire,
twisted screening, paper and fiber, by
Marijke Van Buchem.

8 *Wire Masks*

Wire is very adaptable, easily manipulated and simply joined to make a sturdy armature for large, light sculptural masks. Wire alone can also form a successful mask, providing good vision and portability.

A maskmaker from Trinidad uses wire and pliers to create large costumes and masks for the Trinidadian *carnivale*. He "thinks" wire; when he touches and bends wire, it is almost as if he were drawing curves and lines in the air. He makes visible the link between drawing and sculpture.

If you are not making large wire masks, you will not need a large support structure, and can work with lighter wire. If you do create a large mask, and work alone, the wire structure can be tacked to a wall with a staple gun or anchored to a sturdy table leg.

Sometimes I leave the structure open and the wires exposed, because it looks good to me; other times I seal the wire into the walls of the mask with laminated paper. After some initial work with the wire and pliers, bending and twisting, wrapping and pulling, you will gain proficiency. Experiment. See what the materials are like. You'll develop your own way of working.

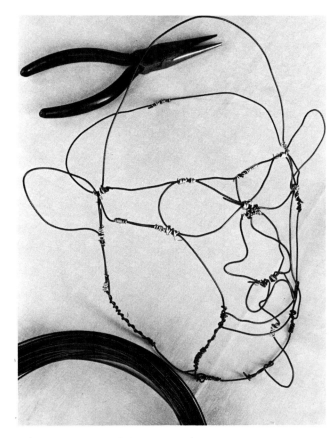

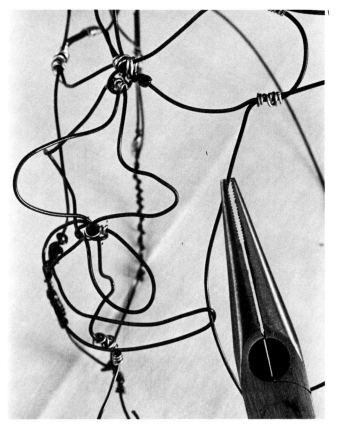

Where wire pieces join one another, bind them neatly with thin binding wire.

Joining wire pieces. Needle-nosed pliers make this process easier.

Materials

16 or 18 gauge wire. This is certainly sufficient for most over-the-head masks and is more easily manipulated with pliers and wire cutters by the beginner. (The lower the gauge number, the thicker the wire.)

Coat hangers

20 or 40 gauge copper or brass-banding wire

Soldering iron and acid core solder (optional)

Pliers, preferably those that are easy to use for bending and cutting wire.

Kraft paper

Clear drying white glue

Brushes

Ivory starch (optional)

Scissors

Paint

Soft florist's wire for binding. Electrical wire with multicolored plastic insulation can be used for decoration. It too can easily be bent or twisted.

Gloves

Beginning the Mask

Wire can be shaped with gentle pressure.

There are many ways to begin a large wire mask. If it is going to be worn over the head, it is a good idea to start with a circle of wire joined at the ends and slipped over the person's head to rest on the shoulders. Another smaller circle can rest on top of the head. To obtain the features or profile of the mask, make a simple drawing with a thick pencil or felt pen on a large piece of paper. Bend the wire along this outline drawing and secure it to the two circles to form the head's basic frame. You need not conform too rigidly to the drawing—more ideas will emerge as you superimpose parts during construction and study the mask from a distance.

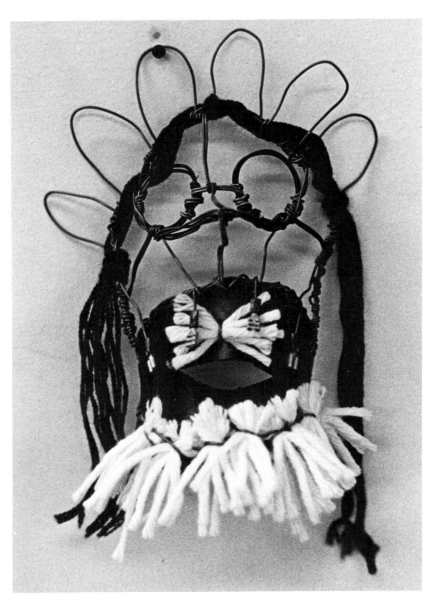

Electrical wire and yarn are the basic components of this see-through mask.

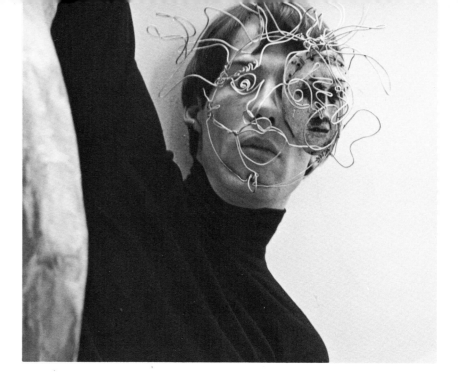

Wire frame mask by Tom Norton.
Photo by Birgitta Ralston.

Experiment with the tools you use. Proceed slowly and smoothly; a rough bump in the wire can be difficult to remove. To form a curve, grip one end of the wire with pliers. The other hand should be 8″ to 12″ away. Pull the wire out slowly. Wear gloves and goggles while working, because the wire may have rough edges, and may spring back toward your face. Practice bending the wire over the edge of a table top, and pinching curved details into the wire with pliers. For sharp edges, secure the wire in a vice and manipulate it carefully. Wire is stored in coils, so creating straight pieces presents a challenge.

Many artists creating large mask structures use chicken wire or hardware cloth (a mesh wire). I find them too heavy to wear, but often use small pieces of either for shaping features and adding to the armature formed by the above method.

When attaching one piece of wire to another, each surface should be grooved or ridged with a circular motion of the pliers until it is nicked or roughened enough to grip the other without sliding. Pressure of the pliers will pinch the two surfaces together. A piece of plasticine, a clothespin or a spring clip can be used to hold wires temporarily before making the joint. Whenever wire pieces join each other, they should be bound neatly with thin binding wire. If the armature has to be very strong, in the case of large carnival masks, apply solder to the wire joints.

Wire covered with paper gives this mask by Karen Schwartz a sculpted appearance.

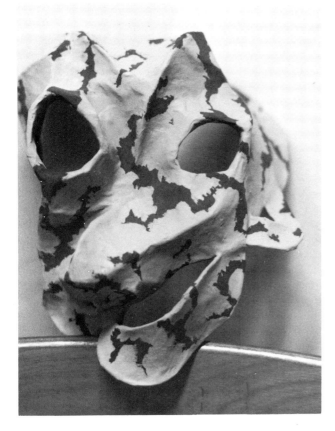

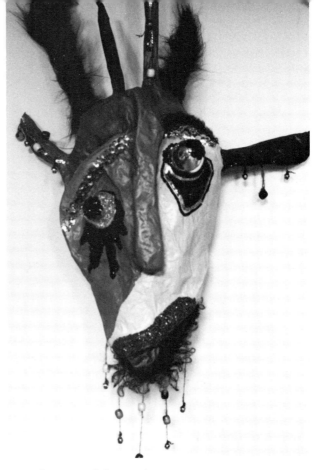

Wire dance mask by Cindy Kuyers.

Chicken wire forms the armature for this large mask.

Covering the Structure

To laminate large pieces of Kraft paper to a wire frame, use a clear-drying casein glue. For his *carnivale* figures, my friend uses starch (concentrated to the strength used for starching nurse's caps, as described on the package). When the first layer is completed, step back and check from different distances and angles to see if the features are effective from a distance. This is the time to make any corrections. Try the mask on occasionally to make certain it is light enough, comfortable and has good visibility.

Opposite: A large wire mask by the author is covered with mulberry paper. Photo by Birgitta Ralston.

This Page: Karen Wieder has glued individual strips of Japanese paper to her wire armature. This light, decorative mask casts interesting shadows.

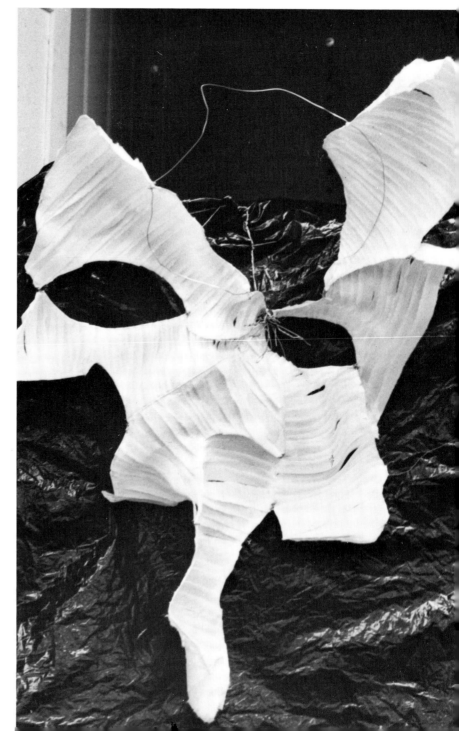

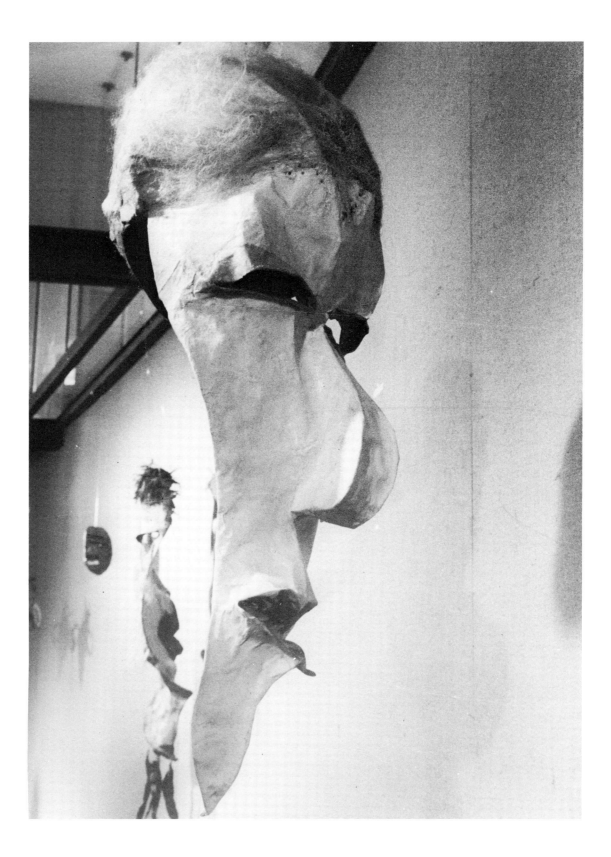

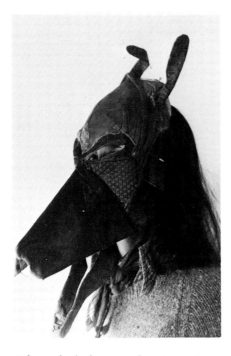

A lampshade frame and various pieces of bent wire were used to make this mask. It is covered with leather which was soaked in glue and water until it could be shaped.

Mask made of wire hardware cloth covered with paper towels and embellished with curled and twisted wire. By Carol Moriarity.

Other Ideas Masks can be made from lampshade forms that have been bought or found discarded. Sometimes there is something in a trash barrel that is perfect for a mask that you have been thinking about. Gutter protectors purchased in hardware stores suggest snouts, headdresses and other features. Electronic supply stores sell a wealth of metal and glass products that can be used in maskmaking. These items, already sturdily made, can inspire an idea and save time.

Wire can be used to make ingenious structures. The more you use it, the more fascinating it becomes as a fresh means of expression. The tools are inexpensive, easy to obtain and extemely portable. I often carry wire and pliers for making small, pendant-sized masks when I take a trip.

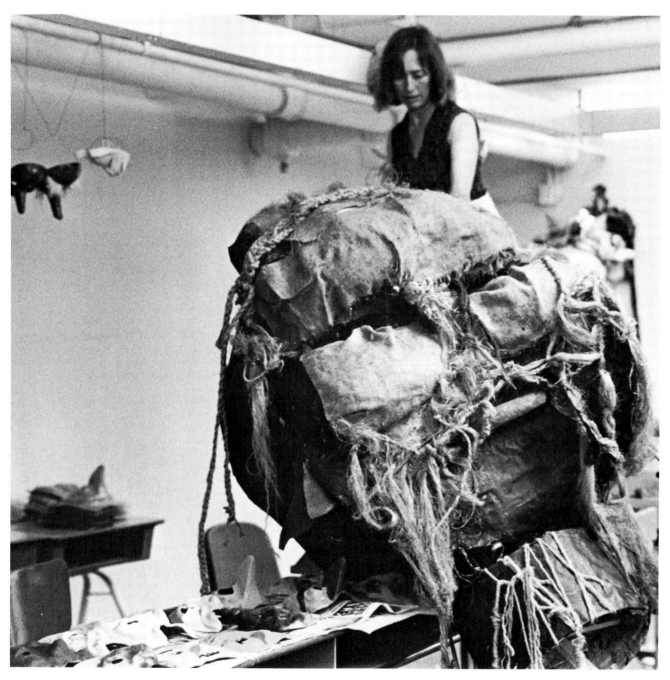

At work on a large processional head
made of chicken wire, fabric and fiber.

9 *Celastic Masks*

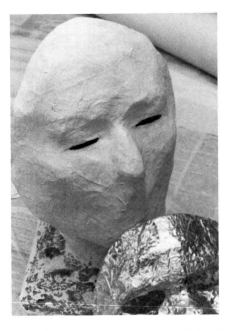

Use celastic to waterproof a mask head or reproduce a form covered with foil.

Use celastic, a plastic-impregnated fabric, when you need a tough, waterproof mask. Dipping celastic in a solvent such as acetone or methyl-ethyl ketone makes the material self-adhesive. It can then be placed in negative or on positive molds, over clay or wire forms, and used as a final layer to waterproof papier-mâché. When it is in a leather-hard stage (after about

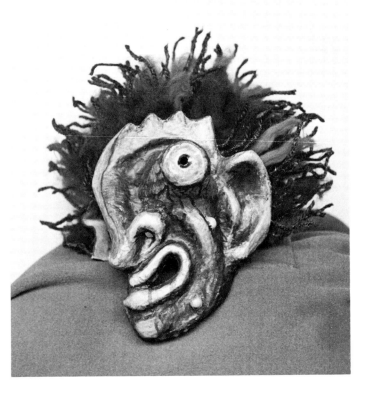

Anna Campioni's mask, *Medusa*, is made of celastic and papier-mâché.

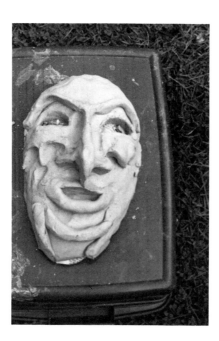

Strengthen a paper mask by adding a layer of celastic.

A clay base like this one can be covered with celastic to form a positive mold.

five minutes) the celastic can be draped or fashioned into free-form shapes. Within an hour this material becomes permanently hard and is ready to be painted with almost any paint. Theater groups use celastic for making large processional masks. Celastic can be purchased by the yard or the roll, and is usually available at theatrical supply houses and major art supply houses. A yard of material is sufficient to make three or four small face-sized masks.

When using celastic, wear rubber gloves to protect your hands. Some plastic gloves dissolve in solvent. Solvents such as acetone and methyl-ethyl ketone give off toxic vapors and are extremely flammable, so work in well-ventilated areas and do not smoke. Use a respirator mask for organic vapors.

Materials

Celastic (fine, medium, heavy)
Scissors
Rubber gloves
Face mask (respirator mask made for organic vapors)
Metal or glass container for acetone
Fan for ventilation
Newspapers to protect work area
Chicken wire armature, strengthened mold or papier-mâché forms
Petroleum jelly or aluminum foil
Acrylic or polymer paints
Brushes

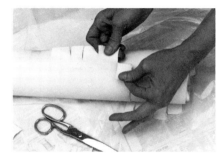

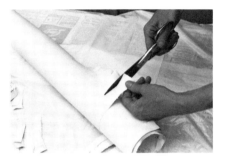

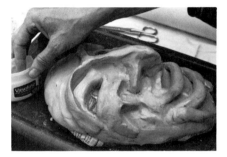

Tearing the celastic will create a smooth surface where pieces overlap.

Cut the celastic from the roll if you need a straight edge.

Apply petroleum jelly over a clay base.

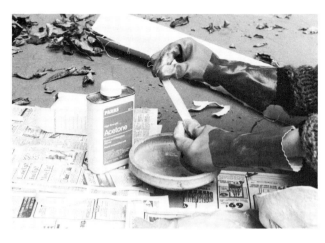

Wear rubber gloves whenever you work with acetone and celastic.

Dip one strip of celastic at a time into the acetone.

Press the strips onto the clay surface.

Celastic will pull away easily from a foil-wrapped mask.

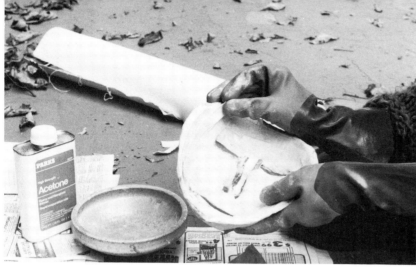

Waterproof the inside of a finished
mask with celastic.

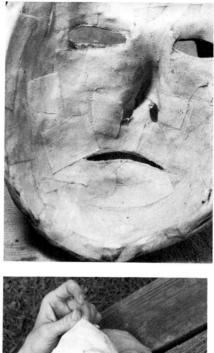

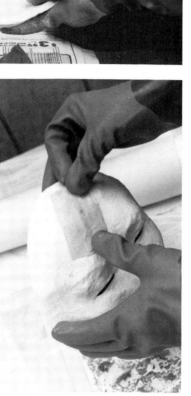

Strips of celastic adhere well to a
papier-mâché head form.

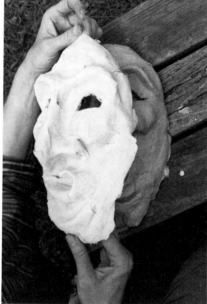

Petroleum jelly allows the celastic
form to be easily released from the
clay.

Tear the celastic into swatches or cut it. When torn swatches
overlap, the feathered edges make a smooth surface. It can be
applied over a chicken wire armature or a clay mold. If clay is
used, it should be covered with petroleum jelly or aluminum
foil to prevent sticking. While wearing rubber gloves, dip the
swatches in acetone for a few seconds and press them over the
armature or clay mold. I have also pressed these swatches into
a plaster gauze mold which has been coated with petroleum
jelly or sprayed with silicone to prevent sticking.

Celastic may be formed into swirls and folds.

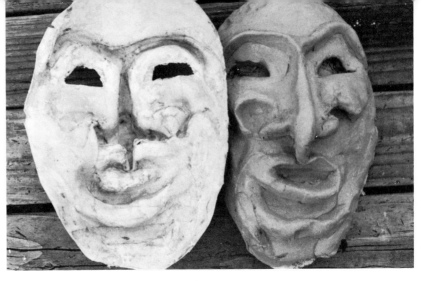

A celastic mask and the clay form from which it was made. The clay can be reused.

A performer wears a small celastic mask. Photo by Birgitta Ralston.

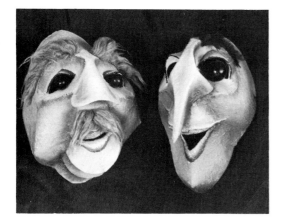

Politician and citizen, celastic and paper. Courtesy Pandemonium Puppet Co. Photo by Bonnie Meier.

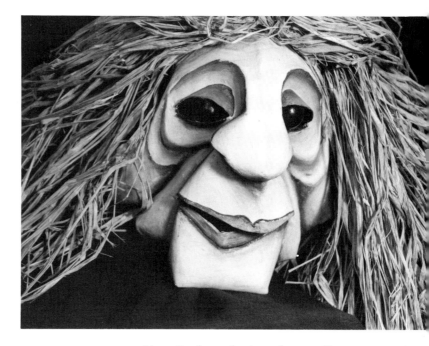

Lizzy Borden, celastic and paper. Courtesy Pandemonium Puppet Co. Photo by Bonnie Meier.

Celastic dries more slowly inside a mold because the acetone evaporates more slowly. Celastic can also be formed into ribbons, banners or free forms, by shaping it when it feels leathery. It takes about half an hour to harden into a rigid shape. A fan will accelerate drying time. If one layer does not feel sufficiently strong, apply another layer as soon as the first is dry, or later. Any paint can be used on the surface of the mask. Unused celastic may be stored for years.

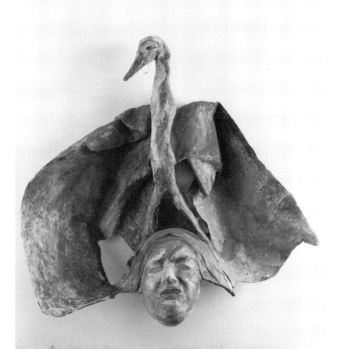

Night Bird was reinforced with celastic, covered with laminated paper and painted. Photo by Norinne Betjemann.

107

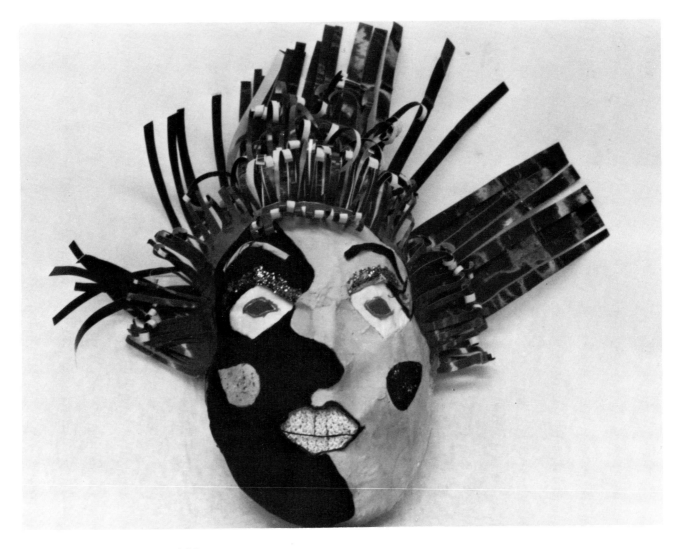

Artist Diane Erle has inserted fabric inside the mouth of this mask, and embellished it with curled adhesive paper, glitter and felt.

10 *Finishing the Mask*

The possibilities for embellishing a mask are as varied as the personalities of people interested in masks. Reading about or looking at masks from other cultures will make you aware that everything from nuts to nails has decorated masks and will continue to do so.

My maskmaking technique requires only a small amount of paint, and, in the case of ceramic masks, almost no glaze. I do extensive sanding to bring out the features and texture of the mask structure, and enjoy retaining the quality of the original materials used.

Side view of a mask made from index cards. The paper has been scored and imaginatively folded.

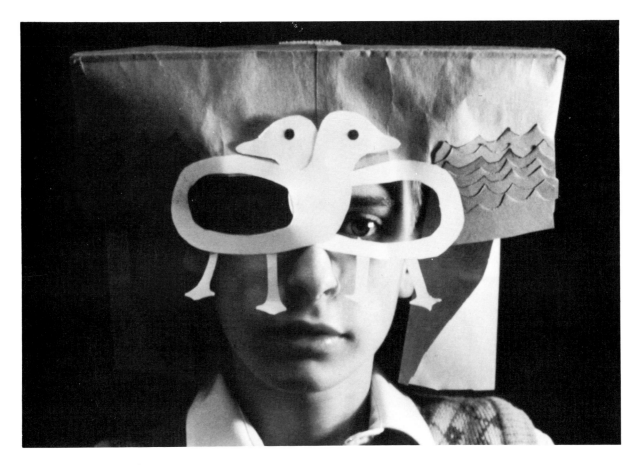

Using a paper bag and some construction paper, a seventh grade student put together this ingenious mask/headdress.

Even flat paper masks can be striking. Courtesy Milwaukee, Wisconsin Public Schools.

Front view of a mask made from index
cards by Melissa Klein. Note its three-
dimensional look.

A light, delicate carnival mask, deco-
rated with paint, paper and metal fas-
teners. By Norma Munoz.

In this section, I will briefly discuss some of the materials
with which I am familiar. As an artist, you must constantly
experiment, collect items for future use and refer to books on
artist's materials and techniques. One invaluable aid is a
sketchbook journal for recording information about masks, for
keeping photographs and notes of ideas and for recording the
materials used for each mask (including the colors mixed for
each mask). It is so easy to forget a unique color mixture or the
source of a certain kind of paper. If you number each mask and
record its materials in the book, there will be no later uncer-
tainty if you wish to reproduce such an effect.

Painting

Before painting the mask, it must be thoroughly dry so it will not continue to shrink. Sand the mask with a fine garnet paper so there are no rough edges in the front or back.

Materials

Gesso is optional, but can be used as a primary decorative layer on a mask. Gesso, usually available at art stores, is a liquid medium containing a white pigment with a binder that is used as a preparatory coating for painting. It is applied with a brush. When dry, the surface is sanded. Use gesso only on a rigid surface; on flexible surfaces it will crack. To create texture on the mask, use a stippling motion with the brush or press a textured fabric such as cheesecloth into the gesso as it dries. Gesso may be used if you are using watercolors, poster paints or gouache. Acrylic gesso is used in combination with acrylic paints.

Poster paints, tempera paints or show card colors are opaque paints which are thinned with water or used straight out of the jar. They are inexpensive, sold in most art stores and have a flat, non-reflective quality. If you are applying the paint in layers and don't wish to have the layers mix, brush a thin veil of acrylic medium between the paint layers. Poster paints can be diluted and sanded. True tempera paints are sold in tubes, not in jars. Many artists mix their own.

Watercolor paints are thinned with water and usually allow the color of the paper to show through. Watercolor is more like an evanescent stain than a firm layer of color, and it dries lighter. Experiment with color mixtures and different brush effects.

Gouache is an opaque watercolor. With it, strong contrasts and spontaneous strokes are possible, and will show up clearly on the mask. It mixes easily, produces rich, glowing colors and can be combined with watercolor.

Acrylic paints are pigments mixed with liquid plastic binder. Acrylics are more flexible than other paints (and so are more suitable for painting on fabric masks) and can withstand changes in temperature. They can approximate most watercolor and oil effects. These fast-drying paints are insoluble in water when dry, so keep the brushes clean. Acrylic gesso is used to provide a good working ground or primer surface for acrylic paints.

Acrylic modeling paste enables the artist to model in relief. It is sold in a can in art stores, can be mixed with any of the polymer colors and is good for creating textures.

These foam paint applicators from the hardware store create interesting effects.

An area set out for painting—the palette of white ceramic, brushes and colored pencils.

Gel medium gives bulk and texture to acrylic colors. It is not essential for the beginner.

Gloss medium imparts gloss to any acrylic color.

Matte medium makes your acrylic color less glossy.

Matte and gloss varnishes are final coats to be used over watercolor, gouache and acrylic paint. They are not to be used over oil paint.

Oil paint can be used on most non-flexible mask surfaces, if those surfaces are prepared beforehand. The range of available colors is similar to that of acrylic or gouache. If you have had no experience with oil paints, you should probably experiment with color mixing by using water-based paints and inexpensive brushes. Consult Ralph Mayer's *The Artist's Handbook of Materials and Techniques* for detailed information on oil painting for beginners.

Acrylic gesso can be painted on as a ground or base. (You can also use real gesso, an inert white pigment with a binder.) Oil paints dry slowly. If applied too thickly or before the previous layer is dry, the paint will crack or discolor.

Color　**Mixing Colors**　Color is so personal and connected to an individual's sensations that it is difficult for one person to teach another to use color. You learn about paint and color by using them.

Most beginners test paint on inexpensive paper before applying it to the mask. I advise my students to get to know each color in its natural state before mixing it, as a color looks different when another color is placed next to it. When mixing colors, be adventurous. You will notice that some colors become muddy when mixed together. Others change in vitality depending upon the color underneath. Try using color with only a little water, and then flood it with water to see what happens. Record the color mixtures with samples in your journal.

For the beginner in painting, mixing paint to match color portraits from magazines is a useful exercise in understanding flesh tones.

Squeeze out a little white from a tube. Add to it even smaller amounts of other colors, keeping records of the combinations and proportions of colors in a sketchbook so that you can reproduce the most successful ones. Try some of these combinations:

> White, plus yellow ochre and light red
> White, plus burnt sienna and a little ultramarine blue
> White, plus cadmium yellow medium and a little deep cadmium red
> White, plus burnt sienna, alizarin and a touch of ultramarine

When using white paint in color mixtures, add other colors to white, rather than adding white to the other colors. This conserves paint. Too much white gives the color a chalky, dull quality. Try diluting each color mixture with water. When you arrive at a color mixture that satisfies you, mix enough to cover

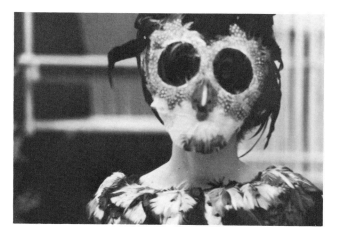

An eighth grade student created this decidedly owlish feathered mask.

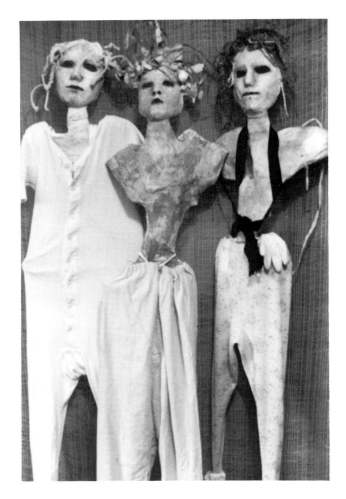

Lifesized mask puppets made from plaster gauze molds covered with mulberry paper and decorated with dowels and fabric.

the area you need to paint, so you won't have to mix more when you are nearly finished.

You will begin to observe a great number of subtle color changes across the surface of the face. To obtain these subtleties, I build up layers of grey or ochres under the flesh color and sand through, or apply the flesh color diluted so the underlayer glows through. For oriental skins, try a mixture of yellow ochre and white with a touch of orange. Cobalt violet added to this basic flesh color gives warm shadows. A sample palette for the beginner might include:

White	Ultramarine Blue
Lemon Yellow	Cobalt Blue
Yellow Ochre	Viridian Green
Alizarin Crimson	Raw Umber
Cadmium Red	Light Red

Generally, each mask requires a different treatment and different colors.

Collage

Collage is an artistic composition of fragments of printed matter and other materials pasted on a picture surface. To attach materials to the mask surface, use white glue, polymer glue medium or other clear-drying glues.

Black and white paint and yarn adorn a powerful mask by a high school student. The mask is made of handmade paper. Courtesy Fulton County Schools, Atlanta, Georgia.

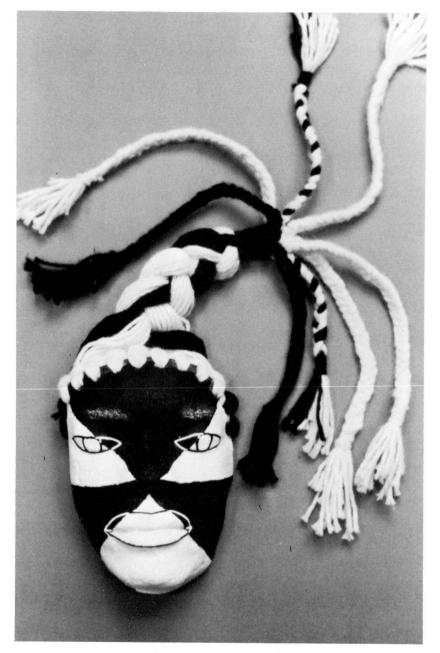

Collage Effects and Ideas

Torn paper edges (déchiré) can be built up in layers (shingled), painted and some layers pulled off.

Partial pasting allows some of the attached papers to remain loose for folding, curling or manipulating.

Stain Oriental papers and then superimpose them over each other for a translucent effect.

When thin papers are wet with glue, **push** or **crinkle** them so they create a wrinkled effect. This is an effective way to make minute facial wrinkles in masks of elderly faces.

Take **rubbings** (*frottage*) of textures with the side of a graphite pencil. Apply these rubbings to the surface of the mask.

Scorching or **burning** paper or fabric can give an old, weatherbeaten effect to the mask surface.

Stencilling gives the mask an ornamental, formal look, and sometimes suggests Chinese opera makeup. Use it to create patterns on some animal masks. A stencil can be made out of paper; dab the paint on with a stiff brush.

Using **weathered political announcements** makes a statement about the period when the mask was made. The mask can then become a kind of diary of events taking place.

Affix cloth to the mask. The softer or more weathered it is, the easier it is to shape the fabric to the mask.

Use old drawings or letters on the surface of the mask to create unusual textures and patterns. Or **attach metal filings**, dust or grasses.

Final Protection and Waterproofing

Polyurethane varnish can be purchased in hardware stores. It comes in a gloss or matte (low gloss) finish, and gives a tough, durable, water-resistant seal.

Varnish sprays are clear sprays used as fixative for pastels and some paintings. One brand name is Krylon; these sprays can be purchased in art stores.

Polymer media are sold in bottles in artists' supply stores. They are available in dull or glossy finishes, and should be applied with a brush.

These commercial products will increase the life and durability of your masks. **These materials can be hazardous to the artist, however; when using them, make sure there is adequate active ventilation. Follow all label instructions carefully.**

Edo
Genroku Period
Year 11, Month 6
(Tokyo, July 1698)

1

Thunder rumbled in the summer dawn. Storm clouds absorbed the light breaking above the hills outside Edo, while ashes drifted upon smoke from a fire during the night. Up a broad avenue in the *daimyo* district, where the feudal lords had their city estates, rode a squadron of samurai. Their horses' hooves clattered, disturbing the quiet; their lanterns flickered in the humid air. Night watchmen, slouching against the high stone walls that lined the street, jerked to attention, surprised by the sudden excitement at the end of a long, uneventful shift. Windows opened in the barracks that topped the walls; sleepy, curious soldiers peered out as the squadron halted outside the gate of Lord Mori, *daimyo* of Suwo and Nagato provinces.

Hirata dismounted, strode up to the soldiers guarding the portals, and said, "I'm here to raid this estate. Let us in."

Resentment evident in their faces, the guards swung open the gates. They'd spied the triple-hollyhock-leaf crests, symbols of the ruling Tokugawa regime, that Hirata and his men wore on their armor tunics. Even the powerful provincial lords must bow to Tokugawa authority. And they recognized Hirata as the shogun's *sōsakan-sama*— Most Honorable Investigator of Events, Situations, and People. They dared not disobey him.

As Hirata invaded the estate with the hundred men of his detective

corps, he walked with a limp from a serious injury that had healed but still caused him pain. Yet he kept up a quick pace at the head of his troops. Cries of confusion erupted as Lord Mori's troops swarmed the courtyard.

"Round everybody up," Hirata ordered his men. "No one leaves or enters the estate until we're done. Search this whole place. You know what to look for."

The detectives hastened to comply. Shouting, defiance, and tussles met them. Hirata, accompanied by a team of troops and his two principal retainers, Detectives Inoue and Arai, marched through the inner gate. Across a formal garden of rocks and twisted shrubs loomed the *daimyo*'s mansion, a large, half-timbered structure with multiple wings and peaked tile roofs, mounted on a granite foundation. A samurai bustled out the door and rushed down the stone path to meet Hirata.

"I'm Akera Kanko, chief retainer to Lord Mori." He was some fifty years of age, pompous and stout. "Why are you intruding on my master?"

"He's under investigation for treason," Hirata said as he and his men advanced on the mansion. "I'm going to inspect his premises and interrogate everybody here."

"Treason?" Akera huffed in outrage; he ran to keep up with Hirata. "With all due respect, but Lord Mori is no traitor. He's a loyal subject of the shogun and an ally of his honorable cousin Lord Matsudaira."

"I'll be the judge of that," Hirata said.

Several months of investigation had convinced him that Lord Mori was conspiring against Lord Matsudaira, who ruled Japan through the shogun. During the three years since he'd seized power after a war with an opposing faction, Lord Matsudaira had evolved from a just, reasonable man to a tyrant fearful of losing his position. He'd demoted and banished officials he didn't trust, and subjected the *daimyo* to strict supervision and harsh fines for perceived offenses. This had spawned widespread disgruntlement and many plots to overthrow him.

Hirata mounted the stairs with growing excitement. Today he would find proof of the conspiracy. His investigation would end with

the arrest, conviction, and ritual suicide of a traitor. Hirata would serve his honor by defending his superior at a time when his honor badly needed serving and his reputation with Lord Matsudaira and the shogun could use some improvement. He was thirty-one years old, with a career as a police officer behind him and three years in this post, and he should have been able to stay out of trouble, but it seemed he never could.

Now Akera looked terrified. Everyone knew that the penalty for treason was death, and not just for the traitor, but for all his family and close associates. "There must be a mistake!"

"Where is Lord Mori?" Hirata asked.

"In his private chambers," Akera said.

"Take me there," Hirata said.

"No one is allowed to disturb Lord Mori without his permission," Akera objected.

"I don't need his permission," Hirata said. "I have Lord Matsudaira's orders."

"Very well."

Resigned yet nervous, Akera led Hirata, Inoue, and Arai to a compound at the heart of the estate. There, a spacious garden, landscaped with lush trees, was so quiet that Hirata could hear frogs peeping and crickets chirping. Insects swarmed over a reed-fringed pond coated with green scum. A cloying, sweet scent of flowers mingled with the rank odor of privies. At the center stood a rustic villa. Ivy draped its barred windows; deep eaves sheltered the veranda. Hirata and his companions approached the villa along one of several covered corridors that extended from the main mansion. They bypassed the guards stationed outside and stepped into the entryway.

The detectives shone their lanterns beyond, illuminating a maze-like space divided by partitions. The air was warmer and staler than outside. Hirata had a sudden impression that something was wrong. He and the detectives exchanged frowns. At the same moment they heard whimpering. The sour, metallic odor of blood hit them.

Behind them, on the veranda, Akera asked, "What is it?"

Hirata motioned Akera to keep quiet. He and his men tiptoed

through the maze of rooms, skirted partitions, edged around furniture. The whimpering grew louder, punctuated by sobs. It came from the villa's far end, where a gap yawned in the partitions. The smell of blood grew stronger. Hirata and his men halted and peered through the gap.

Inside was a bedchamber inhabited by two nude figures, one a man, the other a woman. The man's heavyset body lay prone on a futon. The woman knelt close to the man, bent over him. Her long, black hair veiled her nakedness and her face. She whimpered, sobbed, and gasped as she shook his shoulders. Where his genitals should have been, a red wound glistened. Blood that had spilled from the wound, and from gashes in his torso, drenched the bed and spread in a thick puddle on the tatami floor. A chrysanthemum rested in the puddle, its cut stem submerged, its white petals stained crimson. Nearby, alongside a heap of robes, lay a dagger with a bloodstained blade and the man's severed penis and testicles.

Hirata and his men exclaimed in horrified unison. Akera, who'd followed them, cried, "Lord Mori!"

The woman looked up. Her hair fell aside to reveal her bare breasts and swollen abdomen. Red smears of Lord Mori's blood colored her pale skin. Her delicate, pretty features were contorted by shock and terror, her eyes wild. As she tried to cover herself with her hands, Hirata noted that she was some five months pregnant.

Akera rushed into the room and fell to his knees beside Lord Mori. He shouted his master's name and seized his hand, but Lord Mori neither answered nor stirred.

Detective Arai crouched, felt Lord Mori's pulse, and bent over to listen for breath. "He's dead."

But Hirata barely listened. He and the woman stared at each other in amazed mutual recognition. "Lady Reiko," Hirata said in a voice hushed with disbelief.

She was the wife of Chamberlain Sano, the man Hirata called master. Hirata's horror at the mutilation and death of Lord Mori increased tenfold. "Merciful gods, what are you doing here?"

Reiko shook her head as if dazed. She cowered under the men's scrutiny, while outside the thunder boomed and rain fell in a torrent.

Akera staggered over to her. "She murdered Lord Mori!" he cried, his face livid with rage, his finger jabbing at Reiko in accusation. "She cut off his manhood and killed him!"

2

The rain poured down on Edo. Townsfolk waded through flooded streets. Merchants peered out from behind storm shutters pulled across their shops. Curtains of water veiled the hill upon which Edo Castle stood. Within the castle, guards huddled in turrets and enclosed corridors atop the high stone walls. Soldiers in dripping armor patrolled the soaked passages. But inside his office in a compound near the palace, Chamberlain Sano sat dry and comfortable with General Isogai, who was commander of the Tokugawa army, and two members of the Council of Elders that was Japan's chief governing body.

"We've requested this meeting to discuss some disturbing recent developments," said Elder Ohgami Kaoru. He had white hair and pensive, youthful features. He was in charge of the Tokugawa government's relations with the *daimyo* class.

"The first is an incident in Bizen Province four days ago," continued Elder Uemori Yoichi, the shogun's chief military adviser. He inhaled on his tobacco pipe and let out a deep, phlegmy cough that shook his loose jowls.

"I'm aware of the incident," Sano said. "The outlaw rebels have struck again."

During the three years since the war, the former chamberlain Yanagisawa's underground partisans had still been fighting Lord Mat-

sudaira's regime within the Tokugawa regime. Many had been captured and executed, but the survivors had recruited new troops from among peasants, gangsters, and disgruntled Tokugawa vassals. They concentrated their attacks on the provinces, where the Tokugawa forces were less numerous.

"This time they ambushed Lord Ikeda's army," Sano elaborated. They were after the allies that had supported Lord Matsudaira's ousting of Yanagisawa, and they'd devised warfare tactics that utilized their relatively small forces to maximum effect. These included sniping, ambush, and arson, plus sabotage of buildings, bridges, roads, and agriculture. "They killed twenty men, then escaped into the woods."

Everyone looked none too pleased that Sano was so well informed. He knew they'd have liked to control his access to news, the better to control him. But he had a private intelligence service, his defense against ignorance, a fatal weakness for the shogun's second-in-command.

"My troops are doing the best they can to stop the outlaws." General Isogai had a loud, forthright manner and a bulbous physique. "But they're spread too thin. And Edo is vulnerable because so much of the army is deployed to the provinces. Let's pray that the outlaws aren't planning a major attack here."

"We won't know until it's too late," Ohgami said.

Uemori nodded. "The *metsuke* is spread as thin as the army." The official intelligence service had been working overtime because Lord Matsudaira had its agents keeping tabs on his growing opposition within the government.

Thunder cracked; rain cascaded from the eaves. "This weather doesn't help," General Isogai muttered.

It had been an exceptionally wet rainy season, with serious, countrywide flooding. Every news dispatch contained stories of washed-out villages, of families drowned or homeless.

"Nor does it help that so many townspeople have rushed to take advantage of a bad situation," Ohgami said.

"Crime is rampant," Uemori noted. "Thieves are looting flooded homes and businesses. Edo Jail is overflowing."

"Many members of the *bakufu* have also taken advantage." Ohgami

grimaced in disgust at his colleagues in the military government that ruled Japan. "Officials have embezzled from the treasury and stolen from the Tokugawa rice stores. Tax collectors are taking bribes from *daimyo* and merchants to reduce taxes and falsify the account books. We have such a serious shortfall of funds that we may not be able to pay stipends to the thousands of samurai in the regime."

"Well, we know one cause of those problems," Ohgami said. "It is all the officials who are new to their posts."

During the purge immediately after the war, many experienced officials had been replaced by men whose main qualification was loyalty to Lord Matsudaira. The novices didn't know how to discipline their idle, corrupt underlings.

Sano grew restless because the elders were prone to complain rather than take action. "Well, unless anyone has any solutions, may we adjourn this meeting?" He was nominally their superior, but their seniority and age gave them special standing, and he pretended to defer to them.

"Not so fast," General Isogai said. "We've one more topic to discuss."

"It's the methods you've used to solve the problems," Uemori said.

Ohgami hastened to say, "Not that we mean to criticize you for taking action when others couldn't."

Sano heard the shared, unspoken thought that the shogun was a fool, useless at administration, and Lord Matsudaira couldn't handle the problems either because he was too busy maintaining his political power to bother with the specifics of governing.

"Please go on." Sano knew from experience that the men were about to criticize him, regardless of their disclaimers.

"You certainly have made progress toward straightening out the regime's finances," Uemori said in grudging admission.

Sano had sent his private spies to watch the treasury and the rice warehouses. He'd caught thieves, recovered loot, and restored the flow of money into the Tokugawa coffers.

"And you've reestablished a semblance of law and order in the city," Ohgami said. During the past three years, Sano had built up a

large personal army, which he'd assigned to patrol the streets and help out the police.

"We thank you for taking on tasks that another man in your position might perceive as below his station," Uemori said.

Sano nodded, acknowledging that he'd been given the dirty work of the regime. He'd done what he had to do, and he couldn't help being proud of what he'd achieved. "But . . . ?" he prompted.

Ohgami spoke delicately: "Your methods have been rather, shall we say, unconventional."

That was not a positive attribute in a society that valued conformity and custom.

"I'll say." General Isogai chuckled. "It was brilliant of you to punish the thieving officials and the idle bums by sending them to help out in flood disaster zones. And I like how you made the *daimyo* tax cheats run jails on their estates. That's turning rotten plums into good wine."

Ohgami coughed. "The shogun and Lord Matsudaira appreciate your competence. And you're much admired by many people." Sano had built up a large following of military allies among *daimyo* and Tokugawa vassals who respected him because he was honorable as well as powerful. They included the two elders—who were top advisers to the shogun—and General Isogai, who could lend the might of the Tokugawa army to anyone he wished.

"But you're feared by others because of your control over society," said Ohgami. "You've made a lot of powerful enemies."

Which included people Sano had punished. General Isogai said, "How many assassination attempts on you have there been this year? Three?"

"Four." Sano had been ambushed, attacked on the street, shot at, and almost poisoned. He now employed a food-taster and never went anywhere without bodyguards.

"Police Commissioner Hoshina hasn't missed the opportunity to lure your enemies into his camp," said Uemori.

Hoshina had been Sano's foe for seven years, working tirelessly to bring Sano down.

"I'm aware of that." Sano's expression hinted that if the men had some news, they'd better come out with it now.

"What you may not be aware of is that Hoshina has begun a new campaign to discredit you," Uemori said. "Some of his new allies have great influence with the shogun and Lord Matsudaira."

"Lord Matsudaira can't afford to lose their support," Uemori added. "No matter how much he respects you and depends on you, he may give in to their pressure to get rid of you because he's afraid to offend them and have them turn on him."

The possibility hadn't escaped Sano's notice. "I'll keep that in mind." He experienced a twinge of surprise at the life he led. How far he'd come from his humble origin as a son of a *rōnin,* earning his rice by teaching martial arts! Such bizarre twists of fate had brought him here! And his exalted status was a mixed blessing.

He hated living in constant fear for his life, with hardly a moment of solitude or freedom. Politics was dirty business. He would have prefered a good, clean sword battle any day. And the higher he rose, the greater the danger of falling. Most days Sano was confident that he could stay on top, but he was almost forty years old and sometimes he felt his mortality. His hair was turning gray. Stiff muscles irritated him. A bad beating three years ago, from an assassin dubbed the Ghost, didn't help. Still, his job as chamberlain was not only his duty but his destiny, a source of satisfaction as well as trouble.

General Isogai said, "Here's something else to keep in mind: If you go down, so do a crowd of other folks." His gaze touched on each elder before returning to Sano.

"The time may be coming when we and your other allies can no longer afford to be associated with you," said Uemori.

"For the sake of self-preservation, we may be forced to make different arrangements," Ohgami concluded.

Sano had foreseen the possibility of losing their support; allegiances constantly shifted in the *bakufu.* But that didn't lessen his dismay that it could happen so soon. Should his allies desert him, Sano would be doomed to demotion, banishment, and perhaps death. His family would suffer even more.

"I appreciate your loyalty, and I understand your position," he said in an attempt to appease the men. "What would you have me do?"

General Isogai answered, blunt, forceful: "Back off on making any more enemies."

"Placate the ones you already have," Uemori said.

"Try to avoid getting in any more trouble," said Ohgami.

During the tense, unfriendly silence that followed, Detective Marume appeared in the doorway. "Excuse me, Honorable Chamberlain." The tall, burly samurai had been a member of Sano's detective corps when Sano was *sōsakan-sama;* now he was a bodyguard and general assistant. "Sorry to interrupt, but Hirata-*san* is here to see you."

Sano was surprised; although Hirata was technically his chief retainer, they didn't have much to do with each other these days. While Sano ran the government, Hirata kept busy investigating crimes.

"It can't wait." Marume's expression was somber rather than characteristically jovial.

Sano dismissed General Isogai and the elders. As he and Marume walked down the corridor, Sano said, "What's this about?"

"Your wife. There's been some kind of trouble."

"Reiko?" Alarm jolted Sano. He hurried to his private quarters. There he found Hirata and Reiko kneeling in her chamber. With them was Reiko's old childhood nurse O-sugi.

Hirata looked relieved to see Sano. "Greetings."

"What's going on?" Sano noticed that Hirata appeared healthier, more fit, yet strangely older than the last time they'd met a few months ago. But Reiko quickly captured his attention.

She was wrapped in a quilt, shivering violently despite the summer heat. Her hair hung in damp strings. Her face wore a stunned, sick expression. Her complexion was blanched, her lips colorless. O-sugi hovered anxiously near her, holding a bowl of hot tea. Reiko beheld Sano with blurred eyes, as if she couldn't quite figure out who he was.

"What's wrong?" he exclaimed as he knelt beside her. He started to take her in his arms, but she flung up her hands to prevent him.

"Don't touch me!" she cried. "The blood. It'll get on you."

"We washed it off, little one," O-sugi said in a soothing voice. "It's all gone."

"What blood?" Sano demanded, growing more confused and alarmed by the moment. A disturbing thought occurred to him. "Was it the baby?" He feared Reiko had lost their child.

"No, the baby's fine," O-sugi assured him, but worry clouded her kind, wrinkled face. She held the tea bowl to Reiko's lips. The steam smelled of medicinal herbs. "Try to drink, dearest. It will make you feel better."

Reiko pushed the bowl away. An attack of dry heaves doubled her over.

Sano turned to Hirata. "What happened?"

Hirata's grave expression warned Sano that the problem was serious. "I found her at Lord Mori's estate."

Surprise jarred Sano. He couldn't think what business Reiko had there. "When was this?"

"About an hour ago," Hirata said.

Sano hadn't known that Reiko had left the house. On most nights since she'd become pregnant this time, they'd not shared a bed. Sano often came home late from work, and he'd slept in a guest room rather than disturb her rest. They had so little time together; they seldom talked. He was dismayed to realize that she could have been gone almost every night and he wouldn't have noticed.

"What was she doing at Lord Mori's estate?" Sano asked Hirata.

"I don't know. She hasn't said." Hirata glanced warily at Reiko as O-sugi tried to comfort her. "But . . ." He inhaled a deep breath. Sano recalled the many times when Hirata had fulfilled the chief retainer's duty of telling his master things he needed to hear but wouldn't like. "Lord Mori has been castrated and stabbed to death. I found Lady Reiko alone with him in his bedchamber. She was naked and covered with blood. I'm sorry to say that it looks as if she killed him."

Sano felt his jaw drop as shock slammed through him.

"If she were anybody other than your wife, I'd have arrested her

and taken her to jail," Hirata added. "Instead, I gave her the benefit of doubt and brought her home."

Even while Sano stared at Reiko in dazed disbelief and horror, his mind calculated ramifications. His wife caught at the scene of a murder was bad enough. That the victim was an important *daimyo* who happened to be a major ally of Lord Matsudaira promised disaster. The penalty for murder was death by decapitation, and although the law was lenient for high-ranking members of the samurai class, in this case even Sano's power might not protect Reiko even if she was innocent.

If indeed she was.

Sano experienced fresh horror. This was his wife of eight years, the mother of his son, the woman he passionately loved, whose character he held in the highest esteem. She would never murder anyone!

Yet what had she been doing naked in Lord Mori's bedchamber? They'd drifted so far apart; did he even know her anymore?

He seized her shoulders and demanded, "Did you kill Lord Mori?"

"No!" Reiko's reply was loud with hurt and outrage. But confusion drifted across her gaze. "At least I don't think I did." Her manner turned plaintive: "I couldn't have, could I?"

"Of course not," O-sugi said, staunchly loyal to Reiko.

But Sano was far from satisfied by Reiko's answer. He turned to Hirata, who shrugged helplessly and said, "That's what she told me."

"Well, if you didn't kill Lord Mori, who did?" Sano asked Reiko.

"I don't know." Tears leaked from her eyes.

Impatience girded Sano against the sympathy that rose in him. He shook Reiko. "What happened? Tell me!"

"I don't know," she wailed. "I can't remember."

Sano had heard this from too many murder suspects trying to hide their guilt. "I don't believe you. What were you doing with Lord Mori? I want a straight answer."

She drew a long, shaky breath, swallowed, and rubbed her face. "I was looking for the boy. I was only trying to help."

That made no sense. "What boy? Help whom?"

Reiko spoke over his questions: "I never meant to hurt anyone. Lord Mori was a terrible, evil man."

Coldness stabbed like ice crystals into Sano's bones. What she'd said could be interpreted as a confession to murder. He clutched Reiko tighter. "Maybe you don't realize it, but you're in serious trouble. If you want me to help you, you must tell me the truth. Now, what happened?"

"I *am* telling you the truth!" Hysteria raised Reiko's voice. She twisted in his grasp. "You're hurting me. Let go!"

Sano held on, shouting at her in desperation: "Did you kill Lord Mori? Tell me!" As Reiko sobbed and babbled incoherently, he felt someone watching them. He turned and saw Masahiro standing in the doorway.

"Mama? Papa?" Seven years old, tall and serious for his age, Masahiro carried a wooden sword. His white jacket and trousers were dirty and his hair tousled from martial arts lessons. "What's the matter?"

Sano was dismayed by the sudden awareness that he spent even less time with his son than with Reiko. Masahiro was growing up so fast that Sano barely knew him. Sano's job as chamberlain had taken its toll on his whole family. He hastened to try to shield the boy from the present horror. "Masahiro, go outside."

"But why is Mama crying?" Masahiro asked. "What are you doing to her?"

"Nothing. It's all right," Sano said. "O-sugi, take him outside. Now!"

The nurse bustled Masahiro away. Reiko buried her face in her hands and wept. "I can't believe things have turned out so badly! And I still haven't found him!"

Sano shook his head in incomprehension. But whatever had happened, he must take quick action to protect Reiko and minimize the damage. Turning to Hirata, he said, "Who else knows about this?"

"Just my men and myself." Hirata reconsidered. "And by now, probably everyone in the Mori estate."

That would be hundreds of people, including the *daimyo*'s family

members, retainers, and servants. Sano blew out his breath. "Well, keep the news from spreading any further for as long as possible."

"I've already closed off the estate," Hirata said.

"Good. What have you learned about the murder?"

"Nothing yet. I thought I'd better bring Lady Reiko home."

"I want you to go back to the estate and start figuring out what happened," Sano said. "I'll join you as soon as I can."

"Yes, Honorable Chamberlain." Hirata bowed and left.

Sano wished he could be in two places at once. It had been three years since he had investigated any crimes, but he wanted to handle this one personally. Reassuring himself that Hirata knew what to do, Sano faced his immediate problem: Reiko. He grabbed her hands and pulled them away from her face.

"Reiko," he said, "listen to me."

Trembling, she gazed at him with red, streaming eyes.

"Lord Mori has been murdered," Sano said, speaking slowly and clearly. "You look so guilty that if you were an ordinary citizen instead of my wife, you'd be executed. You still might be, unless we can come up with a reasonable explanation for why you were at the crime scene. Now tell me!"

"I did!" Reiko cried, her voice rising shriller in fresh, insistent agitation.

"You have to do better than that, or not even I can save you." Fear and frustration turned Sano's manner harsh. "Now one more time: What were you doing there?"

Words poured from Reiko in a babbling torrent: "I went to spy on him. I saw him do it." Keening and sobbing, she wrenched her hands out of Sano's. "I wanted to stop him, but I was too late!"

Madness this all sounded! In desperation, Sano slapped her cheek. Reiko screamed. She drew back and stared at him, more shocked than hurt—he'd never struck her before. But she was suddenly quiet.

"I'm sorry," Sano said, regretful and ashamed. "I didn't know how else to bring you to your senses. We don't have much time. And all this excitement isn't good for the baby."

The mention of the baby seemed to revive Reiko's awareness. She

clasped her hands protectively across her swollen belly, sat up straight, and nodded. Her breath was still raspy with sniffles and emotion, but steadier.

"That's better," Sano said, relieved.

"So many things happened. One thing led to another," Reiko murmured. "I don't know where to start."

At this rate, the news of the murder would spread all over town and a maelstrom of hazard and scandal would engulf them before Sano learned anything from her. He mustered his patience. "Start at the beginning."

The dazed confusion cleared from Reiko's face, like mist dissolving in sunlight. She looked more like her usual alert, sharp-witted self. "The letter. It started with the letter. In cherry blossom time."

3 *The Lady's Tale*

Cherry trees in the garden bloomed with radiant pink splendor. Petals drifted to the ground like snowflakes, dappled the grass, floated on the pond, and crowned the stone lanterns. They fell on Masahiro as he shot arrows from a little wooden bow at a straw target. Reiko watched from the veranda, where she reclined on cushions, sleepy and lethargic because she was two months pregnant.

Hirata's wife, Midori, came out of the mansion, carrying a steaming bowl of tea. Plump and pretty, she wore a kimono patterned with cherry blossoms. In one arm she cradled her baby boy. Her four-year-old daughter, Taeko, toddled after her. She knelt beside Reiko and handed her the tea. "Drink this. It will make you more lively."

Reiko sipped the brew of ginseng and aromatic herbs. "When I was carrying Masahiro, I felt so energetic. But I guess every pregnancy is different."

Taeko ran into the garden toward Masahiro. She adored him even though he was too grown-up to pay much attention to a little girl. Now he ignored her and took aim.

"Watch out, Masahiro. Don't hit her," Reiko called.

"I know. I won't." He had the masculine, adult air of an expert and scorn for feminine worries.

A maid appeared, carrying a tray laden with bamboo scroll con-

tainers. "Here are some letters for you, Honorable Lady Reiko." She set the tray beside Reiko, bowed, and departed.

"You get so many letters," Midori said. "Are these from more people who want your help?"

"Probably."

During the past few years, Reiko had developed a reputation as a person capable of solving problems. This stemmed from the fact that when Sano had been *sōsakan-sama,* she'd assisted him with his investigations. Her deeds had been reported in the gossip that circulated through high society and in the news broadsheets sold in town. Controversy surrounded Reiko. Most people thought her unfeminine, scandalous, and disgraceful, but others had come to regard her as a sort of Bodhisattva, a merciful deity who would bring them salvation.

"It's so good what you've done," Midori said. Reiko had been running a sort of private assistance bureau, particularly for women in trouble. She'd found jobs and homes for them, paid for doctors to cure their sick children. "Those people would have died if you hadn't gone out of your way to help."

"I'm glad to do it." Her work made Reiko feel useful. Serving the public also served honor, and occupied the time when Sano was too busy to be with her. She reflected that she and Sano were so seldom together that it was a wonder they'd managed to conceive a second child.

"Other people might have been executed," Midori said.

Reiko had intervened on behalf of people unjustly accused of crimes. She'd investigated their cases and found the real culprits. The daughter of Magistrate Ueda, she'd used her influence with him to get the innocents acquitted. This gave her an outlet for her detective skills, which would otherwise have gone unused because Sano didn't investigate crimes anymore.

"So many have you to thank for protecting them from people who did them wrong," Midori said.

Reiko had also rescued women from cruel husbands, lovers, and employers. "I'm afraid not everybody would thank me."

She began opening the scroll containers, read a letter full of ob-

scene curses, and winced. Evildoers had gotten their comeuppance due to her. She'd made enemies who didn't appreciate her interfering in their affairs. She'd also felt the sting of social disapproval because she took actions unheard of for a woman. Ladies of her class were polite to her and curried her favor, but they talked about her behind her back. Samurai officials looked askance at her, even though they wouldn't dare criticize the chamberlain's wife.

"And I'm afraid I've become a target of everybody who wants something." Reiko read aloud from another letter: " 'Dear Lady Reiko, I need money. Please send me 100 *koban*.' "

The next message was written on cheap paper in calligraphy that was very neat, the characters as square as though printed from a woodblock. As she skimmed the words, Reiko sat up straight. "Listen to this one."

> Dear Lady Reiko,
> Please excuse me for imposing on you, but I need your help. My name is Lily. I am a poor widow. We met at the Hundred-Day Theater in Ryōgoku a few years ago. I helped you then, and I think it's time for you to return the favor. My little boy has been stolen. He's only five years old. Will you please find him and bring him back to me? I'm a dancer at the Persimmon Teahouse in Nihonbashi. I beg you to come and see me there as soon as possible.

Complicated directions to the teahouse followed. Reiko said, "I remember this woman." Lily had been a witness who'd aided Reiko's search for an escaped murderess.

"Are you going to help her?" Midori asked.

"I do owe her a favor," Reiko said. "And to lose a child is a terrible calamity." She looked through the lush, pink cherry trees at Masahiro in the garden.

"Bring me the arrows, Taeko," he called.

The little girl gathered up the arrows he'd shot, pranced up to him, and handed them over. Reiko smiled because he'd found a clever use for his admirer.

"But you're expecting," Midori said in concern. "You shouldn't risk your health."

"I'll be healthier if I'm busy," Reiko said. Furthermore, Lily's plight had aroused her maternal instincts. "At least I'll go and see Lily." She felt the surge of energy that each new investigation, and each new chance to help someone in need, brought her. "A little trip into town shouldn't hurt me."

Reiko rode in her palanquin along the winding passages of Edo Castle. Her bearers carried her downhill, and mounted bodyguards accompanied her through the main gate.

A holiday atmosphere enlivened the *daimyo* district. Ladies in floral kimono spilled out of palanquins, returning from jaunts to temples to view the cherry blossoms. Tipsy from too much wine, they flirted with guards at the gates. In the Nihonbashi merchant district, cherry trees bloomed in pots on balconies. Shopkeepers hawked parasols printed with the pink flowers; confectioners sold cakes decorated for the season. But neither holiday cheer nor the sun-spangled day could beautify the district to which Lily's directions led Reiko.

Blighted rows of buildings looked ready to tumble into canals that stank of raw sewage. Gulls, rats, and stray dogs foraged in trash piles. Cesspools overflowed into the narrow, twisting lanes. Smoke from too many stoves blackened the air. Haggard mothers nursed babies in doorways; children and crippled beggars swarmed around Reiko's palanquin, begging for coins, and her escorts chased them away.

The Persimmon Teahouse occupied the ground floor of a ramshackle building. Tattered blue curtains were fastened back from posts that surrounded a raised floor on which tough-looking male customers lounged. Slatternly maids served drinks. A man beat a drum while three women danced. The dancers wore garish cotton robes; their faces were masks of white rice powder and red rouge. They postured and gesticulated in a lewd manner. The customers laughed and groped under the dancers' skirts. Reiko climbed out of her palanquin

and peered at the women. She couldn't recognize Lily, whom she'd only met once.

The proprietor greeted Reiko's escorts with a broad smile. "Welcome, gentlemen. Join the fun!"

"My mistress is here to see a dancer named Lily," said Lieutenant Asukai, who was Reiko's chief bodyguard.

Surprise showed on the proprietor's face as he beheld Reiko: Ladies of her class didn't frequent places such as this. "Who's your mistress?"

"Lady Reiko, wife of the Honorable Chamberlain Sano."

Now the proprietor looked dumbfounded by a visit from such an exalted personage. Before he could reply, one of the dancers rushed out of the teahouse.

"Merciful gods! You came!" She dropped to her knees before Reiko. "I've waited for nine days since I sent the letter to you. I'd given up hoping. I can't believe you're really here." Lily gazed up at Reiko as if entranced by a celestial visitation. "A thousand thanks!"

"Yes, I'm here to help you," Reiko said, moved by her gratitude. As Lily stood up, Reiko remembered her. She was perhaps forty years old, thin and gaunt under her bright robes. She had once been pretty, but the bones of her face were sharp, the skin sagging on them, her hair limp. "Can we go somewhere and talk?"

"Lily, get back to work," the proprietor interrupted. "You know you're not allowed to entertain personal company." The customers called and motioned for Lily to rejoin them.

Lieutenant Asukai rattled coins in the pouch that hung from his sash. "Our business in exchange for a moment of her time."

The man relented. "All right," he told Lily, "but make it short."

As her escorts entered the teahouse, Reiko noticed a food stall across the street. "Let's go over there." Lily looked as if she could use a meal.

The food stall was a narrow storefront equipped with a ceramic hearth on which the cook boiled two big pots. Reiko and Lily sat on the raised floor. When their meal was served, Reiko dubiously eyed

the scummy tea and the soup that contained noodles, withered bean sprouts, and gray, rancid bits of fish. But Lily wolfed down hers.

"In your letter you said your son was stolen," Reiko said. "When did this happen?"

Lily paused between bites; tears spilled into her bowl. "Two months ago. I haven't seen him since."

"What is his name?"

"Jiro."

"I have a son a bit older," Reiko said. She and Lily smiled at each other; their common experience as mothers transcended their class differences. "In order for me to get Jiro back, first I need to find out who stole him."

"I already know," said Lily. "It was Lord Mori."

"How do you know?"

"I gave Jiro to him. He was supposed to give him back. That was the deal. But he didn't."

There was obviously more to this case than the kidnapping it had seemed when Reiko had read the letter. "What kind of deal are you talking about?"

Lily resumed eating. Between gulps of broth, she said, "I heard that Lord Mori likes little boys. So I took Jiro to his house. Lord Mori paid me to have him for the night."

Reiko couldn't believe what she'd heard. "Do you mean for sex?"

"Yes." Lily eyed Reiko as if she were daft. "What else?"

Shocked, Reiko blurted out, "You rented Jiro as a prostitute to Lord Mori?" Although she knew that child prostitution was legal and common, she'd never come face to face with an example. Now she remembered hearing of the cruelty, moral degradation, and physical pain suffered by the children at the hands of the men. "How could you do that to your own son?" Her sympathy for Lily was rapidly turning to revulsion.

"Do you think I wanted to? Do you think I liked for some man to maul my little boy? I only did it because I had no choice."

Lily glared at the teahouse. "The boss pays me two coppers a day. That, and whatever tips I can wring out of the customers, is all I have

to keep myself and Jiro alive. This year the landlord raised my rent. I couldn't afford to buy food." Envy and contempt filled the stare she gave Reiko. "I bet you don't know what it's like to hear your boy cry because he's hungry."

Reiko felt doubt restraining her compassion toward Lily. "Couldn't you get another job?"

"I've tried. But no one will hire me for any more money than I'm paid now. I've tried selling myself to men, but I've been sick, and just look at me." She spread her arms and lifted her face to the sunlight, which showed her to brutal disadvantage. "Men won't pay much for a scrawny whore like me. But some of them will pay a lot for a boy as beautiful as Jiro."

Lily stiffened her posture as her gaze held Reiko's. "Lord Mori paid enough that I could have fed Jiro for a month. Judge me if you will, but you really don't know how things are for the likes of us."

Reiko realized that she was in no position to criticize. "I'm sorry." She'd never lacked for anything, and neither had Masahiro. The blessing of her rich father and husband had ensured their good fortune. "My life is so different that I have a hard time understanding yours."

"Does this mean you won't help me get Jiro back?" Sudden panic flared in Lily's eyes.

"No, of course I will," Reiko assured her. The boy was innocent and deserved aid no matter what. Lord Mori shouldn't be allowed to get away with stealing him. And Reiko pitied Lily in spite of her disapproval.

Lily expelled a shaky sigh of relief. She gazed at the empty bowl she'd been clutching. "I know I'm a bad mother. I know I don't deserve your help," she said in a humble, shamed tone. "But I really appreciate it." She cast a covetous glance at Reiko's untouched meal. When Reiko passed the bowls to her, she seized on them. "A million thanks!"

"Tell me what happened," Reiko said. "You left your son with Lord Mori. Then what?"

"The next morning, I went back to the estate," Lily said, chewing noodles. "I asked the guards for Jiro. They acted as if they didn't

know anything about him. They said Lord Mori didn't have him." Indignation suffused Lily's face. "They were lying. I demanded that they give me my son. But they said that if I didn't go away, they would kill me." She sobbed, choked on her food, and coughed. "So I had to leave without Jiro."

Reiko's pity melted her disapproval, as she imagined losing Masahiro. She couldn't help wondering if the boy was dead. "Was that the end of it?"

"No. I went to the *doshin* who patrols this neighborhood. I told him what happened and asked him to go to the Mori estate with me and get Jiro back. But he wouldn't. He said Lord Mori was an important man, and there was nothing he could do."

Reiko knew that the police didn't dare bother a *daimyo* who was an ally of Lord Matsudaira. They wouldn't risk themselves for a peasant like Lily.

"I heard that you help people in trouble. I got the idea to write to you." Lily finished off her meal and set down the empty bowl. "You're my last hope."

"I'll do everything in my power to save Jiro for you," Reiko promised.

Lily's face crumpled into tears of joy. "A million thanks! I'll repay you someday, I swear!"

The proprietor shouted from the teahouse: "Lily! You've been gone long enough. Get back to work!"

Lily bowed to Reiko, gave her a final, trusting look, then scurried off. As Reiko climbed into her palanquin and her escorts bore her down the street, she began planning how to go about reclaiming the stolen child.

"I could take some of my husband's troops over to the Mori estate and ask for the boy," she said to Lieutenant Asukai, who rode beside her.

"Lord Mori won't be able to refuse," Asukai said.

"But on second thought, I'd rather not bring my husband into this." Reiko tried to keep her work far removed from Sano because she didn't want to cause trouble for him. Her actions had sometimes jeop-

ardized him in the past, and to involve him in a clash with Lord Mori would be politically risky. "I had better try something less obvious."

The next morning found Reiko seated in her palanquin in a street near the *daimyo* district. Her bearers lounged against the wall of a shop while her guards sat astride their horses, near the neighborhood gate. Reiko peered out her window through the flow of pedestrians, looking for Lieutenant Asukai.

The clever young samurai had become her chief assistant. Soon she saw him coming down the street, escorting a middle-aged woman, dressed in a plain indigo robe and white head cloth, who carried a large basket. Reiko had sent him to loiter outside the Mori estate, follow the first servant who came out, and nab him or her. Had Reiko herself tried it, she would have been too conspicuous, but one more samurai among the thousands in the *daimyo* district was barely noticeable. Now Asukai brought Reiko the woman, a maid headed for the market. Her face showed both curiosity and wariness as he marched her up to the palanquin.

"I'm looking for a little boy who was at the Mori estate two months ago," Reiko said. "His name is Jiro. He's five years old. Have you seen him?"

"No. I don't know anything about any boy." Shoulders hunched in fear, the maid backed away. "I have to go now."

Lieutenant Asukai made a move to detain her, but Reiko said, "Go fetch another servant. Maybe we'll have better luck."

During the next hour, Lieutenant Asukai brought a valet and another maid, but their reaction was the same, fearful disclaimer of knowledge about Jiro. As Reiko watched the valet hurry off, Lieutenant Asukai said, "I think they're lying."

"So do I," Reiko said. "They're afraid they'll be punished for talking about Lord Mori's business. Let's try someone from an estate near his."

Lieutenant Asukai went off and soon brought back a groom from the stable of Lord Mori's neighbor *daimyo*. When Reiko asked him

about Jiro, he said, "I see lots of boys going into Lord Mori's estate. Funny thing, though. Some of them never seem to come out." Then he took on the expression of a man who'd suddenly stepped into a hole. "Forget I said anything."

After he'd absconded, Lieutenant Asukai fetched more witnesses, from whom Reiko heard similar dark, vague rumors followed by abrupt silence. "Fear of Lord Mori extends outside his household," Lieutenant Asukai remarked.

"Yes," Reiko said, "and something sinister is going on inside." Again she wondered if Jiro was still alive.

"Now that we can't get anyone to talk, what are we going to do?"

"We should make discreet inquiries elsewhere."

More than a month passed while Reiko and Lieutenant Asukai questioned their acquaintances among upper-class society. But they gleaned no information about Lord Mori, whose clan and retainers kept to themselves. Hence, Reiko formulated another plan.

A cool, early summer dusk descended upon Edo. The setting sun gilded the rooftops while temple bells rang in the clear air. The tall framework structures of fire-watch towers stood out against the pearlescent sky like ink lines painted on sheer silk. From the base of a tower in an alley in the *daimyo* district, Lieutenant Asukai called, "Hey, you up there!"

The peasant man seated on the platform, beneath the bell suspended from the roof, peered over the rail.

"Come down," Lieutenant Asukai ordered.

Reluctant, yet afraid to disobey a samurai, the man descended the ladder. Reiko climbed up. She wore a padded cloak to keep her warm and a wicker hat that hid her face. Kneeling on the high, windswept platform, she hoped that people who happened to glance at the tower wouldn't notice that it was occupied by someone other than the usual watchman. She gazed around her.

The panorama of Edo spread in every direction. Lights glimmered in windows and reflected from boats on the river. A crescent moon

adorned the sky. Roofs, trees, and shadows hid the activity within the Mori estate, but she had a good view of the main gate. Lanterns burned outside it. She could see the guards stationed in front and anyone who came or went.

At first she observed only Lord Mori's retainers arriving home. Later she noticed men crouched on roofs of the estate next door. They must be *metsuke* agents, spying as part of the routine surveillance on prominent citizens. The moon ascended over the hills; stars appeared while night extinguished the city's lights and traffic thinned. Temple bells signaled the passage of two hours when a woman trudged up the street, leading a small child by the hand. They stopped by Lord Mori's gate. Reiko watched the woman speak with the guards, heard their distant, unintelligible words. The guards let the pair in the gate. Soon the woman came out alone. She trudged away.

After a long, cold, uneventful vigil, Reiko thought she'd never been so glad to see the sun rise. She stretched muscles cramped from sitting in the tower the whole night except for brief descents to relieve herself. Now the woman reappeared, a peasant dressed in faded robes. Again she spoke with the guards. They shrugged and shook their heads. She became agitated; she pleaded with them. They shouted at her, and she fled, weeping.

Reiko had just witnessed a scene identical to the one Lily had described: Another mother had rented her son to Lord Mori and failed to get him back.

Anger filled Reiko because this kind of thing was allowed to happen. She felt more determined than ever to rescue Jiro. But what had happened to him, and to this other child?

Lord Mori's retainers and servants came and went. Two porters carried out an oblong wooden crate. Below the tower, Lieutenant Asukai gestured for Reiko to come down before the day-shift fire-watcher arrived. As she alit on the ground, her mind drew a disturbing connection between the crate and the boy she'd seen last night.

"Go look for two porters who just carried a big wooden crate out of the Mori estate," she ordered Lieutenant Asukai. "Hurry! Stop and search the crate for a dead body!"

He rode off, but after a long time he came back to report that he'd been unable to find the men she'd seen. Edo was full of porters. He'd stopped and searched many, but none of them had come from the Mori estate, and none were carrying anything except groceries. The pair in question had vanished into the crowds.

"I feel certain that Lord Mori is up to no good," Reiko told Lieutenant Asukai while she journeyed homeward in her palanquin and he rode his horse alongside her. "I must get inside that estate and find out what's going on."

That afternoon, Reiko rode in her palanquin up the street she'd watched the previous night. She wore silk robes and lacquered clogs instead of the cloak and wicker hat. Her makeup was perfect, her upswept hair studded with floral ornaments. Her bearers set her palanquin down outside Lord Mori's gate.

"Lady Reiko, wife of the Honorable Chamberlain Sano, is here to call on Lady Mori," Lieutenant Asukai told the sentries.

They summoned servants to notify Lady Mori that she had a visitor. Reiko was glad that her social position entitled her to call on any ladies in Japan, who must see her whether they wanted to or not. Soon Reiko found herself seated in a chamber with Lady Mori.

"I am so flattered that you have come to see me," Lady Mori said. She was in her forties, dressed in an expensive but dull green kimono. Her hair, worn in a simple knot, was threaded with silver. She was slim, but heavy cheeks, full lips, sloping shoulders, and a broad bottom gave her an appearance of weightiness. She spoke with delicate, formal precision. "This is an unexpected honor indeed."

"It is you who has done me the honor of receiving me," Reiko said, equally polite and formal. "I thought I would like to make the acquaintance of the important ladies in society." She couldn't very well say that she'd come in search of a child that the woman's husband had stolen and might have harmed.

"How very gracious of you. Many thanks for choosing my humble self as the object of your attention." Lady Mori smiled; her eyes

sparkled with pleasure. She seemed a nice woman, and Reiko felt a twinge of guilt for exploiting her. "May I offer you refreshments?"

Tea was served by her maid, an older, gray-haired woman who looked vaguely familiar to Reiko. But Reiko couldn't think where she'd seen the woman, who showed no sign of recognizing her. Perhaps the maid had once worked for someone Reiko knew.

"The weather is quite lovely, don't you think?" Lady Mori said while she and Reiko sipped their tea and nibbled cakes.

"Yes," Reiko said. "It's not too warm yet."

This type of trivial conversation was the reason that Reiko usually avoided visits to women of her class. Custom prevented them from saying anything interesting until they'd known one another for a longer time than Reiko wanted to spend. Laboring to make small talk, she looked through the open door at the garden and noticed that the large screen of embroidered silk that stood behind Lady Mori depicted the same landscape of pond, bridge, and trees as outside.

"What a beautiful screen," Reiko said.

"Do you like it?" Lady Mori said eagerly. "I made it myself."

"Very much. How impressive," Reiko said with honest admiration.

"Do you embroider?" Lady Mori asked.

"I'm afraid not." As a child Reiko had taken lessons, but she hated sewing.

The talk progressed to clothes, food, and the shops that sold them. Lady Mori discussed these topics with enthusiasm until Reiko wrenched the conversation to the subject of Lord Mori. "How long will your husband be in Edo?"

"He leaves for Nagato Province in late summer."

Reiko knew that the law of alternate attendance required each *daimyo* to spend four months of each year in the capital and the rest in his province. The feudal lords were divided into two groups, one of which was in Edo while the other was in the country. This restriction kept them from staging a rebellion together, as did the fact that their families remained in town as hostages. Reiko hoped she could find out what Lord Mori had done with Lily's son before he got away.

"What has Lord Mori been doing?" Reiko said.

"Oh, the usual things," Lady Mori said, vague and surprised that Reiko should ask. "He doesn't speak of them to me, of course."

Most men didn't discuss their business with their wives. "He must find more entertainment here than in the country?"

"I suppose so."

Reiko couldn't very well blurt out, *Do you know that your husband beds little boys? What happens to them all?* Perhaps Lady Mori didn't know. Arranged marriages were the norm, and many couples maintained separate personal lives.

"How long have you and Lord Mori been married?" Reiko said.

"Sixteen years."

Maybe that was enough time for Lady Mori to have noticed her husband's sexual practices even if she didn't share them. She wasn't blind; she must have been aware of those boys who frequented her home. But Reiko realized that her visit had lasted so long that unless she departed now, she would abuse Lady Mori's hospitality. She wished she could have a look around the estate, but couldn't think how to ask without arousing suspicion. She must get Lady Mori to invite her back.

Her gaze lit on the embroidered screen. Inspired, she said, "How I wish I could embroider as well as you do!" She gave Lady Mori a hopeful, bright-eyed, encouraging look. "How I would love to learn!"

"I would be delighted to teach you." Lady Mori seemed flattered, and as eager for a better acquaintance as Reiko was. "Why don't you come again tomorrow?"

Every day thereafter, Reiko went to the Mori estate for embroidery lessons. Lady Mori taught her how to sketch a design on silk and fill it in with colored thread. Reiko's chance to explore the estate was when she went to and from the Place of Relief, but the estate was so heavily populated with servants and guards that she could never sneak past them. After five days, all Reiko had to show for her efforts was a silk square with lilies embroidered on it in crooked stitches, dotted with blood from pricking her fingers with the needle.

When she visited Lily at the teahouse and apologized because she hadn't found Jiro, the dancer tried to hide her disappointment. "That's all right," Lily said. "I guess I never really expected to see him again." Her brave acceptance of her loss made Reiko more determined than ever to rescue Jiro, or at least find out what had happened to him.

The sixth month came, bringing the wettest rainy season that Reiko could remember. She and Lady Mori sat sewing. Lady Mori worked on a large landscape panel, assisted by her ladies-in-waiting. Reiko hid her frustration as her thread snarled. She decided that this was the last time, and she must ask Sano for help despite her reluctance.

"My, it's getting late," said Lady Mori. "I believe we've had enough for today." She set down her embroidery. "Will you do me the honor of staying for dinner?"

"That would be wonderful," Reiko said, thrilled because night would be better for her detective work than day.

Maids brought in a lavish meal of sashimi, grilled seafood, dumplings, steamed greens, and sweet cakes. Wine enlivened the chatter between Lady Mori and her attendants. They grew loud, boisterous, and laughed at the slightest joke.

"Have some more wine," Lady Mori said, her eyes feverishly bright from the liquor.

"Thank you." Reiko held out her cup for the gray-haired maid to refill. She drank to keep up the pretense of enjoying the party. By midnight, the other women were too drunk to pay much attention to her, and she slipped out the door.

The rain had momentarily stopped. Smoke from a fire somewhere billowed in the darkness, veiling the wet air. Hazy lights shone through it. Reiko hurried across the garden. Trees dripped water on her and the wet grass drenched her hem and socks. She heard men talking in the distance, but she couldn't see them through the smoke. Although not in immediate danger of being caught, she soon found that searching for a lost boy was harder than she'd anticipated.

The estate was vast, the mansion a labyrinth of wings connected to countless more wings. Lanterns shone in windows here and there, like

glowing eyes. As Reiko circled buildings, two guards loomed suddenly out of the murk. She hid in a doorway, holding her breath until they passed. The house would be full of people, relatives of Lord Mori. Reiko didn't dare intrude, and she doubted that he would quarter a boy prostitute with his family anyway. She groped through courtyards immersed in smoke and humidity, hazy and unreal. The odor of wet earth and drains filled her lungs. She evaded patrolling guards near the immense stables, where horses stomped and neighed. Dogs barked, and she fled to the martial arts ground. Ghost-warriors seemed to duel on the combat field. After some two hours, she realized the impossibility of exploring the whole estate by herself. Yet there remained one place that she most needed to see, the place where Lord Mori would most likely keep a nighttime companion.

If this estate had the typical layout, then the *daimyo*'s private chambers must be located at the center. Reiko navigated there by instinct. Fear drummed inside her. The private chambers would be the most heavily guarded section of Lord Mori's domain, where a trespasser would be killed on sight, no questions asked first. She wished she could bring Lieutenant Asukai with her, but he was with her other guards in the barracks, and she had no time to fetch him. This might be her only chance to find Jiro, if he was still alive.

Ahead of Reiko towered a stone wall. A guard carrying a torch walked past it. She waited while his footsteps receded. Then she slipped through the gate. Some hundred paces distant, a building floated in the smoke, as if upon a misty ocean. Windows formed rectangles of yellow light. The eaves curved upward like dragon wings above the dark, gaping entrance. Reiko crept toward the building, around boulders that rose like reefs in fog, past a pond whose waters gleamed black and bottomless. At the entrance, the shadowy figures of two guards came into view; they conversed and gestured. Reiko thought she sensed someone else nearby, watching her. Her skin prickled. She almost lost her courage, when she heard a sudden, loud cry.

Shrill, human, and filled with pain, it pierced the quiet, vibrated the smoke. It resounded inside Reiko, evoking memories of nights she'd been awakened by Masahiro's cries. This cry belonged to a little

boy; she knew with every maternal fiber of herself. A boy was inside that building, and in distress.

She forged onward, aiming for the side of the building, away from the guards. She was almost there when two more patrolling guards suddenly materialized a few paces from her. She ducked under the veranda. From above her came more cries from the child, and fast, rhythmic thumping noises. She cowered in the dank, dark space while the guards' legs passed by. Then she bolted out and climbed onto the veranda. She crawled across the wet, slick floorboards. Praying that the guards wouldn't spot her, she huddled beside the lit window.

The child's cries rose to panicky, desperate squeals.

Reiko took out the dagger she wore strapped to her arm beneath her sleeve in case she needed to defend herself. She poked it through the wooden grille that covered the window and cut a small hole in the paper pane. The noise inside was so loud, no one there would hear the blade rasping. She glanced furtively around her, but saw only dense, drifting smoke. She peered through the hole.

The cries abruptly stopped.

She was looking into a room in which lanterns suspended from the ceiling lit white chrysanthemums that bloomed in a ceramic vase in the alcove. Giant, gilded chrysanthemums adorned a black lacquer screen. A mural depicted naked men and small boys coupling, in various lewd positions and colorful graphic detail, amid more chrysanthemums. Reiko recalled that the flower was a symbol of male love because its tightly gathered petals resembled a boy's anus. Then her attention riveted on the tableau in the corner of the room.

Atop a quilt-covered futon hunched a man that she presumed was Lord Mori, propped on his forearms and spread knees. He was nude and thickset; black hairs stippled him like bristles on a boar. His body heaved with fast, loud breathing. His mouth was open, his eyes closed, his complexion sweaty and flushed. A wine jar and cup sat on a nearby table. A small, bare leg and foot protruded from beneath him.

Lord Mori pushed himself upright. His penis was erect and gleaming wet. Where he'd lain on the futon was a naked boy, perhaps nine years old. His short black hair stuck up in a cowlick. Reiko couldn't

see his face; it was buried in the quilt. Her eyes widened with alarm at the red bruises around his neck. He didn't move; he didn't utter a sound.

Lord Mori smiled to himself, an ugly grimace of sensual satisfaction. He picked up a dressing gown and put it on. "You can come in now," he called.

For one disturbing moment Reiko thought he was talking to her. Then a door inside the room opened. Two samurai entered.

"Get rid of him," Lord Mori ordered. He had a voice so lacking in expression that it seemed inhuman.

The samurai bundled the boy into the quilt. Handling him as carelessly as if he were a sack of garbage, they carried him out of the room. Reiko turned away from her spy-hole, stunned because Lord Mori had apparently killed the boy during sex and had his retainers cover up the death.

Had he done the same to Jiro?

If so, Reiko couldn't save Lily's son. She couldn't help the child she'd just seen murdered. But wrath flamed inside her. She mustn't let Lord Mori get away with this, no matter that it was legal for a samurai to kill a peasant boy. This was an atrocity that went beyond the limits of the law. Lord Mori mustn't hurt any more children. Reiko must tell her husband what had happened. Sano would punish Lord Mori even though he was a powerful *daimyo* and ally of Lord Matsudaira.

But as Reiko rose to head for home, dizziness unsteadied her. She staggered, her knees wobbly, and dropped her dagger. It hit the veranda with a clatter that sent odd, ringing echoes through her ears. The world spun in another, worse dizzy spell. Blackness engulfed her. She felt herself falling, but she was unconscious before she hit the ground.

A chill woke her from a deep, dead sleep. Reiko stirred groggily. Eyes still closed, she turned onto her side and reached down to pull the quilt over her. But her fumbling hand couldn't find it. Sano must have yanked it onto his side of the bed. She could feel the bulk of

his body, sleeping behind her. A headache pounded in her skull. She felt sticky wetness on the bed, underneath her, between her knees, in the crooks of her arms. A rotten smell crept into her nostrils. Instinctive alarm fluttered her eyes open.

In the dim light of dawn she saw that she wasn't in her own chamber. This room had plain, masculine teak furniture and cabinets that she didn't recognize, and stark white walls instead of the landscape murals she had at home.

Where was she?

Confused, she spoke her husband's name. Sano didn't answer. She reached behind herself for him. Her hand touched bare, unfamiliar flesh, cold as stone. An inkling of fear crept through Reiko. Wide awake now, she turned over on the bed.

And found herself face-to-face with a stranger. He lay on his back, his head twisted in her direction. His eyes were half open beneath their bristly brows; they stared vacantly. His heavy features sagged with stupor. Dark drool that filled his mouth had run down his parted lips onto his cheek.

Reiko screamed and recoiled. She scrambled to her hands and knees. Dizziness whirled the room around her. Pain thudded in her head as she crawled away from the man. Now she recognized him as Lord Mori. Images of bright chrysanthemums, the dead boy, and the men carrying out the shrouded body flashed in her mind. She noticed deep stab wounds that punctured Lord Mori's bulky torso. Blood from them stained his skin. Shock and horror paralyzed Reiko as her gaze moved to his groin, where his male organs were absent and only a grisly red mass of blood, mutilated tissue, and pubic hair remained.

What on earth had happened?

The blood had flowed onto the bed. It was the source of the odor she'd smelled and the wetness she'd felt.

How in heaven had she come to be here?

Distraught, Reiko looked down at herself. She was naked, smeared all over with Lord Mori's blood. It clotted her hair; she could taste its salty, iron flavor in her mouth. Retches and sobs burst from her. She felt an urge to cleanse herself, to cover her nakedness. Where were

her clothes? She looked around and saw them on the floor. Beside them were Lord Mori's severed organs, and a bloodstained dagger.

Her dagger.

Terror assailed Reiko. Even while panic, bewilderment, revulsion, and sickness hindered rational thought, she knew that her investigation had somehow landed her in the worst predicament imaginable. Thunder boomed; rain pattered on the roof. Whimpers, sobs, and gasps came from Reiko that she couldn't stop. In a blind, hysterical effort to make things not so bad, she knelt beside Lord Mori, patted his face, and shook him, desperately trying to revive him. But he didn't respond: She'd known he was dead as soon as she'd touched his cold flesh.

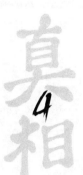

4

"That's when Hirata-*san* came in and found me," Reiko said.

Sano had listened to her story with such amazement and conster-
nation that he'd had trouble keeping silent while she told it. Now he
studied her closely. She was calmer and lucid; some color had returned
to her cheeks. She huddled in the quilt and eyed him with trepidation
as she awaited his reaction.

He hardly knew what to think; his emotions were in turmoil. Pre-
dominant among them was relief that Reiko had a logical, honorable
explanation for what she'd been doing in the Mori estate. Even though
her story was fantastic, he believed it because he trusted her. Yet he
also felt shock at her behavior. He accepted her tendency to venture
into places and take on challenges that no other woman would, but
this time she'd gone too far.

"Why didn't you tell me what you were doing?" he said.

"I should have. I'm sorry," Reiko said, contrite. "But I didn't want
to involve you and get you in trouble with Lord Mori or Lord Matsu-
daira."

"I'm not talking about just your search for the stolen boy," Sano
said. "I mean this private inquiry business you've been running. Why
haven't you ever mentioned it?"

Reiko looked surprised. "But I have. I told you about all my investigations except this one."

Now Sano recalled nights when he'd come home late from his work, Reiko had talked to him, and he'd been so tired that what she'd said hadn't sunken in. Guilt and regret stabbed him. "I'm sorry. I didn't pay enough attention."

If he had, he might have curtailed Reiko's activities before they'd led to this. Except he knew how strong-willed Reiko was; when she set after something, he could seldom restrain her. That the second-in-command of the Tokugawa regime couldn't control his own wife! A familiar frustration tinged Sano's love for Reiko. Yet if he'd been in her position, and a poor, downtrodden widow had asked him to reclaim her stolen child, he would have done the same as Reiko had. He couldn't fault her for trying to correct an injustice. There was no use wishing he could go back to the past and change the present. They had no time to waste, not when Reiko was the prime suspect in the murder of an important citizen and Sano could feel scandal and disaster approaching like a tidal wave.

"After everything that's happened, Jiro is still missing," Reiko lamented. "I don't want to believe he's dead, but after I saw what Lord Mori did to that other boy . . ." She clasped her head between her hands. "What am I supposed to tell Lily?"

Sano had different priorities. "Never mind about that. We have to concentrate on getting you out of the trouble you're in. Listen to me." He took Reiko's hands and held them in a gentle but firm grip. They felt cold, tiny, and fragile. "Someone is going to pay for Lord Mori's murder. It seems probable that it will be you. You trespassed on him. Your dagger is the murder weapon. You were caught at the scene with his blood on you. You could be put to death for that. Do you understand?"

Reiko nodded. Her eyes were dark and deep with fear. As Sano beheld her strained, haggard face, he thought she looked simultaneously ten years older and younger than she was.

"But I didn't kill Lord Mori. This is all a mistake. Everything is going to be all right. Isn't it?" she said in a small voice.

Her plea for him to rescue her pained Sano because he wasn't by any means certain he could. This murder case would call powerful political forces into play. But he said, "Yes. I'll straighten things out. But you have to work with me."

She nodded, reassured. Sano said, "The best way to save you is to determine what really took place last night. Can you remember anything that happened after you spied on Lord Mori and before you woke up?"

"No. That whole time is a blank. Maybe I drank too much. Someone must have killed Lord Mori while I was unconscious, then framed me."

The theory had occurred to Sano. But things were looking even worse for Reiko because she had no proof to back it up. "During your visits to the estate, did you get any idea who might have wanted Lord Mori dead?"

Reiko shook her head, rueful. "I wasn't looking for that kind of information. But there were many other people in the estate that night besides me. The guards, Lord Mori's retainers and family, his wife and her attendants, the servants . . . One of them could have killed Lord Mori."

That there were other potential suspects was in her favor, yet this fact by itself couldn't protect Reiko. Sano needed actual evidence to clear her. He released her hands and stood.

"I'm going to the Mori estate to investigate the murder." He must find the truth about it, which was Reiko's best defense. "Will you be all right?"

Reiko looked up at him and nodded, shaky yet brave, her eyes filled with faith in Sano. He hoped he wouldn't let her down.

In the courtyard Sano met Detectives Marume and Fukida and his other bodyguards. Wearing cloaks and hats to shield them from the drizzle, they rode to the Mori estate. They found two of Hirata's detectives at the gate with the sentries.

"Hirata-san is waiting for you in Lord Mori's private chambers," a detective told Sano. "I'll take you there."

Sano and his men left their horses in the courtyard and continued on foot to the private chambers. The building looked drab with its half-timbered walls streaked by the rain, its gardens sodden and unappealing despite the summer flowers blooming in beds planted around boulders, ponds, and shrubs. People milled around or stood in clusters. Some were guards; others, men and women who Sano presumed were Mori relatives, attendants, and servants. As Sano walked up the stairs to the building, a stout, gray-haired samurai came out the door.

"Finally you're here. It's about time!" he huffed.

Sano paused on the veranda. "And you are . . . ?"

"Akera. I'm Lord Mori's chief retainer. Or at least I was, before my master was savagely murdered." He seemed so furious and upset that he didn't care if Sano thought him discourteous. "Now *Sōsakan* Hirata's men are swarming like maggots all over the estate. This is an outrage! What do you intend to do about it?"

"I intend to find out who killed Lord Mori," Sano said, controlling his temper, his gaze warning Akera that he'd better do the same or else.

The man's indignation deflated, but he looked at Sano with barely concealed scorn. "With all due respect, Honorable Chamberlain, but your wife killed him."

"That's for me to determine," Sano said evenly.

"Oh. I see." Akera's face hardened. "You think you can sweep this crime under the mat and spare your wife the punishment she deserves. Well, you won't, I promise. It's my duty, and that of all Lord Mori's retainers, to avenge our master's death, and I assure you that we will do so."

Sano felt his spirits descend because the Mori clan's huge retinue of samurai out for blood was only the first threat to Reiko and not the worst. He hid his emotions behind a severe façade. "It's your duty to cooperate with my investigation."

Akera eyed Sano with fear, hostility, and resignation. "At your service, Honorable Chamberlain," he muttered.

"First you can answer some questions," Sano said. "What did Lord Mori do last night?"

"He had dinner with me and some of his other retainers. Then he went to his office and read news dispatches from his provinces. I checked in with him to report that all was well on the estate, and we discussed his plans for the next day. Then he retired to his private chambers and went to bed."

Sano noted the huge discrepancy between this story and Reiko's. "Didn't Lord Mori have company?"

"No." Akera looked annoyed that Sano had contradicted him.

"He didn't entertain himself with a young boy who he rented for sex?"

Akera's face darkened with anger. "Lord Mori was an honorable, dignified samurai. He never indulged in prostitutes of any kind."

"I understand that Lord Mori liked to play rough with boys," Sano persisted. "This one was tortured and killed."

"Who gave you that idea?" Suspicion narrowed Akera's eyes. "It was your wife, wasn't it? You talked to her before you came here. She's slandering Lord Mori to save herself."

Sano had expected this denial and accusation, but it worried him nonetheless. In the few moments he'd been at the estate he'd gathered a statement against Reiko and no evidence in her favor. Still, he believed her and not Akera, a man he didn't know who wanted someone to blame for Lord Mori's death. "It would be wise for you to tell the truth. I'll be checking into your version of events and questioning witnesses."

"Go ahead," Akera said, defiant. "Here are the witnesses." He gestured toward some fifty Mori soldiers who'd gathered nearby. They bent a collective, hostile stare on Sano. "All the troops in the Mori retinue will confirm my story and attest to Lord Mori's good character."

They would, Sano knew. The samurai code of honor required their absolute loyalty to their master and fierce aggression toward outsiders they thought had insulted his clan. Sano's spirits dropped lower as a barrier of silence rose between him and the truth about the murder. But all barriers had weak spots, and he'd broken through them before. Moreover, he hadn't missed a critical, heartening element in Akera's story.

"You appear to be the last person to have seen Lord Mori alive," Sano pointed out.

"If you're looking to shift the blame for the murder onto me, it won't work," Akera said with ireful satisfaction. "I didn't kill Lord Mori. Everyone here will attest to my devotion to him. My servants will swear that I spent the whole night in my own quarters and didn't know he was dead until *Sōsakan* Hirata and I found him today."

Sano saw that there was nothing more to be gained from Akera until and unless he could break this alibi that was backed up by the servants' age-old obedience to and fear of their superiors. He faced down Akera with an impassive gaze. "Make yourself available for further questioning. I'll inspect the scene of the murder now."

He, Marume, and Fukida entered the building and found Hirata with Detectives Arai and Inoue in the bedchamber. As they exchanged greetings, Sano viewed the corpse lying on the bed. He stifled a wince; his gaze veered away from the ugly wound in Lord Mori's groin, the severed organs alongside Reiko's soiled knife. Flies buzzed and swarmed over the blood. Sano felt a painful spasm in his own groin, then a sick, dizzying sensation. He'd seen many murder victims, but this injury to the most personal, vulnerable part of the male body almost undid him. The air reeked of decay. For a moment he couldn't breathe.

"Is this how you found him?" Sano managed to ask.

"Yes," Hirata said. "We haven't touched anything here, except to open the windows." The detectives studiously avoided looking at the corpse. Arai and Inoue had had time to get used to it, but Marume's and Fukida's faces were pale. "We preserved the scene for you."

Sano nodded his approval while he noted the room's plain decor. The gilded screen, the erotic mural, the vase of flowers, the wine bottle, and cup were nowhere to be seen. Except for the single blossom that lay, its petals dyed red, in the blood on the floor, the chrysanthemums had vanished as Reiko had said.

Or perhaps the decorations didn't exist. Perhaps the events she'd claimed she'd witnessed here had never taken place.

These unwelcome thoughts rose involuntarily in Sano's mind. He

realized he was treating Reiko with the skepticism that he would apply to any other murder suspect. Dismay filled him; yet the habits formed during years of detective work were hard to quit. Sano paced around the room, looking anxiously for clues to confirm Reiko's story. He opened the cabinets and found nothing but clothes and Lord Mori's other personal items. When he found the spy-hole she'd cut in the windowpane, he felt relieved, and guilty for distrusting Reiko. But it didn't prove that Lord Mori had done the things she said. It wasn't nearly enough evidence to prove Reiko innocent.

"What investigation has been done?" Sano asked.

"I've sent men to search the estate," Hirata said.

"Any results yet?"

Hirata shook his head.

"Well, here are some things I want them to search for." Sano described the chrysanthemum screen, flowers, and mural. He looked at the bed. If anyone had been killed on it besides Lord Mori, it was impossible to tell, and the blood obliterated any signs that sex had taken place. "Also the body of a dead boy about nine years old, and another boy, either alive or dead, aged five years, named Jiro."

"What?" Hirata beheld Sano with surprise, as did the other men.

Sano told them Reiko's tale. He also told them what Akera had said that disputed it. "Finding the dead boy would help prove that things happened the way my wife claims. Finding Jiro would lend credence to her story that she came here to look for him—not kill Lord Mori."

"All right. I'll have my men look." Hirata exchanged an uneasy glance with Inoue and Arai.

"What's the matter?" Sano said.

"I was just going to tell you that I've begun questioning the residents of the estate," Hirata said. "I've found a possible witness to the crime."

"Who is it?"

"Lord Mori's wife."

The woman Reiko had befriended. "What did she say?"

"You'd better hear for yourself." Hirata paused. "I must warn you that you're not going to like it."

．　．　．

Sano found Lady Mori in her chamber in the women's quarters of the mansion. She sat surrounded by five ladies-in-waiting and a gray-haired maid, who inched closer to her in protective unison when Sano entered with Hirata. She seemed an ordinary older woman with a dumpy figure, neatly groomed in her plain, beige silk kimono. But her eyes were red and her face bloated from weeping. Grief blurred the gaze she turned toward Sano.

He knelt before her and introduced himself, while Hirata waited at the door. The room was small, crowded with women, elaborate lacquer furniture, brocade cushions, a mirror, and dressing table. It was also too hot from the charcoal braziers that burned despite the muggy summer warmth. The atmosphere smelled of perfumed oils.

"Please accept my condolences on the death of your husband," Sano said.

"Many thanks. They are most appreciated," Lady Mori said in a gentle voice thick with tears.

"I've been told that you have information about Lord Mori's murder," Sano said. "Is that correct?"

"Yes, Honorable Chamberlain." She cast her eyes downward and wiped them on her sleeve.

Sano didn't like to bother a widow in the raw early stage of mourning, but he couldn't afford to delay hearing Lady Mori's testimony, especially if it could hurt Reiko. "Please tell me what it is."

"Honorable Chamberlain . . ." Lady Mori glanced at him from beneath her swollen red eyelids. "Forgive me if it pains you, but . . . I am sorry to say . . ." Her voice dropped to a murmur. "Your wife killed my husband."

The last thing Sano needed was someone else claiming Reiko was guilty. Hirata flashed him a glance that said, *I warned you.* Anger undermined Sano's sympathy for Lady Mori. "How do you know?" he demanded. "Did you actually see Lady Reiko stab him and castrate him?"

Lady Mori flinched at his blunt, crude words. "No. But I am sure she did it."

"How can you be, when you didn't see her?" Sano heard his voice grow harsher with his outrage at the false accusation.

If Lady Mori feared him, she didn't show it. She aimed her gaze somewhere near his chin, as close as a high-society woman could come to looking him in the eye. She spoke in a reluctant but certain tone: "Lady Reiko was with my husband last night. That much I did see."

"You saw her spying on him from outside his chamber?" Sano imagined Lady Mori lurking in the fog, watching Reiko. Perhaps he could get Lady Mori to confirm Reiko's story while he demolished hers.

Faint surprise crossed Lady Mori's face. "Not outside. Lady Reiko was inside my husband's chamber." Trepidation blended with the sorrow in her eyes. "You were not aware?"

"Aware of what?" Sano said, leery and suspicious.

"I am sorry to be the bearer of information that may distress you as much as it does me, but . . ." Lady Mori crumpled under an onslaught of grief. Her attendants laid soothing hands on her as she sobbed. "Your wife and my husband were lovers."

5 The Wife's Tale

The annual ceremony to open the Sumida River for the summer season began as the sun descended behind the hills and its last rays gleamed red on the water. Musicians, puppeteers, and jugglers entertained noisy crowds that strolled the embankment. Vendors in boats along the shore did a flourishing business in rice cakes, dumplings, watermelons, and sake. People jammed the Ryōgoku Bridge, awaiting the fireworks. Up and down the river floated hundreds of pleasure craft, brightly lit with multicolored lanterns, containing gay revelers.

Aboard one large boat Lord and Lady Mori sat beneath a striped canopy. They smiled at each other as they enjoyed the singing and music from the other boats.

"I wanted to do something special to celebrate our anniversary," Lord Mori said. "Does this please you, my darling?"

"Very much." Lady Mori's heart brimmed with love for him that hadn't diminished in sixteen years of marriage.

Lord Mori poured sake into their cups. "Let us drink a toast to our continued happiness."

As they drank, Lady Mori recalled their wedding day, the priest droning through the rites, the handful of spectators, herself and Lord Mori seated opposite each other. She'd cowered under the drape that

48

hid her face, terrified because he'd been a stranger that she'd only met once, when their clans arranged their union. She knew nothing about him except that he was rich and could provide for her and her nine-year-old son from her previous marriage. That marriage had been a disaster, her husband cold and cruel. When he'd died, she'd never expected to find happiness in a new marriage.

But Lord Mori, whose first wife had died many years past, had proved to be a kind, decent man. To their mutual surprise, they'd fallen deeply in love. Now Lady Mori thanked the gods for him and their wonderful life together, especially because she wasn't the only one who'd benefited.

Her son, Enju, stood at the boat's railing. Twenty-five years old now, he was so handsome that Lady Mori beamed with pride. He held a spyglass to his eye, scanning the bridge.

"Do you see any pretty girls?" Lord Mori called to him. "I know you have a good eye for them."

Enju laughed as he turned to his stepfather. "Is that so bad?" He added teasingly, "You must have been quite a man for the ladies in your day."

"That was before I met your mother." Lord Mori put his arm around Lady Mori. As Enju resumed watching the bridge, Lord Mori said, "It's high time I found a bride for him. I know some lovely, high-bred young women who would do quite well."

He'd not only welcomed his stepson into his life; since he had no issue of his own, he'd adopted Enju as his official heir. Furthermore, he loved Enju as he would a blood child. Lady Mori had her husband to thank for the fact that Enju had grown into a happy, healthy man with a bright future. Someday, Enju would rule Suwo and Nagato provinces as *daimyo*.

"They're setting up the fireworks on the bank," Enju called.

Lord Mori held Lady Mori close and whispered in her ear: "When I get you alone, we'll make some fireworks ourselves."

Lady Mori blushed and smiled at his hint of carnal pleasures to come. Her husband was a wonderful lover who'd taught her the joys of the marriage bed. Even after all these years, desire for him quickened in her.

A boat full of chattering ladies drew up alongside theirs. Enju called, "Hello there!" A lively flirtation ensued, but one lady didn't join in the fun. She was the youngest and loveliest, regal and aloof. Her gaze lit on Lord Mori. A sly smile curved her lips.

"Good evening, Lord Mori," she called through the bars of the railing that surrounded the deck on which she sat.

Her voice had an alluring, provocative tone. Her pose reminded Lady Mori of pictures she'd seen of the Yoshiwara pleasure quarter, in which courtesans sat inside barred windows for customers to view. Lord Mori reacted with surprise that this strange woman had addressed him.

"Good evening," he said. "Have we met?"

"We have now." Her smile deepened. "Please allow me to introduce myself. I am Reiko, wife of Chamberlain Sano."

Lady Mori had heard of the famous Reiko. She frowned in instinctive alarm. She'd never been a jealous wife, but she didn't like for Reiko to talk to her husband.

"Well, I'm pleased to make your acquaintance. Is the chamberlain with you?" Lord Mori glanced over Reiko's boat.

"No, I'm on my own." Batting her eyelashes at him, Reiko touched her rouge-red mouth with her fan. "And I'm quite in need of masculine company. How fortunate that we happened to run into each other."

"Yes. Ah."

Lord Mori sounded pleased as well as discomposed by Reiko's flattery. Lady Mori saw admiration for Reiko in his eyes. Her alarm increased as she noticed the predatory glint in Reiko's.

"May I offer you a drink?" Lord Mori asked.

Reiko slowly licked her lips. "Indeed you may. I am so thirsty."

Lord Mori poured a cup of sake for her. Lady Mori saw that the cup was her own, but he didn't notice. He seemed to have forgotten she existed. While Enju bantered with the ladies, Lord Mori reached across the short distance between the two boats. Reiko reached out through the railing. As she accepted the cup from him, her fingers caressed his.

"Thank you," she murmured.

He poured sake into his own cup. A sudden loud boom rocked the night. The ladies squealed. Enju exclaimed. Brilliant red, green, and gold streamers of light filled the sky. But Lady Mori hardly noticed; she was watching her husband and Reiko sipping their sake, their gazes locked. They reminded Lady Mori of a courtesan and client performing the ritual mock wedding ceremony before the first time they made love. Lord Mori's face wore a dazed, smitten expression. Reiko's showed the triumph of a hunter who'd captured a large prey. More explosions thundered; more rockets burst their colored lights above. Happy cries of awe arose from the river, banks, and bridge. Lady Mori quaked as she felt her perfect world begin to crumble.

For intolerable days thereafter, Lady Mori languished in misery, neglected by her husband. At night she waited up late for him. Whenever he finally came home, she asked, "Where have you been?"

"I had business in town," he always said.

But his eyes always slid away from hers, and she knew he'd been with Reiko. She could smell perfume and sex on him. Even as her heart broke because he'd betrayed her, she dressed herself in new clothes, fixed her hair in a different style, and bought him presents in an attempt to win him back. She tried to entice him to her bed.

"It's late. I'm tired," he would say. "Good night."

Then he would disappear into his private quarters, leaving her to cry herself to sleep alone. The next evening he would ride off, and the ordeal of waiting would begin again. *How could he do this to me?* Lady Mori grieved.

Enju tried to comfort her. "Don't worry, Mother," he said as she knelt before the Buddhist altar in the family chapel and prayed for Lord Mori to love her again. "This affair won't last. Father will soon come to his senses."

Lady Mori knew that Enju felt just as abandoned as she did. Lord Mori had used to spend hours every day with Enju, teaching him the complex business of governing the provinces he would inherit. Now

he rarely spoke to Enju. Lady Mori supposed he felt guilty for hurting her and the sight of her son made him feel worse. How she wished this nightmare would end!

One evening she sat in the garden, listening to the crickets. Lord Mori had taken to staying away for longer periods, and this time he'd been gone four whole days. Lady Mori thought she would die of grief. But now she heard a servant call, "The master is home!"

Her heart leapt with joy and revived hope that he was back to stay where he belonged. But when she hurried to his private chambers to greet him, she heard a woman's shrill giggle. She saw Lady Reiko run through the garden, her robes and long hair flying. Lord Mori ran after her.

"Catch me if you can!" Reiko cried.

They didn't notice Lady Mori. She stood staring in horror that her husband had brought his mistress into their home. Lord Mori caught Reiko. They tumbled to the ground. He tore her robes open. She squealed. He flung off his loincloth, mounted her, and took her there in the grass. Lady Mori watched, fraught with jealousy and despair.

Night after night Lord Mori brought Reiko to the estate. Lady Mori spied on them through his bedchamber window. A sick compulsion made her want to see them together, to wallow in torment. If they knew she was there, they didn't care; they were so absorbed in wild, depraved antics. Once they fought each other naked with swords before they coupled. Another time Reiko whipped Lord Mori until he went berserk with fury and took her from behind, like wolves mating. Lady Mori wondered if this was what her husband had craved all the years of their marriage, if he'd forsaken her because Reiko could give him the excitement that she herself could not. Yet she nursed the hope that he would tire of Reiko, that carnal passion couldn't permanently eclipse longtime love.

Many days passed in this terrible manner. A warm, wet summer night found Lady Mori kneeling on the veranda, once again spying through the window. Her husband and Reiko had just finished making love. They lay naked, her back against him, his arms around her. The rain streamed from the eaves, splashed on the veranda, and wet Lady

Mori's robes. The lamp shone on Lord Mori and Reiko, cozy inside. Suddenly Lady Mori noticed that Reiko's stomach looked swollen. Dismay stirred, cold and ominous as a snake rousing from hibernation, through Lady Mori.

Lord Mori caressed Reiko's belly. "Our child is getting big," he said in a proud, pleased voice.

Lady Mori went sick with shock. Reiko was pregnant, by her husband! But how could the pregnancy be so far advanced, when Reiko and Lord Mori had met such a short time ago? How could the baby be his?

"Well, it's been growing almost five months," Reiko said. "You must have planted your seed the first time you bedded me."

A second, worse shock hit Lady Mori. Their affair had been going on longer than she'd thought. They'd been lovers before that night on the river, when they'd pretended to be new acquaintances.

"Does Chamberlain Sano know?" Lord Mori asked Reiko.

A mischievous smile twisted her lips. "Oh, he knows I'm pregnant. He's very pleased. He thinks it's his baby." She giggled. "He also thinks my son, Masahiro, is his. My honorable husband doesn't know the truth, which is that if I'd waited for him to make me pregnant instead of having love affairs, I'd be barren because he's not capable of fathering a child."

Reiko turned to face Lord Mori. "But you are." Her voice turned husky and seductive; her hand fondled his genitals.

Flattered, he laughed. "Yes, I am virile, with you."

Lady Mori had longed to bear him a child and believed that the fact that she'd been unable was his fault, that he was sterile. After all, she had Enju. But he'd impregnated Reiko. That proved he was potent and Lady Mori was to blame for failing to conceive, for years of regret. Now Reiko would bear him the child that Lady Mori couldn't. Lady Mori wanted to scream, fall on the ground, and claw herself to bloody shreds.

"I think the baby is a boy," Reiko said.

"Good," said Lord Mori. "I've always wanted a son."

New revelation horrified Lady Mori. She'd believed he thought of Enju as his son. Now it was obvious that he cared more for his unborn

flesh and blood than for the stepson who'd loved him these sixteen years. Reiko's child was a betrayal of Enju as well as Lady Mori herself.

Lord Mori pulled Reiko on top of him. She sat upright with his body between her knees, his hands on her middle. He said, "Imagine, a son of mine growing up inside Edo Castle. If Chamberlain Sano manages to hold onto his power long enough, my son will become a top official in the regime."

"What an honor for you." Reiko laughed. "And what a fine joke on my husband!"

Lady Mori was forced to acknowledge that her perfect marriage had been an illusion. Yet she still loved her husband; she still wanted him back. She could no longer tolerate the pain of his infidelity, and she couldn't just wait passively for his affair to run its course. She must take action.

Her first thought was to tell Chamberlain Sano about the affair between Lord Mori and Reiko. Surely Chamberlain Sano would put a stop to the affair and punish his adulterous wife. But he would also punish Lord Mori, strip him of his fief, or even put him to death. Lady Mori devised a better plan.

The next day, she walked into Lord Mori's office, where he was poring over account books. Trembling with nerves and fright, she said, "I—I have something to tell you."

"Very well," he said grudgingly. "Be quick about it."

"You must stop this affair with Lady Reiko," she burst out. Tears welled in her eyes. "You must honor your vow to be a faithful husband to me."

He gazed at her in contempt and scorn. "I will not. I'm in love with Reiko. I don't care about you. And how dare you tell me what to do?"

"If you don't give her up, I'll tell my brother how badly you're treating me." Lady Mori's brother was the *daimyo* of a fief near Lord Mori's. He and she had been very fond of each other since childhood.

He'd arranged her marriage to Lord Mori, uniting their clans, sealing a treaty of peace and mutual support between them, but he would take personally any offense to her. He would retaliate against the offender, and no treaty would stand in his way.

Lord Mori blenched. "You wouldn't tell him."

"Do right by me, or I will," Lady Mori said, emboldened by the fear in his eyes. "And my brother will declare war on you. His army will invade your provinces. He'll have your head as a battle trophy."

Staring at her with amazement, he shook his head. "You would instigate a war to separate me from Reiko? You're mad!"

"Make your choice," Lady Mori said.

"This is just a foolish woman's bluff. No matter how much your brother cares about you, he's too smart to risk everything he has to avenge you!"

"We shall see." Lady Mori walked toward the door.

Before she reached it, Lord Mori called, "Wait."

Lady Mori turned. Her husband sat behind his desk, shrunken by cowardice. "All right," he said with bitter resentment. "I will end the affair."

Lady Mori experienced a sad triumph. "You'll never see Lady Reiko again? You'll tell her it's over?"

He expelled his breath. "Yes." Heartache etched his face. "I'll tell her."

"Tonight," Lady Mori specified.

When night came, Lady Mori was stationed at her spy-post outside her husband's bedchamber. Storms had beset Edo all day; faint thunder heralded another. Smoke from a fire shrouded Lady Mori as she knelt on the veranda beneath the window. Inside the room, Lord Mori and Reiko sat drinking sake together.

"My, but you're quiet," Reiko said. "What's the matter?"

Glum and haggard, Lord Mori wouldn't meet her gaze. "I can't see you anymore." His voice quavered. "This is the last time."

"What are you talking about?" Reiko demanded. Disbelief marked her beautiful features. "We're in love. You said you can't live without me. How can you just cast me off?"

Satisfaction filled Lady Mori. Let Reiko feel the pain of rejection. Let her suffer instead.

"I don't want to," Lord Mori hastened to assure her. "I love you more than my life. To lose you will break my heart. But my wife is jealous. She told me that unless I give you up, her clan will declare war on mine."

"Idle threats!" Reiko scoffed. "You don't believe her?"

Lord Mori hung his head. "I can't take the chance that she can make good on them."

Reiko surged to her feet in outrage. "You mean you won't stand up to her. You think I'm not worth the danger!"

"That's not true!" Lord Mori rose and embraced her. "You're worth the world to me!"

She pushed him away. "Then go tell your wife that you won't bow to her wishes. Tell her that if she's stupid enough to start a war, you'll fight it, for the sake of our love."

His posture sagged. "I can't," he mumbled.

Reiko's eyes flashed sparks of indignation. "Then it's over between us? Even though I'm carrying your child?"

He nodded. Lady Mori had never seen him look so miserable.

"Oh, no, it isn't," Reiko fumed. "No man has ever rejected me. I won't let you go." She sounded like a spoiled, petulant girl on the verge of a tantrum. "I'll show you that you're mine until I decide we're finished!"

She yanked the pins from her hair, which tumbled to her waist. She untied her sash.

"No!" Lord Mori was breathless with alarm.

Reiko dropped her robes to the floor and stood naked. Her pregnant belly protruded round and ripe beneath her breasts.

"Don't. I beg you," Lord Mori whispered. Desire engorged his face.

"You want me." Reiko's smile was tantalizing. "You know you do." She snatched at his clothes, undressing him.

"Stop!" Lord Mori tried to push her away, but she tore open his kimono; she tugged down his trousers and pulled off his loincloth. His manhood sprang erect.

Reiko caught hold of it. "This belongs to me." She fondled him while he moaned. "I never give up anything that's mine."

Lord Mori seized Reiko's hands in an attempt to wrench them off him. "Leave me alone," he ordered.

Yet his voice and his actions lacked force. Reiko knelt. She put her mouth on him. As she licked and teased, he collapsed to the floor. She laughed with triumph as she positioned herself on top of him. "You can't resist me. You'll do what I want."

She spread her legs, took him inside her, and moved up and down. "We'll be together always. Never mind your wife."

Although Lord Mori said, "No! Stop. Please!" he heaved and thrust at her. Lady Mori wept because her husband was so enthralled by Reiko that not even the threat of war could break her hold on him.

"You'll be the ruin of me!" he cried. His hand fumbled under the bed near them; he pulled out the sword that he kept there in case an intruder should attack him in his sleep. He brandished it at Reiko. "Go away, or I'll kill you!"

Reiko stayed. She moved faster, her body pumping, her breasts bouncing. Her expression turned murderous. She grabbed the sword from Lord Mori and held it to his throat. "If you leave me, I'll kill you!" she shouted. "If I can't have you, no one will!"

Lord Mori recoiled in fright, but he uttered wild bellows of passion. Lady Mori knew her plan had failed because Reiko wouldn't cooperate and he was too weak to defy her. Armies could overrun his provinces, and he would lie with Reiko again and again until they slaughtered him. Lady Mori had lost him forever. Sobbing, she fled to her room, where she drank wine until her grief faded into stupor. She slept until morning, when her maid awoke her and told her that her husband was dead.

真

相

6

"You're lying! My wife and Lord Mori were never lovers!" Sano had forced himself to hear Lady Mori's tale until the end, but he could no longer hold back his violent denials. "The child she's carrying isn't his. And neither is our son!"

He didn't believe a word she'd said. This was slander of the most outrageous kind. But his inner voice whispered that he must objectively consider each witness's statement even if it incriminated his wife.

"I apologize for giving you offense, but I have told you the truth," Lady Mori said sadly. "I swear on my honor."

"Your honor is worth nothing in this case," Sano retorted, for here at last was another suspect besides Reiko. "According to your story, you were at your husband's private chambers last night."

Lady Mori visibly braced herself against him. "Yes."

"You saw my wife on the veranda, spying through the window on Lord Mori."

"No. I was the one spying," Lady Mori said, nervous but insistent. "She was inside, with him, just as I described."

Sano countered her with Reiko's version of events: "You and my wife were friends. That night you invited her to dinner. You had a party."

Frosty politeness stiffened Lady Mori's features. "There was no

party. And she was not my friend, she was my husband's mistress. It was he who invited her here."

Sano speculated on what might have happened that Reiko had been unaware of. "You suspected that she had an ulterior motive for befriending you. When she left the party, you followed her. You watched her watching your husband. Did you think she was spying on him for me, for political reasons?"

Lady Mori shook her head. "I watched her seduce him. I heard her threaten to kill him."

"Maybe she had too much to drink at your party." Sano didn't know how much forethought had gone into framing Reiko, but he was acting on the assumption that she had been framed, and Lady Mori was looking to be the culprit. "You stabbed and castrated your husband while he was asleep. You arranged Lady Reiko to look as if she'd done it."

"No! That's not how it was!" Lady Mori cried in horror. "I loved my husband. I would never have hurt him. And I never touched your wife. She murdered him."

Sano lost his temper because even though her story was ludicrous, many people might believe it. Some would welcome a chance to hurt him by persecuting Reiko. "Don't lie to me!" he shouted. "I want to know what really happened."

He seized Lady Mori, yanked her to her feet, and grasped her shoulders. She whimpered in protest. Her attendants gasped in horror at seeing their mistress treated as a common criminal. Hirata moved to restrain Sano.

"Honorable Chamberlain," he warned.

Sano ordinarily didn't believe in using force on suspects because it too often produced false confessions and he disliked abusing his power. He hated to intimidate a helpless woman. But he couldn't let Lady Mori spread her slander about his wife. Not only could it doom Reiko, but it could destroy him. Sano remembered his talk with General Isogai and the two elders. The suspicion that someone connected to him had murdered one of Lord Matsudaira's chief allies was trouble of the kind they'd warned him to avoid.

"Tell me the truth!" he demanded, shaking Lady Mori.

Her head snapped back and forth; she sobbed in terror. But she cried, "I did!"

She seemed to believe her own lies. That would make them sound convincing to anyone she told. Sano had to make her recant. "You killed your husband. You framed my wife. Confess!"

"No! Please don't hurt me!"

Anger consumed Sano. He hated Lady Mori for trying to hurt Reiko. He was furious at Reiko for putting him and herself in this disastrous situation. Lady Mori was a convenient target, and he drew back his fist to strike her.

Hirata caught his arm. "Don't!"

Her attendants shrieked. Marume and Fukida pulled Sano away from Lady Mori. She dissolved to the floor in a fit of tears. The women surrounded her, comforting her. Sano shook off his men. He breathed hard, appalled by his own behavior. Less than an hour into this investigation, and he'd lost control. After so many murder cases, he should be able to discipline himself. But his wife hadn't been the primary suspect in those other cases. He'd not had to prove her innocence while other suspects heaped guilt upon her.

An angry male voice demanded, "What have you done to my mother?"

Sano turned and saw a samurai at the door. He was tall and lithe, in his mid-twenties, dressed in a cloak damp with rain, his two swords at his waist. His face was strikingly handsome, with sensitive features shadowed by consternation. Lady Mori rose, ran to him, and wept against his chest. He focused his dark, brooding eyes on Sano.

"Honorable Chamberlain. May I ask what's going on?"

"You must be Enju," said Sano.

"Yes." Lord Mori's adopted son waited in silence for Sano to answer his question. Despite his mother's description of the lively, young flirt on the pleasure boat, he was evidently a person of few words. Long, thick eyelashes veiled his gaze.

"Your father has been murdered," Sano said.

"So I've heard."

"Where have you been?"

"On business in Osaka. I just arrived home."

Lady Mori cried, "The chamberlain thinks I did it!"

Enju frowned at Sano. "That's not what Akera-*san* told me. He says your wife killed my father."

"She did! Please make him understand that I'm innocent," Lady Mori said, clinging to Enju.

"On what grounds do you accuse my mother?" Enju asked.

"She had the opportunity to murder your father and frame my wife," Sano said.

"Excuse me, but have you given her a chance to tell her own version of events?" A current of hostility ran beneath Enju's calm voice.

"Yes indeed." Sano felt his temper rising again. "She has made a ridiculous claim that my wife was Lord Mori's mistress and killed him during a lover's quarrel." Sano briefly explained.

"There you have it, then."

Sano noted that Enju had remarkable assurance for so young a man addressing a high official. He seemed undisturbed by Lord Mori's death, and although he acted willing to blame Reiko, he hadn't actually claimed that his mother was innocent. This struck Sano as odd.

"How do you know what happened last night?" Sano asked. "By your own admission, you weren't here."

Calculation hooded Enju's expression. "I saw my father cavorting with your wife often enough. It was no secret." *To anyone but you,* said his tone. He shrugged. "Their affair and my mother's attempt to stop it obviously drove Lady Reiko to murder."

It sounded to Sano as if the young man had decided to confirm Lady Mori's damning story about Reiko for some reason other than that he believed it. But Enju was the kind of cool, self-possessed witness who would be hard to shake. Sano knew that mother and son might convince too many people that Reiko was guilty. Yet Enju's behavior was suspicious, and he represented another chance for Sano to exonerate her.

"Someone was obviously driven to murder, but not my wife," Sano said. "I understand that you're Lord Mori's heir."

"That's correct."

"And now that he's dead, you inherit his title and his wealth," Sano continued. "You'll govern his provinces and command all his retainers."

"Yes." Caution narrowed Enju's gaze.

"In other words, you're the person who benefits the most from his death."

Lady Mori gasped. "Are you accusing my son of murder?" She beheld Sano with shocked disbelief that turned to outrage. "He would never commit such a sin against filial piety. He loved his father!"

"Calm yourself, Mother. He can't pin the blame on me." Unfazed, Enju countered Sano's accusation: "I didn't kill Lord Mori. He adopted me, he educated me, he made me the man I am. I would have killed myself before I ever hurt him."

"According to your mother, he abandoned you as well as her for a mistress and her child," Sano said. "If she's telling the truth, you had that reason to want him gone, in addition to the fact that you would inherit his estate."

Not only were mother and son in league to protect each other by lying about Reiko, but maybe they'd conspired to rid themselves of Lord Mori.

Enju smiled, conveying pity for Sano. "The fact is that I couldn't have killed him. I've been traveling for the past four days. My attendants will verify that they spent last night with me in Totsuka." This was a village on the Tokaidō, the highway that connected Edo to points west. "They'll verify that we rode home this morning."

His attendants would say whatever he wanted, Sano didn't doubt. Sano sensed unrevealed dimensions in the young man, but for now Enju had an alibi. Sano felt an urge to beat Enju until his composure shattered and the truth came out of him. One thing that prevented Sano was the knowledge that if he started beating Enju, he might not be able to stop, and killing one of the other suspects would do Reiko no good.

A second was that he had other issues to take up with Enju and

Lady Mori; namely, the missing boy and what Reiko had observed in Lord Mori's bedchamber prior to his death.

One of Sano's guards appeared in the doorway. "Pardon me, Honorable Chamberlain, but there's a message from the shogun and Lord Matsudaira. They want to see you in the palace immediately."

Sano rode toward Edo Castle with Hirata and his entourage. The rain had started up again, and their horses' hooves splashed in puddles along the avenue through the *daimyo* district. Pedestrians were few. The sentries hid in their booths outside the estates; dripping banners printed with clan crests sagged over the portals. The castle was a massive gray blur towering behind a waterfall.

"What do you think Lord Matsudaira wants?" Hirata asked.

"Probably the usual business," Sano said.

Lord Matsudaira summoned him at least once a day, to extract reassurances that the government was running smoothly and learn whether Sano had heard of any new plots against him. But Sano had an uneasy feeling about this particular summons.

He recalled a question that had occurred to him when Hirata had brought Reiko home but he hadn't had a chance to ask. "How did you happen to be at Lord Mori's estate this morning?"

The high stone walls of Edo Castle loomed in the near distance. Soldiers in the guard house atop the main gate had spotted Sano's procession; they hurried out to let it inside.

"It's a long story," Hirata said.

"I'll make time to hear it," Sano said, hoping that Hirata's story could provide a different perspective on the murder, counteract Lady Mori's and Enju's statements, and help Reiko.

7 The Disciple's Tale

Dawn lit the mist that shrouded the Yoshino Mountains, a fifteen-day journey west of Edo. Steps cut into a cliff led up to a remote temple that was home to a small Buddhist sect. The temple bell echoed across the pine forests. Eagles soared above the pagoda whose tiered roof vanished into the sky. Inside the temple precinct, Hirata circled an expanse of bare ground. Wearing a white jacket and trousers, his feet bare, he raised his hands in preparation for combat.

Opposite him circled his martial arts teacher. Ozuno, an itinerant priest, had a stern, weathered face; his gray hair was topped by a round, black skull cap. He wore a tattered kimono, loose breeches, cloth leggings, and frayed straw sandals. His lame right leg, his eighty years, and his unkempt appearance disguised his identity as an expert in the mystic martial art of *dim-mak* and a member of the secret society that had preserved it for four centuries.

Hirata had met Ozuno during a murder investigation and persuaded Ozuno to take him as a disciple. Ozuno had made Hirata commit to an indefinite period of training, then swear not to reveal that he was a pupil. The ancients who'd invented *dim-mak* meant for it to be used honorably, in self-defense and in battle, but they feared that it would be used for evil purposes. Hence, they passed down their knowledge

to only a few trusted students. Hirata was forbidden to use *dim-mak* except in cases of extreme emergency, or to reveal the techniques to anyone except his own disciples someday. Hirata had agreed, because his future depended on mastering them.

His left thigh had been seriously wounded in the line of duty four years ago. Once an expert fighter, he'd become a cripple. He wanted more than anything to regain his strength and prowess, his manhood and honor. This training was his only hope. But it had proved to be more than he'd bargained for.

First had come months of scholarly study. "Why do I need to learn about medicine and anatomy?" Hirata had asked Ozuno. "I'm not training to become a physician."

"You need to know the vulnerable points on the human body," Ozuno had explained in his gruff, resonant voice. "The points are the same as those used by physicians during acupuncture. They're located on junctions along nerve pathways that connect vital organs. Memorize them, and don't argue."

Hirata looked ahead to lessons on the secret combat techniques. But when they came, they brought another unpleasant surprise: *Dim-mak* was the most incomprehensible, vexatious thing he'd ever attempted.

Now, as he and Ozuno faced off, Ozuno said, "You're not using the secret breathing technique. In order to build and channel your inner forces, you must get the maximum air through every part of your body. But you are panting like a dog in summer. You haven't been doing your breathing exercises."

Hirata hated those. The ritual of sucking in and expelling air for hours on end was a tedious bore.

"And you're as tense as if someone poked a stick up your rear end," Ozuno said. "Relax! When your muscles are tense, they contract. They pull your strikes back toward you and decrease their power." His eyes narrowed in disapproval. "You haven't been practicing meditation enough."

"Yes, I have," Hirata fibbed. He also hated meditation, which

seemed like sitting and doing nothing. In the past, he'd been a good fighter without wasting time on it.

"Don't resist that which you do not enjoy," Ozuno said. "Meditation is necessary to quiet the mind so you can forge a link with the cosmos and the infinite knowledge embodied there. Only then can you know the proper actions to take during combat. Otherwise you will fall prey to insecurity and confusion and lose the battle. You will be unable to tap your spiritual energy. I can tell that's the case with you, because I can hardly feel your shield."

The shield was the subtle energy field that surrounded all things. It sprang from a person's thoughts as well as bodily processes. "There's too much chaos in your mind," Ozuno said. "Your shield is so weak that you can't detect the energy from other people's shields and sense threats from them."

"I can feel yours," Hirata said. Ozuno's shield gave off a mighty thrum, like lightning about to strike. Hirata braced himself for combat.

Ozuno sneered. "You're too anxious to beat me. You persist in acting as if your opponent is your adversary. Remember that he's not; he's your partner in your quest for victory. Without him, you can't win. Merge your energy with mine. Don't oppose it."

Hirata had always struggled with this concept of oneness with his opponent. How, in a real battle, could he be partners with someone when they were trying to kill each other?

"We'll practice the no-hit technique," Ozuno said.

That entailed projecting bursts of spiritual energy that impacted the opponent's shield and convinced him that he was being hit even though no physical contact occurred. An expert could drive an opponent to the ground without touching him. Hirata raised his palm at Ozuno.

The priest burst out laughing. "You look like you're constipated. Are you even trying to project your energy?"

"I am," Hirata said, nettled by the constant, insulting criticism that he'd endured from Ozuno for three years.

"Then stop my attack."

Ozuno lashed out. Hirata willed his energy at Ozuno's fist. It

66

should have arrested Ozuno's movement, but instead the blow landed squarely in Hirata's stomach. The breath whooshed out of Hirata. He doubled over, gasping.

"Merciful gods, what a sorry excuse for a pupil you are!" Ozuno began boxing his ears.

"Stop!" Hirata wheezed and ducked.

"After all your training, you should be able to stop me yourself," Ozuno said. "Project a powerful thought of violence toward me. Put me on the defensive."

Even as Hirata tried, Ozuno hit him again and again. "Well? I'm waiting. Oh, forget it!"

He pushed Hirata away. They resumed circling each other. Hirata was dripping sweat, was exhausted from twenty days of lessons. His bad leg ached. Ozuno lunged, raising his hand to strike Hirata's face. Hirata swept his own hand past his face and outward. This should have made Ozuno lose focus and led his blow away from its target, but Ozuno's hand collided with Hirata's chin. Hirata found himself lying flat on the ground.

"Never have I had a pupil so slow on the uptake," Ozuno said. He wasn't even winded. "The gods must be punishing me for some sin I committed during a past life."

Stung, Hirata clambered to his feet and said, "I'd do better if we used swords." Swordsmanship was his area of expertise, and he was angry that for three years Ozuno had focused solely on unarmed combat, his weakness.

"It would make no difference," Ozuno said. "Weapons are only an extension of the self. You must master the principles of *dim-mak* before applying it to sword-fighting."

"But in the meantime, what will happen if an enemy attacks me with a sword?" Hirata said. "How can I fight back?"

Ozuno uttered a sound of exasperation. "How many times do I have to tell you? Combat is more mental than physical. The mind is the foundation of a warrior's power. Conquer your foe's mind and you win, no matter what weapons you don't have."

Defeat washed through Hirata. He turned away from Ozuno and

gazed across the mountains, still hidden in the mist. His goal of learning the secrets of *dim-mak* seemed even farther away than when he'd begun his training. He yearned for the old days before he'd been injured, when life had been so simple. He missed the family he'd left at home.

"One of your problems is that you focus on the physical aspects of your training and refuse to develop your character," Ozuno said to Hirata's back. "You are immature, impatient, and arrogant. You expect things to be easy. You can't take criticism, and instead of trusting me and following directions without complaint or debate, you question my authority and judgment. Unless you change radically, you will fail."

Worn down from the constant humiliation, Hirata trudged toward the gate. "I have to go back to Edo." He'd stayed away much longer than he should have.

"Are you coming back?" Ozuno said.

Hirata paused; he turned to face Ozuno. Their gazes held. Ozuno's face was somber, devoid of his usual mockery. Hirata realized that they'd reached a critical point where he must decide whether to continue his studies or part ways with Ozuno. The idea of quitting his pursuit of his dream horrified Hirata. Yet right now the dream seemed not worth the suffering.

"I don't know," Hirata said.

Fifteen days later, Hirata rode his horse through the gate of Edo Castle on a fine spring afternoon. He looked forward to a meal, a hot bath, a good night's sleep, and time to sort out his life. But when he arrived at his mansion in the official quarter, his wife, Midori, greeted him at the door, holding their daughter in one arm and their baby son in the other.

"Thank the gods you're home!" she cried. "You're wanted by the shogun and Lord Matsudaira. They've been asking for you every day you've been gone."

Hirata's heart sank because he was surely in trouble. He rushed to

the palace, where he found the shogun and Lord Matsudaira at a cherry blossom party. They and their guests sat in the garden, sipping wine, eating delicacies, composing poetry. Pink petals drifted down on them. The shogun smiled in delight, but Lord Matsudaira wore a grim expression: He hated dancing attendance on his cousin, which he had to do in order to maintain his influence over the shogun and his control over the regime.

"Ah, Hirata-*san,*" the shogun called, "join the party."

Hirata knelt and bowed. A servant poured him wine. Lord Matsudaira demanded, "Where in the world have you been?"

"Away on business," Hirata said, quaking inside because Lord Matsudaira took serious umbrage at any offense and seemed even angrier than he'd expected.

"I don't recall giving you permission to disappear for almost two months. What good is an investigator who's never around when I need him?"

"Ahh, don't scold," the shogun interrupted, flapping his hand at Lord Matsudaira. "It's too nice a day for a quarrel."

"Yes, Honorable Cousin." Lord Matsudaira's tone hinted at how much he hated deferring to the shogun. "Will you permit me to take Hirata-*san* for a walk and show him the prettiest cherry blossoms?"

"Certainly."

Hirata braced himself for the reprimand he knew was coming. As they sauntered under the trees, Lord Matsudaira spoke in a low, furious voice: "This recent absence isn't the only problem I have with you. You've been pretty scarce for awhile." He trampled on petals; he swatted angrily at one that drifted against his face. He was less in control of himself, and more insecure, every time Hirata saw him. "When I want to know the progress of your investigations, your men give the reports. They seem to be doing all the work and covering for you."

Hirata was dismayed that he hadn't hidden this fact as well as he'd thought. "My men work under my direction. I can't be everywhere at once. But I'm at your service now."

Lord Matsudaira fixed on him a gaze that measured his dedication.

"Well, that's good, because I have a job that I want you to handle personally, not pass on to somebody else."

He glanced toward the shogun, then led Hirata to the far end of the garden. "It has come to my attention that there are men close to me who may have secretly joined the opposition."

This news surprised and alarmed Hirata. Lord Matsudaira had always been nervous about treachery, but not until now had Hirata heard that treason might be breeding within Lord Matsudaira's inner circle. Hirata realized how out of touch with politics he'd become during his martial arts training. "May I ask who these men are?"

Lord Matsudaira whispered in his ear. The twelve names sent a ripple of shock through Hirata. Those were the most powerful, important men who'd put Lord Matsudaira on top. Together they had the power to knock him down if they wished.

"I want you to investigate each of them," Lord Matsudaira said. "Determine if indeed they are plotting to betray me. And keep your investigation absolutely confidential."

The detective in Hirata welcomed a new, important challenge, but the investigation could take ages. His heart plummeted. When would he fit in his martial arts lessons?

"If I catch you neglecting your duties," Lord Matsudaira went on in an ominous tone, "you'll be free to do whatever you want instead. Do you understand?"

He meant that unless Hirata devoted himself entirely to this investigation, he would lose his post; he would be cast out as a *rōnin,* to fend for himself and his family in a harsh world. No matter how much Hirata longed to be an expert martial artist, he couldn't sacrifice Midori, his children, or his honor.

"Yes, Lord Matsudaira," he said. "You can count on me."

A month later, Hirata sat in his office with Detectives Inoue and Arai, sorting through the information they'd collected on the potential traitors. He shook his head as he skimmed a document. "We've bribed servants, retainers, and family members to spy on all those

men, but not one has reported anything that indicates a plot against Lord Matsudaira."

"We've posted listeners all over the castle and town, but they've heard nothing to implicate the suspects," Arai said.

"Maybe they're innocent," Inoue said.

"Maybe we've wasted a month chasing phantoms of Lord Matsudaira's imagination." Frustration filled Hirata. Every day he spent away from his training, he regretted abandoning it. Each morning he practiced the hated meditation and breathing exercises, in hope that he would soon return to Ozuno. "If we don't find some evidence that those men are traitors, Lord Matsudaira will be displeased rather than relieved."

He and the detectives sat in silence, picturing themselves demoted, exiled, or put to death because they'd failed to produce the desired results. Arai said, "What should we do next?"

"We mount surveillance on the suspects," Hirata said. "We pray that we catch them doing something wrong." The surveillance would take a massive effort. His studies could not resume for months—if they ever did.

"All right. We've got twelve men to watch," Inoue said. "Where do we start?"

"We might as well draw straws," Hirata said.

A guard appeared at the door and said, "Excuse me, but I thought you would want to see this." He gave Hirata a rolled-up, flattened paper. "I found it stuck under the back gate while I was making my rounds."

Hirata unfolded the paper and read the words written there. Surprise interrupted his heartbeat. "Listen."

> *If you want to catch a traitor, look no further than Lord Mori. He is leading a conspiracy to overthrow Lord Matsudaira. He is expecting to receive a secret shipment of guns and ammunition at his estate.*

"Maybe this is the break we need," Arai said, voicing Hirata's hope. Inoue looked skeptical. "Who wrote the letter?"

"There's no signature, and I don't recognize the calligraphy." Hirata asked the guard, "Did you see who left the letter?"

"No. It could have been anybody passing by."

"Anonymous tips are not to be trusted," Inoue said.

"But not to be ignored, either." Hirata knew from past experience that they sometimes told the truth, and he needed every clue that came his way. "If we should catch Lord Mori stockpiling weapons, that would be evidence of treason."

"And what have we got to lose by choosing him as our first surveillance target?" Inoue said.

Arai nodded. "When do we begin?"

"The letter doesn't say exactly when he's due to receive the shipment," Hirata said. "We should begin our watch tonight."

The next eleven nights found Hirata, Inoue, and Arai perched on the roof of the mansion across the street from Lord Mori's estate. Other detectives occupied roofs within estates nearby, whose owners Hirata had ordered to cooperate with his investigation. Gables and trees concealed them. The only person in a position to spot them was the lookout in the local fire-watch tower. Hirata figured that the man wouldn't dare interfere.

The first ten nights passed without event. No deliveries of any kind arrived for Lord Mori. The rainy season began. Huddled on the roof tiles, deluged by storms, Hirata wondered if the anonymous tip was a hoax and he was suffering for naught. On the eleventh night, Hirata peered at the gate while Arai and Inoue dozed under an oiled cloth they'd rigged up on the roof gable to protect themselves from the endless rain. Halfway between midnight and dawn, he'd begun nodding off himself, when a noise in the street jarred him alert. He wakened Arai and Inoue. They saw two porters lugging a big crate, staggering under its heaviness. Three more pairs, similarly burdened, followed. The porters halted outside Lord Mori's gate. The guards admitted them. Hirata crawled up to the peak of the roof. Standing on his toes, clinging to the gable for support, he could just see into Lord

Mori's courtyard, where dim lights from a guardhouse shone through the dripping rain. Figures in the building were silhouetted in the windows. Their movements suggested prying open a box with a crowbar and raising the lid. One man held up a long, thin object. He positioned one end against his shoulder and sighted along it.

It was a gun.

Hirata's heart clamored with exhilaration as he slid down the roof. "Those were the weapons that just arrived," he told Arai and Inoue. "Let's gather our troops and raid the estate."

"Did you find the weapons or any other evidence that Lord Mori was a traitor?" Sano asked Hirata.

They were seated in Sano's office. The room had a musty smell of damp wood and mildewed tatami. Rain streamed down outside. The morning was as dark as if the sun had drowned.

"Not yet," Hirata said. "But it's a big estate. My men are still searching."

"Well, I hope they find those guns," Sano said. If Lord Mori could be proved guilty of plotting against Lord Matsudaira, then no one except his own people would care about his murder. Reiko wouldn't be in as much trouble. "Have you questioned Lord Mori's guards?"

"My detectives did. The guards deny that they took in the weapons. But of course they would. They wouldn't want to implicate themselves in treason."

Chin in hand, Sano contemplated the story Hirata had just told. "Could you have been mistaken about what you saw?"

"I suppose so." Doubt tinged Hirata's voice. "But I was certain at the time."

"Your story doesn't explain why you happened to raid the estate just in time to discover Lord Mori murdered and my wife at the scene."

74

"It must be a coincidence."

"That's too big a coincidence as far as I'm concerned." Sano smelled a setup. "Did you try to find out who sent the letter that put you onto Lord Mori?"

"No," Hirata said, chagrined. "I know I should have. It just seemed more important to find out whether it had any merit. I'm sorry I didn't do a more thorough investigation."

Sano was, too. If Hirata had, they might have had information that could help Reiko. And Sano had even more reason to be concerned. A slapdash job was out of character for Hirata. He'd changed in ways that Sano found disturbing, that boded ill for their relationship as well as the murder case.

"I remember Ozuno from that investigation three years ago," Sano said. "But I had no idea that he'd made you his disciple."

"It's supposed to be a secret." Hirata was obviously upset that he'd revealed it. "I shouldn't have told even you."

But Hirata's first loyalty was to Sano, and not just because Sano was his master. Hirata owed his high rank and all its associated honors to Sano.

"You won't tell anybody, will you?" Hirata said anxiously.

"Not unless it's necessary, and right now I don't see why it would be," Sano said. Obligation worked both ways with them.

Hirata let out a breath of relief. "Then you don't object to my training with Ozuno?"

Sano hesitated. Training with a master such as Ozuno was a once-in-a-lifetime opportunity. Furthermore, Sano couldn't begrudge Hirata the chance to overcome his physical weakness: Hirata had been wounded in the process of saving Sano's life.

"No. But I must caution you," Sano said. "It's not just my approval that you should worry about. Next time you go off to a training session, Lord Matsudaira and the shogun might not forgive you."

"I know." Hirata sounded torn between samurai duty and personal desire.

"And it was dangerous to allow your training to interfere with your duty," Sano went on. "You put yourself under too much pressure to

placate Lord Matsudaira, all the while you're in such a hurry to return to your lessons that you're skipping important steps."

"A thousand apologies," Hirata mumbled, his face full of distress.

"Apologies aren't what I need," Sano said. "I need your help solving this case and clearing my wife. I need to know that you'll give it your full attention and your best effort."

"I will," Hirata said with fervor. "I promise."

Sano only hoped that he could trust Hirata. "Well, we'd better get over to the palace. Lord Matsudaira and the shogun must be wondering what's taking us so long."

In the palace audience chamber, the shogun sat on the dais, cowed by fear of Lord Matsudaira, who knelt below him in the place of honor at his right. Lord Matsudaira's expression was thunderous with rage. The guards stood perfectly still along the walls, as if the slightest movement would bring his wrath down upon them. As Sano and Hirata walked into the room, Lord Matsudaira said, "When were you going to tell me that Lord Mori had been murdered?"

Sano stifled the curse that rose to his lips. Lord Matsudaira must have spies inside the Mori estate, who'd smuggled the news to him. That Sano had delayed reporting the news himself made his situation worse.

"I was planning to tell you after I'd seen what had happened," Sano improvised as he and Hirata knelt and bowed. "I wanted to bring you a report on the progress of the inquiry into Lord Mori's death."

Lord Matsudaira narrowed his eyes, suspicious that Sano had deliberately withheld information and wondering at his intentions. "Well? How did Lord Mori die?"

"He was stabbed and castrated," Sano said.

The shogun gasped in horror. Distress stirred the guards. Lord Matsudaira frowned as though personally insulted. "Did you find out who killed him?"

"Not yet." Sano spoke in a firm, authoritative voice, to hide the fact that he was hedging while he thought what to say.

"Are there any suspects?"

"Everyone in the Mori household is a suspect." But Sano knew he couldn't keep Reiko's involvement a secret forever, and better that Lord Matsudaira heard about it from him than anyone else. "There has been an attempt to incriminate my wife." Lord Matsudaira stared and the shogun gaped. "She—"

"She was found in Lord Mori's bedchamber, naked and covered in blood, alone with his dead, mutilated body." Into the room strode Police Commissioner Hoshina, tall and muscular and proud. His handsome face shone with malevolent pleasure. With him was his chief retainer, Captain Torai, a slighter, lesser version of himself. Both grinned at Sano, relishing his misfortune.

Alarm assailed Sano because his enemy had obviously heard the news from his own spies and rushed here to capitalize on it. Sano recalled the meeting with General Isogai and the elders, and their warning about Hoshina's new campaign to destroy him.

"Is this true?" Lord Matsudaira said, glaring at Sano. "Did your wife kill Lord Mori?"

"It's true that she was found at the scene of the crime," Sano said, "but she didn't do it. I can explain—"

"What's to explain?" Hoshina said. "Lady Reiko was caught literally red-handed."

"It's obvious she's the murderer," said Captain Torai.

Furious, Sano turned on them. "I didn't give you permission to join this meeting. Leave," he ordered. Things were bad enough for Reiko without their accusations.

But Lord Matsudaira motioned them to stay. They knelt, smirking at Sano. Lord Matsudaira fixed on him a gaze replete with menace. "The evidence against your wife is very incriminating."

"It doesn't prove she's guilty," Sano objected. "Please hear me out, and you'll agree that she was framed."

" 'Framed,' " Hoshina scoffed. "Is that what she said? That's the excuse all criminals offer in their own defense." He addressed the shogun: "With Your Excellency's permission, I shall arrest Lady Reiko."

Panic beset Sano. Events were moving too fast in the wrong direction. "I forbid you!"

"He's trying to protect his wife from the law, at the expense of justice," Captain Torai told Lord Matsudaira.

"You're trying to persecute Lady Reiko for your own purposes!" Hirata burst out.

"I haven't heard one reason why she shouldn't be convicted of murder this day," Lord Matsudaira challenged Sano.

Even as Sano opened his mouth to answer, the shogun piped up nervously, "I can't believe that Lady Reiko, could, ahh, do such a terrible thing. She's such a nice, pretty young woman."

He emphasized the word "pretty," as though Reiko's looks were a better proof of her innocence than her character was. But Sano welcomed any support during a battle. "Thank you, Your Excellency." Hoshina scowled. "May I tell my wife's side of the story?"

"Permission granted," the shogun said with a daring look at Lord Matsudaira. He sometimes chafed at his cousin's domination and welcomed opportunities to resist it.

Lord Matsudaira also scowled. "Very well, Chamberlain Sano. I'm listening."

Sano gave a fast, abridged, but persuasive recital of Reiko's tale. When he told about the boy Lord Mori had strangled, the shogun exclaimed in horror. Lord Matsudaira shook his head. Even Hoshina and Torai seemed disturbed. But after Sano described how Reiko had fallen unconscious and awakened to find herself beside Lord Mori's corpse, Hoshina burst out laughing. Torai echoed him.

"That's the biggest lie I've ever heard!" Hoshina said. "If your wife expected you to believe it, Honorable Chamberlain, she must think you're an utter fool."

"I thought the part about spying on Lord Mori was far-fetched." Torai sneered. "No woman does things like that. Not even the unconventional Lady Reiko."

The shogun giggled. Sano's heart dropped because the shogun swayed with whatever wind was blowing the hardest at the moment.

"Lady Reiko's story sounds dubious at the very least," Lord Matsu-

daira said. "Especially the part about Lord Mori stealing and killing children. I've known him for years. He's always seemed a most honorable, decent man."

"There's never been the slightest rumor of a stain on his character," Hoshina rushed to add. "And he was a strong, loyal subject of the regime." His tone reminded Lord Matsudaira that Lord Mori had helped bring Lord Matsudaira to power.

"He may not have been so loyal," Sano said, determined to counter Lord Matsudaira's bias in favor of the murder victim.

"I had him under investigation for plotting a coup," Hirata said, reminding Lord Matsudaira that he himself had suspected Lord Mori of treachery and ordered the investigation.

Lord Matsudaira glanced at the shogun. His expression warned Sano and Hirata that they were verging on a forbidden topic. The shogun was unaware that his cousin had seized control of Japan and the fealty of many of his subjects. No one had told him, and since he rarely left the palace, he saw little of what went on around him. Lord Matsudaira didn't want him to know because he still had enough power to put Lord Matsudaira to death for treason. But no one dared disobey Lord Matsudaira's orders against enlightening the shogun. A conspiracy of silence pervaded Edo Castle.

"Lord Mori was suspected of treason?" The shogun gaped. "Well, ahh, that changes the picture, does it not? If he was a traitor, then, ahh, whoever killed him did us a favor."

"*If* he was," Lord Matsudaira said. "Did your investigation turn up anything against him, Hirata-*san*?"

Hirata described the shipment of weapons. The shogun nodded. Lord Matsudaira kept his expression neutral, but Sano could feel him weighing the evidence, his regard for Lord Mori sinking, and his fear that if Lord Mori had turned on him, then so might his other allies.

But the police commissioner jeered at Hirata: "You *thought* you saw weapons delivered to Lord Mori's estate." He spread his hands. "Where are they?"

When Hirata hesitated, Captain Torai said scornfully, "It's obvious that Chamberlain Sano and *Sōsakan* Hirata have fabricated lies to ruin

Lord Mori's reputation, the better to make his murder seem unimportant and excuse Lady Reiko."

Both the shogun and Lord Matsudaira nodded. Growing more anxious as he lost ground to his enemies, Sano said, "Believe them at your own risk, Honorable Lord Matsudaira. In the interest of security, you should wait until the murder has been fully investigated before you decide my wife is guilty and there's no threat to the regime."

"The murder has been investigated fully enough," Hoshina said. "In fact, Chamberlain Sano has found a witness who completely discredited Lady Reiko's statement." He shot Sano a victorious glance. "It's Lord Mori's wife."

Sano tried to conceal his dismay that Hoshina had found out about Lady Mori and her damning story. "Lady Mori is a suspect herself."

"What did she say?" Lord Matsudaira said.

"She lied," Hirata said.

Lord Matsudaira gritted his teeth with impatience. "I asked you what Lady Mori said. Answer me."

"She said that my wife was involved with Lord Mori and killed him during a quarrel," Sano said reluctantly.

"That does it." Lord Matsudaira smacked his hands down on the floor. The shogun started. "Police Commissioner Hoshina, you may arrest Lady Reiko. Skip the trial. Send her straight to the execution ground."

"It's my pleasure to serve you, Honorable Lord Matsudaira," Hoshina said. He and Captain Torai rose; they grinned at Sano.

"Wait," Sano said, desperate. "If you execute my wife, you'll be putting an innocent woman to death and letting Lord Mori's killer go free!" Horror flooded him because he felt Reiko slipping away from him as if she were drowning in the sea and he were losing his grasp on her hand.

"Better just admit you've lost," Hoshina said.

"We'll let you say good-bye to Lady Reiko before she's dead," Torai said.

"Be thankful that I haven't chosen to punish you for your wife's crime," Lord Matsudaira threatened Sano.

The shogun cleared his throat loudly. Everyone looked at him. "Aren't you all, ahh, forgetting something?" He glowered at their puzzled faces. "I am in charge." Frightened as well as elated by his own boldness, he thumped his fist against his thin, concave chest, then addressed Lord Matsudaira: "*I* decide what happens, not *you*."

"Of course, Honorable Cousin." Lord Matsudaira feigned meekness, but his eyes glinted with ire because the shogun had pulled rank on him. "What do you wish to be done?"

The shogun raised his finger, and inspiration lit his face. Sano exchanged glances with Hirata as his hopes rode on the shogun's whim. "We should consult the witness who was present during the murder."

Sano saw his bewilderment reflected on the other men's faces. Hoshina said, "What witness?"

Their lord regarded them as if he thought them idiots. "Why, ahh, the victim, of course. Lord Mori."

Stunned silence filled the room for a moment. "Pardon me, Honorable Cousin," Lord Matsudaira said cautiously, "but how can we consult a dead man?"

The shogun preened, enjoying his own ingenuity. "Through a medium. I happen to have one here in the palace. She is most talented at communicating with the spirit world."

Sano was astounded even though he knew the shogun was interested in supernatural phenomena and kept fortune-tellers, magicians, and cosmographers at court. The shogun had never before proposed using a medium in a murder investigation. And Sano had doubts that communication with the dead was possible even though many other folk besides the shogun believed it was.

He read the same skepticism on Lord Matsudaira's face. "Honorable Cousin," Lord Matsudaira began to protest.

The shogun raised a hand. "No objections! I have made my decision." He spoke to a guard: "Bring Lady Nyogo here."

As the guard hurried to obey, Hirata gave Sano a worried look. Sano shrugged, indicating that whatever happened now could hardly make things worse. Police Commissioner Hoshina and Captain Torai sank to their knees. Torai was watching Hoshina; he clearly wondered

how this new development would affect them. Hoshina seemed suspended between hope, expectancy, and apprehension. Lord Matsudaira looked thoroughly vexed.

"Nyogo is a lady-in-waiting in the Large Interior," the shogun explained. The Large Interior was the section of the palace where his wife, mother, and concubines lived.

The guard soon returned, bringing Lady Nyogo. Sano had expected a sinister old crone such as many mystics were, but Nyogo couldn't have been more than fourteen years of age. She had a round, smiling, innocent face. Her pink and orange floral kimono clothed a plump, childish body; she walked with a bouncy, skipping gait. Her long braid bobbed. She knelt and bowed.

"Lord Mori has died," the shogun told her. "We wish you to contact his spirit so that we may, ahh, speak with him. Can you conduct a séance for us?"

Her smile widened, showing teeth like pearls. "Yes, Your Excellency," she said in a girlish voice.

She seemed as happy as if invited to play a favorite game. Although Sano had been prepared to dislike her, he couldn't help but find her endearing.

Servants closed the shutters, darkening the room. They placed a table in front of Nyogo and lit candles and incense burners on it. Sano saw Lord Matsudaira mutter to himself, *Superstitious rot!* The shogun rubbed his hands together in eager anticipation. Nyogo bowed her head over her altar. The candle flames illuminated her smooth young face as the incense smoke filled the chamber with potent sweetness. She closed her eyes. Suspense hushed the assembly. Everyone watched Nyogo.

She uttered a piercing wail. Her head tossed; her body rocked violently. Her eyes opened; they rolled up, showing their whites.

"She's going into a trance!" the shogun exclaimed.

Nyogo rocked, gasped, and moaned. Then she went quiet and limp. Her head lolled. An eerie, droning sound came from her mouth. Spasms twitched her. The exposed whites of her eyes gleamed with

unholy radiance. Sano was impressed in spite of his skepticism. The shogun leaned toward Nyogo.

"Lord Mori, are you there?" he called. "Speak to us."

"Greetings, Your Excellency." The deep, masculine voice issued from Nyogo's mouth. Her lips didn't move; her throat seemed merely a channel for the words. "I am at your command in death as I was during my life."

Sano, Hirata, Lord Matsudaira, and Captain Torai stared in astonishment. The shogun nodded, satisfied. Hoshina sat motionless with that peculiar expression on his face.

"We wish to know who, ahh, murdered you," the shogun said. "Can you tell us what happened?"

9 *The Dead Man's Tale*

GENROKU YEAR 11, MONTH 5 (JUNE 1698)

Lord Mori sat in his office with his secretary, dictating let-
ters while enjoying the bright, peaceful day. A servant came to the
door and said, "Excuse me, but you have a visitor. It's an envoy from
Chamberlain Sano."

Anxiety beset Lord Mori. He was timid by nature, always nervous
around people he didn't know, and what could the chamberlain want
with him? He hastened to the reception chamber. There sat a beautiful
woman dressed in luxuriant, multicolored silk robes. Lord Mori
halted in surprise. He'd not expected the envoy to be female. This
was most unusual, most discomfiting.

"Who—what—" he stammered.

The woman bowed and smiled. "I am Lady Reiko, wife of Cham-
berlain Sano."

Lord Mori's surprise increased. Since when did any official send his
wife as an envoy?

Reiko seemed pleased by his reaction. She also seemed completely
sure of herself, perfectly at ease. Lord Mori realized he'd better pay
her some respect or offend Chamberlain Sano. He advanced cau-
tiously into the room.

"I am honored by your visit," he said. "May I ask why you've
come?"

"My husband and I thought I should make your acquaintance," Lady Reiko said. She gazed intently at Lord Mori. He felt that she could see his timidity, his shameful lack of samurai courage. He grew all the more nervous, but dimples wreathed her sly smile. "Please be seated." She gestured toward the space opposite her on the floor, as if this were her domain and he a supplicant.

Lord Mori meekly obeyed. Another, stronger man would have put this brazen woman in her place no matter that she was the chamberlain's wife, but he couldn't find the words. He merely shrank under her continued scrutiny. Her beauty seemed more malevolent than attractive.

"How are things in your provinces?" she asked.

"Very well." Lord Mori thought she resembled a snake with brilliant, jewel-like scales, weaving through the grass in search of someone to strike.

"Oh?" She raised her painted eyebrows. "I hear that you have been having financial troubles."

Lord Mori was too shocked to respond, but not only because finances weren't discussed in polite company and no well-bred woman would mention them. How did Lady Reiko know about his troubles? What was she up to?

"Your father squandered much of your family fortune," Reiko continued. "You inherited many big debts. To make matters worse, the harvest in your provinces has been poor for the past few years. You've been forced to borrow money and incur more debts to cover your expenses and pay your retainers."

She must have learned these shameful facts from her husband's spies. Lord Mori recalled that she was known to involve herself in Chamberlain Sano's business, but why was she here? Surely not just to embarrass him?

"I prefer not to talk about these things." Lord Mori meant to sound severe and silence Reiko, but his voice quavered.

Mischief sparkled in her eyes. "Well, perhaps you'd rather talk about how things are improving for you lately. Your alliance with Lord Matsudaira has certainly helped. I hear he's reduced the amount of

tribute that you pay the Tokugawa regime, and he's granted you loans from his personal treasury. You've become quite the man of status and privilege."

"Lord Matsudaira has been most generous," Lord Mori said, hot with shame that he didn't have the nerve to throw Lady Reiko out of his house. Helpless anger roiled inside him because she'd called to mind some less than admirable facts about him.

He belonged to a clan of proud, ancient heritage but unimpressive accomplishment. His ancestors had survived by allying with men who were stronger, braver, and more ambitious. Their one talent was the ability to pick the winner in a given conflict. Lord Mori had bet on Lord Matsudaira and contributed troops, arms, and money during the war, and Lord Matsudaira had won. Now Lord Mori's future depended on Lord Matsudaira.

"But you shouldn't count on Lord Matsudaira." Reiko said in a low, confidential tone, "His position isn't as strong as it was. He's alienated a lot of people, made many enemies. His need for power, and his fear of losing it, are driving him mad. His rule over the government is slipping."

"Those are just rumors." Lord Mori had heard them; they were all over Edo.

Reiko shook her head; she gave him a pitying look. "I'm afraid they're true: Lord Matsudaira is heading for a fall."

Terror seized Lord Mori. If Lord Matsudaira did lose power, what would happen to him?

"When he falls," Reiko said, "you and his other allies will go down, too. And it won't be long now."

"Merciful gods," Lord Mori exclaimed, unable to hide his dread of another war and his clan's destruction. "What am I to do?"

Reiko smiled. "Fortunately, I can help you. My husband has sent me here to make you a proposition." She beckoned Lord Mori to come closer.

Again he thought of a snake; he could almost hear its death-rattle as it undulated toward him. But he inched nearer to Reiko, unable to resist her. She whispered, "My husband is gaining more allies and

power every day. Soon he'll be in a position to challenge Lord Matsu-daira. He is mounting a secret campaign to take over the government. There will be great rewards for anyone who joins him."

Lord Mori recoiled in shock. "You're asking me to betray Lord Matsudaira! And you want me to help put your husband in control of the country!"

"It's to your advantage as well as ours," Reiko said.

"It's treason!"

She shrugged. "Call it what you please. But my husband will go ahead with his campaign with or without you. And he's going to suc-ceed. If you want security and prosperity, then you should consider his proposition."

"I swore my eternal loyalty to Lord Matsudaira," Lord Mori protested. "It's a matter of honor!"

Reiko's smile mocked him. "There are times when you must choose between honor and survival. This is one of them. If your posi-tions were reversed, Lord Matsudaira wouldn't hesitate to betray you. Don't be a fool."

Offended and furious, Lord Mori clambered to his feet, pointed a shaky finger at the door, and said, "Get out! Tell Chamberlain Sano that I'll never join forces with him!"

She rose, the mocking smile still on her face. "Oh, but you will. Because otherwise, he'll ruin you. And don't think that you can sit back and take the chance that Lord Matsudaira will fight a war against my husband and win. My husband will destroy all Lord Matsudaira's allies before a war ever starts. And you'll be the first to go."

Reiko moved so close to Lord Mori that he could see his frightened face reflected in her glittering eyes. "He'll strip you of your lands, confiscate your wealth. While you and your family starve to death, your honor will be small comfort."

She laughed and glided toward the door. The hem of her robe slithered along the tatami. She paused and turned. "I'll give you a few days to decide whether to join my husband or stand by Lord Matsu-daira. I trust that you'll have come to your senses by then." She added in a warning tone, "If you tell anyone what's been said between us, my

husband will rescind his offer, and you'd best prepare yourself to come under attack."

For the next few days, Lord Mori vacillated. He couldn't eat, sleep, or work, for fear that he would make the wrong decision. He'd never trusted his own judgment, and he wished someone would tell him whether Lord Matsudaira was really in danger and Lady Reiko and Chamberlain Sano could really make good on their threats. He felt utterly alone, helpless, and miserable.

His wife and son noticed his sorry state. On the third evening after Lady Reiko's visit, while they sat at dinner and he picked at his food, his wife said, "Something is wrong with you, Husband." Concern lined her gentle face. "Are you ill?"

"No." Lord Mori spoke gruffly and wouldn't meet her eyes.

"Then what's troubling you?"

"Nothing!" he shouted, his temper cracking under the strain. "Don't fuss over me!"

Enju said, "Father, we're so worried about you. We want to help. You must tell us what the problem is."

"I can't," Lord Mori said. But he'd never been able to keep secrets from these two people that he loved most in the world. He broke down and sobbed as he told them about Lady Reiko and Chamberlain Sano's proposition.

Their eyes glazed with horrified shock. Lord Mori felt even worse because he'd shifted his troubles to them, and what could they do? "Either I stand by Lord Matsudaira and we're ruined, or I break my vow, ally with Chamberlain Sano, and violate my honor. Whatever I do, I'm damned."

"You must uphold your honor," Lady Mori said although her voice was hushed by her fear of losing everything. "Tell Lady Reiko that you'll not turn on your master."

"Yes," Enju said bravely. "It's your duty as a samurai."

Lord Mori beheld his family through the tears that blurred his eyes.

"But Chamberlain Sano will punish you along with me. I can't let him hurt you."

"It's our duty to uphold your honor," Lady Mori said.

"Come what may," Enju said.

Their willingness to suffer for his sake moved Lord Mori to a fresh bout of weeping. They put their arms around him. The three of them embraced as they shared a vision of themselves and three centuries of Mori clan tradition crushed into dust.

"Merciful gods save us," Lord Mori whispered. "There must be some other way!"

During that sleepless night, inspiration came to Lord Mori. He saw how to remain true to his honor and thwart Chamberlain Sano without ill consequences. Hope bloomed amid despair.

The next evening he went to a rundown teahouse far from Edo Castle. He sat alone, clutching a cup of sake. In the dim, lamp-lit room, a few commoners drank and played cards with the proprietor; they ignored him. He peered anxiously outside at the street, visible beneath the curtains that hung across the entrance. Had anyone followed him here? Rain drizzled on the deserted neighborhood. Chamberlain Sano had spies everywhere. They could smell treachery as keenly as a dog scents blood. Lord Mori fidgeted and waited.

A samurai rode on horseback up the street. He dismounted outside the teahouse. As he entered, he shook raindrops off his cloak and removed his wicker hat. He glanced around the room, then knelt opposite Lord Mori.

"A fine night to be out," he said.

"Er, yes." Lord Mori had made discreet inquiries through a trusted friend, who'd arranged this meeting, but his nerves tensed tighter nonetheless. He studied his companion, a fellow of indeterminate age, nondescript appearance, and weary, bland expression. In a crowd, Lord Mori wouldn't have given him a second look. Perhaps that was an advantage for a spy in the *metsuke,* the government intelligence service.

The proprietor came over to them; the spy ordered sake. They drank. The card game grew noisy as the players shouted bets and exchanged good-natured insults. The spy said, "You have something to tell me?"

Lord Mori nodded, but hesitated. His heart raced; he trembled with apprehension. "First you must promise that no one will ever know we spoke. You must never tell anyone where you got the information that I am about to relate."

"Don't worry. Your secret is safe with me." The spy smiled. "This meeting never happened."

Reassured, Lord Mori described Lady Reiko's visit, proposition, and threats.

"That's very interesting." The spy looked impressed in spite of himself. Lord Mori sensed excitement under his blandness. "Many thanks for coming forward." He rose to go.

"Wait." Lord Mori clutched at his sleeve. "What are you going to do with my information? Will you pass it on to Lord Matsudaira?"

"Of course," said the spy.

"And he'll stop Chamberlain Sano from seizing power?" Lord Mori said eagerly.

"Yes, indeed."

"Will he do it before Chamberlain Sano can punish me for not agreeing to help him take over the country?"

The spy smiled. "Chamberlain Sano will be crushed like an insect before he makes a single move. Don't worry."

Lord Mori rushed home to tell his wife and son what had happened. They all celebrated.

"You've saved us!" Lady Mori wept for joy as she hugged him.

"Father, you're so clever," Enju said with admiration.

"Yes, I am, if I do say so myself," Lord Mori said proudly.

He'd never before felt such blissful relief. That night he slept well. In the morning he ate a good meal and caught up on work he'd neglected while fretting about Lady Reiko and Chamberlain Sano. He

looked forward to hearing the news that Lord Matsudaira had banished or executed them.

That night he'd retired to his private chambers, put on his dressing gown, and was ready to climb into bed, when he heard knocking at the door. He opened it and found Lady Reiko standing on the veranda.

"What are you doing here?" Although Lord Mori wasn't afraid of her anymore, he was surprised to see her.

She smiled her mischievous smile. "I told you I would come back." Rain saturated the air and dripped from the trees in the dark, sodden garden, but she looked as immaculately groomed and beautiful as ever. "And here I am."

"How did you get to my private chambers?" His guards shouldn't have let her come.

"Oh, I have ways of getting wherever I want to go," Lady Reiko said. "Aren't you going to invite me in?"

How arrogant she was! How her husband's power allowed her to impose on everybody! But soon she would learn her lesson. Lord Mori didn't have to put up with her rudeness anymore. "I was just about to go to bed." His first impulse was to throw her out of his estate, but then he thought what a pleasure it would be to watch her thinking she had him under her thumb, not knowing what lay in store for her.

"But we can have a drink first," Lord Mori said.

Brimming with vindictive glee, he led Reiko to his sitting room. He bustled around, setting out cups, fetching his best sake, enjoying himself while acting nervous. Let her think him desperate to placate her. As they knelt and drank, he could hardly contain his mirth.

"Toda Ikkyu sends you his regards," she said.

The name jolted Lord Mori. "Who?"

"Your friend the *metsuke* spy," Reiko said. "The one you met at the teahouse yesterday."

Lord Mori felt a chill creep into his bones. She knew about the meeting! He was too upset to pretend he didn't know what she meant, to deny any contact with Toda. "What—how . . . ?"

Reiko laughed. "You thought that if you reported my husband and

me to Toda, he would go to Lord Matsudaira, who would protect you from us. Well, the trick is on you. Toda brought your story straight to my husband. He's my husband's spy, not Lord Matsudaira's."

Such horror dawned on Lord Mori that the liquor he'd drunk curdled into bile in his stomach. He thought he would vomit.

Anger, contempt, and malicious humor glinted in Reiko's eyes. "You fool! You thought you could beat us. You should have joined us instead. But you've lost your chance. Now we know you can't be trusted. Now you'll pay."

Lord Mori shrank from her in terror. He looked around, expecting to see Chamberlain Sano's troops invading his estate. He tried to call his guards, but only a squeak came from his mouth. His throat felt choked up, swollen inside. His heart pounded so hard and loud that it felt like thunder reverberating through him. He realized he was suffering from more than just fright. Struck by panic, he lurched to his feet. Dizziness sent him reeling around the room. What was happening to him?

Reiko's laughter echoed strangely in his ears. Her image wavered before him. "I put poison in your cup," she said in a voice that sounded remote, distorted into an eerie drone. As he gasped and clutched his throat, she said, "But it won't kill you. I'll do the honors myself."

She rose and glided toward him. *No! Leave me alone!* Lord Mori tried to cry but couldn't. He staggered backward into his bedchamber. He collapsed with a thud that shook the floor. Reiko stood over him.

Help! His lips formed the soundless word.

Reiko grabbed his feet and dragged him onto his bed. He tried to resist, but his limbs were paralyzed. He felt the poison spreading a noxious lethargy through him. She untied his sash and opened his robe. His mind was the only part of him that remained alert, his eyes the only part he could move. Wide with terror, they tracked Reiko as she undressed herself. She flung her garments into a corner. She stood naked except for a dagger strapped to her arm.

"I don't want to get blood on my clothes," she said.

She drew the dagger and plunged it into his abdomen. Horrendous pain stabbed him. He uttered a muffled squeal. Blood spewed from

the wound, gurgled in his throat, splashed Reiko. She laughed at his suffering while she stabbed him again and again. Her beautiful, crazed face filled his vision as he swooned. She seized his genitals in her fist and lowered the blade to them.

Wild, helpless outrage thrashed inside Lord Mori. "You won't get away with this," he managed to whisper.

"Oh, yes, I will." Her voice echoed and intertwined with the throbbing of his wounds. "I'm married to Chamberlain Sano. He's invincible. No one can touch him. Or me."

The blade slashed.

10

A horrendous scream burst from the medium. Everyone in the shogun's audience chamber flinched. Lady Nyogo's childish face contorted as though from the pain Lord Mori had felt when the knife cut him. Her body jerked in convulsions; her head tossed. The exposed whites of her eyes bulged. The scream propelled saliva from her mouth. Sano started to interrupt, as he had many times during the séance, to protest the outrageous lies she'd told about Reiko and himself. But the shogun waved a hand, silencing Sano yet again.

"Oh, spirit of Lord Mori," the shogun said, "what happened next?"

Lady Nyogo twitched, groaned, and choked. Police Commissioner Hoshina and Captain Torai watched her, and Sano, with undisguised glee. Hirata looked as beset by apprehension as Sano felt. Lord Matsudaira fixed an ireful, ominous gaze on them. The medium's convulsions diminished; she sagged.

"I felt my heart pumping the blood from me." The deep, masculine voice was now weak, sorrowful. "I felt my life-force waning. The world dissolved into blackness before my eyes." She breathed slow, labored sips of air. "And then I died."

"What did Lady Reiko do?" the shogun asked eagerly.

"I didn't see." The voice faded. "My spirit drifted off into the cosmos. I can tell you no more."

"She's, ahh, coming out of her trance," the shogun said.

Nyogo's eyes closed; her face relaxed. She stirred, blinked, and stretched, as if awakening from a nap. Her innocent, puzzled gaze surveyed the men staring at her. "What happened?" She seemed to have forgotten. "Did I say anything?"

"Yes, indeed," Lord Matsudaira said grimly.

"You did very well," the shogun told her. "You may go now."

As she rose, Sano said, "Wait just a moment." Even though the séance had been impressive, he didn't believe that Lord Mori's spirit had spoken through her. He wasn't about to let her leave until he'd exposed her as a fraud.

Nyogo hesitated; she looked to the shogun.

Police Commissioner Hoshina said quickly, "Your Excellency, we're finished with the girl. We need to discuss the information she's given us. Let her go."

Sano doubted that Hoshina thought the medium was any more genuine than he did. But Hoshina had a vested interest in having everyone else believe her.

"Your Excellency, that séance was a hoax," Sano declared. "None of what Nyogo said happened. That wasn't the spirit of Lord Mori we heard. It was her pretending to be him."

"No, you are mistaken," the shogun said. "She's a genuine medium. I have, ahh, communicated with my ancestors through her on many an occasion." Stubbornness hardened his weak features. "I believe that what she said is the absolute truth. Shame on you for trying to discredit her."

Sano's heart sank because his protest had backfired and he'd angered the shogun, which he couldn't afford to do. Hoshina gleamed with malicious satisfaction.

The shogun said to Lady Nyogo, "You're dismissed." As the door closed behind her, he announced, "Well, ahh, now we know how Lord Mori died and who killed him."

Even while Sano opened his mouth to defend himself and Reiko against the medium's ridiculous accusations, and Hoshina made ready to counter him, the shogun said, "But I don't quite understand *why*." He turned to Lord Matsudaira. "What was all that business about a

war? Why would anyone plot to overthrow you? Why did Lord Mori think you rule Japan?"

Danger thickened the air. Nobody moved. Sano thought the shogun was at long last about to learn what was going on. Everyone waited in suspense for Lord Matsudaira's answer.

"I don't know, Honorable Cousin," Lord Matsudaira said smoothly. "Lord Mori was mistaken about the part of his tale that had to do with me."

"Oh." The shogun nodded as if he preferred this simple explanation to a more complicated, truthful, and disturbing one.

"Then he could also have been mistaken about the part that had to do with my wife and myself," Sano pointed out.

"Perhaps." Lord Matsudaira fixed a hostile stare on Sano. "But perhaps not."

Sano saw that even if Lord Matsudaira suspected the medium was a fraud, he was so insecure that he was ready to distrust Sano.

"Does this mean that not only did Lady Reiko kill Lord Mori, but Chamberlain Sano is plotting to take over the country from me?" Horror filled the shogun's expression.

Before the séance, Sano had thought things couldn't get worse; yet now he, as well as Reiko, had been implicated in the murder. "No, Your Excellency," he said with calm, controlled sincerity, "because she didn't and I'm not."

"He's lying," Hoshina rushed to say. "He's ambitious to seize power, and he sent his wife to do his dirty work for him."

"Chamberlain Sano has built up a huge personal army during the past few years," Torai said. "What is it for, if not to overthrow Your Excellency?"

The shogun looked at Sano with fearful loathing. "I thought you were my friend. How could you betray me like this?"

"I haven't," Sano insisted. "I maintain those troops to keep order and help me run the government for you."

Pushed further onto the defensive, he launched a counterattack at Hoshina: "A few moments ago you were all in favor of believing Lady

Mori's story about the murder. Now you've jumped onto the medium's story, which completely contradicts it. How can you justify that?"

Hoshina grinned. "I like the medium's story better."

That it incriminated Sano certainly benefited Hoshina's campaign against him. Sano said, "There's no evidence to support it."

"Indeed there is," Lord Matsudaira said with dark satisfaction. "Her version of Lord Mori fits the man I knew—a timid, weak soul."

"You may have known Lord Mori, but you weren't present at his murder," Sano reminded him. "You can't verify the critical part of the medium's tale."

"Well, then," the shogun said, eager to think that Sano had not betrayed him and he hadn't been a fool to trust Sano.

"There's enough truth to the medium's tale for us to be concerned about Chamberlain Sano's loyalty," Lord Matsudaira said. "We can't take the chance that he's planning to overthrow you. The Tokugawa regime has lasted ninety-five years because it's always been quick to crush any potential threat. I recommend that you put Chamberlain Sano and his wife to death."

"I agree," Hoshina said.

Captain Torai nodded. Hirata started to protest in Sano's defense. The shogun waved his hand, shushing Hirata. "All right," he said with a sad sigh. "I suppose I, ahh, have no choice. Chamberlain Sano, I hereby sentence you and your wife to death by, ahh, decapitation." He told the guards, "Take him and Lady Reiko."

The guards moved toward Sano. Victorious smiles lit Hoshina's and Torai's faces. Lord Matsudaira nodded, content that he'd eliminated a challenger. Hirata leapt to his feet.

"You can't do this!" he shouted, placing himself between Sano and the guards. "I won't let you!"

"Sit down!" Lord Matsudaira ordered.

Sano was less afraid of dying than furious at the injustice. The three years he'd labored to keep the Tokugawa regime running, to quench insurrections! The previous years he'd spent risking his life to catch criminals! According to the samurai code of honor, his masters

didn't owe him a thing for his services; but neither did he deserve to be killed on the strength of such baseless accusations. He rose, swelling with indignation, and pushed Hirata aside.

"All right," Sano shouted, "take me!" He spread his arms. As the guards seized them, he turned his fury on the shogun, "Execute me if you will. I'm ready to die at your pleasure. But who'll help you run the government when I'm gone?"

"Oh, dear. I hadn't thought of that." The shogun looked aghast at the prospect of managing national affairs by himself.

"I will," Hoshina said, almost salivating because the post of chamberlain was within his reach.

Sano said to Lord Matsudaira, "Whoever killed Lord Mori is still out there, free as a bird. Can you take the chance that he won't kill again? What if Lord Mori's murder was only the first of many? Can you risk another campaign of terror?"

The spirit of the assassin dubbed the Ghost seemed to poison the atmosphere. Indecision flickered in Lord Matsudaira's eyes. Fortunately Sano knew Lord Matsudaira and the shogun well enough to play upon their fears. He said, "History could repeat itself. I caught the Ghost for you. When I'm gone, who will catch the next renegade?"

He swept a scornful gaze over Hoshina. "Certainly not you. Remember that you let the Ghost kill five times before I stopped him." Hoshina and Torai glared. Sano turned back to Lord Matsudaira and the shogun. "If Lord Mori's death is part of a plot to seize power, then whoever is responsible will continue it after I'm dead and laugh at you for punishing the wrong man." He finished with a passion born of his outrage and his will to survive: "Killing me would be a ridiculous waste. You need me alive, to find out the truth about Lord Mori's murder and protect the regime."

There was silence while Hoshina opened his mouth to speak, Lord Matsudaira stopped him with a glance, and the shogun tried to figure out what Sano had said. Sano stood immobilized by the guards. Then Lord Matsudaira heaved a breath of resignation.

"All right," he said grudgingly. "Your Excellency, we must spare

Chamberlain Sano's life so that he can help us get to the bottom of this."

The shogun nodded, happy to have a decision made for him. Lord Matsudaira gestured for the guards to release Sano. Even as they did, Sano felt less relief than a sense that he stood on a narrow line between freedom and the funeral pyre.

"If you'll excuse me, I'll continue my investigation into the murder," he said.

Hoshina burst out, "But Chamberlain Sano and his wife are suspects. He can't be trusted to conduct a fair investigation!"

Lord Matsudaira bent a speculative, antagonistic look on Hoshina. "Everyone is a suspect. Come to think of it, I've noticed that Chamberlain Sano's personal army isn't the only one that's grown. How many troops do you command now? How ambitious are you?"

Hoshina subsided in dismay that Lord Matsudaira's distrust now included him. Captain Torai said anxiously, "But don't forget that Lady Reiko was caught at the scene. No matter what Chamberlain Sano says, she's the most likely culprit. We can't just let her loose as if nothing happened."

"I'll keep her under guard at home," Sano said quickly.

"Fine," the shogun said before Lord Matsudaira could speak. "Go. You're dismissed."

Sano bowed. "Thank you, Your Excellency."

"But if you fail to catch the killer—or if I find out that you and your wife are guilty—be assured that I'll show you no mercy," Lord Matsudaira warned Sano. He turned to Hirata. "Nor you either."

As Sano and Hirata walked out of the room, they passed Hoshina, who muttered, "Good luck, Chamberlain Sano. By the way, I hear that Lady Reiko is pregnant. It's too bad that when you're both executed, your new child will die, too."

真相

11

Sano returned to his compound with Hirata and their detectives. It was a warm, cloudy, dreary evening. Smoke from cooking fires hung in a pall over Edo Castle, which reeked of decay and brimming drains. A hush and pressure swelled the air, as if it were gathering breath for another storm. Sano received silent, respectful bows from the sentries stationed at the gates: Bad news traveled fast.

At the door of the mansion, Reiko greeted him. "What happened?" Her face was pale and wan, strained with anxiety.

"I'm glad to say that you won't be arrested for Lord Mori's murder," Sano said as he and Hirata removed their shoes and swords in the entryway.

Reiko looked relieved for an instant before she read on Sano's face that there was more to the story, and none of it good. "But . . . ?"

"Let's sit down," Sano said.

She allowed Sano and Hirata to escort her to the private chambers. Her steps were heavy, burdened by fear as well as her unborn child. As they knelt, Sano thought she'd never looked so small or vulnerable.

"The shogun has allowed you to stay home, in my custody, instead of going to jail." Sano wished he could shield her from the worst news, but he couldn't withhold it from her. "But Lord Matsudaira and

Police Commissioner Hoshina are too ready to accept that you killed Lord Mori."

"But I didn't! How can they even think it?" Reiko said, aghast. "Didn't you tell them what really happened?"

"I told them what you said, but unfortunately, there are other, conflicting versions of events."

As Sano related Lady Mori's story, Reiko crumpled, her eyes wide with shock, her hands over her mouth. She shook her head in disbelief until he was done. Then she dropped her hands and bunched them into fists.

"Lady Mori is lying!" Anger burned away her fright. "I never even met Lord Mori." Her distraught gaze searched Sano's face. "Surely you don't believe her instead of me. You can't think that I . . . ?"

"Of course not." Yet even as Sano spoke, his years as a detective pressured him to remain objective, to postpone judgment until he had more evidence, just as he would during any other case.

She must have sensed his reservations, for hurt crept across her gaze, like fissures through crystal. "Lady Mori didn't see me do any of those things with her husband because I didn't. I told you the truth this morning." She clasped her hands over her belly and spoke with passionate emphasis: "This is your child, not his."

Sano avoided thinking otherwise. He was disturbed that his ingrained habit of doubting the veracity of crime suspects hadn't gone away just because this one happened to be his wife. Even worse, he sensed Reiko hadn't told him everything.

"Can you think of any reason why Lady Mori would incriminate you?" he asked.

"No. I thought she thought I was her friend." Sudden inspiration altered Reiko's expression. "Unless she found out I was investigating her husband for kidnapping and murdering boys. But I don't see how she could have."

"She might have been aware of your private inquiries and assumed that whatever you were doing would be detrimental to her," Sano pointed out.

Reiko nodded unhappily. "For all the good my investigation did, I wish I'd never undertaken it. I'm sorry I did."

"So am I," Sano admitted, "but it's too late for that."

"We have other problems besides Lady Mori." Hirata sounded as if he were reluctant to bring them up but wanted to spare Sano from delivering more bad news. "She's not the only witness who testified against you."

"And I'm sorry to say that you're not the only one in trouble now." Sano described the séance.

Reiko reacted with a fit of laughter that verged on hysterics. "But that's an even bigger lie than Lady Mori's story! You know you never sent me to enlist Lord Mori in a secret campaign to take over the country, or to punish him for foiling you! That medium is a fraud. You're not plotting against Lord Matsudaira."

Yet as she spoke this last sentence, Sano heard a tinge of uncertainty in her voice; he saw a question in her eyes. He realized that now *she* had suspicions about *him*. Her experience with detective work had made her just as leery as he. And if he didn't know how she occupied herself while they were apart, neither did she know what he did.

"Of course I'm not," Sano said, appalled that today's events had shaken their trust in each other.

"We know you're loyal to the shogun," Hirata said.

But even while he stood up for Sano, doubt showed on his face. Sano was further troubled to see that Hirata didn't quite trust him now, either. They'd spent so much time going their separate ways that Hirata thought he'd changed for the worse.

"We'd better believe one another," Sano said grimly, "because if we don't, why should anyone else think we're telling the truth?"

They avoided eye contact, sharing the dismay that the murder case had driven a wedge between them at a time when they most needed the strength of unity.

"Police Commissioner Hoshina has done his best to convince Lord Matsudaira and the shogun we're lying," Hirata told Reiko. "So far they're leaning in that direction."

"What are we going to do?" Reiko's gaze beseeched Hirata and Sano.

"I've managed to persuade Lord Matsudaira and the shogun to let me investigate the murder," Sano said. "That's progress in our favor. But the only thing that will save us is the truth about the murder. We have to concentrate on figuring out what really happened."

Hirata said, "What really happened is that Lady Reiko was set up to look as if she killed Lord Mori, I was set up to find her, and you were set up to look like a traitor."

Sano nodded: That was credible to him, if not to his superiors.

"Who could be responsible for the whole thing?" Reiko said.

"Hoshina is the obvious suspect. But he's only one of many people who wouldn't mind for me to take a fall." Sano knew the danger of fixating on a single suspect, no matter how likely. "And even though I'm inclined to think that I'm the main target of this plot, it's possible I'm not. Have you made any enemies who would want to hurt you?"

Reiko pondered. "Maybe."

"Well, think of any names you can," Sano said.

"I'll have lots of time to think, since I'm supposed to stay home and I can't go outside," Reiko said. "I wish I could do something more to help you save us."

"Maybe you can," Sano said. "Is there anything else you've remembered about what happened at the Mori estate last night? Anything you didn't tell me this morning?"

"No. I've spent the day going over and over it all, but I can't remember anything else."

"If you do later, be sure to tell me." Sano tried to forget that suspects often withheld information that would compromise them. He tried to rely on his trust in his wife rather than his experiences that had taught him the worst about human nature. He said to Hirata, "We'd better start our inquiries."

"What do you want me to do first?" Hirata asked.

"Look for witnesses and evidence to verify that things happened the way my wife said." *Maybe Hirata will discover something she had omitted,* Sano thought.

"I'm on my way."

"Before you leave the castle, send a detective to check Enju's alibi." Sano had a vague hunch about the strange young man. "I'll work on refuting the statements against us. I think I'll start with our new friend the medium."

After Hirata left, Reiko leapt to her feet. "I can't believe this is happening!" She paced the room as if locked in a cage. "And it keeps getting worse by the moment."

"Don't fret. We have to stay calm," Sano said, although he felt as restless and harried as she did.

"Stay calm?" Reiko stared at him, incredulous. "How can I, when we're both headed to the execution ground for murder and treason?" Wringing her hands, she paced faster. "If they kill me, they'll kill the baby, too!"

The idea horrified Sano as much as it did her, and he remembered Hoshina's threat, but he said, "Getting upset won't help." He rose, put his arms around her, and held her still. "We haven't much time to solve the case, especially with Hoshina pushing Lord Matsudaira and the shogun to condemn us. We can't afford to waste energy or let negative thoughts distract us."

"Yes. You're right." Reiko breathed deeply in an effort to quiet herself.

Sano felt her shuddering. But she moved away and said, "You should go now."

"Will you be all right?"

"Yes," she said bravely.

"Everything is going to be fine," Sano said with more confidence than he felt.

Her anxious gaze held his. "Will you come home soon and tell me what's happening?"

"Yes," Sano said. "Don't worry."

12 The Exile's Tale

In the ocean far beyond Japan's southeastern coast rose the penal colony of Hachijo Island. A full moon that resembled a bleached white skull rode the night sky above the tiny island's two high, peaked volcanoes. Steep hillsides dense with semitropical vegetation sloped down to the coasts, where a ceaseless wind pounded waves against the rocky shoreline. Along a cove was a village of wooden huts with thatched roofs and gardens, surrounded by palm trees, windbreaks made of rocks, and tall grass overgrown with vines. Nearby, a small castle perched on a rise overlooking the sea. Its plaster walls shone white in the moonlight. A banner bearing the Tokugawa triple-hollyhock-leaf crest fluttered from a watch tower.

Inside the castle, the former chamberlain Yanagisawa was enjoying a banquet hosted by the governor of the island. Musicians played the flute, drum, and samisen for the guests. Women served wine and fresh-caught seafood. Charcoal braziers and glowing lanterns warmed the cool night. Talk and laughter drowned out the keening wind.

"Many thanks for your hospitality," Yanagisawa said, raising his wine cup to the governor.

"It's my honor to entertain you." The governor was a middle-aged samurai who'd spent most of his career supervising the exiles on Hachijo. He took pride in his friendship with Yanagisawa, the

shogun's onetime second-in-command. "I hope the refreshments aren't too poor compared to what you had in Edo."

"They're delicious." Yanagisawa appreciated the fresh, simple island fare, but he didn't plan to be eating it forever.

The governor smiled, pleased by Yanagisawa's compliment. "With Lord Matsudaira constantly sending new exiles to our island, food is in short supply. But I've saved the best for you and your men." He signaled the women to pour more wine for Yanagisawa's retainers, who were joking with island officials.

Although Yanagisawa was a prisoner just like all of Lord Matsudaira's other banished foes and the criminals exiled for treason, smuggling, assault, or murder, he enjoyed favorable treatment. The local officials were awed by him because he was the most important person they'd ever been sent. He acted charming and gracious; his handsomeness had helped him win them over. They vied with one another to be his best friend. He'd brought glamour to the quiet, primitive life of Hachijo. Soon he had the run of the place. Most of the women among the natives and exiles—and more than a few men—were in love with him. Yanagisawa and his men had gradually taken over the administration of the island.

This was just as Yanagisawa had planned before he left the mainland.

Now the governor's daughter, Emiko, knelt beside him, bearing a dish of raw oysters. Fifteen years old, lithe, and pretty, she gave Yanagisawa a seductive smile and said, "Please have some. They're aphrodisiacs, you know."

"Yes. I don't mind if I do." Yanagisawa smiled into her eyes as she fed him oysters.

The governor seemed pleased rather than disturbed by Yanagisawa's taking liberties with his daughter and the fact that she was Yanagisawa's mistress. Yanagisawa had recently dropped hints that he would soon be returning to Edo, to his former status as the most powerful politician in the regime. The island officials believed him even though he'd been sentenced to permanent exile. Anticipating that he would soon be able to grant favors such as postings in better locations,

they'd tried harder than ever to please Yanagisawa. They'd practically thrown their women at him.

He intended to take full advantage of their generosity.

Emiko served more wine to the governor and officials. Soon their eyelids drooped; they began yawning. One by one they fell into deep, snoring slumber. The only guests still awake were Yanagisawa and his ten men. He dismissed the serving women. The only one that remained was Emiko.

"Did I do well?" she asked eagerly.

"Very well indeed," Yanagisawa said.

The sleeping potion that he'd smuggled from the mainland, and Emiko had put in the wine at his behest, had done its job. The officials would sleep for hours, but he had no time to lose.

"Hurry," he said, rushing his men from the room. "I've waited three years to get off this damned island. Let's put as much distance between it and us as possible before anyone discovers we've escaped."

Emiko ran after them. "Wait! You promised that if I helped you, you'd take me with you!"

Yanagisawa didn't need her anymore. He hadn't planned to take her, or his wife and family; they would only be in the way. But he didn't have time to argue. "All right, come on."

Outside, they groped their way down stone steps carved into the cliff. The wind tore at them. The moon lit their way along paths between the rocks on the hillside. Below, the ocean roared; waves swirled up white foam. Yanagisawa's heart beat fast with urgency and exhilaration. Tonight marked his first step toward reclaiming his power.

They scrambled down the wooden landing ramp that sloped from the village to the sea, past small fishing boats drawn up for the night. At the end spread the dock. Tied to it were larger craft. One was the ship that had arrived eight days ago from the mainland, transporting new prisoners to Hachijo. It was a clumsy wooden tub with a single mast, a square sail, and a shallow draft. The crew had been waiting for fair weather, and they planned to embark on their return journey tomorrow. The ship was stocked with provisions, ready for the escape that Yanagisawa had been scheming.

Two of his men hurried to the ship and lowered its gangplank. The others found axes they'd hidden under the dock. They ran to the bigger fishing boats, leaped inside, and chopped holes in the bottoms. Yanagisawa wanted the officials stranded on the island until the next ship came in the fall. He didn't want anyone pursuing him or his escape reported to Lord Matsudaira before he'd had time to set his plans in motion.

As the boats sank, he and Emiko and his men rushed aboard the ship. His men pulled up the gangplank. When he'd chosen which retainers to accompany him into exile, he'd been careful to pick four experienced sailors. Now they cast off the ropes. They worked the rudder and sail, steering the ship through the treacherous currents that surrounded the island.

Yanagisawa stood on deck in the bow with Emiko. She chattered about the wonderful things they would do on the mainland. He gazed across the vast sea that rippled with silver moonlight. Cold, salty spray dashed him. Leaning into the wind, he laughed for sheer joy.

"I told you I would return!" he shouted at Edo, invisible in the distance. "Here I come!"

Twelve days passed. The ship made slow progress because of the sluggish wind. Yanagisawa grew impatient to reach his destination. "How much farther to land?" he asked the captain.

"We should be within sight by tomorrow."

But that night a storm blew up. Rain deluged the sea. Lightning seared the heavens; thunder boomed. Fierce wind blasted the ship, which pitched violently on waves as tall as its mast. While the sailors fought to hold it steady, the passengers huddled in the cabin. Furniture and baggage slid. Emiko clung to Yanagisawa as the ship rocked.

"We're going to die!" she screamed.

"No, we're not! Shut up!" After all his scheming, Yanagisawa didn't intend to be thwarted by bad weather.

A sudden, huge crash jarred the ship. Emiko screamed louder as it flung everyone against the wall. Yanagisawa thought lightning must

have struck. A sailor burst through the door, drenched to the skin, wading in water up to his knees.

"We've hit a reef! We're sinking!" he cried as the water filled the cabin. "Abandon ship! Get into the lifeboats!"

Yanagisawa led the rush out the door. On the flooded deck, barrels and nautical equipment floated. The sailors were struggling to untie the two small wooden boats. Rain lashed Yanagisawa. He could hardly see through it. Water swamped him. He cursed in fury. This couldn't be happening! How dare nature interfere with his plans!

A gigantic wave lifted the ship high up into the sky. Yanagisawa felt as though a monster had risen from the depths beneath him and raised him in its fist. Then the ship was falling, keeling over down the wave. Yanagisawa's screams joined the others he heard above the thunder.

He was plunged into the sea. Its cold, heaving blackness engulfed him, assailed him with waves that battered his body. He flailed, desperately trying to get his head above the salty water that stung his eyes, filled his nose and mouth. At last he broke through the surface. He gasped air that was barely distinguishable from sea because the rain drove at him so hard. Lightning illuminated the sky and ocean with its dazzling white veins. Yanagisawa saw the ship nearby, half sunken. Heads bobbed in the water amid debris. He heard Emiko crying. A broken plank floated toward him. He grabbed it and hung on.

The storm lasted the whole night. When dawn came and the sea calmed, Yanagisawa was still clinging to his plank. Weary, sore, and half-drowned, he hauled himself onto it. He looked around at the new day he'd lived to see. The sky was overcast, the ocean like rippling steel. The ship was gone; so was everyone else. Yanagisawa couldn't hear a sound except for the wind and waves. He was alone on the vast, awful sea.

He would have tried to swim for shore, but he couldn't see it. Yanagisawa didn't know how long he floated. As thirst parched him, he weakened, his consciousness faded, and he lost track of time. By day, the sun burned and blistered his skin. Night chilled him. Hunger

gnawed at his insides. He lay helpless, eyes closed, as the waves rocked him toward the realm of the dead. Only his will kept him alive.

Rhythmic splashing noises penetrated his stupor. Voices called. Yanagisawa opened his eyes. Sun and blue sky dazzled them. He saw a boat coming toward him across the water. It was a fishing boat manned by two peasants. Behind them Yanagisawa saw land in the distance. The tide must have carried him in.

The boat drew near. The fishermen hauled Yanagisawa into their boat. As they rowed him shoreward, he had barely enough wits to be grateful that he'd been rescued.

They took him to their village and laid him in a hut. Their women-folk poured water into him and slathered healing balm on his sunburn. Fever enflamed Yanagisawa. He suffered delirious nightmares of sea monsters, fires burning, and warring armies. The women forced bitter herb tea down his throat. Gradually the fever receded. One morning he awoke with a clear head. He was lying on a mattress in a room cluttered with fishing nets, pails, and kitchen utensils. Gulls screeched outside. Yanagisawa saw an old woman kneeling by the hearth.

"Where am I?" he said, his voice an almost inaudible croak.

The woman turned; a smile deepened the wrinkles in her face. "Good, you're awake. This is Matsuzaki Village."

That was on the Izu Peninsula, a knob of land that extended from Japan's southern coast, Yanagisawa recalled. "How long have I been here?"

"Seven days."

Yanagisawa was disturbed that so much precious time had passed. "Thank you for saving my life. I have to go now."

He pushed back the quilt and tried to sit up, but his muscles were too weak. The old woman said, "You must wait until you're stronger."

She fed him hearty fish stews, and day by day he recovered his health. The villagers asked him where he'd come from, who he was. He pretended he didn't know, he'd lost his memory. He didn't want the authorities to find out that their most notorious exile had returned. When he walked on the beach for exercise, he went after

dark in case Lord Matsudaira's spies should happen by. He let the hair grow on his crown and face. After a month, Yanagisawa was as fit as he'd ever been, but nobody he knew would recognize him. Dressed in worn clothes given him by the fishermen, he looked like one of them.

All he had left of his former wealth was a few gold coins smuggled to him after Lord Matsudaira had had him arrested. He'd smuggled them to Hachijo and carried them sewn into the hem of his robe. He gave the villagers one coin as payment for their kindness and some food for his journey. The rest he hoarded. He left the village in the third month of the year and made his slow, exhausting way on foot up the Izu Peninsula then along the main highway that led east toward Edo.

How he missed traveling on horseback, in high style! Now the other travelers took him for a beggar, which was the truth. His food ran out, and he subsisted on alms they gave him or scraps from garbage outside lodging houses. That he'd been reduced to scavenging like a stray dog! When he grew tired, he slept in the woods. Lord Matsudaira would pay for this!

After nearly a month he reached a temple north of Totsuka, a day's journey short of the capital. It was past sunset, the priests had retired, and the lush spring temple gardens were deserted. Doves cooed in the eaves. Yanagisawa trudged up to the abbot's residence, a villa landscaped with blossoming cherry trees. He knocked on the door. The abbot let him inside.

"Are you surprised to see me?" Yanagisawa said as he wolfed a meal of rice, vegetable soup, and tea.

"Not really," the abbot said. "The strong do survive." He was an ageless man who wore a saffron robe with a brocade stole. His shaved head was as round and shiny as a pearl. "How may I be of assistance?"

Yanagisawa had built this temple and supported the sect for ten years. The abbot owed him. "First I need a bath, some clean clothes, and a place to stay."

The abbot nodded. "You are welcome to the guest cottage as long as you wish."

"I also need news," Yanagisawa said. "What's the situation in Edo?"

"To make it brief," the abbot said, "Lord Matsudaira is holding his own. And Sano Ichirō has your job."

This was bad, but Yanagisawa intended to change it. "Will you send a message to Edo for me?"

"Of course." The abbot scrutinized Yanagisawa. "We must do something about your appearance. That's a good disguise, but you look like a tramp."

Yanagisawa agreed. "I have an idea for a better disguise."

The next morning he shaved his face and head. He donned a saffron robe and smiled at his reflection in the mirror. He looked the perfect priest. Then he relaxed in the cottage, waiting for his message to be sneaked into Edo Castle and a response to come. On his fourth evening at the temple, he was strolling in the garden when three samurai approached him. One was a beautiful young man, the others crabbed with old age.

"Excuse me, Your Honorable Holiness," the young man said, "I received a message saying that if I wanted important news about my father, I should come here."

He took a closer look at Yanagisawa, and his expression registered shock and disbelief. "Father!" he cried. "It's you! Did you send me that message?"

"Yes, Yoritomo." During his exile, Yanagisawa had often thought of his son but hadn't known how much he missed him until this moment. Now his heart filled with such warm, intense love that he actually trembled as he beheld his son, a twenty-four-year-old image of himself.

"Oh, Father, I'm so glad you're back!" Radiant with joy, Yoritomo fell to his knees before Yanagisawa and wept.

Tears stung Yanagisawa's own eyes. He raised Yoritomo up and they embraced fiercely. "Are you well, my son?" he said in a voice gruff with affection. He held Yoritomo at arm's length, the better to feast on the sight of him. "How has the shogun been treating you?"

"I'm fine. His Excellency is very kind." In three years Yoritomo had

become a full-fledged adult, but he retained his boyish air of inno-
cence. "I'm still his favorite companion."

Yoritomo was more than just a companion; he was the shogun's
lover. The shogun had had a long romantic liaison with Yanagisawa,
who'd parlayed his influence over the shogun into control over the
regime. Now Yoritomo held the same advantageous position. The
shogun's fondness had protected him after Lord Matsudaira had de-
feated Yanagisawa. Although Lord Matsudaira had exiled Yanagisawa's
family, Yoritomo remained in Edo because the shogun had insisted on
keeping him.

"I'm delighted to hear that you're still close to the shogun," Yanag-
isawa said.

He was even more relieved. Yoritomo represented his second
chance at gaining permanent power over Japan. Yoritomo had Toku-
gawa blood—from his mother, a relative of the shogun—and rumor
had said that he was heir apparent to the dictatorship. Yanagisawa had
started the rumor himself. He meant to make it a reality and rule Japan
through Yoritomo someday. But even though Yanagisawa would use
Yoritomo as he used everyone he could, his son was more than just a
tool. He'd never cared as much for anyone as he did Yoritomo. He had
three other sons, but Yoritomo was more than just his flesh and blood.

"I thought I'd never see you again!" Yoritomo exclaimed.

"So did we," said the old men.

Yanagisawa turned to Kato Kinhide and Ihara Eigoro, members of
the Council of Elders, Japan's supreme governing body and the
shogun's top advisers. His message had asked Yoritomo to bring them
along. They'd opposed Lord Matsudaira and supported Yanagisawa
during the war. They had survived the purges by latching onto Yorit-
omo, whose influence with the shogun protected them from Lord
Matsudaira. Now they looked as amazed to see Yanagisawa as if he'd
risen from the dead, and not especially pleased.

"What's the matter?" Yanagisawa said. "I thought you'd be glad I'm
back."

"Yes, of course we are," said Ihara. He was short and hunched,
simian in appearance. "This is just such a shock."

"How did you escape?" asked Kato, who had a broad face with leathery skin, like a mask with slits for eyes and mouth.

"Never mind that," Yanagisawa said. "I'm here to mount a new campaign against Lord Matsudaira." Once he got rid of Lord Matsudaira, he could inveigle his way back into the shogun's good graces. "We need to make plans."

Kato exchanged glances with Ihara, then said slowly, "This isn't a good time for such a campaign."

"Why not?" Yanagisawa said, disturbed by their lack of enthusiasm.

"The political climate has been unfavorable to you since you've been gone," Ihara said.

"What's happened to my other allies? Don't I have any left?" Yanagisawa controlled the fear that crept through him.

"There are still officials and *daimyo* who are partial to you," Kato said, "but Lord Matsudaira has them virtually under his thumb."

"What about my army?"

"Remnants of it are still fighting Lord Matsudaira," Ihara said, "but he's captured and executed many of your troops and driven the rest underground, scattered them across the country."

Yanagisawa heard the trickle of a water clock in the temple garden; it sounded like his hopes draining away. But he refused to be discouraged. "Well, then, I'll just have to build a new army. If you could talk to my old allies for me, persuade them to contribute some troops . . ." His voice trailed off as he saw Kato and Ihara shaking their heads.

"I'm sorry," Kato said.

"Do you mean you won't support me?" Yanagisawa demanded.

"We can't afford to," Ihara said bluntly.

Rage incensed Yanagisawa. "I put you on the Council of Elders. Without me, you'd both be minor officials in some backwater province. You owe me!"

"We paid off our debts when we risked our lives for you the first time around and barely escaped death," Ihara said.

"It's our duty to keep the peace, not embroil the country in more war," Kato said.

Which meant they were comfortable with the status quo; they didn't want to trouble themselves. The old cowards! Hurt and bitter, Yanagisawa said, "What am I supposed to do?"

"Be patient," Kato said. "Lie low for awhile."

"Wait for a time when you'll have a better chance of success," Ihara said.

That time would never come. The number of Yanagisawa's partisans would shrink as Lord Matsudaira persecuted them. The longer Yanagisawa remained absent from the political scene, the easier for people to forget him. Besides, Yoritomo was getting too old to hold the interest of the shogun, who preferred younger males. Yanagisawa would lose his chance to put Yoritomo at the head of the regime unless he made his comeback soon.

He hid his despair behind a cool, stoic expression. "Since we've nothing more to say, I'll bid you good night."

The elders bowed. Yoritomo told them, "You can start back toward Edo Castle. I'll catch up." After they'd left, he said, "Father, I'm sorry they disappointed you."

His sympathy moved Yanagisawa. "It's all right." The elders would pay for letting him down in his time of need. "There's more than one way for me to rise again."

"Is there anything I can do to help?" Yoritomo asked.

He'd always been a loyal, devoted son, eager to please. Yanagisawa smiled, heartened by his support. "Oh, yes, indeed." He put his arm around Yoritomo as they walked toward the gate. "Here's what we'll do." He whispered in Yoritomo's ear.

13

The medium had vanished.

"Where did she go?" Sano asked Madam Chizuru, the chief lady official of the Large Interior, the women's quarters of Edo Castle.

"I don't know," Madam Chizuru said. She was in her fifties, with a masculine build and a hint of whiskers on her upper lip. "Lady Nyogo wouldn't say."

They stood with Detectives Marume and Fukida in the corridor of the palace that led to the Large Interior. Two sentries guarded the heavy oak door, banded with iron and decorated with carved flowers, behind which lived the shogun's mother, wife, concubines, their attendants, and the palace's female servants. A loud babble of their voices, like twitters from caged birds, penetrated the door.

"When did she leave?" Sano asked, disturbed that the medium had fled before he could question her.

"About an hour ago," said Madam Chizuru.

Right after her fraudulent séance. "When do you expect her back?"

"Not soon. She took a trunk full of clothes."

"She intends to stay gone long enough to avoid you," Detective Marume commented to Sano.

"If I were her, I'd do the same," said Detective Fukida.

"Did anyone go with her?" Sano asked.

"Yes," Madam Chizuru said. "Four bearers and two porters to carry her palanquin and her trunk."

Such an unwieldy procession couldn't travel very far very fast. Determined to find out why the medium had incriminated him, Sano said to his detectives, "Let's catch them."

Speeding downhill through the wet passages, they found no sign of Nyogo. They stopped at the first checkpoint, whose guards told Sano, "Her escorts hurried her through as if wolves had been chasing them."

At the main gate, the sentries couldn't agree on which way Lady Nyogo had gone. Sano and the detectives stood beneath the gate's roof, while pouring rain hid Edo from their view.

"We'll send out search parties," Sano said. "Then we'll go back to the scene of the crime."

He hoped that they would find clues to implicate someone else besides Reiko, especially since the first step in his attempt to exonerate her had failed.

The Nihonbashi merchant district was deserted except for soldiers on patrol and civilian sentries at neighborhood gates. Although the rain had paused, the air was so humid that the clouded sky seemed to engulf the earth. Hirata and Detectives Inoue and Arai rode along winding streets where water dripped down the tile roofs, off balconies, and through drain spouts. Lanterns glowed weakly in a few windows, their reflections shimmering in puddles. Hirata turned a corner, and a lone pedestrian came walking toward him. The man appeared in and out of view as he passed through the lights from the windows then merged into the shadows between them. He limped on a lame right leg, leaned on a wooden staff. Hirata jumped off his horse and hurried to meet him.

"Ozuno!" he called, surprised and delighted to see his teacher. "You're here!"

"You have a habit of stating the obvious." The priest halted. He carried a wooden chest hung from a shoulder harness decorated with orange bobbles. He didn't look pleased to see Hirata.

Hirata was too glad to see Ozuno to care. "This is so convenient, that you're in town. Now we can continue my training."

Ozuno snorted. "Training isn't a matter of convenience. But if you're so eager for more lessons, then come with me. We have a lot of time to make up."

"I can't right now," Hirata said, abashed. "I'm in the middle of an investigation. How about tomorrow?"

Now Ozuno looked gravely disapproving. "The trouble with tomorrow is that it may never come."

"But my master is in danger, and I have to help him."

"You must choose between your training and your duties. I won't waste my effort on someone who merely dabbles in the martial arts instead of dedicating his life to them." Ozuno started to shuffle away.

"Wait!" Hirata hurried after him. "I can't quit my training."

"It wouldn't be much of a loss if you quit," Ozuno retorted as he kept walking. "You've been doing so poorly that I think I made a mistake accepting you as a pupil."

Hirata was desperate to cling to his dream of becoming a great fighter and the teacher upon whom it depended. Exercising the authority that his rank conferred upon him, he grabbed Ozuno and commanded, "I forbid you to go! I order you to come live in my house and train me when my schedule permits!"

They stood in a blur of light that filtered through a window. Ozuno's expression was fierce. "Take your hand off me," he said in a voice quiet yet terrible.

Through his body thundered a blast of energy. It struck Hirata. He snatched his hand away and stepped backward as Ozuno's shield pulsated waves of power at him. His fingers smarted, as if burned.

"You would arrest your teacher, hold him captive, and force him to train you against your will?" Ozuno said, his voice now laced with incredulity. "Merciful gods, there's no end to your pigheadedness!"

"Forgive me," Hirata said, anxious to placate Ozuno, regretting his own behavior. "A thousand apologies!"

"A single 'farewell' would be more to my taste." Ozuno stomped down the wet street.

Hirata followed, horrified by the turn of events. "Do you mean it's over? Just like that, after three years?"

"Three years are even more precious to an old man than to a young one. I shan't waste more of my time on you because unless you change radically, you'll never succeed at *dim-mak*."

"Please give me another chance," Hirata begged.

"Life is full of chances," Ozuno said, limping faster, pounding his staff on the ground. "If by some miracle you make a major breakthrough, I'll take up your training again."

Hirata halted in defeat. "But where are you going?" he called to Ozuno's receding figure. "Where will I find you?"

"Don't worry," Ozuno called over his shoulder as he disappeared through a neighborhood gate. "Should you ever be ready for another try, I'll find you."

Hirata and his men arrived in a rundown neighborhood crisscrossed by a malodorous canals. Voices quarreled inside the tenements whose thatched roofs sagged under the weight of the rain. A peasant emptied a bucket of slops into a street already mired in floodwater and sewage. Sullen men and boys loitered, smoking pipes and drinking cheap sake, on plank sidewalks above the filth. The desolate scene matched Hirata's mood. He consoled himself with the thought that since his martial arts training had been suspended, at least he could focus on getting Sano and Reiko out of trouble.

This was where their trouble had started.

He dismounted outside the Persimmon Teahouse. A lantern within splashed light through the wet, tattered blue curtains. He and Inoue and Arai entered. The proprietor lounged glumly beside his sake jars; a man dozed, his head pillowed on a wooden drum; three women sat bickering together. When they saw Hirata's party, they perked up.

"Welcome," said the proprietor. "How about a drink?"

Hirata and his men accepted. The proprietor served them sake, then nudged the sleeping drummer. "Wake up! Entertain our guests."

The women got to their feet, preparing to dance. Hirata said, "Never mind, thank you. I've come to talk to Lily. Is she here?"

"Lily?" The proprietor frowned. "There's no one here by that name."

Hirata looked at the dancers and drummer, who shook their heads. "I was told that Lily worked in this teahouse."

"Whoever told you was mistaken."

"She was a dancer here three months ago."

"I'm sorry, but I've never had anyone called Lily," the proprietor said.

Hirata stepped outside for a moment, looked at the insignia printed on the curtains, then said, "This is the Persimmon Teahouse, isn't it?"

"Yes. But maybe you're looking for another place with the same name in a different neighborhood. Maybe this woman Lily works there."

Hirata didn't think so. The directions he'd obtained from Reiko before leaving Edo Castle had been clear enough, and this place fit her description. Now he was disturbed that it seemed Lily didn't exist, but not really surprised. The fact that he wasn't surprised caused him even more distress.

All along he'd had private doubts about Reiko's story. The idea that she'd gone to the Mori estate to look for a stolen child, then ended up naked and unconscious at the scene of Lord Mori's murder through no fault of her own seemed far-fetched even for a woman as extraordinary as Reiko.

During his years as a police officer, Hirata had heard some mighty creative excuses from wrongdoers trying to slither their way around the law. He couldn't help wondering if Reiko's case was an example. His friendship with her urged him to deny that she was as guilty as she appeared, but his police instincts warned him against falling for a trick by a murder suspect who was far more intelligent than the average street criminal. Hirata felt torn between his wish to believe and protect Reiko and his reluctance to be a dupe and let a possible murderess thwart justice.

"Lily is about forty years old. She has a little boy named Jiro," he

said to the proprietor, dancers, and drummer. "Does that jog your memory?"

"No, master," they said.

"The boy was stolen. Lily wrote to Lady Reiko, asking for help. Lady Reiko came here to see her. Do you remember?"

Again, a chorus of denials.

"I'll ask you one more time," Hirata said. "Are you sure you don't know Lily?"

"We're sure," the proprietor said.

As the dancers nodded, Hirata surveyed them closely. They were all too young to be Lily. They looked nervous, but he couldn't tell if it was because they were hiding something or from fear of the authority that he represented. His mind buzzed with warning signals that someone wasn't playing straight with him, but he didn't know who it was.

"Come on, let's go," he told his detectives.

Outside, Arai said, "Those people could be lying."

"But why would they?" Inoue said.

Hirata shook his head, at a loss for a good reason. He could see his distrust of Reiko in his men's faces, although they didn't voice it because they knew his deep-seated loyalty to her as well as Sano. He stifled the thought that he didn't know them as well as he once did. Had both their characters been corrupted by power?

"We have to find Lily," he said. "She's the best witness who can confirm Lady Reiko's statement."

He marched down the street, stopped at the first door he came to, and knocked until it was opened by a man wearing a nightshirt and accompanied by a wife carrying a lamp. They blinked drowsily at Hirata.

"I'm looking for a woman named Lily," Hirata said. "Do you know her?"

"No," the man said, and shut the door.

At the next two houses Hirata got the same response. At the fourth house an elderly man answered and Hirata said, "Where's the headman of this neighborhood?"

"That's me."

"Show me your record of everybody who lives here."

The headman complied. The ledger that contained the neighborhood census of names, family relationships, occupations, and addresses showed no Lily or Jiro listed.

"Something is fishy, but maybe not here," Arai said, hinting that it was Reiko's story.

By this time Hirata was anxious to find out the truth and silence the voice in his head that said Reiko had sent him on a wild goose chase. "I want everyone from every house out in the street."

He and Arai and Inoue pounded on doors, yelling orders. Soon they had a crowd of frightened people lined up outside their homes. Hirata told them, "I'm looking for a widow named Lily, who's the mother of a boy named Jiro. Anyone who knows her whereabouts, step forward."

Nobody did. Hirata walked up and down the lines, studying the women, as stronger doubts about Reiko nagged at him despite his tendency to take her word over that of strangers. Planting himself in the center of the road, he announced, "Tell me where Lily is, or somebody will get hurt."

They cowered in speechless fright. Hirata pulled an elderly, white-haired man out of the line and flung him at the detectives, who caught him. "I'll count to ten, and if you don't answer, we'll beat him up. One . . . two . . ."

A younger man hurried forward, fell to his knees before Hirata, and cried, "Please don't hurt my father!"

"Tell me, or else," Hirata said even though he'd often deplored the police's harsh treatment of helpless commoners.

"But I don't know! I swear!"

A little girl began sobbing. "Grandpa, Grandpa!" she wailed, reaching her arms toward the terrified old man while her mother tried to shush her.

Inoue and Arai looked to Hirata for instructions. Standard police procedure called for him to administer the beating he'd promised, then move on to another victim until someone talked. But the little girl reminded Hirata of his daughter. He had no stomach for violent

coercion tonight, especially since he wasn't sure that it would produce the desired result.

Maybe Lily had set Reiko up, enlisted everyone in the neighborhood in a conspiracy of silence, then disappeared. But how much easier for Reiko to invent Lily and Jiro from thin air. Hirata felt his precious comradeship with Sano and Reiko disintegrating. His new position and his martial arts training had weakened his ties with them. Would this investigation sever them for good?

In the meantime, he couldn't justify beating up an old man. "Let him go," he told the detectives.

They obeyed. The old man staggered into the embrace of his family. The other residents gazed at Hirata, fearful that he would turn on them. He said, "I'll be back. If you do know where Lily is, next time I ask you'd better tell me, or I'll throw you all in jail."

He and Inoue and Arai mounted their horses and rode away. Inoue said, "What will Chamberlain Sano say about this?"

"He won't thank us for digging his wife's grave deeper," Hirata said. "We'd better search the surrounding neighborhoods for Lily." He added under his breath, "And pray that we find witnesses to verify that things happened the way Lady Reiko said."

真相

14

"Mama, are you awake?"

Reiko's eyes snapped open at the sound of her son's voice. She was curled up in bed, her fingers gripping the sheet that covered her, every muscle tense. Masahiro hovered at the door. Dull, silver light penetrated the windows. The room looked the same as always, the table, floor cushions, and cabinets in their usual places. But Reiko perceived a difference in the atmosphere, as though the world had changed subtly but catastrophically while she'd slept.

An image of Lord Mori's mutilated, blood-drenched corpse assailed her mind.

Reiko moaned and rolled onto her back, rubbing her eyes, wishing in vain that the murder had been a nightmare that wakening could dispel.

Masahiro hurried to kneel beside her. "Are you all right? Aren't you going to get up?"

"Yes, I'm fine," Reiko said, not wanting to worry him.

She eased her swollen body upright. Her muscles ached as if she'd lain in the same, rigid position all night. Her mouth was sour and dry, her stomach queasy. When she'd gone to bed, she'd thought she wouldn't be able to fall asleep, but exhaustion had plunged her into a long, deep slumber. Now it must be late morning. She could hear the

servants bustling, sweeping, and chattering throughout the mansion. What had happened while she slept?

"I heard the maids say that some man was stabbed yesterday," Masahiro said anxiously. "People think you killed him. You didn't, did you?"

"Of course not." Reiko was dismayed that he knew about the murder and her involvement in it. Yesterday Sano had given orders that no one in their household should tell Masahiro, but this obviously hadn't kept the servants from talking among themselves or Masahiro from eavesdropping. "There's been a mistake. Don't pay any attention to them."

He nodded, reassured. Reiko experienced a sudden, frightening sensation that they were speeding apart, the distance between them widening into infinity. If she were found guilty of the murder, she would never see him again in this world. She felt an urge to scream and claw wildly at the air in a desperate attempt to reach Masahiro.

Instead she said, "Come here. Give Mama a hug."

He crawled into her lap and put his arms around her. She embraced him while her tears dropped onto his shiny black hair. "Mama, you're squeezing me too tight," he said, wriggling free.

Reiko dried her eyes on her sleeve. "Is Papa home?"

"No."

She hoped he was finding evidence that would prove her innocent. "I'll get dressed, then we'll have something good to eat," she said with false cheer.

After she'd put on a silk kimono, styled her hair, and applied her makeup as on any normal day, she told the maids to wipe the puddles off the veranda so that she and Masahiro could sit there. While she sipped tea and rice gruel, he played with his food and chattered. She gazed out at the garden. A low spot in the grass was flooded; insects swarmed. Although the compound was vast, she felt closed in, trapped. She was glad Sano had kept her out of jail, but she wanted to help herself instead of waiting while others determined her fate.

"Masahiro," she said, "go fetch Lieutenant Asukai."

While her son ran off to obey, Reiko wandered through the garden, too agitated to sit quietly. The secret she'd kept from Sano nee-

dled her conscience. She knew that he suspected she hadn't told him everything yesterday. Although she hated being less than honest with her husband, she feared revealing that she wasn't sure that the story she'd told him was true.

She didn't know whether she was innocent and wrongly accused or as guilty as she looked.

Yesterday she'd described to Sano the events as she recalled them, but her mental images of them had seemed flat and sketchy, no more lifelike than scenes from a book she'd read. Her memory, usually so vivid and reliable, seemed to be disintegrating. The more time passed, the hazier her recollections grew. Now she couldn't even form a clear picture of Lily's face. Ominous fear rippled through Reiko. Was she losing her mind?

Most frightening of all was that blank, lost space of time at the Mori estate. What had happened to her then? And how had she gotten to that awful point—the only part of her story she knew to be true—when she was kneeling naked and covered with blood beside Lord Mori's mutilated corpse? Hirata and other people had witnessed that. Everything that she thought had taken place beforehand was uncertain. And while she didn't believe she was capable of murder, she couldn't be sure.

Did I kill Lord Mori, then forget?

Did something happen between us that I've concealed from myself as well as my husband?

Feeling dizzy and ill, Reiko leaned on a tree for support . . . and suddenly found herself seated in a roofed pavilion across the garden. Bewilderment, then panic, struck her.

She had no idea how she'd gotten there.

A few moments—or many—had disappeared from her awareness.

Reiko inhaled deep, shaky breaths. Her stomach muscles were clamped tight around the baby, and she tried to calm down for its sake. She fought the fear that she was going mad. While Sano tried to prove her innocence, she must refute her suspicions about herself.

Lieutenant Asukai came striding down the path toward her. Reiko sat up straight and donned a false, serene expression as he joined her in the pavilion.

"How are you?" he said, beholding her with sympathy.

"I'm better today," she said.

Doubt showed on his face. "Is there anything I can do to help?"

"As a matter of fact, there is. My husband has asked me to think who might have a grudge against me." Reiko hadn't been so rattled by her harrowing experience, or her secret suspicions about herself, that she'd neglected this important charge. "I've come up with a possibility—the Black Lotus sect."

Almost five years ago, she'd helped to expose the crimes of the evil sect and slain its leader. The sect had been disbanded and out-lawed but had proliferated underground, and its members had sworn revenge on her.

"It has followers everywhere," Reiko said, "maybe even in Lord Mori's estate. Maybe one of them killed him and framed me. I need you to ask around town and try to find out."

"I can do that." Lieutenant Asukai seemed pleased to have a part in the investigation as well as a chance to serve her.

"Take my other guards to help you," Reiko said.

"All right." He poised on the verge of departure. "Is there anything else?"

Reiko had to ask whether his memory of events matched her own, even though she didn't want him to think she was going crazy. "Do you remember taking me to the Persimmon Teahouse to meet Lily?" she said in a cautious, halting tone. "Do you remember how I spied on Lord Mori's estate from the fire-watch tower and went to visit Lady Mori so that I could look for the stolen boy named Jiro?"

Lieutenant Asukai regarded her with puzzlement and concern. He hesitated a moment before he said firmly, "Yes. Of course I do. And so do the other men in your retinue. That's what we'll tell anyone who asks us."

His response didn't ease Reiko's doubts a bit. Loyalty had its disad-vantages. She couldn't tell if he did indeed recall helping her with her investigation or if he was claiming he did because she needed him to substantiate her story. He would back her up if she'd said she'd flown to the moon. He would make her other attendants stand by her, too.

Furthermore, he couldn't verify what had happened during her visits to the Mori estate or on the night of the murder. He hadn't been with her; neither had her other men. She wondered if he and they had suspicions that she'd killed Lord Mori, but she was afraid to ask.

"Thank you," was all she could say.

After the lieutenant had gone, she sat twisting her hands in anxiety. More than ever she wished she'd never taken on the search for Lily's stolen child, the little good she'd done. But there was no use wasting time on regret or indulging her fear that she was a murderess. She had to discover the truth. And the truth lay in those lost hours.

First she must calm her mind, the better for buried memories to surface. Reiko positioned herself with her buttocks resting between her heels, her back erect but not rigid, her chin tucked inward, and her hands palms up with the left atop the right. She lowered her eyelids but didn't close them. She rocked back, forth, and sideways until her body was balanced, then sat still. Breathing slowly and deeply through her nose, she let thoughts and emotions go by like clouds drifting in a blue sky. Tranquility slowed her pulse, and she floated up to a higher state of consciousness.

Now Reiko cast her spirit back to that night at the Mori estate. She pictured herself kneeling on the veranda of the private quarters. The gray day and her familiar home surroundings vanished. Immersed in darkness, she heard water dripping and distant voices in the night. She inhabited the self that peered through the hole she'd cut in the window.

Inside the room, Lord Mori lay in his bed, alone. His chamber was a hazy blur of light and shadow. Eyes closed, he breathed heavily in slumber. He rolled over on his side, his eyes blinked open, and he looked straight at Reiko.

"Who are you?" he said, drowsy and confused. "What are you doing here?"

Reiko turned away from the spy-hole. She stood, then whirled into unconsciousness, floated blind in its black oblivion. Moments or hours passed until her vision returned in a sudden splash of light. Around her spun lanterns and walls. She was inside Lord Mori's chamber. Distorted voices and shrill laughter echoed. Blackness immersed her again. Then another splash of light struck her

and revealed Lord Mori. He was naked, crawling and dragging himself away
from her. His eyes were filled with terror.

"No!" he cried. "I beg you! Stop!"

Cuts on his torso spilled blood, which his hands and knees smeared on the floor
as he struggled and wept. "Please!" The chamber reeled around him and Reiko,
blurring the lanterns. Hysterical giggles drowned out his sobs. "Have mercy!"

Reiko screamed.

The sound broke her trance. She snapped back to the present with
disconcerting abruptness. She gasped as she found herself at home.
Rain pattered on the garden. Her heart pounded so fast that she thought
it would explode. Reiko put her head down on her knees while shivers
wracked her, cold sweat bathed her body, and the memories she'd
dredged up from her unconsciousness filled her with horror.

There had been no dead boy in Lord Mori's room.

Lord Mori had seen her, spoken to her.

She'd been with him, alert not unconscious, while he bled from
his wounds and pleaded for his life.

These memories couldn't be true! Yet they'd felt so much more real
than those she'd related to Sano. A dreadful instinct told Reiko that
those things had happened. The new memories prevailed over her ear-
lier ones, like the sun outshining candle flames. What had she done that
was so terrible that she would have invented a delusion to replace it?

Against her will, her mind conjured up answers: *Instead of just spy-*
ing on Lord Mori, I confronted him. I asked him what had become of Lily's son,
accused him of stealing Jiro. He bragged that he'd killed Jiro and mocked my at-
tempt to hold him responsible. I was so angry, I took justice into my own hands.

"No!"

The fervent denial burst from Reiko even as she saw herself draw-
ing her dagger on Lord Mori. She clutched her head. "I didn't kill
him. I couldn't have," she whispered, frantic to convince herself. "I
would never!"

Yet she felt direly uncertain of that. If she couldn't trust her mem-
ory, how could she trust her belief that her honor would have pre-
vented her from killing an unarmed, helpless man no matter what

he'd done? And if there had been no dead boy, what else in her story might not be real?

How about Lily and Jiro? Had she invented them? Reiko was terrified not only because she might have committed murder. Her mind, which she'd always valued as her most important, dependable attribute, had betrayed her. And if Lily and Jiro didn't exist, then why had she gone to the Mori estate?

Reiko thought of Lady Mori. Could there be any truth to the woman's allegation that she and Lord Mori had been lovers? Nausea rose, sour and choking, in her throat.

"I couldn't have! I would never!" she repeated, as if saying it would make it so.

But her suspicion of her guilt burgeoned even larger. With it came the knowledge that she couldn't tell Sano about it. Now an awful new thought surfaced in her. If she could be a murderess, then Sano could be guilty of plotting treason. If she couldn't be sure of herself, then how could she be sure of anyone else, even her trusted, beloved husband?

15

"Has anything been found yet?" Sano asked.

He was standing inside a walled compound within the Mori estate. Here, a large, fireproof storehouse with plaster walls and ironclad doors comprised the estate's arsenal, which was headquarters for the search for the weapons Hirata had seen delivered to the estate. One of Sano's soldiers stood guard.

"Nothing unusual." The soldier opened the arsenal door, revealing the large stash of swords, daggers, spears, and lances that were standard equipment at any *daimyo*'s estate.

"No guns?"

"Just those."

The soldier pointed to nine arquebuses laid atop an iron chest. Sano went in the storehouse and examined them. Their stocks were inlaid with gold designs, their steel barrels oiled to prevent rust.

Lord Mori's chief retainer appeared in the doorway. "Those guns are heirlooms. They've been in the family for more than a hundred years." Akera sounded irritated by Sano's investigation and glad that it wasn't going well. "Don't expect anyone to believe they're proof that my master was plotting a rebellion."

Sano didn't. Brushing past Akera, he said to his soldier, "Continue the search. It's not to stop until this whole place is turned inside out."

Yet his men and Hirata's had been combing the estate all day yesterday and all last night. Now the morning sun was a pale, watery streak in a sky massed with clouds. Sano was losing hope that Lord Mori had been plotting treason; maybe politics had nothing to do with the murder. Sano also began to think that Hirata had been mistaken about the delivery he'd seen, because his detective skills had slipped since he'd begun his mystic martial arts training. Sano wondered how good a job Hirata would do on proving Reiko's story. Yet Sano's own inquiries weren't going well at all.

He and Detectives Marume and Fukida had spent the whole night interviewing the Mori clan members, retainers, and servants. After learning nothing that would help Reiko, he'd left his men still at it while he went to check on other aspects of the investigation. Now, as he exited the arsenal, the detectives joined him.

"Have you found any witnesses or suspects?" he asked them.

They shook their heads. Fukida said, "No one I talked to admits to being inside the private quarters when Lord Mori died. Apparently no one saw or heard anything. Most of them claimed they were asleep in bed. The only ones up were guards on duty. And they all have partners to vouch for them."

"Same here," Marume said. "I take it that you didn't have any luck, either?"

"None except bad," Sano said. "Lady Mori's attendants swear by her story that my wife was having an affair with Lord Mori. They claim they saw him and Reiko together."

"What about Lady Mori herself? Is she sticking to her story?" Marume asked.

"I haven't been able to talk to her again. Her doctor gave her a sedative potion last night, and she's still asleep." Frustration and weariness almost overwhelmed Sano. "I'm sure that many of these people know plenty about Lord Mori and his murder, but they aren't talking. It could be they've been ordered to keep quiet."

"We may need to use stronger interrogation techniques on them," Fukida said.

Torturing witnesses didn't appeal to Sano even though it was not

only legal but a standard police tactic. Innocent people could be hurt, false confessions produced. He would do it if he must to save Reiko's life and his own, but not until he'd exhausted all possible alternatives.

"They may be covering for themselves as well as trying to frame your wife," Marume reminded Sano, "because if she didn't kill Lord Mori, then who could have, except someone in this estate?"

"Someone from outside?" Fukida suggested.

"There's no evidence that any other visitors were in the estate that night," Marume said. "I interviewed the guard captain, and according to him, there weren't."

"According to him," Sano emphasized.

"An assassin could have broken into the estate," Fukida said.

"Then again, the idea that someone not only broke into the estate and killed Lord Mori but framed my wife for the murder seems far-fetched," Sano said. "Police Commissioner Hoshina is my favorite suspect, but could he have managed that?"

"Maybe with help on the inside," Marume said.

Sano and the detectives compared notes. But nobody they'd questioned seemed to have any personal connection with Hoshina. The guards knew him by sight only because he'd visited Lord Mori once or twice. Hoshina had no apparent motive for killing one of Lord Matsudaira's allies except to strike at Sano through Reiko. There was no evidence yet that Hoshina had known Reiko would be in the estate, conveniently at hand to frame for murder that night. Despair bred within Sano.

But he said, "Let's check on the search for the boy that my wife came here to find, and the one she saw Lord Mori kill." He stifled the thought that Reiko had invented them in an attempt to cover up what had really happened. He wished he could shut off the part of his mind that insisted on doubting a suspect whose story didn't jibe with the evidence.

He and Marume and Fukida went to Lord Mori's private quarters. Servants were busy neatening the rooms, putting away items that Sano's troops had removed from cabinets during their search, shelving ledgers and stacking papers in Lord Mori's office. One of the troops stood guard inside.

"Any sign of the boys?" Sano asked.

The man shook his head. "The only children in the estate are ones who belong to Lord Mori's relatives."

One of Sano's soldiers came hurrying across the garden toward him. "Honorable Chamberlain! I think we've found something!"

"What is it?"

"A patch of dirt that looks like a big hole was recently dug and filled in."

"Show me," Sano ordered.

The soldier led him and the detectives to a grove of pine trees surrounding a privy, a small wooden shed attached by a covered corridor to the wing of the mansion that housed reception rooms. Sano and company walked under boughs that fragmented the dim gray sky above and sprinkled water on them. The sweet, medicinal smell of resin didn't quite mask the stench of urine and excrement. Pine needles blanketed the sparse grass, except for a spot where another of Sano's troops stood. Here the needles had been scraped away around an area of freshly turned earth some three paces square.

"My partner went to find a shovel," the soldier said.

While they waited, Sano observed that the site was a good spot to bury a corpse. The reception rooms would be deserted at night, the privy unused. Restless with anticipation and impatience, he paced around the site. He noticed two people hovering nearby. They were Lady Mori and her son, Enju. Just the people Sano wanted to see.

He strode over to them. They bowed in greeting. Lady Mori appeared dazed. Her hair had been cut short, just below her ears, since yesterday. This was the custom for widows who'd sworn never to remarry. She wore an expensive lilac kimono, but the collar of her white under-robe was crooked and her sash carelessly knotted as if she'd dressed in haste. Her eyes were bleary from sleep and tears, her face swollen. In contrast, Enju was sleekly groomed, his expression alert.

"I'm glad you're up," Sano said to Lady Mori. "We can finish our discussion that was interrupted last night."

Lady Mori sighed as if it was the last thing in the world she wanted, but she nodded. "Very well."

"May I ask what is the meaning of this?" Enju said, glancing through the trees toward Sano's men gathered around the plot of earth.

Here was the perfect entry to the topic Sano wanted to discuss. "We're about to dig up one of Lord Mori's secrets." Sano wondered why mother and son had come out to see what he was up to. People suspected of murder did tend to take an interest in the investigations, especially when they were guilty and eager to learn how close he was to catching them.

Lady Mori regarded Sano through a fog of sleep potion and perplexity. "Secrets? What are you talking about?"

"His habit of entertaining himself with little boys that he rents," Sano said.

"What . . . ?" She squinted her eyes, trying to focus them on Sano.

"What's wrong with that?" he finished her sentence for her. "Sex with boys isn't a crime, of course. Neither is keeping them instead of giving them back to their mothers. A samurai can do whatever he likes to commoners. He can even murder them for his own gratification. But making a habit of killing children goes beyond the bounds of propriety. That is a crime, even for a powerful *daimyo* such as Lord Mori was."

A hint of emotion sparked behind the fog in Lady Mori's eyes. Her mouth sagged open. Fear, shock, or simply offense kept her speechless. She backed away from Sano, toward her son. Enju held her arm, supporting her, demonstrating affection even though none showed in his gaze that swept her. Sano sensed love on her side, not necessarily on Enju's. They gave an impression of estrangement even though the young man had behaved with filial devotion toward his mother as far as Sano had seen.

"We don't know what you're talking about." Conviction steadied Enju's voice as he spoke for Lady Mori. "My father did not entertain himself with children. He has certainly never hurt any."

"Then why were boys brought into this estate at night?" Although Sano answered Enju, he looked to Lady Mori. "What did they do here?"

Lady Mori shook her head. "Perhaps someone else, perhaps one of the other men . . ."

"Not one of the other men," Sano said. "Your husband. He enjoyed them in his private quarters. He took his pleasure from strangling them in his bed. And it looks as if he killed one and had the corpse buried over there, under the pine trees, the night he died."

"No. It's not true." Flustered and aghast, Lady Mori said, "Where did you get these ideas?"

"From my wife," Sano said.

"Ah. Lady Reiko. I see," Enju interrupted. A glint of temper appeared in his eyes. "With all due respect, Honorable Chamberlain, but she misled you. She obviously didn't want you to know the real reason why she was in my father's chamber. So she made up a story to make him look bad and herself seem above reproach."

Sano was reminded against his will of his suspicion that Reiko hadn't been completely honest with him. He felt antagonistic toward Enju because he didn't want to think the young man was right and he himself was wrong about Reiko's innocence. Nor did he like realizing that if this were any other murder case, he might agree with Enju.

"It was your mother who fabricated her story," he countered.

"Why would she say that your wife and her husband were lovers unless it were true?" Enju said, disdainful. "Why should she disgrace his memory and their marriage?"

"To avoid the worse disgrace of admitting that he was a cruel, evil pervert," Sano said.

"My husband was a good, decent man," Lady Mori protested.

"You want to hide the fact that you hated him and wanted to be rid of him because you found his bad habits immoral and disgusting," Sano said.

"He had no bad habits! Anyone in this estate will tell you so. He had normal, proper, marital relations with me!" she exclaimed. "I loved him. Your wife—"

"When my wife came into the picture, you saw a perfect chance," Sano continued. "You drugged her wine." He wanted to believe that

Reiko had fallen unconscious the way she'd said, that she'd done nothing during those hours she couldn't remember. He wanted to put his doubts to rest and lay the blame for the murder on Lady Mori. "You killed your husband and framed my wife."

"No! That's not what happened!"

On the verge of hysteria, Lady Mori emitted breathy whimpers; her hands fluttered. Enju clasped them in his and patted them. The lack of warmth in his eyes made Sano wonder about his true feelings toward his mother. He resembled an actor playing a role with mechanical perfection but little heart. Yet his touch seemed to reassure Lady Mori. She froze into a brittle, dignified pose.

"Many apologies, but you are wrong, Honorable Chamberlain," she said quietly. "Your wife seduced my husband that night. Then she killed him because even though he was infatuated with her, in the end he cast her off."

Enju nodded. As Sano fought to control his temper in the face of their obstinacy and his worries about Reiko, a soldier hurried through the pine grove, carrying two shovels. "Come with me," he said. "When we see what's under that ground, you may want to consider changing your story."

Momentary, unpleased surprise showed on Lady Mori's and Enju's faces. They followed Sano to the site and stood a short distance from him and his detectives. The soldiers began to dig. Sano felt surges of hope and apprehension, but he kept his expression neutral. Although he kept an eye on Lady Mori and Enju, he couldn't tell whether they feared what would be found. Her gaze was vacant, her son's opaque.

The soldiers had excavated a mere few scoops of earth before their shovels hit a solid surface beneath. They scraped mud off the top of a rectangular wooden crate. It was wet and muddy, but appeared intact.

"That hasn't been underground long," Fukida said.

"Maybe only since the night before last, when Lady Reiko saw Lord Mori with the boy," Marume agreed.

"And it's big enough to hold a child's body." Anticipation sped Sano's pulse. He felt certain that he had evidence that would prove

Reiko's allegations against Lord Mori, would exonerate her. Sano could hardly contain his excitement.

His troops were digging around the sides of the crate, freeing it from the earth. "Don't bother," Sano said. "Just open it up."

They inserted their shovels under the lid and pried. Sano sensed Lady Mori and Enju holding their breath. He held his own. The lid came up. The soldiers flung it aside, revealing a gray, cotton quilt, clean and dry, protected from the elements by the crate. Sano crouched. Braced for the sight of a dead child, he lifted the quilt.

Inside the crate was indeed a child, but not the youth he'd expected. It was a newborn baby girl, small and delicate. Withered, teeming with insects, but not yet putrefied, she lay curled, her eyes closed, as if still in the womb. The umbilical cord was still attached. Red and blue veins showed through her translucent skin. She'd been washed clean of blood, carefully laid to rest.

The detectives and soldiers exclaimed in surprise. Sano frowned, as much horrified as disappointed. He rose. Everyone stared at the baby.

"Some woman in the estate must have given birth to it, then buried it," Marume deduced.

"She must not have wanted anyone to know," Fukida said.

An estate as large as this harbored many secrets besides the ones Sano had come to uncover, and perhaps criminals other than the killer he sought.

"Maybe the child was born dead," Marume said, "or maybe the mother killed it."

"This might be evidence of a murder," Fukida said.

"But not of the one we thought," Sano said.

He turned to Lady Mori and Enju. The young man bowed with formal courtesy that verged on insolence. He led his awestruck, bewildered mother away without a word. His straight back expressed triumph over Sano.

"What now?" Marume asked.

"I can't ignore this death just because it doesn't pertain to our investigation. I'll have someone tend to the baby and find out whose she

is." Sano covered the tiny corpse with the quilt. He felt beset by complications, overwhelmed by frustration. "Then we'll talk to my informants and spies and find out what they know about Police Commissioner Hoshina's doings. Maybe they'll give us something to tie him to the murder, and Lord Mori to a plot against Lord Matsudaira."

But more doubts and concerns undermined his hopes. With Lily's son Jiro, the unnamed dead boy, and the cache of guns still missing, things were looking even worse for Reiko.

16

Hirata and detectives Inoue and Arai stood in an alley below a fire-watch tower in the *daimyo* district. This was, according to Reiko, where she'd spied on Lord Mori's estate. On its platform high above the tile roofs, a peasant huddled. The wind scattered raindrops on him. The city was so wet that fires were rare, but the instant that people relaxed their vigilance, a blaze could break out and destroy Edo.

"Hey!" Hirata called. The peasant peered down at him. "Who does fire-watch duty at night?"

"Yoshi," came the answer. "He works for Lord Kuroda."

Moments later, Hirata and his men were at the portals of Lord Kuroda's estate a short distance away. The guards summoned Yoshi, a droopy-faced young manservant. Hirata introduced himself, then said, "Did you let someone kick you out of your tower for a night two months ago?"

Yoshi looked at the guards, fearful that they would punish him for shirking his duty. His fear of lying to Hirata won out. "Yes. I didn't want to, but a samurai ordered me to come down."

The samurai must have been Lieutenant Asukai. Hirata was glad that finally a small part of Reiko's story was confirmed. "Did you see a lady climb up the tower?"

"No. I was scared. I got out of there as fast as I could."

"Didn't you ever think to see if somebody was in your place, covering your shift?"

Yoshi shook his head. Hirata couldn't fault him for not bothering to look at Reiko. He'd spotted the figure in the tower himself while spying on Lord Mori's estate, then ignored it. Now he was disturbed that neither he nor Yoshi could verify that it had been her. He thanked Yoshi; then he and his detectives mounted their horses.

"There must be someone who saw Lady Reiko in the tower," Inoue said as they rode through the pelting rain.

"I hope so," Hirata said. "We'll go back to Edo Castle and put every available man out here, and around the Persimmon Teahouse, to look for witnesses who can prove that she was where she was when she said. Then I'll do what I should have done before we ever started our surveillance on Lord Mori."

"That would be . . . ?"

"Tracking down whoever sent that anonymous tip."

Hirata and his detectives spent hours visiting estates in the official quarter of Edo Castle. At each he obtained the names of soldiers who'd been on guard duty when the anonymous letter had been delivered. He asked them whether they'd seen anyone sneaking around who had no business in the quarter, or had otherwise looked suspicious that night. At first the search for the letter's author seemed futile; the guards couldn't recall anything that had happened almost a month ago. Then, at the estate behind his, Hirata met one man who did.

His name was Kushida. He had horsy teeth that protruded when he grinned at Hirata. "Oh, yes. I remember who was around that night. I memorize everybody I've seen during the past month."

"Why?" Hirata controlled his hope because this witness seemed too good to be true.

"It's my hobby."

Hirata supposed it was one way to relieve the monotony of long night shifts.

"Do you want to know how I do it?" Kushida said, tickled by Hi-

rata's attention. "I recite the names over and over in my mind, every spare moment I have. I don't forget the people until a month has gone by since the night I saw them. Would you like to hear my list?"

He began rattling off names, starting with last night's. Behind him, the sentries at the gate rolled their eyes: They'd been entertained in this fashion more times than they liked. At any other time Kushida would have seemed an intolerable bore to Hirata, but now he was priceless.

"Not the whole month," Hirata interrupted, "just the names from the night in question."

Kushida paused long enough to say, "I have to go through the whole list to get to that one," and continued. He rattled the names faster and faster, then stopped, breathless. He held up his finger and slowly recited each name.

Hirata recognized the first eight, which belonged to his neighbors and their retainers. Kushida identified the next three as servants. "There's only one more. It was somebody I've never seen inside the castle before. Chugo Monemon."

"Who is he?" Hirata's pulse quickened with excitement.

"A samurai I know from a teahouse where I go to drink. I said hello to him, but he didn't answer. He acted as if he didn't want to be seen. He's a clerk at Lord Mori's estate."

At Lord Mori's estate, Hirata and his detectives found Sano's troops stationed outside, preventing the residents from leaving and turning away visitors while the murder investigation continued. Hirata told them, "I want to talk to a clerk named Chugo. Find him and bring him to me."

Soon Chugo came out the gate. In his thirties, he had a square face, a solemn expression, and a chunky build. When he saw Hirata, he quailed and stepped backward. Hirata's detectives caught his arms to prevent him from fleeing, but he didn't resist; he muttered, "Can we talk someplace else?"

They walked through the *daimyo* district. Chugo jittered, casting

furtive glances over his shoulder, his expression hunted. Hirata and his detectives sat Chugo in a teahouse on the street that marked the boundary between the *daimyo* district and the Nihonbashi merchant quarter.

Hirata ordered a cup of sake and handed it to Chugo. "Drink up and calm down."

Chugo obeyed, then licked his lips, expelled a gusty breath, and said, "I've been expecting you."

"Then you know what this is about?" Hirata asked.

"The letter I put under your gate."

"Did you write it?"

Chugo nodded. "How did you know it was me?"

"Your friend Kushida told me he saw you."

"Oh. I was hoping he would forget." Chugo mumbled, "I wish I'd never written that letter."

"It's a little late for that," Hirata said.

"Lord Mori was my master, and I should have been loyal to him no matter what he did. But treason was too serious for me to look the other way. I had to report it." His gaze begged Hirata to agree.

"You did the right thing," Hirata said.

Chugo still looked worried. "If Lord Mori's other retainers find out that I told on him, they'll kill me. You won't tell anyone, will you?"

"I can't promise," Hirata said, "but if you'll cooperate with my investigation, I'll keep your secret as best as I can."

"All right," Chugo said even though he seemed far from satisfied.

"First, what made you think Lord Mori was a traitor?" Hirata asked.

"I overheard him talking with his friends. They said they were sick of the way Lord Matsudaira treated them. The tributes he demanded were too high. They're tired of absorbing the cost of a war that was supposed to end three years ago but drags on and on. They're afraid that if he goes down, so will they. They were planning to band together against him."

Anticipation excited Hirata. It sounded as if there had been a conspiracy after all. "Who are these friends?"

"I don't know," Chugo said. "I didn't see them. I happened to be

walking past Lord Mori's office. The door was open, but not enough for me to see them."

"What else did they say? Did they discuss their plans?" Hirata asked urgently. Perhaps the conspirators had fallen out and one of them had killed Lord Mori.

"I don't know. Lord Mori said, 'Somebody's outside. Be quiet.' They stopped talking. I left because I didn't want them to catch me eavesdropping."

Disappointment lowered Hirata's spirits. Vague hearsay didn't equal proof of treason, although men had been put to death for less. "How do you know it wasn't just idle talk?"

"Because of what happened a few nights later," Chugo said. "Some big boxes were delivered to the estate. I was curious, so I peeked inside one. It was full of guns. There would be no reason for Lord Mori to have them, unless . . ."

Unless he was planning an armed insurrection. Hirata's excitement flared anew. "When was this?"

"About two months ago," Chugo said. "I heard the guards say that more guns were expected."

Here was indication that Hirata had seen what he thought he'd seen while spying on Lord Mori. "What happened to the guns? Are they still in the estate?"

"I don't think so. I never saw them again."

Without them, Hirata had no evidence that Lord Mori had been a traitor, nothing to convince Lord Matsudaira that his death was no loss, and no new suspects to draw attention away from Reiko. And nothing to convince Sano that he'd seen what he'd said he had and his powers of observation weren't slipping.

"But I know a place they might be," Chugo said.

"Where?" Hirata demanded.

Chugo looked unhappy because his obligation to Hirata was going to take more time than he liked, as well as incriminate his dead master even more. But he said, "I'll show you."

. . .

"Lord Mori rents this warehouse," the clerk said. "This is it."

He and Hirata and Detectives Inoue and Arai swung off their horses outside a building, one in a uniform row with whitewashed walls and steeply pitched tile roofs that fronted on a quay. Men rowed boats, laden with vegetables, along a canal. All the warehouses except the one that had belonged to Lord Mori bustled with activity as porters unloaded the boats and carried the goods inside. His was silent, its huge doors locked. The quay was crowded and noisy, but at night it would be deserted, a perfect place to receive contraband.

"Let us in," Hirata told Chugo.

Chugo unlocked the warehouse doors and flung them open. Hirata and the detectives strode inside. The cavernous space was warm and dank, lit by barred windows near the roofline. The air had a faint, greasy, metallic odor. Wooden crates stood ranged, ten wide and three high, along one wall. Anticipation leapt in Hirata as he and his men hurried toward them. They raised the lid of one crate. The smell of iron wafted up. Inside, swathed in greased cloth, lay a pile of arquebuses, their long barrels gleaming dully.

Hirata, Inoue, and Arai burst into a simultaneous cheer. "I knew it! Lord Mori *was* plotting a rebellion," Hirata exulted.

"These have to be the weapons you saw," Inoue said.

"Proof doesn't come much better than this," Arai said.

Chugo slouched by the door, looking miserable. Hirata pitied this samurai who'd betrayed his master. "You did the right thing," Hirata assured Chugo again. "Even now that Lord Mori is dead, the rebellion could have gone on without him if you hadn't reported him. You may have prevented another war."

The clerk didn't seem any happier. "What are you going to do with the guns?"

"We'll take them to Edo Castle. They're evidence in the murder investigation." Hirata told Inoue, "Go hire some porters to carry them for us."

Inoue hastened off to obey. Chugo said nervously, "You won't tell anybody that I was the one who led you to them?"

"Not anybody more than necessary," Hirata said.

Unsatisfied yet resigned, Chugo said, "Can I go now?"

"Yes," Hirata said. "Thank you for your cooperation."

Chugo sped off like a rat with its tail on fire.

"It would be nice if we could discover who Lord Mori's co-conspirators were," Arai said.

"Let's see if there are any clues with the guns," Hirata said.

They opened all the crates, removed the guns, but found no letters or other papers to show where they'd come from or who besides Lord Mori owned them. Hirata and Arai repacked the crates. Refusing to be discouraged, Hirata said, "We'll search this whole place."

That promised not to take long. The warehouse appeared empty except for the crates, its floor swept clean. "They were careful not to leave traces of themselves," Arai commented.

"Don't give up hope yet." Hirata looked upward and noticed an enclosure built on a platform high in a corner. A wooden ladder led to it.

Hirata and Arai climbed the ladder. Inside the enclosure was an office with a view out a window that overlooked the canal. It contained a writing desk, a fireproof iron trunk, and a round, open bamboo basket. Arai lifted the lids of the desk and trunk.

"Empty," he said.

"Wait." Hirata gazed into the basket. A repository for trash, it held sunflower seed shells, dust balls, and wadded papers. He picked out the papers and flattened them. There were three, each bearing handwritten characters. Even before he read them, recognition jarred him.

"What do they say?" Arai asked.

Foreboding drummed a warning signal through Hirata. He read the first page: " 'Meeting on night after tomorrow. Observe usual precautions.' "

He shook his head. *It couldn't be.* The dim warehouse echoed with his disbelief.

Arai looked over his shoulder at the second page, which was a roughly drawn sketch of Edo with the castle, river, and a few streets labeled. Hirata read aloud the third page, a list of four *daimyo* and three high-ranking Tokugawa officials. After each name were scribbled numbers in the thousands.

"It looks as if the leader of the conspiracy had scheduled a secret meeting of the men who were in on it," Arai said. "The map could be their battle plan. The list must be their names and the amounts of money and troops they were pledging." These ideas jibed with Hirata's own. "This is good information. Now if only we can find out who wrote this, we'll have them all."

"No," Hirata said, "no, it's not good." Agitated by horror, he thrust the papers at Arai. "This is Chamberlain Sano's writing. If it's what we think, then he's the leader of the rebellion conspiracy."

17

When Sano arrived home late that night, he discovered that the roof above his office had given way under the constant rain. Servants were busy cleaning up pieces of soggy ceiling that had fallen, moving out his furniture, and rolling the drenched tatami. In the adjacent chamber Sano found Reiko spreading his wet books, scrolls, and papers on the floor to dry. Masahiro was blotting them with a cloth. Sano frowned because Reiko looked even worse than when Hirata had brought her home from the Mori estate. She wore no makeup to cover the shadows under her eyes, which brimmed with misery. Brushing back a strand of disheveled hair, she managed a wan smile at Sano.

"What a mess this is," she said. "But I think we can save most of it."

"Good. I'd hate to think that a little rain could bring down the Tokugawa bureaucracy by destroying my paperwork." Because Masahiro was present, Sano matched Reiko's light tone. "But never mind the mess. You should be resting. Let the servants clean up."

Reiko sighed. "I need to keep busy, to distract myself." Sano couldn't help wondering if there was something more troubling her than he knew. She said, "Masahiro, it's time for bed."

"But I have to finish wiping the papers."

"Tomorrow," Reiko said. "Go. That's a good boy." When he'd left, she turned eagerly to Sano. "What's happened?"

Sano hated to dash the hope that brightened her eyes. "I wish I had better news. But I spent most of the day checking with all my informants and spies, and they gave me no clues about Lord Mori, and no dirt on Hoshina."

Trying but failing to hide her disappointment, Reiko separated a stack of wet pages. The thin rice paper tore despite her carefulness. "What about your inquiries at the Mori estate? Did you discover anything there?"

"No guns, no missing boy. For a while I thought we'd found the murdered one buried on the grounds, but I was mistaken." Sano didn't elaborate, lest the tale of the dead baby upset Reiko. "And I'm sorry to say there are no new suspects."

"I thought I would have some by now, but I was mistaken, too," Reiko said. "I sent Lieutenant Asukai to investigate the Black Lotus sect. But even though he managed to chase down some members, they didn't seem to know anything about Lord Mori's murder. And there have been no rumors that the Black Lotus is up to anything other than petty crime."

Sano took the news in stride, but unwelcome thoughts preyed on his mind. He said, "Have you remembered anything else about that night at the Mori estate?"

"No," she said. "I've tried, but I can't."

Her sincerity would have convinced anyone who didn't know her as well as Sano did. He felt her withdraw into herself, as though shrinking from a threat. "Are you sure?"

"Yes, I'm sure." Her voice tightened. "What's the matter? Don't you believe me?"

"Of course I do," Sano said, surprised by her defensiveness that made him more uncertain whether he really did.

She wrinkled her brow in a suspicious frown. "Then why are you pressuring me?"

"I'm not," Sano said. "I just asked—"

Reiko faltered to her feet, away from him. "You think there's something wrong with my story, don't you? Because you couldn't find Jiro or the dead boy, you think I made them up. You don't trust me!"

"That's not true," Sano said, although his instincts denied his words. Years of detective work had taught him that too many protests often signified prevarication.

"Yes, it is!" Reiko obviously saw through him; she'd learned the same lesson while helping him investigate crimes. She was breathing hard, twisting her hands in agitation.

"Don't get upset," Sano tried to soothe her. "It's not good for you or the baby."

" 'Don't get upset?' " Incredulous, she exclaimed, "How can I not get upset when you're treating me like a criminal?"

The sound of a cough at the door startled them. They turned and saw Hirata poised at the threshold. He said, "Excuse me. I don't want to interrupt you, but . . ."

"That's all right," Sano said. His conversation with Reiko could only go from bad to worse if it continued. She nodded, agreeing to postpone their disagreement, making a visible effort to calm herself. "Come in."

As Hirata entered the room, the look on his face told Reiko he'd brought bad news, the last thing she needed to cap this terrible day.

The harder she'd tried to dismiss her new memories as false, sick delusions, the more real they'd seemed. The more she sought an alternate explanation for them, the less she could resist believing they meant she'd killed Lord Mori. The more she told herself that she'd only wanted to save Jiro, the more she wondered if he and Lily were creatures of her imagination. Her fear that she was not only a murderess but a madwoman scourged her. She shouldn't have lost her self-control and reacted to Sano's questions the way she had: If he hadn't had doubts about her veracity before, he surely did now.

"What is it?" Sano asked Hirata.

Hirata spoke with hesitant reluctance: "I went looking for Lily the dancer."

Reiko's nerves tensed even tighter. Her pulse, already racing so fast that she felt shaky, sped faster. "Well? Did she tell you that I went to Lord Mori's estate to look for her son?" She was anxious for confirmation of her own story.

"No," Hirata said. "I mean, I couldn't find her." He explained how the people at the teahouse and in the neighborhood had acted as though they'd never heard of Lily. "She and her son don't seem to exist."

More horror than astonishment struck Reiko. This was what she'd feared yet expected Hirata to say. Her gorge rose; the muscles of her throat clenched against it. She saw Sano watching her. He didn't speak, yet the suspicion in his eyes demanded a response.

"That's absurd," she heard herself say in a voice that didn't seem to belong to her. Such things as this happened only in nightmares! "Of course Lily and Jiro exist." If they didn't, then she must have gone to the Mori estate for some other reason than for their sake. Lady Mori's allegations came back to mind. Had she gone to make love with Lord Mori? Instead of spying on him, had she quarreled with him, then stabbed and castrated him? "Those people are lying."

An uncomfortable silence ensued. Hirata looked to Sano, as if expecting him to come to Reiko's defense. But Sano averted his gaze, frowning. Desolation filled Reiko because Hirata's news had dealt another cut to her husband's trust in her.

Sano said, "Why would they all lie?"

Reiko's hands involuntarily fluttered. She clasped them tight, holding them still. "Maybe they're afraid to tell the truth. Maybe someone threatened them."

"Who?" Sano asked.

His challenging tone dismayed her. "I don't know. Maybe whoever killed Lord Mori and tried to frame me."

"Maybe. But there's the question of proving it." Sano addressed Hirata: "Did you come up with any evidence at all that things happened the way she described?"

"Unfortunately not." Hirata described how he'd failed to prove that Reiko had spied from the fire-watch tower. "I couldn't find anybody who got a good look at her. Fire-watchers might as well be invisible." He hesitated, turned to Reiko, and said carefully, "Lady Reiko, may I ask you if you spoke to anyone else at or around the Persimmon Teahouse besides Lily? Any people who witnessed that you went there and you can call on to testify what your business was?"

Reiko's heart sank deeper because she realized that Hirata didn't trust her either. "No. But Lieutenant Asukai and my other escorts can vouch for me."

"Yes. I know," Hirata said. "I spoke to them a little while ago. They did vouch for you." *But of course they would,* said his tone.

And he distrusted her enough to have double-checked her story. Reiko was devastated to think that both the men she'd thought her mainstays were losing faith in her. Yet how could she blame them?

Sudden excitement filled her. "Wait—I've just thought of something." She hurried to her chamber, rummaged through her writing desk, snatched out a paper, and returned to Sano and Hirata.

"This is the letter that Lily wrote me." She handed it to Sano. "This is proof that she asked for my help and that's why I went to the Mori estate."

But as the men studied the letter, they didn't seem at all relieved. Sano said, "I wonder how a dancer was able to write. Most women of that class can't."

Reiko's excitement deflated. Of course she'd known the fact that most female commoners were illiterate, but she hadn't thought of it in connection with Lily.

"These characters are so rigid and uniform," Hirata said, "as if the author was trying to disguise his handwriting."

He and Sano raised their eyes to Reiko. She gaped at them. "I didn't write that letter myself!"

"No one said you did," Sano said, but his manner was grave, disturbed.

"It was delivered to me at the house!" Reiko had another thought. "Midori was there when it came. I read it to her. She'll tell you."

"We'll look into that," Sano said.

Yet Reiko could feel him thinking that Midori, her friend, would lie for her. And the letter had arrived along with many others; probably no one else had noticed it. *I could have slipped it in among the rest.* Reiko shook her head in denial. She thought back on her trips to the teahouse, her talks with Lily. Although her memories of them were so hazy they seemed like a dream, how could she have not only unwittingly invented such an elaborate fiction, but forged the letter to back it up? She struggled to make sense of the nightmare.

"Reiko-*san*?"

Sano was looking at her, a strange expression on his face. "What are you doing?"

She realized with a jolt that she'd moved to the far side of the room and opened a cabinet on the wall. But she didn't know how, or why. It had happened again, another lapse of time and awareness. Concealing her fear and horror from Sano, she waved away his question. She fixed on the last thought she remembered.

Supposing her story were true, what had become of Lily? Now Reiko was afraid not just for herself.

"You have to find Lily," she entreated Sano and Hirata. "Something bad must have happened to her."

"We'll keep looking," Sano said without much hope or conviction.

Hirata's face was a picture of distress.

"What?" Sano said.

"I think I've found the guns that I saw delivered to Lord Mori's estate." Hirata told how he'd traced the anonymous letter to its source and then inspected the warehouse that the writer had shown him.

Reiko dared to hope that at last something about this investigation was going right, despite Hirata's expression.

"That's the best news I've heard all day," Sano said. "You've found proof that Lord Mori was plotting a coup. It should make Lord Matsudaira and the shogun a lot less inclined to persecute my wife and me. Why aren't you pleased?"

Hirata took a handful of papers from under his sash and gave them to Sano. "Please tell me you didn't write these."

As Sano examined them, Reiko stood beside him and peeked at the three notes. She recognized his writing in the notations that hinted at a secret meeting, a battle plan, and a war chest and armies raised from co-conspirators. "Yes," Sano said. "I did. Why? Where did you get them?"

"From a trash basket in the warehouse where I found the guns." Hesitation marked Hirata's words. "They make it seem as if you were part of the conspiracy. Or even the leader."

"What?" Reiko exclaimed. Shock filled her as she stared at Sano.

"Don't look at me like that," he said, his voice harsh with anger. "I'm not part of any conspiracy. I'm certainly not leading this one."

But Reiko saw confusion in Hirata's eyes, and she didn't know whether to believe Sano herself. It had been bad enough that Sano didn't trust her version of events, but now she had reason for misgivings about him. Ambition and power had swayed many a samurai off the honorable course of loyalty to superiors. The nightmare had taken the drastic, unexpected turn she'd dreaded. Yet Reiko experienced relief that the discovery in the warehouse had distracted Sano from her possible guilt, and spiteful pleasure that their positions were reversed. Now came *her* turn to challenge *his* innocence.

"Then what are these papers?" she asked.

"They're notes I wrote to myself." Sano flung them on the floor one by one as he said, "This is a reminder of a meeting with the Council of Elders. 'Observe usual precautions' means don't let it devolve into an argument between Lord Matsudaira's supporters and detractors. This map is a plan for road repairs in town. And this list is taxes owed by these men."

"But how did they get in that warehouse?" Hirata said, still dubious.

Sano gave him a look that reproached him for his lack of trust. Reiko saw their comradeship undermined even as her marriage crumbled. The murder case was wreaking havoc with all their ties.

"I threw those notes away; I was finished with them," Sano said. "Someone must have stolen them from the garbage and put them in the warehouse with the guns to incriminate me."

"My, but that's a convenient explanation." Reiko couldn't help

wanting to pay Sano back for disbelieving her. "Who could have done it?"

His expression said he understood her need to wound him as he'd wounded her. But as he answered, "I'd put Police Commissioner Hoshina at the top of the list of suspects," his tone censured her for her implied accusation.

Hirata seemed readier to believe him than Reiko was, but not much. He frowned as if at a new, upsetting idea. "If your notes were planted, then the guns could have been, too."

"If that's the case, then there was no rebellion brewing." Reiko cut her eyes at Sano. "How glad I am for your sake."

Anger at her sarcasm darkened his face. "You shouldn't be. If Lord Mori wasn't a traitor, that would leave us back at the beginning, with you at the scene of his murder and Lady Mori's word against yours. And now that we can't find Lily, people are more likely to believe that you killed Lord Mori during a lover's quarrel than that you went searching for one lost child and witnessed him murdering another."

Stung because he seemed to believe the first possibility, Reiko said, "Maybe Lily was an imposter. Maybe someone put her up to setting me after Lord Mori." How she wished she could believe it herself! Desperation ignited her temper. "Except you would rather think I'm guilty, wouldn't you?"

Sano threw up his hands, emitted a sound of disgust, and shouted, "You're talking nonsense!"

"Please, stop," Hirata said, obviously grieved to see them argue and hating to be caught in the middle. "We have to work together."

Reiko knew he was right. She bit back another jab at Sano, who glared but compressed his mouth.

"Maybe nothing about this murder is what it seems," Hirata said. "But whatever the truth is, this new evidence puts both of you in worse danger. What are we going to do about it?"

They all sat down in tense, brief, thoughtful silence. Sano said, "We continue with the investigation. Until we find out what's going on, we keep the evidence a secret."

"That's a wise idea," Reiko said, and Hirata nodded. Then she re-

called something she'd forgotten to tell Sano. "I've thought of two more people who might have wanted to hurt me. Would it be all right for me to go out and investigate them?"

She watched Sano weigh his distrust of her against his hope for a solution to their problems. He said, "I told Lord Matsudaira and the shogun that I'd keep you at home. Can't you send Lieutenant Asukai?"

"I'd rather not. He's willing and clever, but I don't know if I can count on him for something so important. And if I go, I won't be in much more danger than I am now."

"If your enemies get wind of her roaming around town, you could end up in even worse trouble," Hirata told Sano. "Better that she should tell us who these people are and we investigate them."

After pondering a moment, Sano said to Reiko, "You can go. Just don't let anyone catch you outside this compound."

"Thank you. I won't." But Reiko was as miserable as pleased that he'd given in. She knew he'd done it because he feared that her new lines of inquiry were as dubious as he suspected her story was. He would be glad if they proved helpful, but he didn't want to waste his own time chasing false clues.

18

At dawn, Sano was fast asleep, worn out from two days of nonstop work. Detective Marume called through the door of his bed-chamber, "Excuse me, Sano-*san,* are you awake?"

Sano stirred groggily and found Masahiro crowded into the bed be-tween him and Reiko. The boy was usually content to sleep by him-self, but sometime during the night, he'd crawled under their covers. Maybe he was insecure because of the recent, disturbing events. He didn't move; nor did Reiko.

"I'm awake now," Sano said with a yawn. "What is it?"

"Lord Matsudaira wants to see you at his estate."

Dragging himself out of bed, Sano anticipated another bad scene. In the next few very busy moments, he threw on his clothes, his valet shaved him and dressed his hair, and he was out his gate with Marume, Fukida, and his troops. They hurried on foot to the special enclave within Edo Castle where the important Tokugawa clan members lived.

Soldiers patrolled the area or occupied guardhouses along the walls that separated the estates. The sky was overcast and barely light, the air waterlogged, the scene as devoid of color as if the rain had washed it away. Sano and his entourage stopped at Lord Matsudaira's gate, which boasted a three-tiered roof and ornate double ironclad doors.

The guards confiscated Sano's swords and searched him for hidden weapons. Not even the chamberlain was exempted from these strict security precautions.

"Your men will wait out here," the guard captain told Sano.

Guards escorted him into the estate and left him at a large wooden shed built along one side of an elegantly landscaped garden. Its skylights and wide doors were open. Inside, Lord Matsudaira stood at a table that held some hundred bonsai trees of various species and sizes, planted in ceramic dishes. He was repotting a tiny, gnarled pine tree.

"Greetings, Sano-*san*," he said. His voice was quiet, his manner subdued. Dressed in an old cotton robe and trousers, minus his swords, his hands working in dirt, he looked like a peasant instead of a powerful warlord.

Sano bowed, returned the greeting, and entered the shed. It smelled of earth and manure. Why had Lord Matsudaira summoned him here?

Lord Matsudaira said, "I want to talk to you alone."

Yet Sano knew they weren't really alone. There would be guards stationed nearby, although out of sight and earshot. Lord Matsudaira took no chances with his safety.

"Morning is the most pleasant time of day." He gently set the little tree in a new pot and packed soil around its roots. "It's the time before a man is caught up in business, when he can relax and enjoy life. Don't you agree?"

". . . Yes." Sano doubted that Lord Matsudaira had brought him here to share a peaceful moment.

"I thought this would be a good chance for you to tell me what progress you've made on investigating the murder."

Sano obliged with a report that skirted the truth. He told Lord Matsudaira that he'd done preliminary interviews with the residents of the Mori estate, but didn't say they'd confirmed Lady Mori's story and contradicted Reiko's. He described how Hirata had traced the anonymous tip and found the stash of guns in Lord Mori's warehouse, but left out what else Hirata had found. He said he'd begun a search for the medium, who'd suspiciously vanished before he could interrogate her.

When he finished, Lord Matsudaira was silent a moment, planting moss around the base of his tree. "Is there anything more?"

Before Sano could answer, Lord Matsudaira turned to him, held up a hand, and said, "Stop. You're going to lie, and I am sick of lies." His mood turned suddenly vicious. "There's no use trying to hide the truth from me. I know about the messages from you to Lord Mori that have come to light. I know they indicate that you and he were planning a rebellion."

A chord of dismay reverberated through Sano, and not just because Lord Matsudaira knew about the evidence he'd wanted to keep under wraps. "How did you find out about the messages?" he asked as calmly as he could manage.

"That's not important," Lord Matsudaira said. "What have you to say for yourself?"

The evidence must have been leaked to Lord Matsudaira by someone in Sano's retinue or Hirata's. "Those messages aren't what they seem." He should have told Lord Matsudaira about them himself, presented his side of the story, and cut off an attempt to use them against him. Maybe the leak hadn't come from within his camp, but from the person who'd planted the messages in the warehouse. No matter what, Sano should have known he couldn't keep them secret. "I can explain."

Lord Matsudaira slashed his hand through Sano's words. "Just tell me if it's true." Hostility set his features in angry lines. "Were you and Lord Mori conspiring to overthrow me? Are you still?"

"No," Sano declared, as sick of wrongful accusations as Lord Matsudaira was of deceit.

Lord Matsudaira stepped closer to Sano. His direct, unblinking gaze measured Sano's honesty; a twitch of his lips dismissed it as false. "Drop your pretenses. There's no shogun here for you to trick. We might as well get to the bottom of this because there's nobody here except ourselves."

Ourselves and your hidden guards who are ready to jump on me as soon as you call them. Sano said, "I told you yesterday that I wasn't plotting against you. I'll tell you again today that I wasn't—and I'm not. Believe me or don't; it's your choice."

An abrupt change of expression transformed Lord Matsudaira. Now he looked torn between wanting to believe Sano and wanting to prove his suspicions correct. He shook his head, turned away from Sano, and leaned with his hands on the table.

"I don't know whom to trust anymore," he muttered. "I used to pride myself on my instincts, but now I can't tell whether someone is friend or enemy." A sad chuckle heaved his body. "Every day I seem to have more enemies and fewer friends."

Sano felt an unexpected pity for Lord Matsudaira, perched on a mountaintop surrounded by people trying to push him off. But although the crisis had passed, Sano knew he wasn't out of danger yet.

"Merciful gods, how did things come to this?" Lord Matsudaira said in a voice hushed with astonishment.

You overstepped yourself when you made your bid for power, Sano thought but didn't say.

"I made my bid for power because I thought it was the right thing to do, not just for me, but for the country. I wanted to foster prosperity, harmony, and honor." Lord Matsudaira gazed at his array of bonsai. The trees stood aligned in perfect rows, like troops at attention. Their limbs were bent and tied into unnatural positions by his hand.

"I thought I could do a better job running the country than my cousin has done. He let that scoundrel Yanagisawa take over." Contempt for them both wrenched Lord Matsudaira's mouth. "I thought that bringing Yanagisawa down would end the corruption and purify the regime. But too many people preferred things as they were. They opposed my efforts instead of working with me to rebuild the government after the war."

And you underestimated your opponents.

"They've forced me to crush them or die," Lord Matsudaira said.

Sano marveled at his combination of intelligence and naïveté, idealism and ruthlessness, all crowned by arrogance. Perhaps those were the very qualities that transformed a samurai into a warlord.

"They've all but destroyed my dream of forging a new, better, more honorable Japan."

In a sudden fit of violence, Lord Matsudaira swept the pine tree he'd just repotted off the table. It crashed onto the stone floor. The dish shattered. The tree lay with its roots exposed amid spilled dirt. Sano noticed that it was a valuable living antique, perhaps as old as the Tokugawa regime, which had been founded ninety-five years ago. Lord Matsudaira gazed down at the tree as though appalled by what his temper had wrought. Then he turned to Sano, his features contorted by emotion.

"If those messages aren't proof that you're a traitor to me, what are they?" he said.

"Trash scavenged from my garbage and placed out of context," Sano said.

"Then why didn't you tell me about them instead of letting me find out from other sources?"

Sano spoke the truth: "Because I thought you would jump to conclusions without listening to my side of the story. Because it seemed wiser to keep the messages a secret than risk that you would send me and my family straight to the executioner."

Wry self-awareness lightened Lord Matsudaira's mood, although not much. "Fair enough. But that leaves us right where we started. Are you a traitor or aren't you? Do I believe you or heed my suspicions?" His gaze measured Sano. "Give me a reason why I should let you continue investigating Lord Mori's murder even though you're a suspect yourself."

Sano recognized this as a critical juncture where one wrong step could irretrievably doom him, Reiko, their son, and all their close associates. While he pondered his options, he picked up the pine tree. Its branches were intact, but it wouldn't survive if not properly tended. He could say, *Because I've saved you in the past,* which was true; had he not slain the assassin known as the Ghost, Lord Matsudaira's regime might have fallen before now. But Lord Matsudaira wouldn't like this reminder of his vulnerability.

Instead Sano said, "Because who else is there that you can trust any more than you do me?"

Lord Matsudaira gravely considered his answer for a long, sus-

penseful moment. Sano offered him the tree. He hesitated, then took it, but his eyes flashed a warning at Sano.

"If I ever have reason to regret my decision," he began.

An outburst of childish voices interrupted him. Running footsteps squished across the wet garden. A little boy and girl arrived breathless in the shed.

"Grandfather!" they cried. Each grabbed one of Lord Matsudaira's legs.

He smiled fondly and hugged them. "What is it, little ones?"

"He hit me," the girl said, pouting at the boy.

"She hit me first," he protested.

"Well, then, you're even," Lord Matsudaira said. "No more fighting. Run along and play now."

As they chased each other around the garden, he watched them with the same fierce, possessive tenderness that Sano felt toward his own son. Then Lord Matsudaira turned to Sano and said, "Remember that you're not the only man who has a family. If you let me down, they'll suffer, too."

After Sano left the house, Reiko lay in bed, trying to summon the will to face the day. She'd not slept at all last night because her fears and uncertainties had kept her thoughts running in a frantic cycle. She'd forced herself to lie quiet and not waken her husband and son. Now her body and head ached from the effort. Dried tears stiffened her face. She listened to the rain that had begun to fall again. Her chamber felt like a dim cage underwater. She heard the maids cleaning the house; Masahiro had gone off to his martial arts lesson; everyone was busy and productive except her. She must take action, not succumb to the loneliness and despair in her heart.

One thing she needed to do was try to remember more about the night of Lord Mori's murder, to counteract the terrible result of her first attempt.

The other was to confront old enemies.

Both prospects were so daunting that Reiko wanted to pull the

quilt over her head and give up. But she heard Masahiro shouting in the garden as he practiced sword-fighting. She must be strong for his sake if not her own.

She arranged herself on her back with her legs straight and arms resting palms up at her sides. She breathed slowly and deeply, letting her thoughts drift. Her entire body balked at the plunge into the terrifying past, but she persevered. After a long while she entered a meditative trance. Her spirit existed in a space outside herself. She saw herself lying in the bed, while she floated above it, for the instant before her mind zoomed along a black, starlit cosmic tunnel, back in time.

Once again that foggy night at the Mori estate wrapped her in its sounds of water dripping and distant voices, its sensations of dampness and danger. Once again Reiko was kneeling on the veranda of the private quarters, turning away from the spy-hole. She stood, stumbled, and fell as unconsciousness drew her down, down, into a whirlpool of blackness. Once more she drifted in it, until she found herself inside Lord Mori's chamber again.

She lay naked on the bed. His face was above hers, so close that she could smell the sour breath from his open, drooling mouth. His eyes were half-closed, his expression blank. Her arms were embracing him, her legs wrapped tight around his waist. His body humped against hers with repeated thuds that shook the floor beneath them. Reiko felt herself gasping and the slickness of their sweat. Laughter and jeering echoed in her mind.

Even as she recoiled from this vision, it disappeared. Now Reiko was seated upright. She held her dagger, its hilt clenched in both her fists, its blade pointed outward. The image of Lord Mori emerged from a blur of light and motion before her. His eyes were wide and his mouth agape with terror; he flung out his arms in a wordless plea. A mighty lunge propelled her toward him. The blade of her dagger sank deep into his stomach. He howled, deafening Reiko. The jeering and laughter escalated to a maniacal pitch. Blood spewed from the wound onto her.

Reiko cried, "No!" She struggled to bring herself out of the trance, but it enmeshed her as if it were an invisible steel net.

She was slumped over a puddle of blood that seeped across the tatami from

the prone, motionless, naked body of Lord Mori. A white chrysanthemum *floated in the puddle, its petals slowly turning red. Her hands were laid palms up on the floor in front of her. They held Lord Mori's severed, blood-smeared genitals, warm and slippery as fresh meat.*

Serves you right, you evil bastard. The words reverberated, gloating and triumphant, through Reiko. Shock exploded her trance. Her body convulsed in spasms; her limbs jerked. She launched herself upright, fell forward, and wailed.

Someone cried, "Reiko-*san*!"

She turned and saw Midori standing in the doorway. Midori's face was filled with puzzlement and concern. She hurried over to Reiko, knelt, and hugged her. "I heard what happened. I'm so sorry! I would have come yesterday, but the baby was sick. Are you all right?"

Her friend's compassion soothed Reiko. Even though her heart was still pounding and her body trembling, her hysteria faded. Relaxing against Midori, she caught her breath. "Yes. I am. Thank you for coming. I'm glad to see you."

She suddenly realized that not one of the other women she considered friends had come to see her since the murder; nor had her relatives. They must be less curious about her than afraid to associate with such a scandalous criminal as she appeared to be. Yesterday afternoon her father had visited her, but she'd been so upset by her first attempt to relive the night of the murder that she could hardly speak to him. Otherwise she'd been shunned. Even the servants kept their distance from her. She was a pariah.

"I heard you screaming," Midori said. "What's the matter?"

Only that Lady Mori is right: Lord Mori and I were lovers; I seduced him that night; then I stabbed him because he spurned me. And after he was dead, I castrated him. Serves you right, you evil bastard.

Reiko drew a deep, shuddering breath. She couldn't tell Midori that she was now certain she'd murdered Lord Mori and her own memory was the strongest proof. Instead she said, "It must have been a bad dream." *A bad dream that was real and wouldn't go away.*

"I know you didn't do it," Midori said with sincere, heartfelt conviction. "No matter what people say."

Reiko could imagine what they were saying about her. Tears of gratitude stung her eyes. "I appreciate your loyalty."

"Don't worry, Reiko-*san*. Your husband and mine will prove that you're innocent," Midori said.

But Reiko feared that it was only a matter of time until Sano found proof of her guilt. Then his love for her would turn to hatred and disgust. He would let the law take its course with her. Unable to bear these thoughts, Reiko clung to a shred of hope that she was innocent despite her memories, despite Hirata's news that Lily and Jiro didn't exist. Now it was time to take the next course of action that she dreaded.

"I can't just sit here while my husband and Hirata-*san* do everything for me," Reiko said. She went to the cabinet and took out clothes to wear. "I have to help myself or go mad waiting."

"But what can you do?" Midori asked.

"I'm going to talk to some people who might be responsible for murdering Lord Mori and framing me." She summoned a maid and said, "Fetch Lieutenant Asukai."

While Midori helped her dress and arrange her hair, Reiko pondered which enemy she should confront first. They were all people she'd run afoul of while doing her private detective work. But the one that was most conveniently at hand also had ties to Lord Mori.

When Lieutenant Asukai arrived, Reiko told him, "Bring me Colonel Kubota of the Tokugawa army."

真
相

19

As Sano left the Tokugawa enclave with his retinue, one of his soldiers came hurrying along the passage to him. "You'd better have good news for me," Sano said, tense from his meeting with Lord Matsudaira.

How narrowly he and his family had escaped death! And Lord Matsudaira had given him extra incentive to solve the crime. Yesterday Sano could have watched Lord Matsudaira fall without regret; he'd taken so much abuse from the man that he'd felt little sympathy for him until a few moments ago. Today he shouldered responsibility for a comrade who aspired to honor and had a family he loved whose fate depended on the outcome of the investigation and the balance of power.

"I do have good news," the soldier said. "It's from the men you sent looking for the medium. They've found Lady Nyogo. She's at the nunnery at Kan'ei Temple."

The panther bides its time, springing neither too late nor too early.
Inside his estate, Hirata stood in a pavilion surrounded by white sand raked in parallel lines around mossy boulders and gnarled shrubs. He was practicing a martial arts exercise that Ozuno had taught him.

Envisioning himself as the panther in a jungle at night, he held himself perfectly still and relaxed, yet ready to pounce. He breathed slowly while he listened to Ozuno's voice in his mind.

Be at one with the cosmos, at peace with yourself. Should an enemy come near, your nonchalance will lull him into thinking you are no threat and put him off guard. If you draw your weapon, if you reveal that you sense an attack at hand, you will lose the advantage of surprise.

Hirata pictured an assassin creeping into the edge of his vision. He tried to project a calm, tranquil mood even as his mind wandered to the murder investigation.

Be in the here and now! Don't journey into the past or future. That'll get you killed, you fool!

He couldn't stop worrying about Sano and Reiko's future and his own. Stealing even this brief time for his training could jeopardize them all. He closed his eyes, the better to concentrate on the exercise.

Keep your eyes open! Don't shut out the world! A warrior must learn how to achieve inner peace in any circumstance. Only then can he know the proper actions to take during combat. Otherwise he falls prey to insecurity and confusion.

Soon Hirata's bad leg cramped from standing too long. He shifted, trying to find a more comfortable position.

Don't be distracted by physical sensations. Feel the energy flowing inside you as you breathe.

Alas, the world clamored with stimuli that Hirata couldn't ignore. Rain pelted the roof and sand; the breeze dashed drops against him. Mosquitoes buzzed. Hirata stifled a desire to swat them. His face itched from bites.

Feelings are obstacles within yourself that you must not let distract you. You must learn to exercise control over them. If you cannot, then neither can you exercise control over an opponent during battle.

As Hirata doggedly persevered, Midori came hurrying toward him. "Husband! What are you doing?"

"Nothing," Hirata said, annoyed by the interruption.

"Oh." Midori's face took on a familiar look of reluctant forbear-

ance. She understood how important his training was to him, but she thought it kept him away from home and his duties too much and the risks outweighed the benefits.

"What do you want?" Hirata asked.

"Here's Detective Oda." Midori had brought the samurai with her. "He wants to tell you something."

She flounced away. As Oda approached him, Hirata tried an experiment. He formed a mental image of himself lunging at Oda and projected his mental energy in a wordless, violent threat toward the detective.

Oda joined Hirata in the pavilion. "What's the matter?" he said with a laugh. "Why are you looking at me like that?"

"Never mind," Hirata said curtly. His mental attack should have frightened Oda, but his powers weren't working any better than they had at the temple.

Maybe Midori was right.

"Tell me the news," Hirata said.

"I've investigated Lord Mori's stepson's alibi," Detective Oda said. "I rode to Totsuka and found that Enju seems to have spent the night of the murder at an inn there. His name was signed in the guest book. It's also in the records at the checkpoints along the highway between Totsuka and Edo."

"When do the records say he came back to town?"

"The afternoon of the day you discovered Lord Mori's body."

"So it looks as if Enju didn't have opportunity to kill his stepfather." Hirata was disappointed, but Enju wasn't cleared yet. Records didn't tell the whole story. "Did you find anyone along the road who actually recognized him and remembers seeing him?"

"I asked hundreds of people, but no," Oda said. "The innkeeper and some checkpoint officials recalled a man who went by the name Mori Enju. Their descriptions seem to match him. But we can't be sure that it was really him they saw, or someone else using and signing his name."

"He could have sent someone else out there while he stayed home and murdered Lord Mori. The estate is so big he could have hidden

there with no one the wiser." But Hirata knew this was pure speculation.

"There is a bit of news that might please you," Detective Oda said. "I talked to a patrol guard who knows Enju and remembered him, but not from this trip. He ran into Enju and Lord Mori traveling from their province to Edo just after the New Year. He overheard them arguing on the road."

"Oh? What did they say?"

"The guard thinks Enju said something like, 'No. I won't do it. Not ever again.' Lord Mori said, 'You'll do as I say.' Enju was furious. He rode off, calling over his shoulder, 'You'll be sorry.'"

"Well," Hirata said, gratified, "it sounds as if things weren't as perfect between them as Lady Mori said. Enju certainly bears more investigating."

"That may be difficult because nobody inside the Mori estate will talk about the family," Detective Oda said.

"Even if nobody inside wants to talk, someone outside might," Hirata said.

Seated on the dais in the audience chamber, Reiko took a deep breath, steadying herself for a confrontation that would not be pleasant.

Two guards walked into the room, escorting Colonel Kubota. He was a samurai in his forties with a proud carriage that compensated for his short stature. He wore an ornate armor tunic and metal leg guards, but Reiko knew it was all for show. He spent his days inspecting and drilling troops; he rarely practiced martial arts himself. During the war he'd sat on his horse at the edge of the battlefield, yelling orders to the soldiers; his sword had never left its scabbard.

He used what combat skills he had in more intimate quarters.

He had bland, soft features, his mouth upturned in a permanent smile. Wrinkles around his eyes signified good humor. But his gaze was hard and cruel as he beheld Reiko.

She nodded at her guards. They left, but she'd given them orders to wait outside the door in case she needed them.

Colonel Kubota dispensed with formal courtesies required of a visitor. "How dare you have me dragged away from my work and brought to you?" His voice was quiet, but threatened to blare into furious shouting. Reiko had heard it happen before. "What's this all about?"

"Greetings. Please be seated." Suppressing her revulsion toward him, Reiko gestured to the floor below and opposite her.

He knelt, bristling with resentment. "If you weren't the honorable chamberlain's wife, I wouldn't have come. I'd just as soon spit on you." Although his features remained set in their pleasant lines, anger burned in his eyes. "Isn't it enough that you destroyed my marriage? What more do you want with me?"

"I must remind you that you were the one who destroyed your marriage," Reiko said evenly. "You beat your wife for twenty years. When I met her last summer, she had bruises all over her body. She had dizzy spells because you'd banged her head against a stone floor."

"A man can treat his wife however he pleases," Colonel Kubota huffed. "It's her duty to submit to him. Setsu had no right to bring you into a private family matter."

His wife had heard of Reiko's services to people in trouble and turned to her for help. Reiko remembered how the small, frightened woman had sat in this very room, whispering her tale of torture at the hands of her husband. When Reiko had agreed to rescue her, Lady Setsu had wept with gratitude. She'd also warned Reiko that the colonel would turn his wrath on her.

"You had no right to interfere," he said. "You had no right to take the law into your hands and get Setsu a divorce."

"Someone needed to interfere. And the law should protect innocent citizens from harm." Reiko had gone to her father the magistrate, explained Lady Setsu's plight, and asked him to intervene on her behalf. Magistrate Ueda had granted the divorce, against Colonel Kubota's wishes, in the Court of Justice. He'd also decreed that if Kubota went near his wife, he would be sentenced to live as an outcast for

three years. The decree was not just unconventional, but unheard of. Colonel Kubota had exploded in a fit of rage and shouted curses at his wife, at the magistrate, and most of all at Reiko.

"You took Setsu away from me." His smile was ugly, distorted by animosity. Reiko knew he wasn't angry at her because he loved and missed his wife. "Now she's living in my country villa that you had the magistrate steal from me, on money that he forced me to settle on her."

"It was only fair that you should return the dowry she brought to your marriage," Reiko said. "That villa was part of it. She deserved some compensation for her years of suffering."

"You did more than compensate her." Kubota bunched his fists, as though ready to strike Reiko. "You severed my connection with an important clan. You disgraced me in public." Fury tensed the sinews in his neck. Hatred blazed like flames from him. On the verge of exploding as he had in the Court of Justice, he said, "Someday I'll take my revenge on you."

"Maybe you already have," Reiko said.

Perplexity mingled with his rage. "What are you jabbering about now?"

"Lord Mori has been murdered, and I've been framed. I'm wondering if you had something to do with that."

"Oh. I see." Colonel Kubota's eyes kindled with malicious enjoyment. "You're in trouble, and you think I'm to blame."

"Are you?" Reiko asked.

"What in the world gave you that idea?"

Other than the fact that you hate me? "You knew Lord Mori fairly well," Reiko said, aware of court gossip.

"Yes. So what?" Disdain and impatience tinged his voice.

"If you paid him a visit, he would have let you into his private quarters."

"*If* I did," the colonel said.

Reiko watched Kubota closely, but all she saw was his familiar rage behind his bland, smiling features. "Perhaps you saw me there. Perhaps you saw a good opportunity to pay me back for the problems I caused you."

"And you think I stabbed and castrated Lord Mori? You think I knocked you out, stripped you naked, smeared you with blood, then left you beside him?" Colonel Kubota said, shaking his head in disbelief. "How am I supposed to have done that without anyone seeing?"

"You tell me."

He waved off her prompt, dismissing her theory. "You think I would kill an important *daimyo* who was an ally of Lord Matsudaira, just to get even with you?" An incredulous laugh burst from him. "Don't flatter yourself. You're not important enough for me to take such a risk."

Reiko knew her theory was far-fetched, but she said, "You're a violent man with a quick temper. When you beat your wife, you never expected to suffer any consequences. Maybe you didn't think you would if you killed Lord Mori because I would take the blame."

"Maybe," Colonel Kubota mocked her. "The fact is that I couldn't have killed him. I wasn't there."

Reiko remembered that Sano had said he'd found no evidence of outsiders, except for her, in the estate on the night of the murder. "You could have bribed one of Lord Mori's retainers or servants to kill him."

Colonel Kubota chuckled. "You have all the answers, don't you? Well, what you don't have is proof that I killed Lord Mori and framed you."

"I'll leave the proof to my husband to find," Reiko said, although she was more convinced of her own guilt than Kubota's. "He's investigating the murder."

"You're going to tell the chamberlain your crazy theory?" Fear shone through Kubota's indignation as Reiko saw him imagine the persecution that Sano could bring to bear upon him.

"He asked me to think of people who want to hurt me," Reiko said. "He'll be interested to hear about you."

"You mean that you and he will try to pin the murder on me, in order to save your pathetic skin." The muscles in Kubota's face twitched while his breath puffed loud with his rage. "As if you haven't already

done enough to ruin me, now you're going to accuse me and drag my honor through the mud. Well, I won't let you get away with it!"

He lunged at Reiko, his hands extended to grab, his eyes filled with murderous intent. She reached inside her sleeve and whipped her dagger from its sheath.

"Stop!" she ordered. "Don't come any closer!"

Even as she thrust the blade at him, her guards burst into the chamber. They seized his arms. He struggled, his face so distorted, so savage, that he looked like a monster. This must be how his wife had often seen him. Lady Setsu was safe now, but Reiko's own heart thudded with lingering fright. He would have killed her had she not taken precautions.

"Show Colonel Kubota out," she told her guards. "We're finished."

"Oh, no, we're not," he shouted as they hauled him toward the door. "You'll be sorry you ever crossed me, you little whore! I'll see that you pay for what you did to me!"

20

Ueno Temple district was located at the northeast corner of Edo, the "devil's gate." Built to guard the city against evil influences from that unlucky direction, it occupied hilly, rural terrain. Houses and shops lined the road to the foot of the hill crowned by Kan'eiji, the main temple. Sano and his entourage joined crowds of pilgrims passing by the Kanda fruit and vegetable market and the quarters of the shogun's infantry escort. Along a side road that skirted Shinobazu Pond, teahouses sold rice steamed in leaves from the pond's famous lotus plants. On the firebreak outside the district, food stalls, souvenir and gambling booths, itinerant preachers, dancers, acrobats, and tightrope walkers abounded. As Sano crossed one of three small bridges over a stream, passed through the Black Gate, and rode up the hill along an avenue lined with cherry trees, a pang of nostalgia saddened him.

Here at Kan'eiji, he'd met Reiko for the first time, at the formal meeting between their families. They'd strolled among blossoming trees while they covertly studied each other. How young and beautiful she'd been! He could hardly believe that nine years had passed since then, or that the love and happiness they'd found together might soon be destroyed.

He and his party arrived at the nunnery, which was secluded be-

hind a high bamboo fence. In a garden outside a building with half-
timbered walls and a veranda overhung with wisteria vines, little girls
chased one another around flower beds. They squealed with delight
and high spirits. Sano thought they must be novices, or orphans taken
in by the convent. A nun with a shaved head and severe features,
dressed in a plain hemp robe, watched over them. She caught sight of
Sano, clapped her hands, and said, "Girls!"

They scrambled into a line and fell silently to their knees. The nun
bowed to Sano. The girls followed suit.

"Welcome, Honorable Master," said the nun. "How may I serve
you?"

Sano introduced himself. "I want to talk to Lady Nyogo. Please
bring her to me."

"I'm sorry, but there's no one here by that name."

The nun's tone was even, her manner sincere, but Sano per-
ceived the lie they concealed. "Have you been ordered to hide
Nyogo?"

She hesitated, glancing at the girls frozen in their row near her.

"Did someone threaten to punish them unless you kept Nyogo
away from me?" Sano asked. "Was it Police Commissioner Hoshina?"

Her face stiffened. She didn't answer.

"If you bring me Nyogo, I'll protect your girls," Sano said. The nun
didn't move; she obviously didn't put much faith in his protection. Al-
though he hated to threaten, he saw no expedient alternative. "If you
refuse, I'll punish you myself."

She inclined her head. "Girls, go inside and study your lessons."
They scrambled up and filed into the building. She followed them.

Sano waited. Soon the nun appeared in the doorway shadowed by
the wisteria vines. She had her hands on the shoulders of a small
woman, whom she propelled onto the veranda. Leaving the woman
there, she retreated. The woman stood, arms folded, her face averted
from Sano, gazing sideways at him.

At first he didn't recognize Lady Nyogo. She wore a plain indigo
cotton kimono instead of the bright robes he'd last seen on her. Her
hair was knotted atop her head instead of hanging in a braid. She was

a decade older than she'd looked at the séance—not a girl, but a full-grown adult in her twenties.

As Sano walked toward Nyogo, her face took on the expression of a cornered dog. She sidled along the veranda, then turned and bolted.

"Stop!" Sano bolted after her.

Nyogo ran, skirts flying, across the garden toward the gate. She saw Sano's entourage outside, veered, and raced to the wall. As she climbed it, Sano caught her sash. He yanked hard; she tumbled down onto the ground. She clambered to her feet and faced Sano.

"Why did you tell that story full of lies about me yesterday?" Anger roughened his voice.

"I didn't," Nyogo said. Her voice was deeper than during the séance, with a brazen tone. "It was Lord Mori. I only said what his spirit told me to say."

"Oh, I don't doubt that you were told what to say. But it wasn't by Lord Mori. You're a fraud."

"No. I communicate with the dead. They speak through me." Although Nyogo backed up against the wall, she met Sano's gaze. Hers was bright with nerve and guile.

They both knew she had nothing more to lose by defying him than by admitting her fakery. Well, Sano would give her more. "I could kill you for what you said about me."

Her eyes darted, seeking rescue. "You can't. I'm the shogun's favorite medium. He believes in me."

"The shogun isn't here to save you," Sano said. "Your life is in my hands."

"He won't like it if you kill me." Nyogo's voice trembled.

"He's probably forgotten you already." Sano spoke with conviction born of his knowledge of the shogun's flighty mind. "The longer you're away from court, the less likely he is to remember that you exist, let alone care about you."

Nyogo flung up her hands in self-defense. "If you touch me, he'll punish you," she insisted, although fear shone through her craftiness.

Sano shook his head. "He won't know I did anything to you. You're going to disappear without a trace. No one will ever know

what happened to you. Except you, and me." He pointed his finger at her, then himself.

Her mouth twitched. Calculation glinted in her eyes. "But if I cooperate with you . . . ?"

"Then I'll spare your life," Sano said.

Nyogo hesitated, then said, "That's not enough. If I tell you what you want to know, my life is worth nothing. Force me to talk, and I'm a dead woman."

"Die now, or take a chance on surviving later." Sano stifled the pity he felt for her, a pawn of powerful men. "It's your choice."

She wilted and sighed. Sano was as much shamed because he'd coerced this deceitful but hapless woman as relieved that she'd capitulated. This was exactly the kind of thing the former chamberlain Yanagisawa would have done. Sano stepped back from Nyogo and said, "Who told you to lie about me?"

"It was Police Commissioner Hoshina," she said reluctantly.

It was just as Sano had suspected. Satisfaction eased his guilt at how he'd obtained her confession. "He told you to say I was plotting to overthrow Lord Matsudaira?"

". . . Not exactly. There wasn't time before the séance for him to tell me what to say. But I'd been listening outside the shogun's audience chamber. I had an idea of what was going on. And Hoshina-*san* had said I should use whatever chance I got to make you look bad to the shogun."

"When did he say that?"

"Two years ago. When he brought me to the palace."

Sano felt a grudging admiration for Hoshina's ingenuity. Hoshina had planted Nyogo inside the court to undermine his enemies' influence with the shogun. Sano had underestimated Hoshina, whom he'd always deemed more rash than clever.

"The séance was my big chance," Nyogo continued. "So I made up that business about you and your wife and Lord Mori." She smiled, mischievous and proud of herself. For a moment she resembled the child she'd appeared to be yesterday. "It was pretty good, wasn't it? Hoshina-*san* was very pleased."

"No doubt." Sano was as impressed by her inventiveness as by her performance. Now he knew the reason for that peculiar look he'd seen on Hoshina's face when the shogun had suggested the séance. Hoshina had been hoping that Nyogo would perform to his advantage and afraid she would let him down. She'd acquitted herself so spectacularly that Sano's interest in her went beyond the valuable information she'd just given him.

"Who are you?" he asked. "Where did you come from?"

"My name really is Nyogo," she said, "but I'm not a noble lady. My parents are fortune-tellers in the Ryōgoku entertainment district. When I was young, they taught me their trade. I learned how to guess what people are thinking and what they want to hear. I pretend to be a little girl, because that way they trust me."

"I see." Intrigued despite his distaste for such fraud, Sano asked, "Then you branched out into doing séances?"

"Yes. My mother thought I would be good at it. And I am," Nyogo said, matter-of-fact.

"How did you meet Police Commissioner Hoshina?"

"There was talk around the district that he was looking to hire a medium. He was offering lots of money. Anyone who wanted to apply should go to his house. I went. There were lots of other people. He tried us all out and picked me."

Sano imagined Hoshina auditioning mediums, looking for the one who could play upon the shogun's susceptibilities, who could further his own aims. "Well, I think he chose well."

"Do you?" Nyogo's eyes sparkled with cunning. She cocked her head and clasped her hands behind her back, in the pose of a small, beguiling child. "I could work for you instead of Hoshina-*san*, if you like."

"Oh, you could, could you?" Sano said, impressed with her quick-thinking audacity.

"Yes. I can make the shogun think you're wonderful and Hoshina is a traitor instead of the other way around. He listens to me—or rather, he listens to his dead ancestors who speak to him through me."

Sano inwardly shuddered to think that the day had come when he must resort to such deceit to keep his place at court. "No thank you."

"Are you sure?" Nyogo's cheeks dimpled. "I can really help you."

"I'm sure." Even though deceit had kept Yanagisawa in power for some twenty years, Sano couldn't trust a turncoat like Nyogo.

"You aren't going to just leave me here, are you?" Fear turned her voice shrill, aged her face. "Police Commissioner Hoshina will find out I talked to you. He'll kill me." She extended her clasped hands to Sano. "You have to protect me. I beg you!"

"Don't worry," Sano said. "You're coming with me."

She was his only witness against Hoshina, his only source of evidence that he was not a traitor nor Reiko a murderess. He wasn't about to let any harm come to Nyogo.

While his men took her to a good, safe hiding place, he would have a little talk with Police Commissioner Hoshina. It was high time they settled a few matters.

A ferryman rowed Hirata and Detectives Inoue and Arai across the Sumida River. The rain-stippled waters lapped high against their banks. The men huddled under the windblown canopy until the boat docked at the eastern suburb known as Mukojima—"Yonder Isle."

Across the embankment spread a pleasure resort where crowds viewed the cherry blossoms in spring, the harvest moon in autumn, and the snow in winter. It was drenched and desolate now. Hirata and his men rented horses at a stable. They rode past the Mimeguri Shrine, into countryside that had once been the Tokugawa hunting grounds. The current shogun, a devout Buddhist sworn to preserve animal life, had banned hunting. Now vegetable gardens and rice paddies lay quiet and peaceful under the gray sky. Peasants no longer dominated by game wardens worked their fields. Hirata and his men dismounted near some thatched huts.

They'd spent the morning on a hunt for people formerly employed at the Mori estate. Archives in the ministry that supervised the *daimyo*

class had yielded the name of the Mori clan physician who'd left the estate two years ago. Physicians to high society were a small, exclusive group, and Hirata had tracked Dr. Unryu, through his friends, to this village.

After knocking on a few doors, Hirata found a middle-aged woman who said, "Dr. Unryu is my father. Please come in." She led the way to a backyard where an elderly man crouched by a pond, dropping crumbs into the water. "Father, you have visitors."

Dr. Unryu's face was benign, creased with many wrinkles, and marked with age spots. He smiled and bowed. "Greetings."

Hirata and his men joined Dr. Unryu by the pond. Gigantic orange carp surfaced amid lily pads and gobbled the food. "Those are nice fish," Hirata said.

The doctor nodded, gratified. He strewed the remaining crumbs and rose shakily to his feet. "Breeding them is my hobby since I retired. I used to work for the Mori clan. I was their physician for twenty-eight years."

"That's why we've come to see you." Hirata introduced himself and his men. "We're investigating the murder of Lord Mori, and we need your assistance."

"Murder? Lord Mori? How terrible." Concern deepened the wrinkles around Dr. Unryu's eyes, which were still clear and intelligent. "How did it happen?"

Hirata explained that Lord Mori had been stabbed to death, but omitted the details. "Everyone in the household is a suspect. That includes Lord Mori's wife and stepson. I need to know about their relations with him."

Dr. Unryu hesitated.

"How did he treat them?" Hirata prompted. "How did they get along?"

"When I left his employ, he told me to keep everything I'd seen or heard at his estate to myself," Dr. Unryu said.

"I'm sure he wouldn't mind your disobeying his order if it could help us catch his killer," Hirata said.

Dr. Unryu shook his head; his brow creased in thought. "I presume that Enju is Lord Mori's heir?"

"Yes."

"Lord Mori has been paying me a pension since I retired. It's not much money, but it supports my daughter and me. If Enju should find out I talked to you, he might take it away."

"If Enju takes it away, I'll pay it." Hirata sensed that the doctor had information well worth the expense.

Reassured, the doctor nodded. "I should mention that I didn't have much to do with Lord Mori, his wife, or Enju. They were blessed with good health; they didn't need me very often. I mostly treated other people at the estate. But I recall two things that you might like to know about. The first happened the year before I retired. Lord Mori took ill with severe chest pains. It was heart trouble. He almost died.

"I was constantly at his bedside. So were his chief retainers. But Enju never came near him." Disapproval inflected Dr. Unryu's voice. "His heir should have comforted him, or at least paid the respects due to him. I thought it very strange that Enju didn't."

Hirata thought that Enju's behavior didn't jibe with his mother's story about their idyllic family life.

"Neither did Lady Mori," said the doctor. "Every day she asked me how her husband's health was, but she never even spoke to him. And Lord Mori never asked for her or Enju. It seemed he knew they wouldn't come."

It sounded to Hirata as if the widow as well as the heir had been on bad terms with Lord Mori. Perhaps Lady Mori and Enju had been so sorry he'd survived that they'd done away with him themselves. But Hirata needed more than just speculations to back up this theory. A motive would help.

"Why do you think they acted that way?" he asked.

"I don't know. None of the family ever confided in me."

"What was the other event you remember?"

"Something from when Lord and Lady Mori had recently married.

Lady Mori and Enju had lived in the estate for just a short time. Enju was quite a lively, friendly little boy. He liked to watch me prepare medicines. He asked clever questions and seemed truly interested in the answers. But after a while he stopped coming to see me. I thought he'd found other things to do. Then one day Lady Mori summoned me.

"She said Enju had been having bad dreams, waking up and scream-ing at night. And he'd been wetting his bed. She asked me to cure whatever was wrong with him. When she brought him to me, I was shocked at how much he'd changed. He was quiet, sullen. When I tried to examine him, he didn't want me to undress him or touch him. He cried and fought so hard that I couldn't perform an examination."

"What did you do?" Hirata asked.

"I gave him tea brewed from mantis egg case, dragon bones, and oyster shells for incontinence, and licorice, sweet flag root, and biota seeds for nervous hysteria."

"Did he get better?"

"I had only Lady Mori's word for it. After I'd treated him for a few days, she told me to stop; that was enough."

"Did you ever find out what was wrong with Enju?"

"No. But I had a distinct feeling that Lady Mori knew."

Hirata thanked Dr. Unryu. As he and the detectives rode away from the village, Arai said, "Something must have been pretty wrong between Enju and Lord Mori, if Enju wouldn't even visit Lord Mori on what looked to be his deathbed. Do you think it had anything to do with his murder?"

"I'm sure." Hirata had a strong albeit unfounded hunch. It might have been the cause of the argument between Lord Mori and Enju, in-volving something Enju had been ordered to do but didn't want to, overheard on the road.

"What do you think Enju's childhood problem was?" Inoue said. "Could it be related, too?"

"I don't know, but maybe," Hirata said. "It sounds as if something bad happened to him after his mother married Lord Mori. But what-ever it was, Enju lied about his relationship with his stepfather. He has a little explaining to do. So does Lady Mori."

21

"With all due respect, Lady Reiko, but maybe this isn't such a good idea," Lieutenant Asukai said.

In the back entryway of the private chambers, Reiko put on a shaggy straw rain cape. "I can't just sit home and wait any longer. I must help my husband find out who killed Lord Mori." After her clash with Colonel Kubota had failed to prove that it wasn't him, she felt more desperate to solve the mystery. "And I know of more people who need to be investigated."

"Tell Chamberlain Sano or *Sōsakan* Hirata. Let them investigate," Asukai suggested.

"They have enough to do already." Reiko slipped her feet into thick-soled wooden sandals that would raise her above the puddles in the streets. "If my clues don't lead anywhere, it's better that I wasted my time than theirs."

Concerned and protective, Asukai said, "Let me go find your suspects and bring them here to you."

"It will be quicker if I go myself."

"I could talk to your suspects for you. Just tell me what to ask them."

Yet Reiko thought this was no time for a solo test of his untried detective skills. "I appreciate the offer, but I've made up my mind."

"You shouldn't leave the compound," Lieutenant Asukai persisted. "If Lord Matsudaira finds out, he won't like it."

"He won't find out," Reiko said, bundling her hair up inside a cotton kerchief.

"If people should see you—"

"They'll never recognize me." Reiko clapped a wicker hat on her head, picked up an umbrella and a basket. She looked for all the world like a maid going on an errand.

Lieutenant Asukai frowned, troubled enough to oppose his mistress. "It's dangerous outside." He stood between Reiko and the door. "And it's not just your own safety you're risking."

"If we don't solve this case, I'll be executed. My baby will never be born," Reiko said. And she couldn't bear to think that it might be the child of a murderess. She must prove otherwise. "Either help me, or please stand aside."

Resignation drained the fight from Lieutenant Asukai. He opened the door to the wet, gray day, but he said, "You can't take your palanquin. People will know it's you inside. And you can't walk far in your condition."

"There's a place down the boulevard from the main gate where I can rent a *kago*." The basket-chairs, suspended from poles and carried by men for hire, were a cheap form of public transportation. "You and my other guards will meet me there and follow me at a distance."

She made her way through Edo Castle's passages and checkpoints without incident. She'd learned from past experience that maids were virtually invisible. Soon she was seated in the swaying, jouncing *kago* while its bearers trotted toward town. A sense of freedom exhilarated her. She felt buoyed by hope, vibrantly alive.

Reiko tried to forget that she might not be free or alive much longer.

The trip to and from Ueno had taken Sano all morning and part of the afternoon. Now, eager for his confrontation with his enemy, he rode with his entourage through the Hibiya administrative

district. He'd never been to Police Commissioner Hoshina's house—they weren't exactly on visiting terms. He was almost as curious to see how Hoshina lived as determined to wring some facts out of him.

Hoshina had an estate near the edge of the district. It was one of the farthest from Edo Castle. Only a road and a drainage canal separated its perimeter wall from the Nihonbashi merchant quarter. This location could owe to Hoshina's low seniority at court or the fact that police carried a taint of death from the executions they ordered. Furthermore, his position in Lord Matsudaira's inner circle had always been shaky. But he'd made the most of his estate.

Sano and his men dismounted outside a gate with triple-tiered roofs and double doors hung on polished brass pillars. Hoshina's family crest adorned a huge banner that drooped in the rain. Sentries wearing flashy armor greeted Sano in a polite but cold manner. A horde of troops accompanied Sano and his men into the estate. If Sano hadn't already known he was entering hostile territory, there was no mistaking it now.

The troops led him inside a mansion so big that it dwarfed its ground. The corridors were floored with shining cypress, the coffered ceilings painted and gilded in the same style as the shogun's palace. Servants hovered in rooms furnished with teak cabinets, metal filigree lanterns, and lacquer tables of the finest workmanship. The air smelled of expensive incense. Hoshina's voice carried down the corridor toward Sano.

"That's not big enough."

"But if we make it any bigger, it will be practically right up against the wall," said another man's voice. "You won't have any view."

"I don't care about the damned view," Hoshina said. "I want a reception room that's fine enough for important guests."

"We'll have to enlarge the foundation. That will cost a lot extra."

"To hell with the cost. I won't have people thinking that I'm some rustic from the provinces who doesn't know how to entertain. I won't have them laughing behind my back at me."

Sano and detectives Marume and Fukida reached the threshold of a room of modest proportions, filled with gray, humid, outdoor air.

Inside, Hoshina stood with a samurai who held an architectural plan they were examining. The doors along one wall were open, revealing stone blocks set in the muddy ground, a base for an extension that would double the room's size. Hoshina looked up from the plans at Sano.

"What are you doing here?" His face showed offense that Sano would visit him without invitation, and fear that Sano had overheard him and he'd exposed himself.

Sano felt a twinge of pity for Hoshina, who was so insecure, cared too much about other people's opinions, and thought fine, expensive material things would make up for his lack of self-worth. But pity didn't ease their mutual antagonism. And Hoshina's human foibles didn't make him any less dangerous.

Quite the contrary.

"I have news that you might find interesting," Sano said.

Hoshina raised his eyebrows in hopeful, exaggerated surprise. He clapped his hand over his heart. "Your wife has been convicted of murder. She's on her way to the execution ground. And you're soon to follow."

"I'm sorry to disappoint you," Sano said. "What I've come to tell you is that I've had a talk with a friend of yours."

"Who would that be?" Hoshina glanced at the architectural plans as if impatient for Sano to leave so he could go back to his business.

"Lady Nyogo," Sano said.

Hoshina's head snapped up. He tried to conceal his dismay, but failed. "How——?"

"It's hard to keep a secret in Edo," Sano said. "You should remember that the next time you want to hide a witness in a murder investigation. Especially one that has conspired with you to bear false evidence."

"I don't know what you're talking about." Hoshina waved his hand at the architect and said, "You're dismissed. Redo those plans." The architect left. Hoshina said, "I never conspired with Lady Nyogo. I don't even know the woman."

"That's not what she says. She told me all about how you planted her in the shogun's court. Do you want to hear what else she said?"

"She said all she needed to at the séance. She revealed your plot to overthrow Lord Matsudaira."

"She's admitted that the séance was just an act," Sano said, "and the story about me was pure fabrication. She also confessed that you put her up to it."

"That's sheer, ridiculous rot." Hoshina made a sound of disgust. "What did you do, beat her until she told you what you wanted to hear?"

"Not at all," Sano said. "I just convinced her that giving you up was in her best interests."

Hoshina stared in consternation, but recovered. "She obviously lied about me to save her own skin from you. It's her word against mine. She's a peasant woman; I'm the police commissioner. Nobody's going to believe her."

"I wouldn't be too sure about that," Sano said even though Hoshina had a point. "Your plan to use Lady Nyogo to manipulate the shogun worked a little too well. She's got him eating out of her hand. All she needs to do is hold a séance and have one of his ancestors tell him I'm innocent and you forced her to make up that story from Lord Mori's ghost." Sano added, "Incidentally, you shouldn't have been so quick to trust Nyogo. She was quick to betray you and offer to work for me."

"According to you."

But Hoshina was clearly disturbed that his plan might have back-fired. He gazed at the unfinished extension, as if wondering whether he would live to complete it. Then he turned to one of his guards; a glance passed between them. The guard started out of the room.

"In case you're going to the convent to silence Lady Nyogo, don't bother," Sano said. "She's not there anymore."

The guard halted. Hoshina's lips moved in a soundless curse. Sano said, "You'd have done better to kill her to keep her quiet. Did you think you could hide her until Lord Mori's murder case was settled, then bring her back to court and use her again?"

"Do you think you can hide her while you try to wiggle your way out of trouble?" Hoshina's eyes gleamed with his intent to brazen his own way out of trouble. "I have an idea: Let's both go visit Lady Nyogo and ask her what the truth is."

"Forget it." Sano wasn't allowing Hoshina near the only person who could remove suspicion from Reiko and himself and point it elsewhere.

"If you expect her to do you any good, you can't keep her under wraps forever. You'll have to bring her forward to testify in your defense." *And I'll get her before she can,* said Hoshina's grin.

"You overestimate your abilities," Sano said. "Do you really want to gamble that you can come out ahead of me? Miss your chance at Lady Nyogo, and she'll reveal that you forced her to trick the shogun. He won't like that you played him for a fool. And Lord Matsudaira won't like that you clouded the waters around the murder case by using it to further your personal ambitions. You'll find yourself kneeling on the execution ground with your hands chained behind your back and your head lying in the dirt in front of you."

"That's wishful thinking," Hoshina scoffed.

But Sano saw through Hoshina to his weak core of insecurity. His cowardice trembled behind the nerve he wore like an armor suit that was too big. "If you want to die, fine. But I'm going to give you a chance to save your life."

Hoshina narrowed and shifted his eyes, suspecting a trick, calculating risks.

"Admit to the shogun and Lord Matsudaira that Lady Nyogo falsely incriminated my wife and me in her séance because you ordered her to do it," Sano said, "and I'll lighten your sentence."

"My sentence? For what?" Hoshina seemed to realize that Sano was talking about more than the penalty for deceiving their superiors. Fright showed on his face.

"For murdering Lord Mori," Sano said.

He'd hoped to surprise Hoshina into betraying some sign of guilt. But Hoshina's mouth fell open in shock that was either genuine or

such a good imitation of an innocent, wrongly accused man that Sano had underestimated his acting talent.

"I didn't murder him," Hoshina said. "You must be insane!"

"You stood to benefit from the murder," Sano said. "Frame my wife, bring me down at the same time."

"That's ridiculous!" Hoshina demanded, "How would I have framed Lady Reiko? How would I have even known she was in the Mori estate?"

"The same way you know many other things that happen around Edo," Sano said, alluding to the police's network of spies. "Accept my offer, and I'll convince Lord Matsudaira to let you keep your head."

Hoshina spat air. "I was at a banquet at the treasury minister's house that night. There were twenty other guests. They'll tell you I was with them. It lasted until dawn. I couldn't have killed Lord Mori."

This alibi didn't alleviate Sano's suspicions. "You have plenty of people to do your dirty work for you."

"Why would I have killed Lord Mori? He was an important ally of Lord Matsudaira." Increasingly agitated, Hoshina stomped in a circle, as if trapped in the logic that Sano was weaving around him and trying to bull his way out. "Merciful gods, do you think I'm as mad as you are?"

"Give up now, and maybe you won't even be banished," Sano said. "I've heard that you're having problems with the *daimyo* class. You've been charging them big fees for police protection, then harassing their troops unless they pay." Sano had his own spy network to thank for the information. "The last thing Lord Matsudaira needs is trouble between his regime and the *daimyo*. The last thing you want is trouble between you and him. And trouble is what you'll get if he should find out that you've been robbing his allies to pay for enlarging your house."

"Shut up!" Hoshina yelled. "That's none of your business. It has nothing to do with the murder."

"Did Lord Mori threaten to report you? Is that why he had to die?" Sano added, "If you make a deal with me, I won't tell Lord Matsudaira

what you've been up to. I may even be generous enough to let you keep your post. This is your last chance."

Hoshina stopped circling; he faced Sano. There was a long moment of silence fraught with his urge to leap at immediate salvation rather than trust his ability to weather the future. Then he said, "For the last time, I didn't kill Lord Mori." Each word was spoken through teeth bared in a snarl and underscored with antagonism. "And you can't prove I did. You can take your offer and shove it up your behind."

Detectives Marume and Fukida and Sano's guards bolted toward him, ready to avenge the insult to their master. Hoshina's men surged to restrain them. The room vibrated with tense muscles and breaths held.

"You'll regret that you turned me down," Sano said evenly. "You're not as good at covering your tracks as you think you are. When I'm finished with this investigation, we'll see who wins this ridiculous feud that you've been waging with me."

Hoshina laughed, reckless. "Why wait until then?" Sweat droplets glistened on his forehead. "Let's settle things right now. Bring Lady Nyogo before the shogun and Lord Matsudaira. I won't stop you or lift a finger against her. We'll just see who believes her or not."

Sano was vexed because Hoshina had called his bluff. Lady Nyogo was the only card he held, and it was too risky to play. Even if she did admit the truth about the séance to their superiors, it was anyone's guess how they would react. In the past Sano had always managed to bring them around to his point of view, but there was always a first time. And Sano had goaded Hoshina into fighting for survival just as hard as Sano would. To take his stand now was tantamount to riding into battle with an untested sword. And the stakes—Reiko's life as well as his own—were too high.

Especially with mounting evidence that Reiko was guilty and his own worsening doubts that she was hiding facts that could incriminate her.

"We'll see," was all Sano could say.

He and his entourage strode from the room with as much dignity as they could muster, on a burst of Hoshina's laughter. "You're afraid," Hoshina called after them. "You're afraid you'll lose!"

．　．　．

Outside, while they mounted their horses, Detective Marume said, "Good try, but that didn't go exactly how we planned."

"Thank you for pointing it out," Sano said as they rode through the administrative district and the rain showered them. For that one moment he'd almost had Hoshina!

"If you don't mind my saying, you should have gotten rid of that bastard a long time ago," Marume said. "It would have saved you a lot of trouble."

"Maybe." Even though he saw the benefits of political assassination, Sano felt bound by honor to resist the temptation. He was sick of Hoshina's schemes, but sicker at the thought of becoming as corrupt, self-serving, and destructive as his predecessor.

"It's not too late," Fukida said.

Sano smiled wryly. "Hoshina is worth more to me alive than dead right now, even though I agree that I'll have to eliminate him somehow and very soon." He could feel a showdown coming like a distant fire through a forest. "He's my primary suspect. I can't kill him before I can place the blame for the murder on his shoulders—if in fact he deserves it."

"Well, I don't think we'll get any further with him," Marume said. "What's our next move?"

"We'll try another path to the truth," Sano said. "If Hoshina is guilty, it's bound to lead us back to him."

22

An uncomfortable ride in the *kago* took Reiko to the south end of the Nihonbashi Bridge that spanned Edo's main canal. Here was the geographical center of the town, the spot from which all distances in Japan were measured, and the starting point of the Tokaidō, the road that linked Edo with the Imperial Capital in Miyako. Travelers arriving in or leaving town crowded around large wooden placards, bearing official notices, that were erected near the foot of the bridge. At quays spread along the canal, dockworkers hauled bamboo poles, vegetables, barrels of sake, lumber, and bales of rice from boats to warehouses. The *kago* bearers stopped at Reiko's destination, the entrance to a road beyond a wholesale market.

Lieutenant Asukai and her other escorts, who'd ridden on horseback some fifty paces behind her, caught up with her as she heaved herself out of the basket-chair. She asked the bearers to wait for her. Her escorts walked with her past the shops and food stalls along the street, which was divided at midpoint by a deep, narrow drainage canal. Crossing the bamboo bridge, she paused to gaze at the brown water that flowed sluggishly between steep stone embankments, the scene of a murder two years ago.

A dead thirteen-year-old girl named Akiko had been pulled out by garbage collectors who'd spotted her floating corpse. At first it

seemed an unfortunate accident—she'd slipped on the muddy path, fallen in the water, and drowned. But when her family had prepared her body for the funeral, they'd discovered bruises around her neck. She'd been strangled to death, then dumped in the canal.

"It's a disgrace that somebody could do that," Lieutenant Asukai said, echoing Reiko's thoughts. "Especially since she was with child."

Her family had also discovered that Akiko was pregnant, a fact she'd hidden beneath loose clothing. Reiko felt her stomach muscles tighten around her own unborn child as she said, "He was desperate. But that's no excuse for murder."

"At least he didn't get away with it," Asukai said.

They proceeded to a building that contained a barbershop in which men sat smoking and chatting while barbers trimmed their hair or shaved their faces. Reiko and her guards went down a passage to the rear of the building, which faced the backs of other shops across an alley. When she knocked on the door to the proprietor's living quarters, a maid answered.

"I've come to visit your mistress," Reiko said.

The maid looked down her nose at Reiko's humble garments. "Whom should I tell her is calling?"

"Lady Reiko."

The name dissolved the maid's haughtiness: She knew Reiko was always welcome in this house. "Please come in."

She seated Reiko and Lieutenant Asukai in a parlor that contained modest but good-quality furnishings—fresh tatami and cushions covered with tasteful, printed fabric on the floor, a wall of polished wooden cabinets. An altar in the corner held an unlit candle and incense burner, a rice cake and sake cup, and a doll with a rosy china face, dressed in a red kimono.

A woman hurried in. She was small and fragile, in her thirties but with hair streaked with gray and soft skin lined by hardship. "Lady Reiko!" she exclaimed. "How wonderful to see you again."

Reiko saw as much pain as pleasure in her smile. She regretted the bad memories that the sight of her had surely revived in the woman.

"I'm sorry to arrive without warning. I hope I'm not causing you too much trouble."

"None at all," the woman said. She knelt and bowed to Lieutenant Asukai. "May I offer you both some refreshments?"

"No, thank you, we've already eaten," Reiko said in customary, polite response.

"Oh, but you must have something. And I must fetch my husband."

"I wouldn't want to take him away from his work."

"Don't worry. He'll want to see you."

She summoned servants, who spread a lavish repast of tea, cakes, and wine before Reiko and Lieutenant Asukai. Reiko was moved yet shamed by the generosity that she felt she'd done little to deserve. After they'd eaten, the barber joined them.

"Greetings!" His voice was hearty, his face a likeable blend of intelligence and good nature. He smelled of the camellia oil he used to dress his customers' hair. "It's been a long time since we last met. I hope you're well?" His gaze noted her thickened figure. "Shall I wish you congratulations?"

Reiko saw memory dim his eyes. "Yes. Thank you."

The sight of a pregnant woman must forever cause him pain. The sad shadow of Akiko darkened the room. Her baby had died with her; she would never give her parents grandchildren. Everyone looked at the altar that enshrined her favorite doll.

"It is we who should thank you, Lady Reiko," the barber said. His wife nodded. "You brought our daughter's killer to justice when no one else would."

The police had given Akiko's murder scant attention because they were busy helping the army hunt fugitive rebels. After a few cursory inquiries, they'd concluded that Akiko had been killed by a stranger passing through the neighborhood. Her parents, unsatisfied, had written to Reiko.

Upon questioning folk in the neighborhood, she'd learned that a certain young man had been seen near the canal the night Akiko died. He was a clerk named Goro, employed by her father; he had a reputation as a bully and womanizer. At first the other workers at the bar-

bershop had been too afraid of Goro to speak against him, but Reiko had convinced them that if they did, they wouldn't have to worry about him anymore. They'd told her he had bragged that he'd taken advantage of Akiko. Reiko and her guards had taken him aside for a little talk.

Cornered, he'd claimed that the girl had been his willing partner in sex. He'd claimed he hadn't known she was pregnant and hadn't killed her. Reiko hadn't believed him; rather, she'd suspected he'd raped Akiko, and when she'd told him she was expecting his illegitimate child, he'd wanted to be rid of her, Reiko had convinced Magistrate Ueda to charge Goro with murder. During his trial, Goro had broken down and confessed that he'd killed Akiko because she'd threatened to tell her parents what he'd done to her and he didn't want to lose his job.

Now Akiko's father said, "After Goro was convicted, I promised that I would do anything I could to repay you. If you ever need my help, all you have to do is ask."

"I need your help now. That's why I'm here," Reiko said. "Perhaps you've heard that Lord Mori has been murdered, and I am the chief suspect."

The couple exclaimed in astonishment: The news hadn't yet trickled down the social scale to them. The barber said, "But of course you're innocent."

His wife said, "No one who knows you could think you would ever do such a thing."

Their faith in her moved Reiko, especially since friends of her own social class had abandoned her and she'd lost faith in herself. Tears she'd kept under control threatened to flow. She said, "I'm trying to find out who killed Lord Mori and framed me. It has to be someone who wanted to hurt me or my husband or both of us."

"It can't be Goro. He's dead," the barber said. The clerk had been executed soon after his trial.

"I was thinking of his family," Reiko said.

As soon as Magistrate Ueda had pronounced Goro guilty, his parents had exploded into loud, hysterical rage. His mother had shouted

at Reiko, "My son is innocent! You hounded him into confessing! May the gods strike you down and your spirit be reborn into a life of misery!" Both parents had been dragged from the court, still cursing Reiko.

"Where are they now?" Reiko asked.

"They moved away from the district," said the barber.

"Their son's disgrace was too much for them," his wife clarified. Her expression showed pity. "They were shunned by everyone in the neighborhood."

Reiko admired her generous spirit that had sympathy to spare for the suffering of their daughter's murderer's kin. "Can you tell me where they went?"

The barber shook his head. "They left in the night. No one saw them go. They didn't even tell the neighborhood headman where they were moving."

As she fought disappointment, Reiko said, "If you hear anything about where they might be, will you let me know immediately?"

"Of course," the barber said.

Reiko thanked the couple for their kindness. They accompanied her and Lieutenant Asukai to the door, where the wife said, "I'll chant prayers for good luck for you, Lady Reiko."

"I hope the gods listen to her," Asukai said as he walked Reiko down the path. "What do you want to do now?"

"Look for Goro's family. Maybe the neighbors have heard news of them."

Asukai's expression was dubious, skeptical. "They certainly had a grudge against you, but I can't see them as capable of killing Lord Mori or setting you up. They're just simple, merchant-class folk. How could they have gotten close enough to a *daimyo* to kill him, never mind think up a scheme to get you in trouble for it?"

"I've already thought of that."

"Then how can you believe they're responsible for what happened to you? Why spend any more time on them?"

"Because there are connections and patterns that are invisible to us.

And because I remember the last thing Goro's mother said to me when she cursed me."

The words spoken two years ago echoed in Reiko's mind, a threatening prophesy of the future now about to come true. " 'Someday you'll find out what it's like to be punished for something you didn't do.' "

A walled enclave within Sano's compound held valuables that included money, government records, and spare household furnishings. "I want to look at those weapons that Hirata-*san* found," Sano told the guard who let him and Marume and Fukida through the gate. The weapons were the only material clue found during his entire investigation. He hoped a close examination of them would yield important facts. "Where are they?"

Square, identical storehouses, built with thick plaster walls, tile roofs, and iron doors to protect their contents from fire, stood in rows like a small, deserted city. "Here," the guard said, opening the door of one storehouse.

Marume and Fukida entered and opened the shutters. Following them inside, Sano breathed dank air that smelled of metal and grease. He peered through the dimness at the thirty wooden crates on the floor.

"I need more light than this," he said.

The detectives helped him move the crates onto the pavement outside. Fortunately the rain had paused. An eerie, silver glow lit the early evening sky. The air was still warm, and Sano and his men sweated while working. When they had the crates lined up between the storehouses, they removed the lids.

Fukida picked up and read a paper that lay atop the arquebuses inside one crate. "Detective Arai did an inventory of the guns. There are twenty in each crate, six hundred total. All appear to be in good working order."

"Are those his only observations?" Sano asked, concerned not just because they were so limited.

When Fukida nodded, Marume said, "What else do we need to know?"

"Where Lord Mori got them would be helpful." Sano wondered why Hirata had left an important task to his subordinate, apparently without checking the results.

"That might tell us who was conspiring with him to overthrow Lord Matsudaira," Marume agreed. "But didn't Hirata-*san* say he searched the crates for documents to show where the guns came from and didn't find any?"

"Yes. But documents aren't the only means of tracing guns." Sano thought Hirata should have been aware of this fact, should have taken it into account. "Help me inspect these for gunmaker's marks."

Looking over each gun, they found characters and crests, etched into the barrels or branded on the wooden stocks, that identified the craftsmen who'd made them. "Four different gunmakers so far," Marume said after they'd gone through twenty crates. "Two of them have big workshops in Edo. They supply guns to the Tokugawa army."

"Maybe someone in the army is in on the conspiracy," Fukida said.

"They also make guns for the *daimyo*," said Marume. "Don't count them out."

These possibilities heartened Sano. The army and the *daimyo* class could offer plenty of treason suspects besides himself—but he shouldn't jump to conclusions. "There have been thefts from the arsenal during the three years since the war," Sano pointed out. "These guns could have gotten into Lord Mori's warehouse via the black market."

"I don't recognize the other two marks," Fukida said.

Nor did Sano. "They must belong to craftsmen in the provinces."

He and his men were down to the last three crates. As soon as Sano lifted out a gun he saw on its stock a circular crest with a chevron inside. He felt a mixture of triumph and dismay.

"Is something wrong?" Fukida asked.

"That's a new mark," Marume said, peering at the gun. "I don't recognize it."

"Neither do I," said Fukida.

"I do," Sano said. He had good reason to, whereas his men didn't and neither did Detective Arai, who'd done the inventory and overlooked the marks. "It belongs to a workshop in the Hatchobori district. They make guns for the Edo police force."

"I didn't know the police had guns," Marume said. "They don't carry them."

"Many of the commanders have them for target practice. That's their hobby." A former police commander himself, Sano knew this. "They've built up quite a collection."

"This is just what we've been looking for." Excitement animated Fukida's serious features. "A clue that points to Police Commissioner Hoshina."

"He could have been putting together a gang to overthrow Lord Matsudaira's regime and do away with you at the same time," Marume said to Sano.

"Maybe he recruited Lord Mori and put him in charge of collecting guns for another war," Fukida said.

"Maybe Lord Mori had second thoughts," Marume said, "and Hoshina was afraid he would report the conspiracy. That would explain why he'd have wanted Lord Mori dead."

"What if he went to the Mori estate and happened to see Lady Reiko there?" Fukida speculated.

Marume pantomimed shooting a bow and arrow. "Two birds at once. Down goes Chamberlain Sano as well as Lord Mori."

The detectives had followed Sano's line of thought to a conclusion that obviously delighted them. Sano was gladdened, too, that the guns had implicated Hoshina in murder and treason, but less happy about how and when this clue had come to light.

Fukida handled a gun, frowning at the telltale mark. "I wonder why *Sōsakan* Hirata didn't notice this. He used to be a police officer."

"It seems as if he'd have recognized—" Marume interrupted himself. He and Fukida glanced at Sano, then away.

An uncomfortable silence fell.

Sano knew they were thinking the same thing he was: *Hirata didn't even look for the marks. He missed an important clue.*

"No harm done," Marume said, too loudly.

"We have the evidence against Hoshina now," Fukida said.

Sano sensed their desire to protect Hirata, their friend and former comrade. He tried not to calculate what Hirata's mistake might have cost him, although he couldn't help wondering, *What if I'd had this information about the guns yesterday?*

He said, "Do you think we have time for a ride to the police district before the rain starts again?"

Marume and Fukida grinned, happy at the prospect of gathering more timber for Hoshina's funeral pyre. "We have time, rain or not," Marume said.

23

Quays and warehouses abounded in Hatchobori, the district where the police commanders known as *yoriki* lived in estates grouped together like an island amid the townspeople's dwellings. They were famous for the airs they put on and the bribes they took. As Sano rode along a quay with his entourage, they passed a *yoriki* riding with his attendants. Sano recognized him as Hayashi, a former colleague. He wore expensive chain mail, probably his latest gift from a lord whose retainers had gotten in a brawl and who'd paid him to hush up the affair. He bowed coldly to Sano: He still resented the fact that Sano had been promoted over him, especially because Sano had been a misfit in the exclusive police brotherhood.

The shooting range was a favorite haunt of the *yoriki*. It was surrounded by wharves for firewood and bamboo poles, invisible behind a wall topped with sharp iron spikes. Lanterns hung over the gate flamed and smoked in the damp evening air. Two samurai youths lolled inside a guard booth. When Sano's party stopped before them, they rose and bowed.

"Chamberlain Sano wants to go inside," Detective Marume said.

The guards exchanged fearful glances that seemed an odd response to such a simple request. They had similar square jaws and chunky

physiques; they looked like brothers. One said, "I'm sorry, but we're closed today."

"The field is flooded," the other hastened to explain.

"That's no problem," said Marume. "Chamberlain Sano isn't here to shoot. He only needs to see the guns."

The guards spoke in rapid, panicky succession: "Nobody except the police commanders is allowed in the arsenal." "Police Commissioner Hoshina's orders."

"The honorable chamberlain outranks your boss," Marume said. "Open up."

The guards reluctantly obeyed. Riding in, Sano asked them, "Who's the caretaker of the arsenal these days?"

"Me," mumbled the younger man.

"Come with us."

Inside was a long patch of muddy ground, weed-covered in some places, under water in low spots. At one end stood flat, wooden, man-shaped figures riddled with bullet holes and a suit of armor mounted on a wicker horse. Opposite was the arsenal, a shed with stone walls, an iron-shingled roof, and an iron door and shutters. A similar, smaller building held ammunition and gunpowder. As Sano and his men rode toward the arsenal, he heard his name shouted. He turned and saw Captain Torai, chief retainer to Police Commissioner Hoshina, riding after them so hard that his horse's hooves splashed up fountains of water.

"What a surprise to see you here," Torai said as he caught up with Sano. "I didn't know you were interested in shooting."

"Only when I see someone I'd like to shoot," Sano said.

Torai's grin gave his face a wolfish cast. "May I be of assistance?" he said, obviously eager to find out what Sano was up to.

"No, thank you." Sano kept riding.

"He wants to see the guns," blurted the caretaker, who hurried alongside him on foot.

"Oh?" Torai sped up his horse, placing himself between the arsenal and Sano. "Why?"

"Just testing a theory," Sano said.

Torai blocked the door to the arsenal. "What theory?"

"Do you want us to get rid of him, Honorable Chamberlain?" Detective Marume asked.

"It's my duty to oversee anything that happens here," Torai said, belligerent now.

Sano decided Torai might come in handy. "Stay if you wish, but get out of the way." As he and his men dismounted, he ordered the caretaker, "Open the arsenal."

When he stepped inside, the caretaker held up a lantern to illuminate walls lined with iron cabinets. Detectives Marume and Fukida opened these, revealing hundreds of compartments that each contained guns rolled up in oiled cloth.

Marume's breath whistled out of him. "This is enough weapons to start a war."

"There's certainly more than I remember." Sano wondered if Police Commissioner Hoshina was indeed plotting a coup, and building up the arsenal in preparation.

"So what?" Torai asked from the doorway.

Ignoring him, Sano asked the caretaker, "Do you keep an inventory of the guns?"

"Yes, Honorable Chamberlain." The youth looked even more nervous. He removed a ledger from a cabinet and opened it to show pages filled with characters.

"We're going to look through all the guns, compare them to the inventory, and see if any are missing," Sano said.

"They aren't," Torai said. "Unless you're blind, you can see that all the compartments are full."

Marume and Fukida unwrapped guns, which included pistols as well as arquebuses, bearing the marks of many different craftsmen. Some were old, elaborate works of art; others modern, plain, and utilitarian. Sano and the caretaker marked off each in the ledger. By the time they were finished and emerged from the arsenal, they'd found thirty compartments that held, instead of guns, wooden dowels wrapped in cloth.

"How about that," Sano said. "Thirty arquebuses are unaccounted for. What happened to them?"

Captain Torai looked surprised, and disturbed. Sano thought he hadn't expected any weapons to be missing. Torai turned on the caretaker. "Well?"

"I don't know. Maybe, uh, maybe the police commanders borrowed them and forgot to tell me."

"There you have it." Torai sounded relieved, although uncertain as to what trap he was trying to evade.

"Never mind the excuses," Sano said. "I can tell you exactly what happened to those guns. *Sōsakan* Hirata confiscated them with some others from a warehouse that belonged to Lord Mori. They're a sign that someone on the police force was conspiring with Lord Mori to stockpile weapons and stage a coup. And my candidate is Police Commissioner Hoshina."

"That's absurd!" Torai was clearly less alarmed than disbelieving.

"Are you so sure?" Sano asked. "How much do you know about what he does when you're not with him?"

Torai made a sound of disgust. "Hoshina-*san* isn't the only person who had access to the arsenal. Someone else on the police force could have taken the guns."

He turned a hard, searching gaze on the caretaker, who looked terrified. By this time Sano had no doubt that he was an accomplice, whether willing or not, to the theft. The caretaker started to back away across the shooting range.

"Not so fast," Sano said.

The caretaker faltered to a stop. Sano intended to find out exactly what he knew about the missing guns. A little pressure and surely he would incriminate Hoshina. Now a look of concern came over Torai's face as he read Sano's thoughts.

"Go back to your duties," he told the caretaker.

"Stay," Sano commanded. His troops surrounded the man. "You're coming with me."

"Hoshina-*san* is loyal to Lord Matsudaira. He's not involved in any coup," Torai insisted.

"Maybe you're right. There are other ambitious men on the police force." Sano stared at Torai. Maybe he wasn't really surprised about the missing guns. "What have you been up to behind your master's back?"

Another man might have been alarmed because the tainted wind of treason had blown onto him. Police Commissioner Hoshina certainly had; yet Torai feigned puzzlement, looked behind him as if to see who Sano was talking about, then shrugged and grinned. "You're just stabbing in the dark to save yourself."

"You have all the answers, don't you?" Tired of verbal sparring, frustrated because Torai had pointed up the flimsiness of the evidence he'd found, Sano shifted the conversation to another track. "Well, if you're as smart as you seem, you can tell that your master is in trouble."

"Not as much trouble as you are," Torai said with malicious pleasure.

"You're wrong," Sano said. "The only evidence against me is a story told by a medium who's recanted it and is now on my side. The evidence against Police Commissioner Hoshina is guns from this arsenal found in an illegal cache."

"What about the notes in your handwriting that were also found with the cache?"

"Planted there," Sano dismissed them scornfully, although he was perturbed because the news had reached his enemies. "Don't put too much stock in them. Weigh the evidence. Guns are heavier than papers with ambiguous scribbles on them. Hoshina's side of the balance is heading down faster than mine. You don't want to join him at the bottom. I'm going to offer you a deal."

The captain arched his brows, skeptical yet listening.

"Turn witness against Hoshina," Sano said. "Give him up for treason and the murder of Lord Mori. In exchange, you can keep your head and your rank."

"Forget it," Torai said disdainfully, without a moment's hesitation. "You're the traitor. Your wife's the murderer. Hoshina-*san* is innocent. I'm not bailing out on him, especially when you're not in a position to keep any promises."

Sano realized that Torai was made of stronger stuff than his supe-

rior. Torai had stood his ground whereas Hoshina had nearly caved in. Whether or not he really believed in Hoshina, he was determined to stick with him. Torai was the type of samurai who aligned the course of his life with his master's and never deviated, for good or bad. Every regime in history had been built on men like Torai; no warlord could rise to power without them.

"Very well," Sano said. "You'll regret your decision when you find yourself kneeling beside Hoshina on the execution ground."

"Your wish is not mine to fulfill," Torai retorted. "Now if you'll excuse me, I'm not wasting any more time on this conversation."

He stomped out of the arsenal. Sano, Marume, and Fukida watched from the doorway as he mounted his horse and rode away through the deepening night.

"He should have jumped at your offer," Fukida said. "You have a stronger case than ever against Hoshina."

"Unfortunately, my case is founded on logic that won't convince everyone," Sano said. "We know that as well as Torai does. Let's go back to the castle and find Hirata-*san*. Maybe he's had better luck with his inquiries today than we with ours."

As he and his men rode off, Sano did not look forward to the talk he must have with Hirata.

They arrived home as the wet, gray day melted into grayer twilight. But Sano had no chance to look for Hirata. His chief aide met him at the door and said, "The Honorable Elders and the Supreme Commander of the Army are waiting to see you."

Sano desperately needed to continue his investigation, but he couldn't put off his three important allies. He joined Ohgami, Uemori, and General Isogai, who sat in his audience chamber. Their solemn expressions warned Sano that this was not a social call. "Greetings," he said, bowing to them, then taking his seat on the dais.

They bowed in return. General Isogai said, "We warned you." His loud voice and shrewd gaze were hard.

"But you didn't stay out of trouble." Disapproval marked Ohgami's

pensive features. "First your wife is involved in the murder of Lord Mori; then you're implicated in treason."

"Merciful gods, you attract problems like shit draws flies!" Uemori coughed in disgust, his jowls wobbling.

Sano remembered his last meeting with them, when they'd advised him that his political position was shaky and he should exercise caution. It seemed as if ages had passed since then. The last thing he needed now was their censure. "Unforeseen circumstances arose. You can hardly blame me for them."

"Perhaps not," Ohgami said, "but we do fault you for the way you're handling this murder investigation."

"You've managed to antagonize both Lord Matsudaira and the shogun," General Isogai said, "not to mention that you've opened yourself up wide to attack by Police Commissioner Hoshina."

"This is exactly what you don't need," Ohgami said.

"And neither do we," Uemori said.

The three men glared at Sano. He felt his own antipathy stir toward them. As usual, their criticism didn't help, and they were wasting time he couldn't afford to waste.

"Well, my honorable colleagues," he said, "I thank you for your show of support."

"We're here to do more than show support," Ohgami said. "We're going to tell you exactly what to do to get yourself out of this sorry mess."

"Go right ahead. Some practical solutions would be helpful for a change," Sano said.

The elders looked to General Isogai, who said, "Let Lady Reiko take the blame for Lord Mori's murder."

"What?" Astonishment struck Sano. He couldn't believe he'd understood correctly or hide his horror.

"You heard me," General Isogai said. "As far as Lord Mori's murder is concerned, Lord Matsudaira and the shogun want blood for blood. Throw Lady Reiko to the executioner, and they'll be satisfied. As far as the treason is concerned, a little sacrifice on your part would go a long way toward convincing them that you're their loyal subject."

"That's out of the question." Sano was so incensed by this preposterous advice that he lost self-control and sputtered with rage. "Lady Reiko is my wife." He didn't mention that he loved her. Love had no place in his colleagues' world. "I would never sacrifice her for anything."

The elders grimaced in disdain. General Isogai said, "You can get yourself another wife. There are many other women you can choose from. What's important is your political position."

"And yours," Sano said, bitter. "You're asking me to put the mother of my son and our unborn child to death in order to save your own skins!"

"It's fortunate that you already have an heir," Ohgami interjected. "You can always beget another one later if you need it. And of course we're concerned that if you go down, you'll take us with you. But let's not be crude."

Sano was so astounded by their cold, venal insensitivity that he couldn't speak.

"Let's be rational instead," Uemori said, deliberately mistaking Sano's silence for agreement. "Lady Reiko was caught naked and covered with blood beside Lord Mori's corpse. Her dagger was the murder weapon. She did it, there's no question."

"Do you really want to live with a woman who stabbed somebody to death and cut off his manhood?" General Isogai shook his head. "I don't see how you can sleep at night."

"She didn't do it," Sano burst out. Even though he knew Reiko hadn't told him everything, he couldn't admit to them, or himself, that she might be guilty.

They gave him pitying looks. "Believe she's innocent if you want," General Isogai said, "but we've heard that you haven't turned up a scrap of evidence in her favor."

"I will," Sano declared. "It's just a matter of time."

"Time is what you don't have," Ohgami said. "You can't protect her much longer."

"The thing to do is cut your own losses," General Isogai said.

"Don't let Lady Reiko drag you with her to the execution ground. Dump her."

Their nerve infuriated Sano. He hated the fact that their solution was the wisest for a man in his situation. "I refuse!"

They exchanged glances that said they'd expected as much. "You'd best weigh your decision very carefully," Ohgami said. "We warned you that if you continued on your reckless course, we might wish to sever our association with you."

"We've done what we could on your behalf," said Uemori. "We've assured your other allies that you're in control of the situation and talked them out of withdrawing their support from you. We've urged Lord Matsudaira to give you the benefit of doubt. Those are the only reasons he's allowed you a free rein thus far. But your attempts to clear Lady Reiko have been futile. We won't be destroyed by your stubborn loyalty to her."

"To speak bluntly," General Isogai said, "it's either her or us, and by us, I mean all your allies, not just we three in this room. Stand by her, and you stand alone."

Sano didn't hesitate for an instant, even though he knew that if he decided in favor of Reiko, he was not only finished as chamberlain, but without allies to counter Lord Matsudaira's distrust of him and oppose Police Commissioner Hoshina's campaign to ruin him, he was certain to be condemned to death as a traitor. "It's her," he said even though he knew he'd just drastically reduced his chances of saving Reiko.

Rising, he gestured toward the door. His companions looked disappointed but unsurprised as they stood and bowed. "Fine," General Isogai said. As they left the chamber, he said, "Go ahead and dig your own grave."

24

Reiko stood in the corridor near the reception chamber, watching General Isogai and the two elders walk out past her. They paid her no attention. She'd just returned from the city, she still wore her peasant clothes, and they didn't recognize her. She'd come looking for Sano, and the door to the chamber had been open; she'd overheard the whole the conversation between him and the men. Now, sick with horror, she clutched the wall for support.

Sano rushed out of the chamber and bumped into her. "Excuse me," he said, obviously mistaking her for a maid. Then he took a second, surprised look at her. "Reiko-*san*? Why are you dressed like that?" He clasped her shoulders. "You're soaking wet. Where have you been? What's the matter?"

She gulped, trying to quell the nausea that rose up in her throat. She couldn't answer. A faint contraction tightened her stomach muscles around the baby inside her.

Dismayed comprehension branded Sano's features. "How long have you been here?"

"Long enough," Reiko managed to gasp out.

Sano picked her up and carried her to their private chambers, where he laid her on the floor cushions. He held her hand, watching her anxiously while she sucked deep, tremulous breaths and her heart

raced with panic that she was going into premature labor. Cold sweat drenched her skin, which was already chilled from the rain that fallen on her while she rode in the *kago*.

"I wish you hadn't heard that," Sano said. "I'm sorry."

"I'm the one who's sorry." Anguish and self-hatred filled Reiko. "I've put you in such a terrible position."

"It's not so terrible that it's hopeless," Sano said, but as though trying to convince himself as well as her. "With friends like General Isogai and the elders, I hardly needed enemies. I'm better off without them."

Reiko couldn't believe that, and she saw that neither did Sano. Bereft of allies, accused of treason, tied to a wife accused of a politically sensitive murder, he could number his days in the regime—and in this world—as few. Still, she was outraged as well as hurt by the men's attitude toward her. "They told you to abandon me! They want me to die so that all their problems will go away!"

"Never mind that," Sano said firmly. "I told them I'd stand by you, and I will."

He tightened his grip on her hand. His love and loyalty moved Reiko to such gratitude that tears streamed from her eyes. Yet she couldn't let him be destroyed for her sake.

"I think you should do what they want," Reiko said.

Sano stared at her as if she'd gone mad. Then irritation showed on his face. "This is no time to talk nonsense."

He thought she was testing his commitment to her, trying to wangle reassurances by suggesting that he should give her up. Reiko saw that he was impatient because he didn't want to play games; he didn't understand that she was serious.

"I mean it," she said, withdrawing her hand from his. "You should."

As Sano exclaimed in angry protest, she said, "Tell Lord Matsudaira that I've confessed to murdering Lord Mori. Tell him that I promise to commit *seppuku* to atone for my disgrace and restore my honor."

"Never!" Sano's eyes brimmed with shock. "How can you even think of such a thing?"

"It's the proper thing for me to do." During childhood Reiko had been taught that honor, duty, and family were more important than the individual. She'd absorbed society's values despite her unconventional personality. Now the time had come to abide by them. "All I ask of you is this: Convince the shogun to let me put off my death until after my baby is born." Her voice trembled; she fought back tears. "Make him understand that the baby is innocent and doesn't deserve to die."

"I won't listen to any more of this. Stop it!" Sano seized her arms. "What in hell has gotten into you?"

She gave him her first reason, which would pain him less than her second: "If you stand by me, I'll be convicted for Lord Mori's murder and put to death anyway. You'll be executed for treason. Your enemies will kill Masahiro so that he can't grow up and avenge your death. Our whole family will be destroyed." Breathless with her struggle against her emotions, she concluded, "It's better that I should die, so the rest of you will be safe."

Sano's forehead creased in a frown of utter bewilderment. He glanced around the room, as if searching for the wits he thought had taken leave of Reiko. "Are you doing this because you've lost faith in me? Do you think I can't solve the murder and save us all?"

"Can you?" Daring to hope in spite of her despair, Reiko said, "Did you find out something today?"

"Yes," Sano said. "I've found Lady Nyogo the medium. She admitted that Police Commissioner Hoshina put her up to that fake séance. And I've traced the guns that Hirata-*san* found. They came from the police arsenal. Hoshina has to be part of a conspiracy to overthrow Lord Matsudaira; he must have framed me to divert attention from himself."

Reiko spotted the problem. "Hoshina denied it, didn't he? You didn't take the news to Lord Matsudaira because you thought it wasn't likely enough to convince him and clear us. And it's even less likely now, after you've lost your allies." She read the answer on Sano's face. Her dashed hopes made her despair all the more painful.

"It's still evidence against Hoshina," Sano insisted. "I'm getting

closer to beating him. And you've been investigating, too, haven't you?" He gestured at her disguise. "What have you learned?"

Reiko told him. But her theory that Colonel Kubota or the family of the murderer she'd sent to his execution could be responsible for framing her seemed outlandish now. She'd been stretching the limits of possibility to believe it. All she'd gained was more threats from Kubota, the last thing she needed.

"Don't lose hope," Sano urged, although he was clearly disappointed that her inquiries had yielded no more salvation than his. "Just be patient. I'll clear us both, I promise."

There seemed nothing else to forestall Reiko's decision to sacrifice herself. "You can't," she said bleakly. "At least not me."

"Why not you?" Sano said, puzzled. "I don't understand."

Reiko shook her head, compressed her lips. It was too terrible to explain.

Anger infused Sano's expression. "Whatever is causing you to act like this, I'm not going to tell the shogun you confessed." His tone was adamant. "I won't cast you off as though you were extra weight in a lifeboat that's sinking."

Desperate because he wouldn't cooperate, Reiko cried, "Unless you do as I ask, I'll commit *seppuku* right now, never mind the baby." She whipped out the dagger from under her sleeve. "I'll save two out of four of us while I can!"

She clutched the hilt in both hands. Her whole body and spirit recoiled from her intent to kill not only herself but this child that she'd loved with intense maternal passion since the day she'd known she'd conceived it. She pointed the blade at her belly.

A shout of horror burst from Sano: "No!"

He grabbed the dagger. His hands crushed and wrenched hers, trying to pry the weapon out of them.

"Give it to me!" Reiko screamed. "Leave me alone!"

"This is madness!" Frantic, Sano grappled with her. "You're going to stop it right now!"

He wrested the dagger away from her, leaped up, and held it out of her reach. "Why are you doing this?" he demanded.

"I already told you!" Reiko was distraught, breathless, falling apart.

"Never mind the excuses. Tell me the truth!"

His love shone through the fury in his eyes. Her resolve abruptly shattered. Reiko plunged into a storm of uncontrollable weeping. She gave in to her urge to unburden herself.

"I killed Lord Mori," she cried. "I deserve to die."

Shock hit Sano; he opened his mouth and sucked in his breath so hard he almost choked on it. Yet as he watched Reiko sob, he felt less surprise at her confession than a sense that the inevitable had finally come to pass. He realized that he'd been dreading this moment. All his doubts about Reiko's story, all the warnings signaled by his detective instincts, had prophesied it. All his efforts to believe in Reiko, to excuse evidence against her, had failed. Now he knew what she'd been trying to hide from him.

She was a murderess.

Sano felt none of the satisfaction that he'd felt upon solving other crimes. Dazed by horror, he walked to the cabinet and put the dagger inside so it couldn't hurt anyone. Then he knelt beside Reiko, who buried her face in her hands and wept.

Those slim, delicate-looking hands had stabbed and castrated Lord Mori.

Yet Sano's heart balked at accepting what his mind had deduced and his ears had just heard. Reiko looked up at him, her face awash in tears, her eyes filled with dread as she waited for him to speak.

"No. It can't be," he said, as vehement in his denial as unconvinced by it.

She fell toward him, head down, hands pressed against the floor. "I'm sorry," she moaned. "I'm so sorry!"

This was the nightmare of all nightmares. "Why did you do it?" he said, marveling that he should ask her the question that he would ask any other criminal who confessed, as if tying up loose ends were the only thing on his mind.

"I don't know," Reiko wailed. "I can't remember!"

This struck Sano as bizarre, unfathomable. "How could you forget something like that?"

Reiko sat up, clutching her head. The kerchief came loose; her hair tumbled down. "There's something wrong with my mind. I've been having spells."

Sano was more mystified than enlightened. Even though he felt revolted by the prospect of learning the details of Reiko's crime and exactly what had driven her to it, he had to know the worst. "Suppose you tell me the whole story."

She wiped her eyes, smoothed her hair, and swallowed sobs. "I've been doing meditation, recovering lost memories from that night at Lord Mori's estate. I've had two visions of things that happened. In the first, I was in his room while he was asleep. He woke up and looked at me. He asked me who I was and what I was doing there. Then he was crawling on the floor, dripping blood from cuts all over his body. He begged me for mercy."

Sano listened in horror that grew with every word she spoke. It sounded as if Reiko had entered the chamber of her own volition, surprised and attacked the helpless Lord Mori.

Reiko shuddered and continued, "The other vision was even worse. I was in bed with him. He was on top of me. We were—" She clawed her arms as if to tear the flesh that had touched Lord Mori's, shaking her head violently.

Imagination completed the awful picture in Sano's mind. His horror multiplied beyond belief. It seemed that his wife had seduced Lord Mori that night, just as Lady Mori had claimed.

"Then I had the dagger in my hands. I lunged at Lord Mori. I stabbed him." Reiko pantomimed. Sano flinched. "And then—" She retched and emitted strangled gasps. "Then I was kneeling over a puddle of blood. The red chrysanthemum was in it. I was holding Lord Mori's manhood." Again Reiko pantomimed. Sano could almost see the severed, bloody organs in her palms. "And then I said—I said, 'Serves you right, you evil bastard!'"

She flung herself facedown and wept so hard that her body went

into spasms. "So you see, it's true. There's no escaping it. I killed him! I deserve to be punished!"

Sano was so aghast that he couldn't speak. Earlier he'd regretted that he didn't have solid evidence to prove how the murder had really happened. Now he did. Reiko's own memories were the strongest evidence against her. Yet he felt a strange sensation of relief because Reiko had finally been honest with him. Now that the air between them was clear, he was more inclined to give her the benefit of doubt than before.

"Maybe those visions don't mean what they seem to," he said.

She sat up and regarded him through red, swollen, disbelieving eyes. "What else could they mean?"

"Maybe you only imagined the things you saw in them."

"I couldn't have. They felt so real." Reiko was despairing yet adamant. "They did happen. I know they did, no matter how much I want to believe they didn't."

"Maybe they were dreams. Dreams can seem very real. There could have been poison in the wine you drank, that gave you such powerful hallucinations that you thought they were memories of things that really happened."

"But we don't know that! How can we be sure that I didn't do what I remember doing?"

"I know you." Sano took her damp, cold, frail hands in his. "I know you couldn't have killed Lord Mori."

A shadow passed over her face, like clouds dimming a landscape already laid to waste by storms. "It's not as if I've never killed before. Why not this time?"

Sano shied away from the idea that his wife had grown so accustomed to taking lives that there were no moral obstacles to prevent her. "Those other times, you killed to defend yourself or protect other people. That wasn't murder. And you had no reason to kill Lord Mori. You said so yourself."

"Maybe I confronted him because he strangled the boy. Maybe I asked him what he did with Lily's son. Maybe I wanted to punish him for killing them both." Reiko exhaled a sigh of desolation. "Or maybe

there was no boy, no Lily, no Jiro. Those are the parts of my story that don't seem real to me now. Maybe I killed Lord Mori because we were lovers and he jilted me."

She regarded Sano with suspicion in her eyes. "Or maybe I did it to punish him because he tried to betray you."

"No," Sano said, dismayed that she should think there was truth to the story from the séance in spite of the fact that the medium had confessed to fraud. "That's not so. And even if you can't remember everything that happened that night, you surely couldn't have forgotten everything that led up to it."

"Couldn't I?" Reiko's face was a mask of self-doubt and fear. "I feel as if I've gone insane. I don't know what I'm capable of anymore. All I'm sure of is that I killed Lord Mori."

"What I'm sure of is that you didn't," Sano said with growing, passionate conviction.

But she shook her head. "It's my duty to die. It's your duty to do as I asked you."

"Never!" Sano drew Reiko close. He felt shivers coursing through her as she leaned against him.

"This is worse than all those other times we've been in trouble, isn't it?" she whispered. "We've done the things that saved us then, but this time we've failed. This time is really going to be the end for us, isn't it?"

"No, it isn't," Sano said, determined to keep up their spirits.

Reiko lifted her face to his. Her eyes, wide with panic, beseeched him. "What can we do?"

He summoned his confidence, tried to infuse it into her. "We trust in ourselves. We don't give up trying to find out the real truth about the murder."

"But both our investigations have reached dead ends. What if this is the one crime we can't solve, when it matters the most?"

He felt their child move inside her body, heard Masahiro's voice in the distance. "Don't even think about that."

They sat silent, drawing comfort from their closeness. Sano wished he could stop time, could preserve this moment while they were still

safe together, could shut out the dangerous world. But a manservant came to the door and said, "Excuse the interruption, but *Sōsakan* Hirata is here to see you."

Sano didn't want to leave Reiko, and this was one instance when he didn't welcome seeing his friend, but he couldn't put it off. "I'm coming," he told the servant.

Reiko clung to him, her face as panicky as if she thought he would never return, and he said, "You'd better put on some dry clothes. I'll be with you soon."

She nodded. Sano tore himself away. He found Hirata alone in the audience chamber, looking tired but elated.

"I've discovered something that might be important," Hirata said.

Once more Sano was struck by how Hirata had changed. His image seemed brighter than the single lantern in the room could account for, as if his rigorous training had reduced his flesh so that the energy inside him showed. But although the change might be good for Hirata, it hadn't been for the investigation.

"What is it?" Sano asked.

Hirata frowned slightly at the coolness in Sano's manner. "It's Enju. His alibi has a lot of room for doubt. And there's reason to think that he and Lord Mori weren't the most loving father and son in the world."

He described how Enju could have arranged for someone to impersonate him traveling on the highway. He went on to the doctor who'd said that living at the Mori estate had changed Enju for the worse, and neither the young man nor his mother had attended Lord Mori during his near-fatal illness.

Sano was momentarily distracted from his problems concerning Hirata. "So your discoveries have brought us back to the family."

He'd been so focused on Hoshina, he had to remind himself that Lady Mori, if not Enju, had been at the estate that night and invited Reiko there herself. Although he still favored Hoshina as the source of

his troubles and Reiko's, he couldn't dismiss Lord Mori's closest relations. Especially when incriminating them could exonerate Reiko.

"Lady Mori and Enju should be investigated further," Sano said.

"I can do that tomorrow," Hirata offered.

Here was the time to tackle the difficult issue. Sano said, "We'll discuss that later. We have something else to talk about first."

"What?" Hirata said, obviously wondering if something disastrous had happened—or if he'd done something wrong.

Sano decided not to tell him about Reiko's revelations. "I examined the guns from Lord Mori's warehouse. I found a possible connection between some of them and Police Commissioner Hoshina." As he explained about the craftsmen's marks and the weapons missing from the police arsenal, surprise blended with dismay in Hirata's expression. "I must ask you why you didn't notice the marks."

Hirata opened his mouth to speak, closed it, then flopped his hands. "I guess I should have. I don't know where my mind was."

But they both knew it had been on esoteric martial arts techniques. Sano mustered the stomach for what he needed to say. This sort of personal exchange was more difficult than a sword-fight. "You missed an important clue. If I hadn't taken a look at those guns myself, it might have gone undiscovered."

Hirata hesitated, clearly torn between the impulse to apologize and the urge to defend himself. "But you did look. You found the connection to Hoshina. And it doesn't seem to have made any difference. You haven't arrested him yet? You're still under suspicion?"

"True," Sano said, "but if you'd found it yesterday, it might have made a difference. Since then, Lord Matsudaira has found out about my notes in the warehouse. The evidence implicating Hoshina might have convinced him yesterday and gotten me off the hook. Today it's not enough because his trust in me is almost gone. I can't risk a major move against Hoshina now."

And if Sano had known about the guns this morning, he would have had more leverage to use on Hoshina, could even have forced a confession from him.

Now Hirata stared in horror because Sano's fortunes had declined so drastically and his slip had cost Sano a valuable chance. "But maybe we can still find a way to beat Hoshina. Maybe one mistake isn't so bad."

"It wouldn't be so bad if this were your only mistake, but it's not. First there was that anonymous tip." Sano wondered which of them felt worse. "Nobody can know what would have happened if you'd traced it earlier, but you might have discovered that Lord Mori was plotting a coup before he was murdered, and he might have been executed before someone could frame Reiko or implicate me in the plot."

The defiance went out of Hirata, and he fell to his knees. Ashen and mortified, he bowed. "I'm sorry. I don't know what else to say, except that I will commit *seppuku* to make amends."

Sano was both alarmed by and opposed to this plan. Although ritual suicide was required of a samurai who neglected his duty to his master, Sano thought death was often too quickly chosen, an avoidance of facing and correcting one's transgressions. He couldn't allow Hirata such a harsh punishment for mistakes, no matter how serious, after everything Hirata had done for him over the years. Nor could he bear that both his wife and his friend were ready to take their own lives.

"Get up," Sano said. "I forbid you to commit *seppuku*. What I want is for you to stop trying to dedicate yourself to your martial arts and serve me at the same time."

Hirata lurched to his feet. Even though his bad leg had mended, his movements still lacked grace. "I can do both," he said in a tone that rang with more desperation than conviction. "I'll prove it."

"That won't work," Sano said, even though their history pushed him toward giving in. "You know as well as I do."

Misery exuded from Hirata. "If you order me to give up my training, I will."

Now Sano faced a dilemma. He knew that even though Hirata's samurai honor had been compromised by a divided mind, Hirata wouldn't disobey a direct order. But he couldn't deny Hirata the thing that was making him a whole man again. He couldn't afford to pay the

price of another slip himself, when Reiko, their unborn child, and Masahiro would also pay. But although he could dictate Hirata's actions, he couldn't enforce the kind of loyalty he needed.

"The choice is for you to make," Sano said. "If you choose your training, I'll release you from my service."

And their nine years as master and retainer, the most sacred bond in the samurai code of honor, would end. Sano felt a shattering sensation in the air.

The ghastly look in Hirata's eyes said he felt it, too. A wide, lonely distance opened between them. Hirata said in a cautious voice, "May I investigate Enju and Lady Mori tomorrow?"

He was begging for another chance to demonstrate that he could serve duty as well as his personal interests. Sano said, "You can come with me while I investigate them."

Comprehension lowered Hirata's gaze. "Well." His tone was subdued. "In that case, shall I come back in the morning?"

"Yes."

They bade each other a polite farewell. Sano watched Hirata walk away through the wreckage of trust broken, of nine years' friendship negated at the worst possible time. First Reiko's terrible confession; now this estrangement. Standing alone in the damp, drafty chamber, Sano felt as though his world were crumbling from within even as hostile external forces assailed it.

真
相

25

Soon after daybreak, Sano joined detectives Marume and
Fukida and the rest of his entourage in his courtyard. The wind
moaned through the castle as they mounted their horses. Lightning
stitched an incandescent seam through storm clouds. Thunder purred
like a tiger creeping down the hills toward town.

Hirata arrived with detectives Inoue and Arai. In through the gate
behind them rode a host of samurai who wore the Matsudaira crest on
their armor.

"Greetings, Honorable Chamberlain. Are you going somewhere?"
the leader said in a manner that bordered on insolence.

Sano recognized him as one of Lord Matsudaira's top retainers. "As
a matter of fact I am." He was going to re-interrogate Lady Mori and
her son. "What brings you here, Kubo-*san*?"

"A message from Lord Matsudaira." Kubo gave Sano a bamboo
scroll case. "I suggest that you read it before you go." He and his men
turned and departed.

Apprehension stole through Sano. He knew better than to expect
good tidings in formal messages delivered by disrespectful envoys. He
read the scroll and frowned because the news was even worse than
he'd expected.

"What does it say?" Hirata asked.

Sano read aloud: " 'This is to inform you that a special court will be convened this afternoon at the hour of the monkey. You will be tried for treason and your wife for the murder of Lord Mori. Come prepared to defend yourselves. Your judges will be His Excellency the shogun, Police Commissioner Hoshina, and myself. We will question witnesses, examine evidence, establish your guilt or innocence, and decide your fate accordingly.' "

Hirata and the detectives looked as dismayed as Sano felt. "Why all of a sudden?" Hirata said.

"My position has weakened overnight," Sano said.

"But our investigation's not finished," Hirata said. "We haven't anything to prove you're innocent."

"That's exactly the way Lord Matsudaira wants it," Sano said. "He's decided I'm a liability." His allies must have put out the word that they'd deserted him. An official without allies was powerless, a pariah. "He wants to cut me loose before my bad air can contaminate him."

Understanding and anger showed on Hirata's face. "And he's going to let Hoshina help him. Hoshina must be overjoyed."

"Indeed," Sano said, "because there's no doubt about the verdict in this trial."

"You can get the shogun on your side," Marume said.

But he didn't sound any more hopeful of that than Sano was that the shogun could stand up to both Lord Matsudaira and Hoshina working against Sano.

"If only I could have brought Hoshina down before this happened." Anguish filled Hirata's eyes because his mistakes had lost Sano the chance.

"There's no time to waste on talking about what could have been," Sano said. "We have only a few hours to prepare some kind of defense for my wife and me."

"Do you still want to interrogate Lord Mori's widow and stepson?" Fukida asked.

Sano thought a moment. "No. I can predict that if they killed Lord Mori, they'll lie. Even if I force them to confess, Lord Matsudaira and

Police Commissioner Hoshina won't accept that as proof of my wife's innocence. It's time for a radically different approach. Come with me."

"Where?" Hirata asked. "To do what?"

"I'll explain on the way," Sano said.

"Aren't you going to tell Lady Reiko what happened?"

"I can't," Sano said. "She's already left the house. I'll leave a message for her. Let's solve the crime before she gets home, so it won't matter what a close call we had."

A hired palanquin carried Reiko through the *bancho,* the district where the rank and file of the Tokugawa vassals lived. Live bamboo fences enclosed hundreds of small, rundown residences. The vassals were poor compared to their landed superiors and the rich merchant class, and the rains had reduced their neighborhood to a swampy slum. They rode and Reiko's bearers trudged through ankle-deep puddles swimming with manure. Reiko kept the window of her palanquin open a mere crack so she could see where she was going. This was a place where she mustn't show her face because people might recognize her.

Near a residence distinguished by characters carved on a wooden sign outside, she called for her bearers to stop, put her hand out the window, and signaled her escorts, who rode behind her. Lieutenant Asukai dismounted, ran up to the gate, and knocked. As he spoke to someone hidden by the leafy bamboo, she fought the despair that threatened to overwhelm her.

Last night she'd promised Sano that she wouldn't give up hope. Last night they'd gone to bed together knowing that it could be the last time. They'd made love, careful of the baby. Afterward, safe and cherished in Sano's arms, Reiko had been able to think that everything would turn out all right. But when dawn had come, defeat had slithered under her skin, cold and poisonous as a snake, hissing, *You murdered Lord Mori. You will pay.* Now she was forcing herself to go through motions that seemed pointless.

From behind the bamboo fence emerged a thin, gray-haired lady.

Asukai led her up to Reiko's palanquin, opened the door, and said, "Please get inside."

The woman saw Reiko, and dismay crossed her shriveled features. Reiko thought about how glad people were to see her when they wanted her help, and how they preferred to avoid her after she'd done what they'd asked but things hadn't turned out the way they wished.

"Please don't go, Madam Tsuzuki," she said. "I only ask a moment of your time."

The woman reluctantly climbed into the palanquin and knelt as far from Reiko as possible. She said, "I heard what happened to you." She avoided Reiko's gaze. Her gentle voice didn't soften her obvious hostility. "What are you doing here?"

"I didn't kill Lord Mori," Reiko said. "I'm trying to find out who did and prove my innocence. I need your help."

Obligation to Reiko weighed like a visible burden upon Madam Tsuzuki. She looked unconvinced, but she said, "My apologies. I shouldn't judge you when I don't know anything but rumors. And I shouldn't blame you for what you found out about the girl who was engaged to my son."

She and her husband, an Edo Castle guard, had asked Reiko to investigate the girl's family. Although samurai usually married within their class and knew all about their prospective in-laws, the son had fallen in love with a woman whose parents were artisans. Owners of a lucrative business, they were eager to marry their daughter into the samurai class. The Tsuzukis had been willing to accept a social inferior into their clan because of her rich dowry. This was a not uncommon practice by which commoners rose in the world and samurai improved their finances. But first the Tsuzukis had wanted to make sure that the girl and her family were of good character.

Reiko had questioned their neighbors and learned that they'd moved to Edo from Osaka ten years ago. The man had started as a peddler, then opened a small market stall, which he'd built into his current large shop. They were well respected, but nobody knew any-

thing of their past. They never discussed their life in Osaka, where Reiko had sent one of her attendants to inquire about them.

"It's not your fault that the girl turned out to be *eta*," Madam Tsuzuki said.

Reiko had discovered that the family were outcasts, shunned by society because their hereditary link with death-related occupations such as butchering and leather tanning rendered them spiritually unclean. Most *eta* were doomed to a miserable existence cleaning streets, hauling garbage, or working at other dirty, menial jobs, but the man had had rare ambition and talent. He'd moved himself, his wife, and their daughter to Edo, where no one knew about their disgraceful origins, and changed their names. But Reiko had given her attendant an example of the man's distinctive work to show around Osaka, and an *eta* he'd met in the street had recognized it. The results of her investigation had put an end to the wedding plans: A samurai couldn't marry an outcast.

"You did me a service," Madam Tsuzuki said, "but why do you think I can be of service to you?"

"It's about your son," Reiko said.

Tears filled the woman's eyes and ran down her face. "He married her anyway. His father and I disowned him. He is dead to us."

Reiko pitied this woman who'd lost her son due to his defiance of a strict, centuries-old taboo. She regretted that her well-meant efforts had caused a family tragedy. "Where is he?"

Instead of answering, Madam Tsuzuki asked, "What does he have to do with your problems?"

"He sent me this," Reiko said, taking a letter from beneath her sash.

The woman averted her gaze from her son's handwriting. Pain closed her eyes. Reiko read aloud, " 'Lady Reiko, you are an evil, meddlesome witch. You have ruined our lives. Someday I will hurt you as much as you have hurt us.' "

Madam Tsuzuki turned a look of horror on Reiko. "You can't think that my son is responsible for what happened to you?"

He was as good a suspect as Colonel Kubota and better than the

family of the clerk that had been executed for murder because of Reiko. "He belonged to a gang that included men from Lord Mori's retinue." Such samurai gangs spent their idle hours roving the town, drinking, brawling, and chasing women. "They were a way into the Mori estate. And he's intelligent enough to invent an elaborate murder scheme." Besides, the fact that he'd been disowned gave him all the more reason to hate Reiko. "What do you think? Could he have done it?"

"I don't know." Madam Tsuzuki shook her head helplessly. "I don't know what my son is capable of or who he is anymore. I haven't seen him in a year, since he told us he was going to marry that woman against our wishes and his father told him to leave our house and never come back."

"Where did he go?" Reiko said.

"I don't know. But *her* family might. Ask them."

Sano, Hirata, and their detectives and entourage gathered in the neighborhood where Reiko had claimed she'd met Lily and all her problems had begun. Rain dripped off sagging roofs and balconies; mildew and green moss infected damp, dingy, plaster walls. The streets were deserted, but as Sano and his men dismounted and tied their horses to posts, people peeked out windows at them.

"There's the Persimmon Teahouse," Hirata said, pointing at the drab storefront overhung with a wet blue curtain.

Sano gave it scant attention as he walked by. "Never mind that for now."

"Do you want us to round up all the residents for questioning?" Hirata asked.

"That probably won't work any better than before." Sano kept moving, past shops and a little shrine.

"What are we looking for?" Detective Marume asked.

"I'm not sure," Sano said. "I'll know it when I see it."

He attuned himself to his surroundings. Instinct told him that the answers were here. He opened his mind to all stimuli. He smelled

nightsoil bins in an alley, heard voices chanting prayers inside houses, tasted garlic in charcoal smoke that wafted from a kitchen. He felt new hope as he continued along the street, alert for whatever he'd come to discover.

His men followed him silently. They came to a shop halfway down the block, whose door was open a crack. It seemed to beckon Sano. He went up to the storefront, stood under the overhanging eaves, and looked inside while Hirata and the detectives peered over his shoulder.

It was a stationer's shop, filled with writing brushes, ink stones, ceramic water jars, scroll cases, and stacks of paper. An old man knelt at a desk. Opposite him sat a young woman. "The baby was sick with a cold, but he's better," she said. "My husband is working hard. I'm well, but I miss you." The old man wrote down her words as she continued dictating, "Good-bye for now. With love from your daughter, Emiko."

Sano pictured a different, older woman sitting in her place; he heard another voice: *Dear Lady Reiko, please excuse me for imposing on you, but I need your help.* The old man was probably one of the few literate people in his neighborhood. Shops like his were patronized by folks who needed letters written or read for them. Sano felt the tingling sensation of excitement that told him he was on the right track. He slid the door open wider and stepped into the shop.

The proprietor bowed to him. "I'll be right with you, master."

Sano nodded, but was looking at the letter that the man carefully blotted dry. The inked characters were square-shaped, neat, precise, and familiar. The man rolled the page into a bamboo case and handed it to the woman; she paid, thanked him, and left. He asked Sano, "How may I serve you?"

"I want to talk to you about a letter you once wrote," Sano said. "It was for a dancer named Lily."

The old man's courteous smile faded. "I respectfully beg to disagree; I've never had a customer by that name."

"Yes, you did," Sano said. "I've seen the letter. It was sent to Lady Reiko, my wife. I recognized your calligraphy." It was proof at last that Lily existed, that Reiko hadn't imagined her in a fit of madness.

Fear crept into the old man's withered features. "A thousand apologies, but I don't know any Lily." He turned to Hirata, who'd crowded into the shop with Sano. "I told you so the other night, when you were here."

"Yes, you did. I remember you." Hirata said to Sano, "I threatened to beat him if he didn't tell me where to find Lily, but he wouldn't. Neither would the other folks in the street."

And Hirata had backed off because he'd believed them rather than Reiko's story and didn't want to hurt innocent people, Sano thought. But now the old man had unwittingly furnished proof of a conspiracy of silence. Now Sano and Hirata were desperate.

"Today we're going to give you another chance to tell the truth," Hirata told the old man.

He shut the door. He and Sano stood over the old man, who shrank behind his desk. "Please don't hurt me!" he cried, raising his hands to fend off blows.

"Just tell us where Lily is," Sano said, "and we won't touch you."

"I can't!"

The small, stuffy room reeked of the man's old age and terror. Sano said, "Who threatened you into keeping quiet?"

"Some samurai. I don't know who they were. They came here two days ago." Anxious to placate Sano and Hirata, the old man babbled, "They went from house to house, looking for Lily. They didn't find her; she was already gone. They told us that if anyone asked about her, we were to say we didn't know her, or they would come back and kill us all."

"Don't be afraid of them. I'll protect you." Urgency mounted in Sano. He grabbed the old man by the front of his robe. "Now where is she?"

Even though the old man whimpered and quaked, he cried, "I promised her I wouldn't tell!"

"Now we're getting somewhere," Hirata said.

"Why did she disappear?" Sano asked.

"She heard that those samurai were after her. She came hurrying into my shop, all frightened. She begged me to write a letter for her."

"A letter to whom?"

When the old man didn't answer, Sano turned him to face Hirata, who drew his sword. Hirata held the blade to the man's chest. They didn't have time to waste on gentle persuasion. The man shrieked, then blurted, "It was to Lady Reiko."

Sano was surprised because Reiko hadn't, as far as he knew, received a second letter from Lily. "What did she tell you to write?"

"That some bad men were after her, and she had to hide. She begged Lady Reiko to save her."

"If she expected help, she would have said where she would be," Sano said. She must not have had a chance to send the letter to Reiko. "Tell me!"

"I can't!" The old man pressed his back against Sano, shrinking away from Hirata's blade. "I would never forgive myself if anything happened to her."

"Listen," Sano said, turning the old man, "those people will find Lily eventually. My wife would want me to rescue her, and I will, but first you have to tell me where she is."

Fearful hope battled defiance in the man's eyes and won. "All right," he cried. "Just please let me go!"

Sano did. The old man crumpled onto the floor. Ashamed and woeful, he said, "I guess I can't do any more harm than I've already done. Lily said she was going to Ginkgo Street. There was a fire there before the rains started. She was going to hide in a building that hadn't quite burned down."

"Exactly where is this building?" Sano demanded.

The man gave complicated directions through Edo's maze of neighborhoods.

"Thank you," Sano said. "You did the right thing. I'm sorry we were so cruel to you."

He opened the door and called to some of his troops who were waiting outside: "Take this man to my compound. Guard him with your lives. He'll testify on behalf of Lady Reiko at her trial." He assigned more men to protect the residents of the street, then said to

Hirata, Inoue, Arai, Marume, and Fukida: "Come with me. We have to find Lily. She's the most important witness of all."

As the troops led the old man out of the shop, he began to weep. "It's too late. You can't save her. And it's my fault."

Sano was about to ignore him and go, but he realized there was more to the situation than he'd thought at first. "Wait. What do you mean?"

"There was another samurai who asked me where Lily went. Just before you came. I told him." The man sobbed, overcome by guilt and grief. "I shouldn't have. But my granddaughter was with me. He threatened to cut her throat."

Someone had beaten Sano to the witness. Sano demanded, "Who was he?"

"I don't know. He didn't give his name, and I've never seen him before. He rode off as if demons were chasing him."

His hysterical voice followed Sano, Hirata, and the detectives as they raced down the street toward their horses: "Merciful gods, he's going to kill her!"

26

The palanquin bearers let Reiko out on the wide main street that ran through Edo. Here were located the city's best stores, which served the richest citizens. Today the weather had kept most customers at home. The usual displays outside the storefronts were absent, the shutters partially closed to keep the rain off the fine household furnishings inside. Reiko was glad to find the street so deserted; she didn't want to run into anyone she knew. The longer the time she spent sneaking around like a fugitive, the more she feared getting caught. But she had to keep moving, had to keep trying to exonerate herself no matter how sure she was that she never would.

A Tokugawa soldier rode by. Reiko hastily ducked inside a shop whose entrance curtains bore a picture of bamboo canes. Lieutenant Asukai followed her into a showroom filled with articles made from bamboo. Screens lined the walls; baskets sat on shelves; lanterns hung from the ceiling. All featured the intricate designs that had made the shop famous. Near the door was a display of its specialty—cricket cages. They weren't the simple type in which children placed crickets they'd caught so they could take them indoors and listen to them sing. They were elaborate miniature houses, pagodas, and castles, made for wealthy connoisseurs. The talent that had gone into them had raised

their creator from outcast to artisan to successful merchant, a transformation virtually impossible.

The store was empty except for three clerks kneeling at a counter strewn with ledgers for recording sales and *sorobon* for calculating prices. One of the men rose and approached Reiko. "Welcome," he said, bowing. "May I serve you?"

It took Reiko a moment to recognize him. The last time she'd seen him had been at his parents' home, when they'd asked her to investigate his prospective bride. Then his crown had been shaved in samurai fashion; now his hair was cropped short all over his head. Then he'd worn silk robes and two swords; now, cotton robes, no weapons. His face, which she recalled as handsome but childish, had a new, mature strength.

"Greetings, Tsuzuki-*san*," Reiko said.

He took a second look at her, and emotions played across his features in a sequence too rapid for her to sort them out. Lieutenant Asukai put his hand on his sword, in case Tsuzuki should attack Reiko.

"Well," Tsuzuki said, smiling with sardonic merriment. "Funny meeting you again."

Reiko cautiously relaxed, but Asukai stayed close to her. She said, "My congratulations on your marriage."

"So you know about it. Did my mother tell you?"

"Yes," Reiko said. "I asked her where to find you, and she said your in-laws might know. I came to see them. But I didn't expect you to be here." She'd thought he and his bride had run away together, as starcrossed lovers did.

He pantomimed a laugh: His smile opened and his eyes narrowed, without sound. "Oh, I've been here ever since my parents disowned me. My father not only cut me off with no money, but he got me kicked out of the army. Luckily, my wife's parents were more accepting. They took me in even though I was a worthless *rōnin*. Now I'm a clerk and apprentice."

Roaming around the shop, he touched several baskets. "These are my work. Not bad, eh?" Genuine pride underlay his self-mocking

tone. "But it'll be a long time before I can do anything like this." His manner turned reverent as he pointed to the cricket cages. "My father-in-law did those."

Tsuzuki tilted his head and studied Reiko. "Say, why are you here? To see what became of me?"

"That's one reason. This is the other." Reiko handed him the letter he'd written.

As he read it, bitter nostalgia darkened his face for a moment before he smiled sheepishly. "I'm sorry," he said, giving the letter back to Reiko. "But I was so mad at you, I had to get it off my chest."

"You're not mad anymore?" Reiko suggested.

Again came his soundless laugh. "Oh, I was for a while. But pretty soon I started to think you did me favor.

"I used to be a good-for-nothing lout. My friends were just like me. We didn't care that we were wasting our lives. Now I've lost my gang as well as my family. I don't get drunk every night, or pick fights, or gamble and run up debts. I earn my own living instead of mooching off the Tokugawa regime. And you know what? I used to think merchants were beneath samurai, but my in-laws are fine people." His voice expressed genuine respect for them. "Finer than my parents, who care more about status and customs than what's inside people's hearts."

Looking over his shoulder, he said, "I'd like you to meet someone."

A young woman hovered in a doorway that led to the rear of the shop. She cradled a baby in her arms. When Tsuzuki beckoned, she shyly approached.

"This is my wife, Ume," he said, "and our son."

Ume bowed; he introduced Reiko to her. As they murmured polite greetings, Reiko noticed that Ume was strong, robust, and beautiful, the child plump and rosy with good health. She also noticed the affection with which Tsuzuki regarded them.

"I'm glad you came," he told her. "If not for you, things wouldn't have turned out this well. I'm glad for a chance to thank you."

"I must thank you for keeping my family's secret," his wife said. "If there's anything we can do to repay you, just ask."

It would have been proper for Reiko to tell the authorities that the family were *eta,* which would have resulted in them losing their business and being sent to the outcast slum. But she'd not wanted to destroy everything they'd worked so hard to achieve.

"Please forget the letter I wrote you," Tsuzuki said. "That's not how I feel anymore. You don't have to be afraid that I'll hurt you." He regarded Reiko with curiosity. "What else did you want?"

"I'm not going to find it here." Despair washed through Reiko because she'd finished her inquiries and they'd come to nothing. Owing Tsuzuki an explanation, she said, "Maybe you've heard that Lord Mori has been murdered and I'm the principal suspect?"

"No, I haven't. News from up high takes awhile to trickle down here."

"I'm looking for the person who killed Lord Mori and framed me," Reiko continued. "I thought it might be you."

She'd been counting on that, but Tsuzuki was truly happy with his lot in life. She believed that he had indeed cut his ties with samurai society and would have had no way inside the Mori estate. Her search for the murderer must end at herself.

"Well, I'm sorry I can't oblige," Tsuzuki said. "There must be other people who had it in for you. Who else did you run afoul of with your investigating?"

"There's Colonel Kubota."

"I know him. A powerful man, and pretty mean. What did you do to him?"

When Reiko explained, Tsuzuki whistled in amazement. "You really know how to offend people. You'd better watch out for Kubota."

"There's also the family of a clerk named Goro. He was executed for a murder that I investigated," Reiko said. "But I haven't been able to locate them."

Tsuzuki started to shake his head, then stopped. "Wait. Did he strangle a pregnant girl?"

"Yes," Reiko said. "How did you know?"

"It was in the news broadsheets," his wife said. "I remember."

"That's not how I heard about it." Tsuzuki lit up with surprise and

glee. "Hey, I may be able to help you after all." Irony twisted his mouth. "Who'd have thought I would ever want to? But listen to this:

"One night about a year ago, in the old days, my gang had a party at Lord Mori's. I drank a lot, and I passed out in the garden. When I woke up the next morning, I heard two women talking. One was complaining that her son, Goro, had been put to death for strangling a girl that he'd raped and gotten pregnant and throwing her body in a canal. The other woman said maybe he deserved it. But the first one insisted that he was innocent even though he'd confessed."

Reiko stared in astonishment. "His mother was inside the Mori estate? How can that be?"

"I don't know," Tsuzuki said.

"Who was the woman she was talking to?"

"Sorry."

A wisp of memory from her visits to the Mori estate solidified in Reiko's mind. She pictured the gray-haired woman who'd seemed familiar, whom she hadn't been able to place. Revelation exploded in her mind like a bomb.

She had an enemy inside that estate, one who'd been plotting retribution against her for two years, and had somehow ended up in the right position to exact it. The clerk's mother was Lady Mori's personal maid. Here was the connection between her past experiences and her present troubles.

Ginkgo Street resembled an abscess in a line of rotting teeth. The fire had burned an entire square block in a poor neighborhood on the edge of the Nihonbashi merchant quarter, which was hemmed in by canals that had kept the blaze from spreading. Buildings were reduced to black fragments of walls, charred beams, broken roof tiles, and cinders. Ashes blackened the puddles through which Sano and his men rode. The odor of smoke lingered. The area was deserted; the rains had delayed the rebuilding. It was eerily silent, as though haunted by the spirits of people who'd died in the fire. It was a good place for fugitives to hide.

Lightning crooked a finger down the heavens; thunder crashed. Drops pelted Sano as he noticed one building in better shape than the rest, located across the ruins by the canal at the northern edge. It looked to have all its walls and part of its roof, which was made of heavy, fireproof tiles.

"That must be where Lily is hiding," Sano said. He pulled back on the reins. "We'd better not let her see us coming."

He and his men jumped off their horses. Sano, Marume, and Fukida ran along the road, past the burned houses, to approach the building from the front. Hirata, Inoue, and Arai stole through the ruins toward the back. Sano slipped around the corner, treading softly on the footpath by the canal, above houseboats battened down against the storms. The building rose above piles of debris. The roof had caved in; the remains of a balcony dangled from the front. During a lull in the thunder, a high-pitched, frantic scream shrilled from the building.

"What was that?" Sano said.

He and the detectives were already running toward the doorway. A samurai stepped out of it. Sano bumped smack into him. He slipped on the muddy path and went down on one knee and hand. He looked up at Sano. Their gazes met in surprised recognition.

"Captain Torai," Sano said.

Dismay showed on Torai's face. Marume said, "What are you doing here?" At the same moment Sano noticed bright red splotches on the white collar of Torai's under-robe.

Torai scrambled upright and fled in the opposite direction. An awful suspicion gripped Sano. "Stop him!" he ordered Marume and Fukida.

They bolted down the path after Torai. Sano hurried into the house. Dim, cavernous space smelled of dampness and burnt wood. The faint light that came through holes in the ceiling illuminated rain dripping onto dirty, warped floorboards. Partitions divided the house into sections where different families must have lived. These were open to Sano's view as he ran past them; the doors had been removed. All were empty except for wet debris. Sano hastened down the pas-

sage to a chamber away from the worst damage to the roof. In a corner lay a faded quilt, a bundle of clothes, and a basket of rice balls—signs of habitation.

"Lily!" Sano called.

His voice echoed through the house. No answer came. Sano spied a straw sandal lying on the floor, its toe pointed at the threshold where he stood. He turned. A line of red splotches led farther down the passage. As he followed them, he smelled iron in the dank air. The splotches grew larger, running into the puddles, then into a pool of blood that spread, glistening crimson, across the floor of the last room.

In the center of the pool a woman lay like a broken doll. Her coarse, black hair was thick with blood, her cheap floral kimono drenched red. Her hands were flung up. Bloody gashes marked their palms. Her head was beneath a window whose paper panes had burned. Light from it bathed her white face, her open mouth revealing teeth awash in more blood. Her eyes seemed to stare in terror at her last sight, the attacker who'd cut her throat from ear to ear.

Horror at this violent death, pity for the victim, and fury at her murderer rose up in Sano. Shouting a curse, he pounded his fist against the door frame.

Hirata, Inoue, and Arai joined Sano. "What happened?" Hirata said. They saw the corpse and exclaimed in unison. Lightning flashed outside, searing the gory spectacle of death into Sano's eyes. "Is that Lily?"

"As far as I can tell," Sano said. Her age and gaudy clothes matched Reiko's description. His triumph at learning her whereabouts turned to the disappointment of utter failure.

Bending down, Hirata touched the blood. "It's still warm. She must have been killed just now."

"Yes," Sano said. "We were too late. He beat us to her by only a few moments."

"Who?" Hirata asked.

"Captain Torai." Sano explained how he'd met Captain Torai com-

ing out of the building. "There was blood on his clothes. He ran. Fukida and Marume are chasing him."

"So it was Torai who threatened the people around the Persimmon Teahouse into keeping quiet about Lily."

"With help from his friends, on Police Commissioner Hoshina's orders, no doubt."

"But why did he go to the trouble of tracking her down and killing her now?" Hirata asked.

"To tie up a loose thread," Sano said. "Hoshina wants to make very certain my wife is convicted and I'm ruined at our trials today. The last thing he wants is for me to bring in Lily as a witness for our defense and make Lord Matsudaira change his mind about us. Which I could have done, if we'd found her trail sooner. But there's still hope. Even though we've lost Lily, there's one witness left."

"Captain Torai?"

"None other. He's been in on Hoshina's plot to cover up evidence in the murder investigation. He knows all about it. I'll bring him before Lord Matsudaira and the shogun and tell them he murdered an important witness."

"The blood on him should help convince them," Hirata said.

"They won't care about the death of a peasant woman, but they won't take kindly to being tricked," Sano said. "I think Torai will finally betray Hoshina to save his own skin. That should help clear my wife."

"And good-bye to Hoshina in the process," Hirata said.

"That should knock some wind out of the campaign to make me out as a traitor," Sano said. "But let's go give Fukida and Marume a hand, because first we need to catch Captain Torai."

27

真相

Eager to find Sano and tell him she'd made a major discovery, Reiko headed toward Edo Castle with her entourage. As she neared the main gate, someone ran up to her palanquin and looked in the window.

"Reiko-*san!*" It was O-sugi, her old nurse, drenched by the rain. "I'm so glad I've caught you!"

"What's the matter?" Reiko said, surprised.

"Don't go home," O-sugi said, trotting alongside her.

"Why not?"

"He's at the house."

"Who?"

"That man who came to see you yesterday. Colonel Kubota."

Reiko started. "What's he doing there?"

"He came to arrest you. He's got a lot of soldiers with him. They're waiting for you to come back."

"But why?" Reiko said, as much mystified as disturbed. She called for the bearers to stop. Her procession halted some fifty paces from the gate. "How could he just barge in like that? Why didn't the guards keep him out?"

"He has orders from the shogun," O-sugi gasped out. "You're go-

ing to be tried for murder at the hour of the monkey. He came to take you to the palace."

"*What?*" Shock and disbelief stunned Reiko. "I've heard nothing about this. The shogun and Lord Matsudaira gave my husband permission to investigate the murder. He's not finished yet. Why should they have set my trial today?" Today, when she and Sano had no evidence with which to prove her innocence.

"I don't know." O-sugi began to sob in terror.

And the time of the trial was some two hours away. Why had Colonel Kubota come to take her so soon, and why him of all people? The whole thing made no sense to Reiko, until she realized what must have happened.

Sano's fall from power had begun. Last night his allies had deserted him; today Lord Matsudaira had turned on him. Lord Matsudaira had convinced the shogun to stage a trial that would surely end with her convicted of Lord Mori's murder and sentenced to death. Sano couldn't protect her anymore because he himself was wide open to attack.

"Don't go home," O-sugi pleaded. "That man is up to no good. Don't let him take you!"

Colonel Kubota must have gotten wind of what was going on and led the troops that would bring Reiko to the palace. He'd gone to fetch her early because he wanted time before her trial to punish her for ending his marriage. A shudder ran through Reiko as she imagined what form his revenge would take.

Lieutenant Asukai ran up to her. "What's going on?"

As Reiko explained, she saw her horror appear on his face. He said, "What are we going to do?"

They looked up at the castle that loomed in the rainy distance, bristling with watch towers, full of armed soldiers who'd surely been told that the chamberlain's wife had gone missing and were on the lookout for her return. It was no longer home to Reiko but a death trap.

"If my husband is in there, I'll never get to him before I'm

caught," she said. And Sano couldn't investigate Lady Mori's maid, solve the crime, and exonerate Reiko before Colonel Kubota got his hands on her.

"You're right," Lieutenant Asukai said. "We have to take you someplace safe."

A plan occurred to Reiko. Under any other circumstances it would have been foolhardy, but now she had nothing to lose. "I know one place they'll never look for me."

There she would find out the truth about Lord Mori's murder.

Sano, Hirata, Inoue, and Arai rode up to a gate that led out of the neighborhood where Captain Torai had killed Lily. It was the last of six gates through which Torai could have escaped. Sano and his men had already checked the others, and had neither picked up his trail nor seen any sign of Marume and Fukida. Sano asked the sentry, "Did a samurai run through here a little while ago, with two others chasing him?"

"No, master. But there was one who rode through by himself. He was in a big hurry."

"He must have had his horse stashed near the building," Hirata deduced. "He lost Marume and Fukida."

"Which way did he go?" Sano asked the sentry.

The sentry pointed and shrugged. A short distance beyond the gate, the street branched into two roads that snaked into a another neighborhood. Not a soul was in view. The rain had washed away hoof prints or any other signs of Torai.

"We'll split up," Sano told his men. "We have to get him to the palace in time for my trial and Reiko's."

Inoue and Arai galloped off along one branch of the road. Sano rode with Hirata down the other. They passed a shrine, blacksmith shops, and emerged into a marketplace. Sano spotted Torai beyond the stalls. He was cantering on his horse, looking around as if to see if anyone was pursuing him.

"There he is," Sano said. He and Hirata galloped toward Torai.

Torai saw them, slapped the reins, and took off. As they chased him through the crooked streets that surrounded the market, he suddenly turned a corner. Sano and Hirata veered after Torai, down an alley so narrow they had to ride single file. Sano, in the lead, gained on Torai. Their mounts collided amid pounding hooves. They ducked to avoid clotheslines stretched across balconies. Sano leaned forward and grabbed a tassel dangling from Torai's armor tunic.

"I've got you!"

Torai looked over his shoulder with an odd, triumphant sneer. He kicked his horse, which put on a burst of speed. The tassel broke off in Sano's hand. Sano and Hirata barreled ahead, trying to catch up. Rainy daylight at the end of the alley loomed near. Torai galloped out, skidded to a halt, then rounded on Sano and Hirata. Just inside the alley, they yanked on their reins to avoid running straight into him.

"What the——?" Hirata said.

Behind Torai appeared five samurai. He laughed as they all blocked the alley.

"It's an ambush!" Sano realized that there were too many men to fight. "Let's get out of here."

As soon as he and Hirata managed to turn their horses in the narrow space, they saw, at the opposite end of the alley, another squadron of six samurai. Police Commissioner Hoshina sat astride his horse at the forefront.

"We've got you, Chamberlain Sano," he said.

Sano kept his expression stoic although he felt a sick, falling sensation as he faced Hoshina down the alley. Hoshina and his troops must have been lurking nearby when Torai murdered Lily, and they'd rejoined forces after Torai had escaped Marume and Fukida. After all Sano's skirmishes with Hoshina, was this the end?

Torai and his comrades blocked Sano's exit at the rear. After Sano had survived nine years in the political battlefield of the Tokugawa regime, had his luck finally run out?

He and Hirata were spectacularly outnumbered, at the mercy of Hoshina, who had no mercy. But Sano drew his sword. So did Hirata, in front of him. "Move," Sano ordered Hoshina. "Let us through."

Hoshina uttered a laugh pitched high with glee and nerves. "Stubborn to the end, eh, Chamberlain Sano?" Torai and his other men laughed, too. "If you try to get past us, you're even more foolhardy than I thought."

Sano envisioned himself and Hirata slaughtered in a fierce, bloody rout, swords hacking at them until there was nothing left except gore. His muscles contracted. He smelled the sweet stink of his own fear and Hirata's even though they hid it behind their hard, calm faces. His mind worked frantically. He'd always prided himself on his ability to outthink his enemies. Well, he'd better do it now.

Sano turned to Torai and said, "We found Lily. We know you killed her."

"So what?" Torai said, grinning. With her blood on his collar, he looked like an executioner.

"You ordered him to get rid of her so she couldn't testify on my wife's behalf," Sano said to Hoshina. The longer he kept them talking, the more time he had to effect an escape.

Hoshina's smile bared teeth that gleamed with saliva. "You won't live long enough to tell anybody."

But Sano noticed that Hoshina stayed out of his reach instead of moving in on him. Hoshina was afraid of Sano, even with the numbers on his side. He knew a trapped beast was dangerous. Sano took a little heart.

"If you kill me, how will you explain it to Lord Matsudaira?" Sano asked.

Hoshina sneered at Sano's ploy. "We were bringing you to your trial. You resisted. You and Hirata-*san* were killed in the fight."

"He's not going to believe that," Sano said. "He'll know you murdered us in cold blood."

"Even if he does, he won't care," Hoshina said. "You poor sap, Lord Matsudaira is finished with you. Why do you think he's putting you on trial? He wants to find you guilty so he can get rid of you with a clear conscience and everything official and proper."

"In that case, he won't be happy that you've deprived him of my trial," Sano said.

"Shut up," Torai said, then called to Hoshina, "he's just trying to stall you."

Doubts flickered in Hoshina's eyes: Sano had gotten to him. He couldn't resist answering, "I'll bring Lord Matsudaira around." His voice brimmed with overconfidence. "I always do."

"Maybe you don't know that more of my men know what Torai did because they were with me when I caught him leaving the house where he killed Lily." Sano could tell from Hoshina's glance at Torai that he was right. "They'll tell my whole army. It'll come after you to avenge my death."

"They'd never get through my troops," Hoshina said, but Sano heard a falter in his tone.

"Enough of this," Torai groaned. "Let's kill them now."

Sano played on Hoshina's insecurity: "You can't. If you do, you'll be signing your own death order."

Hoshina dangled between his preference for playing politics instead of taking direct action and his reluctance to appear weak in front of his men. Finally he said, "I'll take my chances."

"If you insist. You've been wanting to do me in for seven years. Here I am. Come get me." If you dare, said the gaze Sano leveled on Hoshina.

Torn between his lust for Sano's blood and his ingrained caution, Hoshina hesitated.

Torai cried, "Come on, come on, what are you waiting for?"

Sano knew that Hoshina didn't want to be accountable for killing him. Hoshina looked furious because he knew Sano knew.

"If you don't want to kill him, let me!" Torai begged.

Instead Hoshina said, "Quiet!" His mouth pursed as he formed and discarded ideas. He whispered to one of his men, who nodded and rode off in a hurry.

"What in hell are you doing?" Torai demanded, so frustrated that he forgot his subservience to Hoshina. "Get rid of him now, or you'll be sorry."

"Oh, I'm getting rid of him, never fear," Hoshina said.

After some moments, a shout came from behind him and his troops. Hoshina beckoned down the alley to Sano and Hirata.

"Drop your swords and come over here."

"If you want us, come get us," Sano said.

Hooves clattered up behind him. Sharp steel pricked his nape above his armor tunic. Turning, he saw Captain Torai, seated on his horse, holding a long, pointed lance. "Do it," Torai said.

Much as Sano hated to give up his weapon, he knew it was no use against all these troops. He and Hirata let their swords fall.

"Both of them," Hoshina ordered.

Sano and Hirata threw down their short swords.

"Move," Torai said.

As they rode forward, Hirata whispered to Sano, "What are they going to do to us?"

"I guess we'll find out," Sano said, calm even though primed for the worst.

"Stop," Hoshina said when they neared his end of the alley. He and his troops backed up, spread into a circle in the street outside. Into it stepped four peasant men carrying a palanquin. Bearers for hire, they looked confused and frightened.

"Get inside the palanquin," Hoshina said.

It looked to Sano like a slow ride to hell. When neither he nor Hirata obeyed, Hoshina told his troops, "Give them a little help."

The troops dismounted, swarmed around Sano and Hirata, and dragged them off their horses. During a brief, savage scuffle, Sano kicked one man in the chin, punched another in the throat. Hirata butted his head against faces, kneed groins. By the time they were wrestled onto the muddy ground, three troops lay bleeding and unconscious. The others lashed Sano's and Hirata's wrists behind them, bound their ankles, then knotted the wrist and ankle cords together so their knees were bent and they couldn't move. The troops tied their sashes around their mouths as gags and flung them into the palanquin.

As the door closed, Hoshina said, "Enjoy the ride. It'll be your last."

. . .

Reiko's procession drew up outside the Mori estate. A horde of samurai blocked the open gate, shouting angrily, spilling into the street while rain poured down on them. Peering out the window of her palanquin, Reiko saw fists waving and tussles breaking out. Some of the men wore flying-crane crests on their armor. They were Sano's troops.

Lieutenant Asukai dismounted, ran over to the crowd, and called, "Hey! What's going on?"

A guard who wore the crest of the Mori clan shoved Asukai. "Get lost!"

One of Sano's soldiers saw him and Reiko's other guards. "Asukai-san. What are you fellows doing here?"

"We've come to see Lady Mori," Asukai said.

"Forget it," the soldier said as the Mori guards manhandled him and his comrades into the street. "Chamberlain Sano ordered us to guard the estate, but they're trying to throw us out."

"We don't have to put up with the likes of you anymore!" shouted a Mori guard.

Reiko realized that Sano's authority had weakened so much that the Mori retainers no longer needed to tolerate his occupying their domain. Clambering out of the palanquin, she shouted to Lieutenant Asukai: "We have to get in there!"

Someone in the crowd yelled, "Don't let them drive us away from our duty to our master! Fight!"

Suddenly all Sano's troops had their weapons in hand. Blades waving, they drove the Mori men in through the gate. Lieutenant Asukai beckoned to Reiko's other bodyguards, told one to ride back to Sano's estate and fetch more troops, then drew his sword. He grabbed Reiko by the hand.

"Let's go!"

Accompanied by her five remaining guards, they hurried after the brawling crowd and cleared the portals. Inside, men slashed, whirled, and collided in fights around the courtyard as Reiko and Lieutenant Asukai ran past them. Other Mori troops stampeded from within the estate. They charged at Reiko and Lieutenant Asukai. He slashed one down. Reiko's guards assailed the others.

"Come on!" Asukai shouted to his comrades as he tugged Reiko toward the inner gate. But they were busy fighting; they couldn't get past the Mori troops. He said to Reiko, "If we wait for them, we'll get killed."

"Then we won't wait," Reiko said, even though this was enemy territory, she was pregnant and vulnerable, and she needed more than Asukai to protect her. This was her one chance to clear herself. If she didn't take it, she was dead anyway.

In the confusion of the battle, she and Asukai slipped through the inner gate. "Where to?" Asukai said, panting. He stared in surprise at the blood on his sword. Reiko realized that this was the first time he'd ever killed.

"The women's quarters," she said. "This way."

Running through gardens, they hid behind trees and pavilions to avoid troops rushing to join the battle. They reached the wing of the mansion where the women lived. Lieutenant Asukai shoved open the doors. He and Reiko stepped into Lady Mori's chamber, which was brightly lit with lanterns, hot and close. A familiar scene greeted Reiko.

Lady Mori sat with her ladies-in-waiting, a large piece of embroidery spread on the floor between them. The gray-haired maid knelt beside Lady Mori, holding a tray that contained scissors, needles, and skeins of colored thread. The ladies-in-waiting gasped at the two wet, bedraggled intruders who'd burst in on them. Lady Mori's hands froze on her embroidery. The maid paused while offering the tray to Lady Mori. Their expressions went blank as they stared at Reiko. For a moment the only sounds were the women's quickened breathing, the distant battle noises, and a murmur of thunder.

"Hello, Lady Mori," Reiko said. "I can tell you never expected to see me again."

Lady Mori leaned back as Reiko took a step toward her. Her heavy cheeks sagged and her full lips parted in shock. "What—" She groped for words. "How dare you come here? After what you did to my husband!"

"You mean after what *you* did," Reiko said. On the way to the es-

tate, she'd figured out the gist of what must have happened. Now she wanted the whole story. "I have some business to settle with you. And with your maid." She turned to the woman. "Hello, Ukon."

"Oh, so you've finally recognized me," Ukon said in the brassy, insolent voice that Reiko now remembered hearing in the Court of Justice.

"I'm sorry it took me all this time," Reiko said, "but you've changed since your son's trial."

Ukon's hair had been black then, her complexion smooth for a woman in her late forties, her figure plump and fashionably dressed. Now she wore the faded indigo uniform of a servant. Her hair was solid gray; deep wrinkles etched her face. She was gaunt, as though her flesh had melted from the bones and muscles beneath the skin.

"Having a son put to death for a crime he didn't commit will do that to you," Ukon said. Her eyes gleamed with the hatred she'd kept hidden during Reiko's past visits. She set down her tray of scissors and thread, as if to free her hands for a battle.

"He was guilty. Believing he was innocent is something that only his loyal, devoted mother could do," Reiko said.

"He didn't kill that girl." Ukon was adamant.

"And you're not just loyal to him, you're deluded enough to blame me for your troubles," Reiko said.

"You are to blame. You dragged him in front of the magistrate. He was so frightened that he confessed." Two years hadn't shaken Ukon's certainty.

Reiko saw that she'd been right about Ukon; even though the woman had admitted nothing yet, she was the person behind Reiko's troubles. "You're also bold enough to take the revenge on me that you promised. But how did you happen to be here? Was it just a coincidence?"

Ukon smiled with a glimpse of decayed teeth. "Not just. I've been trying to get near you since the day my son was executed. I applied for work here because I thought it could lead to a job at Edo Castle, in your house. When you showed up here, I thanked the gods for my good luck."

"Then you figured out how to make me find out what it's like to be punished for something I didn't do," Reiko said, citing the threat Ukon had hurled at her in the Court of Justice. "You framed me for the murder of Lord Mori. But why him? How did you have the nerve?"

Lady Mori watched Reiko with an expression of nascent fear. She said to Ukon, "She knows! You promised me nobody would find out!"

"She doesn't know anything she can prove." Ukon aimed her scorn at Reiko as well as Lady Mori. "Just keep quiet, and we're safe."

Reiko saw that although Ukon wasn't to be so easily pressured into confessing as her son, Lady Mori was a different matter. Reiko said to her, "Ukon couldn't have done it by herself. At the very least, she needed you to invite me to dinner that night. What else did you do to help her?"

In any conspiracy there is a weaker partner. Lady Mori hunched her shoulders, like a bird trying to hide under its wings. She began to stammer.

"Be quiet!" Ukon said sharply.

Forgetting her fear, Lady Mori regarded Ukon with indignation. "How dare you speak to me like that? Show some respect!"

"My apologies, Honorable Mistress," Ukon said, her impatience not hidden by her false courtesy, "but I'm trying to keep you out of trouble."

"You promised there wouldn't be any trouble," Lady Mori said angrily. "And now this." She pointed at Reiko as if she were dog dung on the floor. "I told you it wouldn't work."

No love lost between them, Reiko thought. All the better for her. "Why did you help her murder your husband?" she asked Lady Mori.

"I wasn't just helping her. *She* was helping *me*," Lady Mori said.

Reiko realized that there was more to the situation than she'd thought. The crime wasn't as simple, nor the motive as straightforward.

"Shut your mouth, you idiot!" Ukon yelled.

Lady Mori drew herself up in a snit. "I have had enough of your uppity ways, of your ordering me around as though I were the servant, not you. I shall talk to Lady Reiko if I wish."

"Talk, and it's all over for both of us, you fool," Ukon said. "She'll have us put to death!"

They apparently didn't know that Sano was on the verge of being deposed, the Mori troops were slaughtering his, and Reiko and Lieutenant Asukai would have a hard time getting out of the estate alive. Reiko said, "Tell me about the night Lord Mori died."

"No!" Ukon grabbed Lady Mori and tried to put a hand over her mouth.

"Let go! How dare you touch me?" Struggling, Lady Mori said to her attendants, "Get her off me!"

They pulled Ukon away. Lady Mori wiped her face, smoothed her garments, and wrinkled her nose as if Ukon's touch had contaminated her. When she turned to Reiko, the temptation to confess had overcome her fear. Reckless daring sparkled in her eyes. "Ukon and I discovered that we had interests in common. I'll tell you exactly what happened."

28

During the ride that seemed endless, Hirata lay beside Sano in the palanquin. Facing in opposite directions, confined in a space so small they couldn't even turn over, they squirmed in a futile attempt to loosen their bindings. They couldn't talk around their gags, let alone call out loud enough to be heard by anyone who might help them.

From outside came the city noises of roving peddlers hawking tea, children playing, women chattering. Thunder punctuated the rhythm of the palanquin bearers' feet. Hoofbeats signaled Police Commissioner Hoshina and his troops following the palanquin. Hirata thought of Midori and his children, whom he would never see again. Resisting the urge to struggle harder, he forced himself to lie still. He inhaled and exhaled the slow, deep breaths of the secret technique that Ozuno had taught him. He tried to tap his inner spiritual energy and the infinite wisdom in the cosmos that would enable him to save himself and Sano.

But if that had been hard enough to do at the mountain temple, it was impossible now. Hirata could barely catch his breath, let alone control it. The gag in his mouth was soaked with the saliva that almost drowned him. His bad leg ached viciously. Panic took over his mind,

thwarted meditation. A curse on Ozuno, who'd misled him to believe that the mystic martial arts were any use! He would like to see Ozuno get himself out of this predicament!

But of course Ozuno would never have gotten into it in the first place. He'd have defeated Hoshina and his army at the start. Misery filled Hirata as he faced the fact that now he would never master the secret art of *dim-mak*. Shame added to his woes because he'd let Sano down, failed as a samurai. All his work, the trouble, the humiliation had been for nothing.

"It all began the day after you came to call on me the first time," Lady Mori told Reiko. "That morning Ukon said to me, 'I must warn you about Lady Reiko. She's no good.'"

"I said, 'You shouldn't criticize someone who is your superior, especially when she's my friend.' But Ukon said, 'Please listen to what I have to say. Then decide for yourself whether you want to be friends with Lady Reiko.' Well, I thought that was very presumptuous of her." She cast a resentful glance at Ukon.

Ukon sat with her arms folded, her expression furious. "If you want to confess and die, suit yourself. But leave me out of it!"

"She had previously told me that her son, Goro, had been accused of killing a girl he'd gotten with child," Lady Mori continued. "She said he didn't do it. Now she said that you'd had him arrested, Lady Reiko. Your father the magistrate convicted him. He was executed. She said it was your fault."

Reiko pictured Ukon spewing her obsession and hatred into Lady Mori's ear on many occasions that included the morning Tsuzuki had overheard them. How fate linked people together and set events in unpredictable motion!

"I said maybe Goro was guilty, maybe she was just looking for somebody to blame for his death," Lady Mori said. "But she believed in him even though he'd confessed. She said you should be punished for what you did to him."

If Reiko hadn't known Tsuzuki, she wouldn't be here now. If Ukon and Lady Mori hadn't met up, Lord Mori would still be alive, Reiko wouldn't be in trouble, and perhaps neither would Sano.

"At first I didn't believe her," Lady Mori went on. "You seemed like a perfectly nice, harmless young woman. And you didn't seem to remember Ukon. I told her that if you had really done what she'd said, you would have remembered her."

"Should have." Malicious humor curled Ukon's mouth. "Forgetting me was your mistake."

None of this would have happened if Reiko hadn't had a taste for detective work, hadn't started her private inquiry service. When had everything really begun? Perhaps when she'd married Sano. She wondered what he was doing now and felt such a strong prescience of danger that it dropped an invisible barrier between her and the other people in the room. Lady Mori went on talking, Ukon cursed at her, but Reiko couldn't hear them; for a moment she could only see their lips move; she was imprisoned by her fear for Sano. She could barely stifle the urge to bolt from the room and run in frantic search of him.

"But Ukon didn't give up trying to convince me that you were evil," Lady Mori said. "She said, 'If someone hurt you and your family, how would you feel? Wouldn't you want revenge? Wouldn't you want them to suffer the way they made you suffer? How could you bear to live as long as your enemy was alive?' "

Her voice quavered and shrank. "Day after day she talked. I began to believe that her son was innocent, that he'd been wronged by you. And I began to understand how she felt." A shadow of emotion dimmed her face. "Because I had felt that same way for so many years."

Sudden comprehension startled Reiko. "Then it's true. Lord Mori did entertain himself with boys. He did kill some of them. And you knew."

"Yes. I knew."

Reiko felt vindicated because Lady Mori had finally admitted she'd lied. "You hated being the wife of a monster. Is that why he had to die?" The murder had clearly not been intended for Ukon's benefit

alone, and the victim hadn't been her choice alone, either. "You wanted to make him pay for disgracing you?"

"No." Lady Mori gave Reiko a disdainful look. "You think you're so clever. You think you have it all figured out, but you don't. My own relations with my husband were of no importance. Ukon knew that very well. She knew everything else that he had done. Everyone in this house did."

Reiko frowned, puzzled because she'd thought she'd begun to untangle the reason for the murder, yet now, for a second time, it seemed she had a ways to go. "What else did he do? What did Ukon know?"

"She said, 'You have a son. You love him the way I loved mine. How did you feel when he was hurt? Don't you hate Lord Mori for what he did to Enju?' "

"Do you mean he used Enju the way he used those other boys?" Reiko was shocked. "His own son?"

Lady Mori's disdain deepened. "Why are you so surprised? Lord Mori liked boys. When I remarried, Enju was a boy of just the right age for his taste."

Reiko realized she should have known. Lord Mori, a powerful man accustomed to taking what he wanted, wouldn't have confined himself to the peasant boys he rented, or hesitated to take advantage of his new stepson. It wasn't exactly incest; Enju and Lord Mori weren't related by blood. But Reiko doubted that even a blood tie would have protected Enju.

"Lord Mori wasn't interested in me at all," Lady Mori said. "At our first meeting, before we became engaged, he spent the whole time talking to Enju, playing with him. I thought that meant he would be a good stepfather." She gave a bitter laugh. "I was too naïve to understand what it really meant."

Why, Reiko wondered, hadn't she thought of Enju being one of Lord Mori's boys? A mother herself, she didn't want to believe that such things were done to children by men who were supposed to be their fathers. Maternity had blinded her.

"Then your story about your love for Lord Mori, and your perfect marriage, was a complete lie," Reiko said.

Tears glittered in Lady Mori's eyes. "It was the way I wished things were."

"When did you realize they weren't?"

"A few months after I married Lord Mori. Enju's whole nature changed during that time. He had been such a happy, friendly little boy. He turned sullen, withdrawn. He would wake up screaming from nightmares. When I asked him what was wrong, he wouldn't tell me. I had him treated by a doctor, but it didn't help."

Reiko remembered Sano telling her what Hirata had learned from the Mori clan physician. They should have suspected that Enju's symptoms had resulted from sex forced on him.

"He began walking in his sleep, or so I thought at first. I would go to his room at night to check on him, and he would be gone. I searched for him all over the estate, but I couldn't find him."

Because he'd been in Lord Mori's private chambers, Reiko deduced, a place his mother hadn't thought to look.

"One night I lay down on his bed to wait for him to come back. I fell asleep. I woke up when I heard him crying. He was curled up beside me. There was blood on his kimono." Lady Mori's face showed the fear she must have felt. "I undressed him. The blood was coming from his bottom. I knew then what had happened. Someone had taken him from his bed, and—"

She gulped down the words that were too terrible to speak. "I said, 'Enju, who did this to you?' He cried and said, 'I can't tell you. He said he would kill me if I told.' The next night I hid near Enju's room. I saw my husband take Enju to his chambers. I followed them." Her throat muscles contracted, strangling her voice. "And I heard."

A shiver passed through Lady Mori, a memory like a bad wind that stirred her whole body. Her eyes closed; their lids quivered. "I heard Enju crying while Lord Mori groaned and wrestled him like a wild beast."

Even as Reiko imagined the horror of it, she observed that part of Lady Mori's story was true. She *had* spied on sexual sport in the private chambers, although not between Lord Mori and Reiko and not on

the night he'd died. Reiko felt sick herself. "How could you let him do that to your son?"

"I was afraid of him. Afraid he would kill us both if I interfered." Lady Mori hastened to say, "But I did try to stop him. The next day, I asked him to leave Enju alone. But he said he was in charge and he could do whatever he pleased." She sobbed at her own helplessness. "I went to my brother, who's a *daimyo*. I told him I wanted to leave Lord Mori. I begged him to take Enju and me in. But he was afraid of Lord Mori, too. He didn't want to start a war. He said that if I left Lord Mori, I would be on my own, with nothing, and Lord Mori would keep my son."

Reiko noted that another part of Lady Mori's story was also true. She had sought family support, although not to end an affair between Lord Mori and Reiko, and been refused.

"There was nothing for Enju or me to do except suffer in silence." The weight of misery and guilt visibly crushed Lady Mori. "We grew apart. He knew that I knew what Lord Mori was doing. He blamed me because I didn't protect him. He was just a child, he didn't understand how helpless I was. What could I have done?" She appealed to Reiko, eager to justify her inaction. "Steal him away, and try to bring him up by myself?"

That would have been Reiko's first thought under the circumstances. But although she was tempted to despise Lady Mori for her weakness, she knew the world was a harsh place for a woman alone and poor. She saw the rationale for staying and enduring. "So you waited for Enju to get older and Lord Mori to lose interest in him."

"Yes!" The word burst from Lady Mori in a cry of pain. "If only I had known what would come next. Lord Mori did lose interest in Enju when he grew up, but he wasn't finished with him." Anger and revulsion contorted her face. "He made Enju find boys for him and arrange for them to be brought to the estate."

Reiko shook her head, amazed because she'd thought that the tale of the Mori family couldn't possibly get worse. That Lord Mori had turned his stepson and former sexual object into a procurer!

"But that's not all," Lady Mori continued. "When Lord Mori killed the boys . . ." She put her face in her hands and wept so hard that Reiko could barely understand her as she said, "He made Enju dispose of their bodies."

That Lord Mori had turned his heir into an accomplice to murder! Yet even while fresh shock hit Reiko, she saw a chance to solve part of the mystery. "What did Enju do with them?"

"He took them to a crematorium in the Zōjō Temple district. He paid the undertakers to burn the bodies and not tell anyone."

This was what must have happened to the boy that Reiko had seen, and the reason Sano had been unable to find the body. Enju, or someone else, had followed the procedure, and the boy was ashes by now. Reiko had another question she desperately wanted answered. "Was there a boy named Jiro? This spring, in cherry blossom time?"

Lady Mori shook her head woefully. "I don't know. There were so many boys."

"Try to remember," Reiko urged, anxious to learn whether Jiro and Lily existed, and if so, to find out what had happened to the child.

"I didn't want to see. I looked the other way."

Torn between pitying her and deploring her for burying her head in the sand, Reiko said, "You were lucky. You still have Enju. Think about the mothers who never saw their sons again after Lord Mori had them."

Lady Mori covered her ears. "I don't want to think about them. There was nothing I could do. Besides, he didn't kill them all. I don't know what became of the ones he didn't."

This raised but didn't satisfy Reiko's hopes that Jiro was real and alive. Still, at least Reiko now knew much of Lady Mori's true story. For years Lady Mori had seethed with anger at her husband; then arrived Ukon, with her own bone to pick. After Reiko had come on the scene, they'd discovered their common interests. Both thought their sons had been misused by evil, powerful people; both had hungered for revenge.

"So you came up with a plan to kill two birds with one arrow." Yet

Reiko still needed to fill in the gaps in her memory. "But what exactly happened that night?"

"You don't remember anything?" Ukon said.

"Nothing after I fainted outside Lord Mori's chambers," Reiko said.

Lady Mori moaned. "Please don't make me talk about it. I can't bear to even think of it."

"Then I'll tell her." Ukon radiated malice at Reiko. "It's not fair that you should forget." Eager to have Reiko know the worst, she cast aside caution. "I want you to hear."

Sano lay exhausted in the palanquin with Hirata, his lungs heaving from his struggles, his muscles cramped. He'd managed to loosen the ropes around his wrists, but not enough to free his hands. He thought of Reiko, her trial. He couldn't help her anymore. She was on her own, her death certain.

He thought of Masahiro, and such anguish filled him that he almost beat his head against the hard plank floor. His death would leave his son helpless, his future in peril.

His anger at Hoshina kept his fear and despair at bay. He tried to concentrate on where he was going. Although he'd lost his sense of direction, he knew he was heading out of town because the city noises had diminished. Hoshina was taking him and Hirata somewhere isolated to dispose of them. Sano rested awhile, then strained at the ropes around his wrists and managed to stretch them a bit wider. He tried to think of a plan to save his life and Hirata's.

Nothing occurred to him.

A stench filtered into Sano's nostrils, putrid and familiar. Now he knew where he was—near the *eta* settlement, where the outcasts lived. He'd been here once, on an investigation. The stench came from the tanneries run by the outcasts, situated away from town so the smell wouldn't offend the citizens and the taint of death wouldn't pollute their spirits.

The bearers slowed their pace and muttered in disgust. Captain Torai called, "Get a move on." Their feet sloshed in the gutters that ran through the settlement. The reek of sewage added to the tannery stench and nauseated Sano. The commotion of the settlement engulfed him. The rattle of buckets, axes chopping, laughter and curses, the wails of the sick and dying, formed an auditory picture of humanity crowded too close together in squalor. Men shouted, brawling. "Get out of the way," Captain Torai ordered. A crowd scattered. "Turn left. Slow down," Torai said. Sano felt the palanquin's motion correspond to Torai's orders. Again he strained at the ropes. They were slippery with blood from chafing his wrists. "Go in there. All right. Put it down."

The palanquin tilted and rocked as the bearers eased the poles off their shoulders. It thumped onto the ground, jolting Sano and Hirata. Hooves clopped and armor creaked as Hoshina and his retinue gathered around them. The quality of the sound suggested a wide yet enclosed space. The tannery stench was so overpowering that Sano felt swamped by it. He heard the men jump off their horses, then smooth, metallic rasps of swords drawn.

Panic rippled through Sano, through Hirata's body next to him. The bearers cried, "No, masters! Please!" in voices shrill with terror. There was a scuffle, hissing noises and thuds, exclamations of horror quickly stifled.

Even as Sano realized what had happened, Hoshina said, "Take them out." The palanquin door opened. Torai and another man reached in, grabbed Sano and Hirata, and dragged them onto the ground.

Sano found himself in a courtyard surrounded by low buildings with peeling plaster walls. The source of the stench was a pit in the center. Dead horses protruded from the murky water, which bubbled with gases and sent forth corrosive lye fumes. Two of Hoshina's men held swords that dripped blood. Before them lay the corpses of the palanquin bearers, who'd been killed so they couldn't spread word that Hoshina had kidnapped two high officials. More troops guarded

four frightened men with shaggy hair and bare feet, dressed in ragged, dirty clothes. They were the *eta* whose rendering factory Hoshina had commandeered for disposing of Sano and Hirata.

A pair of legs clad in ornate metal shin guards strode up to Sano's face. Twisting his neck, Sano saw Hoshina grinning down at him.

"Well, Chamberlain Sano," Hoshina said, "our positions are finally reversed. I must say it feels good." His voice was jittery with excitement, anticipation, and fear of his own daring. He kicked Sano hard in the ribs. Sano stifled a grunt of pain. Hoshina laughed and ordered his troops, "Sit them up by the pit."

Soldiers dragged Sano and Hirata across ground slick with mud, blood, and entrails and littered with broken bones, to the water's edge, and propped them on their knees. Stiff and sore from the ride, Sano hoped the men wouldn't notice that his ropes were loose enough that he might squeeze one hand through. Hoshina jerked the gags out of Sano's mouth, then Hirata's. Now Sano could taste the noxious fumes that wafted over them.

"Any last words before you disappear forever?" Hoshina said.

Sano looked into the pit. Greenish bubbles burped around the decomposing horse carcasses. He swallowed.

"Don't you think I've chosen a good place for you to vanish?" Hoshina sounded eager to be reassured. "It'll be as if you both dropped off the face of the earth."

Because the *eta* would be too afraid of Hoshina to talk even if anyone would listen to them. Sano reminded himself that he had only one death, and it was the biggest test of his samurai character. He must face it with dignity and courage, not waste it on fear. He saw Hirata's rigid expression and knew his friend was thinking the same thoughts, fighting the same battle for self-control. At least they would die together.

"I'm glad to see that you have some imagination," Sano answered Hoshina. "I thought you were totally without any."

Although Hoshina laughed, he looked irate: This wasn't the attitude he wanted from Sano. "Still a wise bastard to the end, eh?"

"Let's get on with it, already," Torai muttered. He and the other men restlessly paced the courtyard.

Hoshina seemed as if he'd rather draw out Sano's demise, the better to enjoy it. "You're treating this as a joke, when you should be using your famous wits for some better purpose. Such as giving me a reason why I should spare your life."

Sano wouldn't give Hoshina the pleasure of hearing him beg for mercy. "I'd rather talk about Lord Mori's murder. If this is the end for me, it can't hurt you to tell me how you killed him and managed to frame my wife." Before he died, at least Sano wanted the satisfaction of knowing the truth.

"Don't you ever give up?" Exasperation crossed Hoshina's face. "I told you before, and I'll tell you now, *I was not responsible for the murder.*" He spoke through gritted teeth.

"Well, you must have been part of Lord Mori's conspiracy to overthrow Lord Matsudaira. You must have planted my notes in the warehouse with the weapons."

"For the last time, I wasn't! And I didn't!"

"But you were responsible for Lady Nyogo lying about me during the séance." Sano was determined to get a confession not only for its own sake, but because it might put off his death a little longer.

"Yes, yes, all right." Hoshina impatiently waved away Sano's words. "But everything I did was after the fact. The first I heard of Lord Mori's murder and your wife was right before I walked into your meeting with Lord Matsudaira and the shogun. I only took advantage of what happened."

"Do you believe him?" Hirata said, incredulous.

Sano did, in spite of himself. "He's got no reason to lie anymore." And if Hoshina were the mastermind behind the whole plot against Reiko and Sano, he would be bragging about it. Sano had been wrong about Hoshina. How strange that his investigation should end in a showdown between them anyway.

"Then who did kill Lord Mori and set Lady Reiko up to take the blame?" Hirata asked.

"I suppose we'll never know." Sano resigned himself to the fact.

"Enough of this," Hoshina said. Now that he realized Sano wasn't going to grovel, he was in a hurry to get things over with. His eyes twinkled with cruel mischief. "I do believe I'll give you the pleasure of watching your comrade die first. Torai-*san,* you may do the honors."

29

"We decided that Lady Mori should invite you to dinner that night," Ukon said. "I put a potion in the wine I served you."

"What kind of potion?" Reiko asked.

"Coptis, lotus, and biota seeds, longan berries, white peony buds, belladonna, and opium."

Reiko was aghast to hear that she'd been drugged with such a potent concoction. No wonder she'd lost her memory, had mental lapses, and thought she was going insane: It had played havoc with her mind. She was lucky to be alive, glad to know at last what had happened.

"We waited for you to fall asleep," Ukon said. "When you sneaked out of the party, we followed you."

Reiko pictured herself stealing through the estate, trailed by the two women. No wonder she'd felt as if she were being watched.

"How convenient for us that you ended up at Lord Mori's private chambers." Ukon snickered. "You saved us the trouble of carrying you there. And how convenient that you passed out right on his doorstep."

"So that's how you got me under your control," Reiko said. "But what about Lord Mori? He wasn't unconscious and helpless."

"Oh, yes, he was. Earlier in the evening, I'd put the same potion in

his wine as yours." Ukon preened at her own cleverness. Reiko remembered the decanter she'd seen in Lord Mori's room. "And he'd dismissed his guards. By the time you fainted, he was all alone and too sleepy to mind very much when we dragged you into his room."

Sudden dizziness washed over Reiko. Time whirled backward. For a moment she was in Lord Mori's room. *He was in the bed. He blinked in confusion and mumbled, "Who are you? What are you doing here?"* Her vision had been a real memory, a fragment of what had occurred. Now it expanded to include the hazy figures of Ukon and Lady Mori, who were with him.

"We undressed Lord Mori. It was hard because even though he didn't fight us, he was big and heavy," Ukon said.

Reiko frowned, assailed by another flash of memory. *The two women struggled to remove Lord Mori's robe from his inert body. Their voices echoed through her semiconsciousness.*

"Then we undressed you."

Their hands roughly tugged off her clothes, turned her, and stripped her naked as she lay limp and unable to resist.

"We'd planned to kill Lord Mori with his sword," Ukon said. But we found a dagger strapped to your arm. We decided to use that, the better to make it look as if you'd killed him. It was a little harder to decide which one of us should do it."

Lady Mori, who'd been sitting in crushed, miserable silence, now said, "I had so looked forward to killing him, but when the time came, I lost my courage."

With Lord Mori's nude, drowsing bulk in front of them, Ukon gave the dagger to Lady Mori. Reiko was amazed by how much information her mind had subconsciously recorded, how the women's confession had triggered a flood of memories. *Lady Mori cried, "No! I can't!"*

" 'You do it,' I begged her." Lady Mori pantomimed pressing the dagger on Ukon.

"I said, 'He hurt your son, he's your problem, you should be the one to punish him,' " Ukon continued.

The dagger passed back to Lady Mori, while tides of sleep wafted Reiko in and out of darkness.

"She made me," Lady Mori said.

A flurry of motion; cries; a scuffle. Ukon pushed Lady Mori to her knees beside Lord Mori. "I'll help you."

"She put her hands over mine on the dagger. We raised it up over him." Lady Mori placed her fists one atop the other and lifted them above her head. "And then . . ." She closed her eyes, turned her face, and winced.

The two women plunged the dagger into Lord Mori's stomach. Blood spurted. Reiko watched, dazed and numb.

"I thought one stab would be enough." Lady Mori's voice penetrated Reiko's memory. "I thought he would die right away."

A howl burst from Lord Mori as pain roused him. His arms and legs thrashed.

"He wasn't supposed to wake up. I guess he didn't drink all his wine," Ukon said. "He gave us quite a fright."

As the two women fell backward, they pulled the dagger out of him. Ukon's shout mingled with Lady Mori's shrill, hysterical laughter. Reiko gasped as past and present collided.

"He tried to get away from us," Ukon said.

Lord Mori was on his knees, his face a picture of terror and bewilderment. Dripping blood onto the floor, he crawled away from the women, from Reiko. He fell, then dragged himself across the room while Lady Mori screamed and screamed.

"We needed to finish him off, but she was a useless wreck." Ukon flicked a disgusted glance at Lady Mori, whose eyes stared with the panic she'd felt that night, her hands clapped over her mouth as if to stifle the screams. "So I went after him."

Lord Mori cried, "No! I beg you! Stop!" Reiko had mistakenly thought he was talking to her, that she'd stabbed him. *Ukon brandished the dagger. Her mouth twisted with murderous intent, she slashed at Lord Mori. The blade cut his torso as he rolled on the floor and sobbed.*

"Have mercy!"

His hands, knees, and feet scrabbled in the blood that spilled from him as he struggled to escape, as his wife doubled over in the corner and vomited.

Lady Mori retched, spewing vomit onto the floor, sickened by

what she'd seen that night. Reiko thought how fallible memory was, how the gaps in hers had led her to think herself guilty of murder.

"Finally he died," Ukon said.

But how to explain the other memories, in which Reiko had coupled with Lord Mori then stabbed him?

"No more!" Lady Mori frantically waved one hand to silence Ukon while the other clasped her stomach and her body heaved. Bile dripped from her mouth. "Please . . ."

"Please, let's get out of here!"

"Not yet," Ukon said. "We've still got work to do."

The chamber revolved around Reiko; the lanterns blurred above her. Ukon appeared in her field of view, her face ugly with hatred as she stared down at Reiko. "It's not enough that you'll be blamed for killing him. Execution is too good for you." She turned to Lady Mori, who was moaning in the background. "Come here. Help me lift her."

"I want her to hear," Ukon insisted.

As her consciousness waxed and waned, Reiko heard Lady Mori say, "No, I don't want to," and Ukon snap, "You have to. I helped you. Now it's your turn to help me. It's only fair."

"We dragged you onto the bed," Ukon said, "then we put Lord Mori on top of you."

His face was above hers, so close that she could smell the sour breath from his open, drooling mouth. Reiko had only thought it was breath; it had been the reek of decay. *His eyes were half-closed, his expression blank.* Because he was dead.

"We wrapped your arms and legs around him," Ukon said. "I sat on his back and bounced up and down."

His body humped against hers with repeated thuds. Reiko felt herself gasping, the slickness of their sweat. But she'd only thought it was sweat, when it was really blood from his wounds.

"It was hilarious." Ukon clapped her hands and chortled. *She rode Lord Mori like a horse, laughing gleefully.* "How does it feel to know you made love with a dead man?"

"It was disgraceful," Lady Mori moaned. "You are so vulgar, so filthy, so disgusting!"

Lieutenant Asukai, who'd listened in shocked silence until now, said, "You should be ashamed of yourself for treating Lady Reiko that way!"

Reiko sank to her knees in relief that she hadn't been Lord Mori's mistress. Yet she gasped in horror at the image of Ukon playing with them as if they were puppets made of flesh.

"It was no more than you deserved." Ukon's malicious cheer was undiminished by her audience's reaction. "I decided that as long as you were going to die for Lord Mori's murder, you should share in the fun."

Enlightenment flashed through Reiko. "You sat me up. You tied my hands around the dagger. Then you threw us at each other," she said, appalled.

Lord Mori emerged from a blur of light and motion before her. His mouth was open as if in a wordless plea, his arms flung wide. A mighty lunge propelled her toward him. Reiko revised the scene in her mind. *Lady Mori held her upright. Ukon shoved Lord Mori toward her. The blade of her dagger sank deep into his stomach. He howled.* No, not him, but Ukon. *She bayed in triumph as she danced around Reiko and Lord Mori, whooping like a madwoman.*

Her laughter rang out harsh, maniacal, and chilling now. "That was the best part," she said. "Afterward, we laid you beside Lord Mori's body and we cleaned up the room. We left you there. We took away the chrysanthemums and the painted screen and burned them in the woods. Then we went back to the women's quarters to wait for the news that Lord Mori was dead and you'd murdered him."

Reiko's satisfaction at knowing the truth at last mixed with fury at the two women. But she also had a question.

"Just one thing," Reiko said. "There was a big step from you wanting to get even with me, Lady Mori wanting to get even with her husband, and what you did about it. Whose idea was it to kill Lord Mori and frame me?"

Ever since Captain Torai had dragged him and Sano out of the palanquin, Hirata had been directing his spiritual energy at their captors. All the while he'd knelt by the pit and listened to Sano argue

with Police Commissioner Hoshina, he'd tried to attack his enemies' shields, the auras of mental and bodily energy they radiated. But they didn't seem to feel a thing. Hirata felt like a child shooting make-believe arrows while his last moments slipped away.

Now Torai strode up to Hirata, grinning because it was finally time for action. He made a mock bow to Sano, who looked on in helpless horror while straining at his ropes. Hoshina stayed beside Sano, watching with an anticipation almost carnal. Hirata felt Torai's shield throb with confident power, while despair weakened his own. Torai posed near Hirata and swung up his sword. Hirata's neck prickled in anticipation of the cut that would extinguish his life. He hurled one last, parting shot of energy toward Torai . . .

. . . and felt something flex inside him, some strange combination of muscles and will he'd never known he had. His perceptions altered. The rendering factory, the other people in it, and the entire world seemed shockingly immediate, the colors so intense and details so intricate they dazzled his eyes. He could hear his companions breathing and the noise from the distant city. Through the tannery stink he smelled the ocean far away. The energy exploded out from a deep place at his very core, like steam from a geyser.

Torai's body jerked as if skewered by lightning. He hesitated with the sword paused at its zenith. His stance shifted. The triumph on his face dissolved into confusion as Hirata's energy struck him and his mind warned his body that it was under attack despite a lack of any visible sign.

"What are you waiting for?" Hoshina demanded.

Hirata lunged at Torai. A roar burst from his throat, so loud that all his sinews vibrated. They snapped the rope that tethered his wrist and ankle bonds. His feet sprang off the ground. He hit Torai with tremendous force. Torai exclaimed in surprise. As they crashed to the dirt, the sword flew out of Torai's hand. Hirata arched his back, thrust his feet through the circle of his arms, and brought his hands in front of him. The energy coursing through him made his muscles as fluid as water. He flowed over Torai, who squirmed beneath him. He grabbed for the weapon with his bound hands.

Hoshina said, "What in the—?"

Hirata's vision splintered like a magic mirror that showed him everything around him even as it focused on the sword. He saw Sano whip his right hand loose from his bonds. Sano grabbed Hoshina's ankle. Hoshina yelped, kicked free, but lost his balance and fell. Torai jumped on Hirata. His knees pounded Hirata's back, pressing him onto the ground. He seized the hilt of the sword at the same time Hirata did.

They grappled, thrashed, and rolled over and over. Hirata lost his grasp on the sword. While on the bottom, Torai shoved his foot against Hirata's stomach. Hirata flipped backward, landed on his feet. Torai sprang up, raising the sword to lash at Hirata.

Hirata's awareness extended into the future. He saw a shimmering, transparent image of Torai burst from the flesh-and-blood man. For a split instant he watched the image wield its sword, noted how the blade carved through the air. Acting on reflex, he thrust his hands into the blade's path.

Present and future merged. Torai swung the sword just as Hirata had foreseen. The blade whistled between Hirata's hands. Its slick, cold, steel sides grazed his fingertips and palms before its blade sliced the ropes around his wrists. His hands were free. Torai gaped. He swung the sword again.

Again Hirata saw the shimmering ghost of Torai in the next instant, divined the path the sword would take. Hirata leaped, corkscrewing his body sideways. Torai's blade cut the ropes from his ankles. Hirata twisted in midair and landed on both feet like a cat. Torai shouted to his men, who stood staring in dumbfounded amazement: "Don't let him get away!"

While they and Torai charged at Hirata, Sano and Hoshina fought on the ground. Hoshina tried to jerk his sword out of its scabbard while Sano held onto his wrist. Cursing, he punched Sano's face while Sano struggled against the ropes that still trussed him. Two of Hoshina's men ran toward them, brandishing swords at Sano.

Hirata's kaleidoscopic vision zeroed in on a butcher knife that lay

beside a heap of bones. He dove for the knife. It was in his hand almost before he reached it. He flew in front of Hoshina's men, blocking their way to Sano. He slashed one man's throat, whirled, and cut the rope that leashed Sano's tied hand to his bound ankles. Sano locked both hands on the hilt of Hoshina's sword. Hoshina bucked under Sano as he clawed at Sano's fingers. Sano bashed his forehead against Hoshina's nose. Hoshina let go of the sword. Sano gained possession of it. He clambered to his feet, used the blade to cut away the ropes from them, and faced down Hoshina.

"Somebody give me a sword!" Hoshina shouted, frantic.

A sword flew through the air. Hoshina caught it. As he and Sano begin slashing at each other, troops rushed to defend Hoshina. Hirata planted himself near Sano, back to back. Although he couldn't see Sano or Hoshina, their energy fields created a sensory picture in his mind. He moved with them, guarding Sano's rear, as Torai and the troops converged on them.

The men assailed Hirata in a tornado of whirring blades. But their ghostly future-images were always a step ahead of them. Hirata dodged the iridescent arcs their swords would follow. He flung up his knife to parry each strike before it neared him. He was fighting the battle in an extra dimension, and he was the only person aware of it. Exhilaration filled him, stoking his energy higher. While Sano and Hoshina battled, circling the pit, Hirata flowed along with them like Sano's shadow. He felt Hoshina slice at Sano's head and Sano duck. Hirata ducked, too, avoiding the tip of Hoshina's sword as he hacked his butcher knife where the ghosts appeared.

It sliced real flesh when the men appeared there an instant later. They seemed to hurl themselves at his blade. It was an extension of himself, guided by his mind as if fused with his muscle and bone. Four men dropped, howling in agony, spurting blood from mortal wounds between the plates of their armor. Hirata drove the remaining four, including Torai, away from Sano, who was still fighting Hoshina. One more impaled himself on Hirata's knife and fell dead. Their battle spilled out of the rendering factory, into a street lined with shacks.

People scattered. Hirata whirled amid flashing sword arcs, glided behind his opponents and their ghosts, until the last two soldiers turned and ran for their lives.

"Cowards!" Torai shouted after them. "But who needs you?" Panting and sweating, he faced Hirata, his expression crazed with his determination to fight until he won. The best swordsman of his gang, he'd managed to avoid Hirata's precise, deadly strikes; there wasn't a scratch on him. Maybe he had a touch of mystical power. "I can take you by myself."

Hirata felt his strength flagging. Not even the mystical power that pulsed in him could burn away the poisons that fatigue spread through his blood. His bad leg ached. As he and Torai warily circled each other, he realized that such a huge expenditure of energy couldn't go on forever. He sensed an equally huge tidal wave of exhaustion rushing toward him. He had to win this battle in the next few moments before it hit.

When Torai lunged, Hirata could barely see his ghost; he dodged barely soon enough to miss a fatal gash to the neck. Now, as they fought, Torai began to match Hirata's expertise. Now Hirata noticed the disadvantage he was at because Torai's sword was twice as long as his knife. Hirata parried every strike but landed none. Torai's ghost faded. The extra dimension vanished. Torai gained strength as Hirata lost it. Torai's blade cut his shoulder. Hirata felt pain sting and warm blood flow. Torai laughed.

"Now I've got you!" He moved in closer, lunging and slashing more fiercely as his confidence grew.

Hirata began to limp, a bad sign. He recalled the last lesson Ozuno tried to teach him. While frantically plying his knife with his right hand, he raised his left and swept it away from his body. Torai's gaze involuntarily followed it. Distracted, he paused just long enough for Hirata to launch a cut at his head. Torai regained concentration in time to parry, but Hirata's strike knocked him off balance. He stumbled. Hirata lashed out again, but the wave of exhaustion loomed closer. His cut missed Torai by a full hand's breadth. Torai recovered and came charging after him. The knife was heavy in Hirata's grasp. His whole

body felt weighted down. He raised his left hand and moved it around, aiming bursts of energy toward different points on Torai's body.

Torai flinched as if hit on his chest, legs, and shoulders. His eyes skittered, trying to see what ailed him. He swung his sword wildly, the blade coming nowhere near Hirata. His face took on a look of terror because Hirata had seized control of his mind. The no-hit technique reduced him to a mass of twitches. He and Hirata were partners in a strange dance in which Hirata's hand commanded every spastic move Torai made. Torai's next swing carried his whole body with its momentum. He went reeling past Hirata, who backhanded the knife across his side. Torai shrieked.

Blood gushed from his wound. He crumpled onto the filthy street, moaned, and thrashed once. The savage light went out of his eyes as he glared up at Hirata.

The wave of exhaustion broke upon Hirata with overpowering force. Bones and muscles turned to sludge. His racing heartbeat slowed as his body demanded rest. The knife fell from his hand; his eyes closed; his knees folded. Slumber as deep as death claimed him before he collapsed on the ground beside Torai, his partner in combat, who'd joined forces with him to achieve this victory.

His last thought was that he could no longer help Sano.

30

"It was her idea," Lady Mori said, pointing at Ukon.

"No, it was hers," Ukon said.

They were both to blame, but Reiko wanted to know who the ringleader was. She suspected it was Ukon, and she wondered why Ukon didn't rush to claim the credit for their plan, especially since she'd already owned up to carrying it out.

Ukon said to Lady Mori, "Don't you remember that you said to me, 'Wouldn't it be nice if my husband and Lady Reiko both died?'"

"Yes . . . but I was just talking." Lady Mori wrinkled her forehead. "I don't think I really meant it."

"Of course you did."

Reiko was surprised that maybe the gentle, meek Lady Mori had instigated the whole thing.

"But you were the one who said, 'Lord Mori and Lady Reiko are too healthy and strong to die anytime soon. We need to make it happen,'" Lady Mori said.

"Well, you said, 'We could sneak into Lord Mori's chamber some night and stab him,'" Ukon retorted. "'And next time Lady Reiko comes over, we could kill her, too.'"

Lady Mori shot back, "You said you didn't just want Lady Reiko

dead. First you wanted her to be disgraced and punished for something she didn't do, just like your son."

"Well, you said why not get rid of them both at the same time and be done with it all at once?"

"That was you! You were the one who thought of killing him and making it look like she did it."

"Well, maybe it was. But you egged me on."

Peeved and resentful, Lady Mori said, "Ha! As if you needed any encouragement."

Reiko doubted she'd ever get to the bottom of this, and it didn't matter. She had more important things to think about. She heard fighting and yelling outside: Lord Mori's troops were still battling Sano's. She whispered to Lieutenant Asukai, "How are we going to get these two out of the estate?"

"Well, it would have worked if you'd kept your big mouth shut," Ukon said angrily.

"My mouth is no bigger than yours," Lady Mori flared. "You're the one who spilled the whole story because you wanted to brag to Lady Reiko about what you did to her."

"I only talked after you said enough to get us killed, you stupid fool!"

Lady Mori puffed herself up with indignation. "You rude, dirty peasant! Don't you dare talk to me like that. I'll—" She abruptly fell silent. Her anger transformed into dismay as she gazed past Reiko.

Reiko turned and saw a young man standing in the doorway. His handsome face wore an expression of total shock. Ignoring the other people in the room, he stared at Lady Mori.

"Enju," she said in a faint voice. Her hand clasped her throat. "How long have you been there?"

"Long enough to hear everything." He shook his head, as if trying to deny what he'd heard. "Mother, is it true?"

Lady Mori cringed from the horror in his voice. Tears of shame filled her eyes. "I never wanted you to find out."

"You killed Father." Enju looked stricken, dumbfounded.

"I couldn't bear the thought of you knowing that his blood is on my hands." Lady Mori reached them toward Enju. "I did it to punish him for what he did to you. Because I couldn't protect you then. Will you forgive me?"

Enju hastened to her, knelt, and took her hands in his. "Oh, Mother." His voice was thick with emotion.

Lady Mori embraced him, pressing her cheek against his head. Reiko was moved in spite of herself. She understood the all-importance of a mother's debt to her child. Lady Mori had had the right intentions. If only her means had been different.

Running footsteps accompanied voices shouting outside. Lieutenant Asukai opened the exterior door. A horde of soldiers wearing Sano's crest overran the garden. Asukai called to them: "Hey! What's going on?"

"We've subdued the Mori troops and occupied this place," the commander said.

Relief provoked a deep sigh from Reiko. Lieutenant Asukai said, "Good. We need an escort back to Edo Castle."

"Will do," said the commander.

Just in time for Reiko to bring the two murderesses to testify at her trial and exonerate her. "Lady Mori and Ukon, you'll have to come with us," she said.

Enju turned to Reiko and said, "No," obviously upset because his mother would pay with her own life for what she'd done. His grip tightened on Lady Mori's hands. "I won't let you take her."

Lady Mori withdrew her hands and spoke with sad resignation: "It's all right, Enju. I'm willing to accept my punishment."

"Mother, no!"

As she rose, he clutched at her skirts like a child. She stroked his face, smiled tenderly down at him. "He's gone. I can die in peace, knowing that I did right by you at last."

Enju released her. His posture slumped; he began to weep in ragged, painful sobs. Reiko pitied both son and mother from the depth of her spirit because she couldn't help imagining herself defend-

ing Masahiro and him torn from her as she went to answer for shedding blood on his behalf. She could almost forgive Lady Mori.

Lady Mori glided toward Reiko, Lieutenant Asukai, and two soldiers who'd entered the room. She said with quiet dignity, "I am ready to go."

"Well, I'm not," Ukon declared. She looked stricken, as if she'd just absorbed the fact that she'd confessed to a crime and her life was in jeopardy. She also looked utterly offended. When the soldiers moved toward her, she flung up her hands and said, "Don't you touch me."

"It's over, Ukon. Give up," Reiko said.

"But it can't be over," Ukon said, shaking her head in frantic disbelief. "After I've planned and hoped for so long, after how hard I've worked . . ." Sorrow crazed her eyes; her voice rose to a wail. "You weren't supposed to win!"

She took a step toward Reiko. Reiko backed away, as much shaken as revolted by Ukon's passion. She couldn't help sympathizing with the woman's desire for revenge, even though she herself was the target. Blood vendetta was a time-honored part of the samurai code of honor that Reiko embraced. Ukon's intentions, however misguided, were as true as Lady Mori's. Could Reiko have reacted with any less fury had anyone harmed Masahiro?

But these justifications didn't excuse Ukon's crime. Reiko said, "You took a gamble, and you lost. Now you have to take the consequences. You might as well come peacefully."

Ukon clawed at her hair. "I won't! It's not fair that you should get my son killed and then get out of the trap I set for you." She sprawled her wild gaze over the people in the room. Lady Mori watched her with distaste, Enju with leery fascination. "If I'm put to death, Lady Reiko will go free to hurt other people. It's not fair!" She tore at her bodice, leaving bloody scratches on her chest.

"Accept your fate," Lady Mori told her. "Have some dignity for once in your miserable life."

Reiko said to Lieutenant Asukai, "We don't have much time before the trial. Arrest her."

He and the soldiers took hold of Ukon's arms. "Leave me alone!" she cried.

With a strength unexpected from a woman her age, she wrenched free of the men. She launched herself toward the door. Lieutenant Asukai sped after her. He caught the end of her sash. She fell on her knees. As he dragged her like a dog on a rope and the soldiers rushed to help him, she struggled, her hands scrabbling at the floor, Lady Mori's embroidery, the tray of colored threads. "Let me go!"

She twisted her body and lunged up toward the men like a snake striking. Clutched in her hand were the scissors, which were small and dainty yet sharp and made of steel.

"Look out!" Reiko cried.

Ukon stabbed at the soldiers. Her scissors gouged one in his eye. He howled, his hand clasped over the wound. His comrade swore and drew his sword on Ukon as she slashed at him and Lieutenant Asukai.

"No!" Reiko exclaimed. "I need her alive!"

"It's not fair that I should lose my dream of revenge on you," Ukon raged at Reiko. She ran around the room, evading Lieutenant Asukai and the soldier who chased her. "That's all I have left in the world!"

The soldier caught her arm. As he wrestled her, she plunged the scissors into his thigh. He yelled and let her go. Lieutenant Asukai circled Ukon, flinching every time she thrust the scissors at him. He lunged at her, but she sidestepped him and charged toward Reiko.

"I should have killed you that night we killed Lord Mori!" she shouted.

Reiko pushed up her sleeve and grabbed the dagger strapped to her arm. This should have taken her no longer than a heartbeat, but pregnancy had slowed her reflexes. Because she hadn't practiced martial arts in months, her movements were clumsy, her whole body slack. Before she could unsheathe the dagger, Ukon struck at her. Reiko dodged, but not soon enough. The blades cut her shoulder.

Pain ripped a cry from her. The heaviness of her belly slung her off balance. She fell sideways. As she hit the floor, Ukon was on her. Ukon's fist plunged, the scissors pointed toward Reiko's eye. Reiko snatched for them. The blades pierced her palm. Ukon stabbed again

and again. Reiko beat frantically at Ukon, who shouted, "I'm going to kill you now, if it's the last thing I ever do!"

Lieutenant Asukai hauled her off Reiko. But Ukon writhed in a fit of flailing arms and legs. She threw him against a wall and hurled herself upon Reiko again. More stabs gashed Reiko's arms as she flung them up to protect her face. Ukon's weight immobilized her, crushed her swollen middle.

"It's not fair that you're with child when I can never have another," Ukon shrieked. Spittle flew from her mouth. Her face was so distorted by rage that she looked demonic. "I hate you! I hate you! Die!"

She aimed the scissors in a brutal thrust at Reiko's stomach, at the child inside. Panic invaded Reiko. She grabbed Ukon's wrist in both her hands. The scissors points jabbed her belly as Ukon tried to drive them home. Her free hand clawed at Reiko's. As they thrashed, vying for control of the weapon, Reiko fought with a determination she'd never before known, the ferocity of a mother wolf protecting her young. But Ukon was a mother gone insane because she'd lost hers. While pregnancy weakened Reiko's power, madness fed Ukon's. She howled and raked the scissors in a zigzag down Reiko's belly.

Reiko screamed in horror as they cut her skin. Consumed by the most ferocious rage she'd ever felt, she heaved Ukon off her. Ukon reeled, stumbled, and landed on her back. Reiko whipped out her dagger and flew at Ukon, shrieking in agony. She slashed with all her might at Ukon's grinning face.

Lieutenant Asukai caught Reiko before she could kill the woman. The two wounded soldiers seized Ukon. This time she didn't resist. She dropped the scissors, which were stained with Reiko's blood. Panting and wheezing, she laughed hysterically.

Lieutenant Asukai took the dagger from Reiko and eased her to the floor. "Are you all right?"

"No, oh, no!" Sobs of terror convulsed Reiko as she gazed down at her belly and the crimson stain spreading across her robes.

"A child for a child!" Ukon crowed as the soldiers led her and Lady Mori out of the room and Enju hurried after them. "We're even at last!"

Inside the rendering factory, Sano and Hoshina lunged and slashed at each other. Both Sano's legs were asleep, his circulation cut off by the ropes that had immobilized him too long. They felt numb as chunks of wood. Although he tried not to stagger and show his weakness, they could barely hold him up. A million thanks to Hirata for slaying most of their enemies and drawing the others away; his mystic martial arts training had paid off when it mattered most. But now Hoshina had the advantage. Sano had to seize it from him or die.

"You're all alone now," Sano said as they retreated, lunged, and slashed again and again. "You might as well surrender."

"I could say the same for you." Hoshina grinned.

He loosed a barrage of swipes that Sano barely dodged. A prickling sensation crept through Sano's calves. While he struck at Hoshina, he said, "When's the last time you won a battle?"

"This time," Hoshina said, parrying.

"That's wishful thinking." When Hoshina counterattacked, Sano crouched, narrowly evading a cut to the head. He lurched around Hoshina. "When's the last time you even fought anybody?"

Hoshina whirled with an ease Sano envied. "In practice at Edo Castle yesterday." But he sounded irritated because they both knew that although he'd once been a police officer who'd fought criminals in the streets, he was an idle bureaucrat now.

"Practice is no substitute for a life-or-death fight like this," Sano said.

"Well, it's better than nothing," Hoshina flared. "Sure, you defeated the Ghost, but that was three years ago. Since then you've spent more time using a writing brush than a sword!"

He hacked with swift fury at Sano, driving him backward. Blood flushed through the veins in Sano's legs. Agonizing spasms gripped his muscles. He winced as he ducked and parried. The pit was behind him. Teetering on the edge, he flung out his arms to keep his balance. Hoshina aimed a savage cut at his stomach. As Sano jerked backward, his legs gave out. He fell into the pit.

Thick, slimy, foul water splashed up around him. He sank beneath its bubbling surface. The lye burned his eyes before he could close them. Nauseated by the liquid stench that filled his nostrils, he gurgled. The putrid taste penetrated his lips even though he clamped them shut. The pit was deeper than he'd thought. While he flailed, trying to stand up, he almost let go of his sword. His head cleared the water just long enough for him to gulp air before his feet slipped on the muddy bottom and he went down again. Chunks of submerged, decayed meat floated against him.

He heard Hoshina laughing through the water that churned in his ears. Managing to raise himself, he retched, spat, and shook slime off his face. Every particle of him felt contaminated by the taint of death. His eyes sore and bleary from the lye, he saw Hoshina standing beside the pit.

"If you could see yourself!" Hoshina sobbed with uproarious laughter. "This is priceless!"

Sano waded toward the edge of the pit. As the spasms cramped his legs, he tottered. Hoshina slashed at him. Leaping away, Sano lost his footing. He swiped at Hoshina and almost fell. He tried to get past Hoshina and climb out of the water, but Hoshina ran alongside the pit faster than Sano could trudge within it.

"I've got you now!" Hoshina said as he sliced at Sano.

Fury begot cunning. Sano splashed armfuls of water at Hoshina.

"Hey!" Offended, Hoshina sprang back from the pit to avoid contamination.

Sano scrambled up its side. But he skidded on the muddy slime, all the way under the water again. Hoshina struck at him. The blade grazed his scalp. As he burst up for air, Hoshina's blade came swinging at his face. He gasped a deep breath and sank just in time. He crouched on the bottom, eyes shut, doubled over with his arms protecting his head, holding his breath.

Hoshina's sword stabbed down at him so fast that it seemed like a thousand blades impaling the murk above Sano, carving the soup of rotten flesh and lye. The sharp point impinged on Sano's back, his shoulders. He forced himself not to move.

When he didn't come up, the stabbing ceased.

In the watery stillness and quiet, Sano sensed Hoshina examining his blade and wondering if the blood on it meant Sano was dead. Sano couldn't hold his breath much longer. His heart pounded; his lungs demanded that he inhale. The lye burned into his wounds. He tried to gauge exactly where Hoshina was standing. Just when he thought he must come up for air or drown, Sano felt Hoshina bend over the pit to look for him.

Sano erupted out of the pit, his sword raised. Through the viscous water that streamed off his face he saw the blurry image of Hoshina in front of him. Sano swung his sword at it with all his might.

Hoshina screamed.

He lifted his sword, too late. He took Sano's strike clean across his neck.

Sano felt his blade slice through flesh, muscle, bone. A huge red fountain of warm blood sprayed him. Hoshina's severed head splashed into the pit, an instant before his body toppled onto Sano.

31

The seventh month of the year brought clear, hot weather to Edo. The rainy season had finally let up. Reiko sat in her sunny private chambers with Midori, while in the adjacent room Masahiro had a reading lesson with his tutor. Little Taeko peered over his shoulder at his book as he read aloud. Midori helped Reiko remove the bandage on her belly. Underneath was a jagged, healing red cut.

"It looks better," Midori said. "There's no festering. You were very lucky."

"Yes, I was." Reiko's heart still seized whenever she thought about that terrible moment when Ukon had tried to stab her. On each of the nine days that had passed since the attack, she'd burned incense and offered prayers of thanks to the gods that the scissors hadn't penetrated deeper.

The baby kicked. Bulges appeared on her stomach. Midori smiled. "I see that Masahiro's little brother or sister is as strong and healthy as ever."

"After all we've been through together, it's a miracle." Yet Reiko couldn't help wondering how the violence and evil would affect her child.

Midori applied herbal ointment to the scar. "It's wonderful that you've been exonerated."

The high drama at the trial had kept the Edo gossip mill busy ever since. When Reiko and her escorts had taken Lady Mori and Ukon to the castle, Ukon had gone stark raving mad along the way. They'd had to tie her hands and lead her like a wild beast behind the palanquins that carried Reiko and Lady Mori. She'd wailed, sobbed, and cursed all the way to palace, where the shogun and Lord Matsudaira had already convened.

Everyone had waited almost an hour for Police Commissioner Hoshina. When the trial began without him, Ukon had been too incoherent to testify. The story of Lord Mori's murder had been told by Lady Mori. The shogun and Lord Matsudaira had believed her. Since Hoshina wasn't there to dissuade them, Lord Matsudaira had recommended that Reiko be pronounced innocent and Lady Mori and Ukon sentenced to death. The shogun had obliged.

"Those terrible women have been punished," Midori said now, "and good riddance to them."

Lady Mori had gone meekly to the execution ground, but Ukon had resisted to the end. She'd torn off her clothes, beaten her head on the floor, kicked and bitten the soldiers as they dragged her from the room. The shogun had said, "Well, ahh, that's the most shocking thing I've ever seen."

No sooner did he speak, than Sano and Hirata arrived.

"What took you so long?" Lord Matsudaira asked. "You not only missed your wife's trial; you almost missed your own."

Sano looked at Reiko. He read in her face that she'd been acquitted; relief and love flashed between them before he turned to Lord Matsudaira. "My apologies, but I had important business to attend to."

Everyone including Reiko listened with new, dumbfounded shock as Sano told about Lily's murder by Captain Torai, his kidnapping by Police Commissioner Hoshina, and the battle at the rendering factory. "Hoshina and Torai lost," Sano said. "They're both dead."

In the silence that followed, Lord Matsudaira narrowed his eyes, calculating what this news meant for him. Then the shogun said, "Ahh, that's too bad. But I never really liked them anyway."

Reiko couldn't believe the shogun's callousness. Sano seemed glad

the shogun didn't take him to task for killing two high officials. He said, "Now, about the treason charges against me. I swear I'm innocent. Does anyone have any evidence to the contrary?"

No one did, now that Hoshina was gone.

"I recommend that we drop the charges against Chamberlain Sano and let him keep his post," said Lord Matsudaira.

"Done," the shogun said.

Now, as Reiko put on a fresh bandage, she said, "If not for Hirata-san, I would be a widow." Sano had told her the details of the battle. "I owe him a great debt for saving my husband's life."

"He did no more than his duty," Midori said, but she looked radiantly proud of Hirata.

"I haven't seen him since the trial," Reiko said. "Where is he?"

"I don't know." Midori sighed. "He left this morning. He didn't say when he'll be back."

Sano had also left this morning, for some unnamed destination and one of many secret meetings since the trial. As Reiko wondered what was going on, she dressed for a trip.

"You're not going out on more private inquiry business, are you?" Midori said disapprovingly. "Remember what happened last time."

"This is something I have to do," Reiko said. "I must fulfill my obligation to the dead."

The establishment known as Blow-Dart Beach wasn't located on a beach, but in the theater district. Nor did it offer the popular game in which players blew darts through wooden pipes at targets. It was an elegant two-story house, separated from the teahouses, shops, and actors' dwellings around it by a fenced garden. Reiko, Lieutenant Asukai, and her other bodyguards walked up to the gate. Asukai rang the bell.

A manservant answered. He frowned at Reiko and said, "No women allowed."

"Make an exception for this one," Asukai said.

He strode through the gate, elbowing the servant aside. The body-

guards ushered Reiko after him. They passed through the front garden, an entryway, and a corridor that led to a private world. Here, plum trees shaded a party of men and boys. They lounged on cushions on the grass and in a wide, round, sunken bathtub filled with water. The men wore dressing gowns, loincloths, or nothing. The boys, who ranged in age from perhaps five years to fourteen, were clad in gaudy, feminine kimonos. Servants wandered among them, passing drinks, food, and tobacco. A band of musicians, dressed as women but obviously male, played the flute, samisen, and drum. In this world, the blow-pipe was a man's penis, the dart his seed, and the target a young boy who aroused him for a price.

Music and conversation ceased. Everyone stared at Reiko. She felt grossly out of place here, in one of Edo's best-known male brothels, but she spoke up bravely: "I'm looking for a boy named Jiro. Is he here?"

There was no answer, only silent disapproval.

For nine days, ever since Sano had proved that Lily had existed, Reiko had been searching for the dancer's son. She'd pursued the slim chance that he was one of the boys that Lord Mori hadn't killed during sex. She'd sent Lieutenant Asukai to investigate Lord Mori's circle of friends. One had admitted that Lord Mori had passed a boy on to him. He was low on cash because of gambling debts, and instead of sending the boy home when he was done with him, he'd sold him to Blow-Dart Beach.

Now Asukai put his hand on his sword and said to the customers, "Speak up, unless you want trouble."

There was a stir in the corner. Someone pushed a boy at Reiko. In spite of his feminine clothes and the rouge on his lips and cheeks—or perhaps because of them—Reiko could see Lily in him. She smiled with relief and gladness.

"I'm Lady Reiko," she said. "Your mother sent me."

His round, solemn eyes beheld her with distrust. "My mother doesn't want me. That's why I'm here."

Reiko saw, to her dismay, that Jiro had been damaged and hardened by months in the sex trade. "That's not true." She realized that

she had much explaining to do. "But we'll talk about it later. Come with me."

She held out her hand. Jiro hesitated a moment, shrugged, and took it. She could tell that he'd only obeyed because going off with a stranger was better than staying where he was.

"Hey, he's my property," objected a man who looked to be the brothel owner.

"Shut up and just be glad I don't kill you," Lieutenant Asukai said.

As he escorted Reiko and Jiro from the brothel, Reiko dreaded telling the boy that his mother was dead. Maybe Jiro would take heart from the fact that Lily had had the courage to try to get him back from the man she'd rented him to in a desperate bid for their survival. Reiko only hoped that a kind home with her would make up for his suffering. But at least she'd rescued Jiro as she'd promised Lily she would.

The landscape in the eastern hills outside Edo resembled a classic painting by an ancient court artist. The distant city below was a glare of sunlight hazed by smoke from fires that had resumed full force now that there was no rain to discourage them. But high altitude cooled the forest. Refreshing breezes blew on Sano, General Isogai, and elders Ohgami and Uemori as they reposed inside a rustic pavilion built on a hilltop.

"Thank you for doing me the honor of visiting my summer estate, Honorable Chamberlain. It's nice to get away from the heat, isn't it?" Ohgami said, fanning himself.

"Yes." But Sano wasn't deceived by the pretense that this was a mere holiday jaunt. "May I ask what you want to say that can't be said in town?"

Disapproving glances passed between the elders. Uemori puffed on his pipe, coughed, and said, "You haven't changed in spite of your recent experiences. You still have a tendency toward directness."

"That's a point in his favor, as far as I'm concerned." General Isogai grinned at Sano. "Congratulations on getting out of that mess. Thought you were done for this time."

"I'm glad you're in favor with Lord Matsudaira again," Ohgami added.

"You should have had more faith in me." Sano spoke lightly, but his tone was edged with rebuke toward the men and his other allies for deserting him in his hour of need. They'd lined up in hordes outside his mansion to pay their respects, bring lavish gifts to appease him, and eat their pride. He'd forgiven them instead of punishing them. "I hope that next time you'll know which side to bet on. Because if you lose, the winner might not be so generous."

"Generosity, nothing," General Isogai snapped. "We have mutual interests."

"Indeed we do," Sano agreed mildly. He couldn't dispute that they needed one another. "None of us can stand alone."

"From bad comes good," Uemori said. "Getting rid of Hoshina made all your trouble worthwhile."

"With him gone, his faction has dissolved into handfuls of squabbling malcontents," Ohgami said. "None of them are strong enough to stand between you and Lord Matsudaira."

"That's what really saved you," Uemori reminded Sano. "Without Hoshina to set him against you, Lord Matsudaira is willing to accept that Lord Mori was a traitor and you aren't."

"Even though you never really proved it," Ohgami said, referring to the fact that Sano hadn't had any more solid evidence at the end of his investigation than at the beginning. "The medium's confession doesn't count. You could have forced her to admit that she faked that séance."

Hence, it was still Sano's word against his enemies'. Sano knew there were many people, including these three, who weren't sure he wasn't guilty. But nobody dared make an issue of that.

"Do you think Lord Matsudaira actually believes Chamberlain Sano is innocent?" Uemori asked Ohgami and General Isogai.

General Isogai shrugged. "Doesn't matter. That has to be his official position."

Because Sano was stronger than ever, with little to check him now that Hoshina's faction was dissolved, many of Hoshina's old cronies had rushed to jump on Sano's ship. Sano was the biggest man in Japan

next to Lord Matsudaira. Everyone had better think carefully before they accused him of anything again. At first Sano had been angry that a taint of suspicion still hovered around him, but he couldn't complain; it beat death by compulsory ritual suicide.

"Things are better for you than they were before Lord Mori's murder," Ohgami said.

"That's old news," Sano said blandly. "Forgive my impatience, but will you please get to the point?"

The elders looked toward General Isogai. General Isogai looked around to make sure there was nobody else within earshot, then said to Sano, "Don't get too complacent. Lord Matsudaira is still dangerous to you."

"Do you think I don't know that?" Sano said, aware that he was a bigger target and his position more precarious than ever.

"Sure you do," General Isogai said. "What I don't think you realize is that it's time for you to move against Lord Matsudaira."

Sano shouldn't have been surprised, but for a moment he couldn't reply.

"He who strikes first and catches his opponent off guard has the advantage." Uemori spoke with the wisdom of his decades as the regime's chief military adviser.

"Now is your best chance," Ohgami said.

Finding his voice, Sano said, "You want me to overthrow Lord Matsudaira?"

"That's right," General Isogai said. "We and your other allies are behind you all the way."

"We understand that things have changed so suddenly and you've been so busy that you haven't had the opportunity to make any plans," Uemori said. "We'll give you time to think about our proposal."

"But don't take too much time," General Isogai said. "Hesitation will get you killed."

The temple hadn't changed since Hirata had left. Mist still veiled the Yoshino Mountains; eagles still soared above the pagoda; the

bell still echoed across the pine forests. But as Hirata climbed up the steps cut into the cliff, his awareness of the place encompassed the tiniest birds, insects, and lichens in the woods, the planets, stars, and the infinite cosmos beyond. His spirit balanced within their totality. The energy coursing through him relieved the weariness of the fifteen-day ride from Edo. He entered the temple gate and paused, his heightened senses testing the air for Ozuno's presence.

The pulsation of his teacher's shield led Hirata to the main precinct where the worship hall dominated a courtyard. Ozuno limped toward him, leaning on his staff, across the paving stones. Hirata met him in the middle.

"I didn't think you'd be back," Ozuno said, irritable as ever. "What happened? The Tokugawa regime threw you out on your behind? You have nowhere else to go?"

"No," Hirata said, "a miracle happened."

"What nonsense are you talking?"

"I finally got what you were trying to teach me," Hirata said. "I used it to defeat my enemies. I saved my master's life."

As he elaborated, a most gratifying expression of amazement dawned on his teacher's face. Ozuno gaped, scratched his head, and squatted on the ground as if cut down to size by the news.

"The cosmic winds blow me to hell!" he said.

This moment was supremely worth all the toil and frustration Hirata had endured, all the abuse he'd taken from Ozuno. "The last time we met, you told me that if a miracle happened, you would resume my training."

"Indeed? I suppose you expect me to keep my bargain," Ozuno said, recovering his orneriness.

Hirata spread his arms. "When do we start?"

"No time like the present." As Ozuno stood up, he looked closely at Hirata, waiting for him to make some excuse.

"Fine," Hirata said.

Sano had given him an indefinite leave of absence, his reward for his heroics. The shogun and Lord Matsudaira had agreed to it. For once Hirata had all the time in the world to devote to his training. His

only problem was leaving Midori and the children. But his previous dabbling in the mystic martial arts had started something that he had to finish, no matter the sacrifice. That day at the *eta* settlement had set him on a path of no return.

"All right," Ozuno said, resigned. "We'll begin with ten days of meditation and breathing exercises."

"Not that again," Hirata protested. "Haven't I proved that I'm beyond it?"

Ozuno frowned in severe rebuke. "You've proved that you haven't changed as much as you think. You're still the same, pigheaded fool. You don't understand that a warrior must never give up practicing the basics."

"But I'm ready for something more advanced now," Hirata said.

"Really?"

Ozuno lashed out at Hirata with his staff. Hirata never saw the blow coming. It landed smack across his stomach. As he cried out in surprise and doubled over in pain, Ozuno kicked his rear end. He found himself facedown on the pavement.

"If you're so advanced, you should have sensed that I was going to hit you and counterattacked me," Ozuno said.

Hirata rolled over and groaned. Ozuno said, "Winning that battle was just beginner's luck. Get up, you fool. You've got a long way to go."

"Surely you're not going to do what General Isogai and the elders want," Reiko said, alarmed. "You're not going to challenge Lord Matsudaira?"

"It's something I must consider," Sano said.

He and Reiko sat in the pavilion of their garden in the coolness of the evening. They kept their voices low in case there were spies lurking in the shadows. Lanterns glowed in the windows of the house. Fragrant incense burned to repel mosquitoes. Across the garden, Masahiro carried a lantern, pulled up worms for a fishing expedition. Reiko stared at Sano in disbelief.

"You mean you might actually do what you were falsely accused of

doing—betray Lord Matsudaira?" She was so shocked that her mouth gaped and closed several times.

Sano's expression was dark, conflicted. "I know how it sounds."

"You would try to seize power after you were almost put to death for treason?"

"It's less a matter of ambition than survival."

"Have General Isogai and the elders manipulated you into believing that?" Reiko said, incredulous.

He rose and stood at the railing that enclosed the pavilion, his back to her. "No. I was surprised that they were keen on the idea, but I've been thinking about challenging Lord Matsudaira since before they suggested it."

"You have?" Reiko had thought that nothing else could surprise her anymore.

"It's been on my mind every time I remembered how sick I am of having to defend myself against Lord Matsudaira," Sano assented, "every time I wondered how to prevent more crises like the one we've just been through. Every time I imagine how much better my life would be if Lord Matsudaira were gone, overthrowing him seems like the logical solution."

The anger in his voice troubled Reiko even though she understood it and she, too, was angry at Lord Matsudaira, because he'd almost condemned her to death for a crime she hadn't committed. Yet she couldn't bring herself to agree with Sano.

"It would be dangerous," she said. "You could lose."

"I could lose by doing nothing," Sano said. "Lord Matsudaira likes me well enough now, but he could turn on me again at any time. He's not exactly comfortable with how powerful I've become. And I still have enemies. They wouldn't mind joining with Lord Matsudaira to crush me while they can."

Reiko couldn't argue with that, but she had other, stronger objections. "To be so disloyal to your superior would violate the samurai code of honor."

Sano turned slightly, and the light from the house gilded the wry smile on his face. "Bushido is a double standard. On one hand, it keeps

the lower-ranking samurai in their places. On the other hand, every warlord who's risen to power has done it at the expense of a superior, and there's no disgrace attached to that."

His cynicism troubled Reiko. In the space of a few days, he'd changed from her husband who marched along a distinct line that divided right and wrong to a stranger who perceived infinite shadings between them. Yet she found herself nodding. The murder case had changed her, too. She was as sick of being suspected, accused, and threatened by Lord Matsudaira as Sano was. Maybe it was time to stand up for themselves, to secure the future of their children. And Sano deserved an opportunity to govern the nation more fairly than his colleagues had. But the idea of his staging a coup terrified her even though his allies and army were strong and his chances of winning worth a gamble. The idea of war and bloodshed daunted any mother, even a samurai woman.

She rose, stood beside Sano, and laid her hand on his. "Promise me you won't act rashly."

He covered her hand with his other. "I promise that whatever I do will be carefully thought out in advance."

Together they looked at Masahiro's lantern zigzagging across the dark garden. "I just pulled up a big worm!" Masahiro called, excited. "I'll catch lots of fish tomorrow."

Reiko smiled, distracted from her thoughts for a moment. "This investigation didn't turn out the way we wanted. It seems only the beginning of something even more serious."

Sano nodded, then mused, "That's not the only reason I'm dissatisfied with the outcome. I have a feeling there's something not right, something unresolved."

"Do you? So do I," Reiko said, glad because he shared her suspicions.

"I never did learn who planted my notes in that warehouse," Sano said. "I've got people still investigating, but no clues have turned up."

"Have you found out who was in on Lord Mori's plot to overthrow Lord Matsudaira?"

"No, and not for lack of trying. That's the other thing that bothers

me. It's as if the conspiracy that almost got me killed never existed."

"I can't believe that it was irrelevant to Lord Mori's murder," Reiko said, "or that it could just fade away like smoke after the fire is gone."

"Nor can I," Sano said. "There's something we're missing about this case."

"What can it be?" Reiko asked.

"I wish I knew." Sano gazed up at the starlit sky. "Astrologers say that the movements of a celestial body that's far, far away in space can determine our destiny. We can't see it. But it's there."

Epilogue

The stars wheeled above the temple outside Totsuka village, a day's journey from Edo. There the exiled former chamberlain Yanagisawa admitted two travelers into his small, austere cottage hidden by pine trees. His shaved head and saffron robe glowed in the lantern light. The men bowed to him and removed the hats that shadowed their faces.

"Greetings, Father," Yoritomo said.

"Welcome, my son." Yanagisawa turned to his other guest. "Welcome, Enju-*san*. Or, I should say, Lord Mori."

"Yes," Enju said, "I'm *daimyo* now that my stepfather is dead."

"Your new position becomes you," Yanagisawa said, noticing that Enju was no longer the diffident young man who'd hidden a lifetime of pain behind lowered eyelashes and a controlled expression. Now Enju's face was relaxed and serene, his gaze open and direct. Confidence had given him new vitality. He stood taller, as if he'd shed a heavy burden.

"I owe you a great debt," Enju said. "Without everything you've done, I wouldn't be where I am today. A million thanks."

"I can't take all the credit," Yanagisawa said modestly. "Some of it goes to Yoritomo, for bringing us together."

He smiled at his son, who flushed with delight at the praise. Yori-

tomo had proved to be an intelligent accomplice who hadn't wasted the past three years at court; he'd spent them watching and listening. He'd identified men for Yanagisawa to enlist in his campaign to seize power. Some were old allies, fugitive troops from his army, *daimyo* clans oppressed by Lord Matsudaira, and disgruntled officials. Some were young samurai who were eager for combat or had relatives conquered by Lord Matsudaira and been treated badly by him. Others were just bored, unhappy, or looking for a cause. Yoritomo had recruited them, brought them secretly to the temple, and they'd agreed to help stage Yanagisawa's comeback. They now numbered in the thousands, including their troops.

Enju was one of them.

They sat, and as Yanagisawa poured sake, he remarked, "I must say that things have worked out well for us all."

"They certainly have," Yoritomo said, accepting a cup. "With Lord Mori gone, Lord Matsudaira has lost a crucial ally."

"And I've gained one." Yanagisawa handed a cup to Enju, who'd pledged the huge Mori army to him. "A toast to our alliance. May it triumph over our enemies."

They drank. "It's already eliminated my worst one," Enju said in a voice replete with satisfaction.

When Enju had shown up at the temple the first time, it hadn't taken Yanagisawa long to coax from him the reasons for his grudge against the world in general and his stepfather in particular. Enju had craved a sympathetic ear. Yanagisawa had listened to Enju describe how Lord Mori had forced him to submit to sexual relations, then to serve as a procurer of boys and accomplice to their murders. Yanagisawa had tried to manipulate Enju into assassinating Lord Mori, but Enju had lacked the nerve. What finally happened had worked even better, Yanagisawa had to admit.

Enju poured another round of sake. "Let's drink to my late stepfather. May he enjoy the place in hell reserved for perverts and murderers." He raised his cup, and everyone drank. "But let's not forget my dear mother. May she spend eternity with her evil husband."

Yanagisawa had also learned that Enju's hatred of Lord Mori ex-

tended to his mother, who'd sacrificed him to keep her husband happy. After the toast, he said, "Your mother did us a big favor. She picked right up on your hints that Lord Mori would be better off dead. She mentioned the idea to that maid of hers, and the rest is history."

Enju giggled, more drunk on elation than liquor. "You should have heard them arguing about whose idea it was to kill him. She forgot that it was mine. She took the blame and protected me. She never guessed how much I hated her. I put on a good act, if I do say so myself. She never suspected that I tricked her into doing my dirty work."

"Here's to the late Lady Mori," Yanagisawa said, and they downed another round.

"While we're at it, down with Lord Matsudaira!" Enju exclaimed.

He also hated Lord Matsudaira, who'd condoned Lord Mori's offenses against him and hundreds of other children in exchange for military support. Yanagisawa knew that Enju had spent years hiding his grudges, pretending to be a loyal subject. But this was the one place he need not pretend. Here he'd found someone who would take his side, in exchange for his soul.

"I propose a toast to my brilliant father." Yoritomo gave Yanagisawa a look of admiration. "That was such a good idea to have your man inside Lord Mori's retinue send Hirata the anonymous tip that Lord Mori was a traitor and plant those guns in the warehouse."

"And to have him steal those notes from Chamberlain Sano's trash and plant them with the guns," Enju said.

Yoritomo looked disturbed by this part, even though he drank with his companions. "Chamberlain Sano has been a good friend to me. Was it really necessary to attack him?"

"Yes," Yanagisawa said. "Nothing personal against him, but he has my job. I want him out of it."

Although Yoritomo nodded, he didn't seem convinced.

"Everything had to happen the way it did, or nothing would have turned out right," Yanagisawa said in an effort to smooth over the conflict between him and the son upon whom his future depended. "Sano was evidently part of the grand scheme. Had I left him alone, we might not be sitting here congratulating ourselves now."

"Fate operates in strange ways," Enju agreed. "How else to explain how Lady Reiko got caught up in our plot?"

Yanagisawa laughed. "That was an unexpected bonus. When my spy brought me the news that Lord Mori had been murdered, I knew right away who'd killed him, but when I heard that Lady Reiko was the primary suspect, you could have knocked me down with a feather."

"I felt sorry for her," Yoritomo murmured.

Not Yanagisawa. She'd too often inconvenienced him by helping her husband, and a strike against Reiko was a strike against Sano. "That should teach her to meddle where she doesn't belong. But my favorite lucky happenstance is that Police Commissioner Hoshina is gone. With his faction out of the way, my path back to the top is a lot clearer."

Yanagisawa had tried to brand Hoshina a traitor by incorporating guns his henchmen had stolen from the police arsenal into a fake plot that would also ensnare other enemies of his. But that wasn't what had finally done the trick.

"Here's to Sano for killing Hoshina," Enju said, raising his cup to another toast they all drank.

"It's just too bad that Sano is still chamberlain and more powerful than ever," Yanagisawa said. "But he won't be for long."

Dark excitement charged the air as the three men contemplated the power struggle to come.

"You won't hurt Chamberlain Sano when you oust him, will you?" Yoritomo said anxiously.

"I promise I won't."

But Yanagisawa believed promises were meant to be broken when necessary. And he knew that someone was bound to be destroyed during his bid to seize control of the Tokugawa regime. Better Sano than himself.